W9-BFA-412

Poser® 4 Pro Pack

f/x & Design

Richard Schrand

Publisher
Steve Sayre

Acquisitions Editor
Beth Kohler

Product Marketing Manager
Patricia Davenport

Project Editor
Jennifer Ashley

Technical Reviewer
James Ricks

Production Coordinator
Meg E. Turecek

Cover Designer
Jesse Dunn

Layout Designer
April E. Nielsen

CD-ROM Developer
Chris Nusbaum

Poser® 4 Pro Pack f/x and Design

Limits of Liability and Disclaimer of Warranty

The author and publisher of this book have used their best efforts in preparing the book and the programs contained in it. These efforts include the development, research, and testing of the theories and programs to determine their effectiveness. The author and publisher make no warranty of any kind, expressed or implied, with regard to these programs or the documentation contained in this book.

The author and publisher shall not be liable in the event of incidental or consequential damages in connection with, or arising out of, the furnishing, performance, or use of the programs, associated instructions, and/or claims of productivity gains.

Trademarks

Trademarked names appear throughout this book. Rather than list the names and entities that own the trademarks or insert a trademark symbol with each mention of the trademarked name, the publisher states that it is using the names for editorial purposes only and to the benefit of the trademark owner, with no intention of infringing upon that trademark.

The Coriolis Group, LLC
14455 N. Hayden Road
Suite 220
Scottsdale, Arizona 85260

(480)483-0192
FAX (480)483-0193
www.coriolis.com

Library of Congress Cataloging-In-Publication Data
Schrand, Richard.
 Poser 4 pro pack f/x and design / by Richard Schrand.
 p. cm
 Includes index.
 ISBN 1-58880-099-7
 1. Poser (Computer file) 2. Computer animation. 3. Computer graphics. 4. Human figure in art--Computer programs. I. Title.
TR897.7.S3784 2001
006.6'96--dc21 2001028862
 CIP

CORIOLIS

Printed in the United States of America
10 9 8 7 6 5 4 3 2 1

A Note from Coriolis

Thank you for choosing this book from The Coriolis Group. Our graphics team strives to meet the needs of creative professionals such as yourself with our three distinctive series: *Visual Insight*, *f/x and Design*, and *In Depth*. We'd love to hear how we're doing in our quest to provide you with information on the latest and most innovative technologies in graphic design, 3D animation, and Web design. Do our books teach you what you want to know? Are the examples illustrative enough? Are there other topics you'd like to see us address?

Please contact us at the address below with your thoughts on this or any of our other books. Should you have any technical questions or concerns about this book, you can contact the Coriolis support team at techsupport@coriolis.com; be sure to include this book's title and ISBN, as well as your name, email address, or phone number.

Thank you for your interest in Coriolis books. We look forward to hearing from you.

Coriolis Creative Professionals Press
The Coriolis Group
14455 N. Hayden Road, Suite 220
Scottsdale, AZ 85260

Email: **cpp@coriolis.com**

Phone: (480) 483-0192
Toll free: (800) 410-0192

Visit our Web site at **creative.coriolis.com** *to find the latest information about our current and upcoming graphics books.*

Other Titles for the Creative Professional

Canoma Visual Insight
By Richard Schrand

3ds max™ 4 In Depth
By Jon McFarland, Rob Polevoi

Bryce® 4 f/x and Design
By R. Shamms Mortier

Softimage®|XSI Character Animation f/x and Design
By Chris Maraffi

Character Animation with LightWave'[6]
By Doug Kelly

Digital Compositing In Depth
By Doug Kelly

To Larry Weinberg, Steve Cooper, Karen Carpenter,
and the entire staff at Curious Labs
and
To Dan Farr and everyone at Zygote and DAZ 3D
—Richard Schrand

&

About the Author

Richard Schrand is the author of six other books on 3D modeling and graphic and Web design, including *Canoma Visual Insight* and *GoLive 5 f/x & Design*, both published by The Coriolis Group, Inc. On top of this, he writes tutorials for numerous online sites and has contributed to many other computer software-related books. Recently, he began teaching Web design and Photoshop courses at a Nashville, Tennessee arts college. In his spare time he continues to build his business, GRFX ByDesign, located in the Nashville area.

Previously, Richard was in the broadcasting industry, working in such diverse markets as Charleston, South Carolina, and Los Angeles, California. Throughout that 28-year career, he won numerous awards and accolades, which included being listed in seven *Who's Who* publications since 1995, including *Who's Who in America* and *Who's Who in the World.*

Richard is married, has four children, two grandchildren, and an omnipresent dog named Demus who refuses to move out from under his feet as he works with his computers.

About the Contributors

The Poser 4 Pro Pack Color Studio is filled with the diverse visions of a premiere group of 3D artists. My thanks goes out to each of them for donating their time and talent, which has helped make the Color Studio a true showcase of what can be accomplished using Poser and the Poser Pro Pack. I also thank John Brugioni for his important contribution to Chapter 14, and James Ricks for providing the back-cover image as well as sharing his new technique, outlined in Appendix B.

Keith Ahlstrom started Le Blanc Noir Studio in 1989, where he specialized in promotional photography for the entertainment industry. His primary inspiration comes from 1940s-style movie stills, art deco, the art of Patric Nagle, and his background as a stage magician. He began dabbling in combining his photographs with digital imaging over a decade ago and continues to explore his unique style in these two diverse areas.

John P. Brugioni (Python scripting expert and coauthor of Chapter 14) has degrees in physics and applied physics and has been writing software in a variety of languages and on a variety of platforms for over 20 years. John has also worked on a range of analytical, modeling, simulation, and visualization projects. He currently works developing realtime 2D and 3D visual displays for distributed training systems. In his spare time he runs Red Ink Digital Modeling, which builds props and other Poser-related items for sale under the DAZ 3D brokering program. He resides in Manassas, Virginia, with his wife and children.

Willow DuNaan is the co-founder of the Poser Forum, the first Poser-based online community. She has been involved in art and design for most of her life, and attended art school in Dallas, Texas. She originally purchased the first version of Poser to assist her with her sketch art, but soon became enamored with digital media. Her work is inspired by color and the artistry of classic painters, and each image she creates is imbued with some personal meaning that might not be readily apparent to the viewer. She is married to Ian Grey, the director of the Poser Forum.

Phil Cooke is a plumber by trade who got tired of working in the cold and damp. The transition between that occupation and pursuing his hobby of creating Poser-ready props is a rather long and convoluted story. Suffice it to say, he now enjoys the fruits of his labors, providing free and low-cost add-ons to Poser users. Somewhere along the way he moved from England to Kentucky, but that's another (long) story.

Ken Gilliland got his start in the digital art world with a TI-99/4a personal computer. Back then, all computer graphics were drawn on graph paper and coded into hexadecimal notation. As software and hardware improved, he graduated to drawing with a joystick and, eventually, a mouse, and became a driving force within the TI-99/4a computer community. As the popularity of the TI-99 waned, Ken concentrated more on traditional forms of art—painting and drawing—which he showed at group shows and a local gallery. As the new art products for the personal computer became available (Fractal Sketcher, Painter, and Poser), Ken began to work digitally again. However, it wasn't until the release of Poser 4 that he began to focus seriously on 3D digital art. Since then, he has become noted for his unique compositions, animal models, and textures. In January 2001, the Orlando Gallery in Los Angeles featured signed, limited edition prints of his 3D digital art.

Catharina Przezak was born in Poland and is multilingual, speaking Polish, Dutch, German, and English. She is a graduate of a visual arts school and enjoys such diverse arts as oil painting, sculpture, music, and dance, and cultivates a love for photography and Web design as well. Her greatest interest is now digital computer graphics. After nine years as a successful model in television, video, and print media, Catharina made a serious change in career direction—she is now recognized worldwide as one of the best digital character and UV texture map creators on the Web.

James Ricks (artist of this book's back-cover image) has drawn, doodled, or painted ever since he can remember. Although relatively new to 3D graphics, he has taken to the art form like the proverbial duck to water. What he especially enjoys is finding new and exciting ways to texture the objects he creates—a throwback to his fine arts background. His images contain wonderful textures that sport vibrant colors. James has contributed images to such books as *3D Creature Workshop 2nd Edition*, and numerous galleries on the Web feature his work. He invented the glow technique featured in Appendix B, and served as technical editor for this book. James is married to his best friend, Lisa, and has two sons, Tanner and Blake, both of whom also enjoy doodling and painting.

Ken Sisemore began his digital design work way back in the dark ages (1995) with Adobe Photoshop. Two years later, he moved into 3D design using Bryce and Poser. Much of his modeling is created in Rhino 3D. He currently works on an ongoing online comic book called *Jack*, which features an alien trapped on Earth. His self-proclaimed style is a conglomeration of the macabre, B-movies, and sci-fi, with a healthy dash of the weird.

Magda Vasters was born in Poland and now lives in Germany. She has been drawing since she can remember. At present, she works by day as a Web designer and programmer and spends her nights drawing and texturing. She began her adventure with digital art long ago with Aldus Photostyler and Corel Photopaint 4. About five years ago, she began experimenting with 3D art and the Bryce 2 demo version. She has since then worked with different software, but creating in Poser and Bryce is always her first love. She started to make serious creations about two years ago in Bryce 3D and Poser, and since then has been working like a crazy creating her own version of art.

Robert Whisenant currently serves in the United States Navy. Following his second tour of duty, he plans to pursue his lifelong dream as a design professional in the civilian sector. Robert's abilities as a figure designer/modeler are completely self-taught. He began working with Poser 2 as a hobbyist. Compelled to figure out "why?" and "how?" Poser figures work the way they do, he began to dissect existing figures and build his own. In December 1999 he helped pioneer a brokering program with Zygote Media Group, Inc. (**www.zygote.com**) in which he offered figures designed specifically for Poser. In December 2000, the Poser Division of Zygote spawned an independent company, DAZ Productions, Inc., which focused solely on Poser content. Rob's designs can now be found on their Web site (**www.daz3d.com**) alongside DAZ 3D images. Up-to-date information regarding Rob can be found at his Web site (**www.rbtwhiz.com**).

Acknowledgments

As with any creative endeavor, no matter how individual it may seem on the outside, there are people who help prod the project along, either through offering friendship and support on a personal level, or support and well-deserved critiques on a professional level. This book combined both these factions as the writing process progressed. So bear with me as a take a moment to thank as many people as my addled mind can remember. And, if I leave anyone out, remind me, so I can make sure to add you in the next time.

To Beth Kohler and Jennifer Ashley whose support and critiques helped bring this book to life.

To the design and production team at Coriolis: Meg Turecek, production coordinator; Laura Wellander, Color Studio designer; Jesse Dunn, cover designer; and April Nielsen, layout designer.

To the book's technical editor, James Ricks, for wading through the first draft of the book and helping to spot the (very) few mistakes.

To my agent, David Fugate at Waterside Productions, for putting up with my ever-expanding list of needs and foibles. And to Maureen at Waterside Production for putting up with my numerous calls.

To Gus Bailey and Jim Owens (or would that be Jim Owens and Gus Bailey?) for their continued support.

To Taurean Blacque and his brood—you're definitely an inspiration.

To Shamms Mortier, a friend and fellow toiler.

To everyone at Nossi College of Art for putting up with my teaching eccentricities.

To my family—my wife Sharon, daughters Cyndi and Courtney, sons Richard and Brandon, parents, Ed and Jane, in-laws John, Adrienne, Barbara, and Bob. Thanks for always being in my corner.

And to all my past, present, and future creditors: The check is in the mail!

—*Richard Schrand*

Contents at a Glance

Part I Poser Basics

Chapter 1 New to the Pack 3

Chapter 2 Making Poser Your Own 25

Chapter 3 Deformers 71

Chapter 4 Character Development 93

Chapter 5 Image Is Everything 119

Part II Advanced Techniques

Chapter 6 The Setup Room 153

Chapter 7 Parental Controls 177

Chapter 8 Lighting Tricks and Techniques 201

Part III Motion and Web Integration

Chapter 9 Advanced Animation Modifiers 225

Chapter 10 The Art of Lip-Synch 249

Chapter 11 Creating and Displaying Viewpoint Media 267

Chapter 12 Creating Flash Animations 291

Chapter 13 LightWave and 3D Studio Max Integration 305

Chapter 14 The Full Python 319

Appendix A Resources 359

Appendix B The Ricks Effect 363

Table of Contents

Foreword by Steve Cooper, Curious Labs xxv

Foreword by Chad Smith, DAZ 3Dxxvii

Introduction ... xxix

Part I Poser Basics

Chapter 1 New to the Pack ..3
Poser Preview 4
Additions in Depth 6
 Viewports 6
 Working with Multiple Panes 10
New Compatibility Features 12
 LightWave and 3D Studio Max 13
 Viewpoint Experience Technology 16
The Setup Room 18
 Dem Bones, Dem Bones . . . 18
Flash-y Animations 19
 Flash File Formatting 20
2D Motion Blur 21
Material Animation 22
Python Scripting 22

Chapter 2 Making Poser Your Own25
One View No Longer Fits All 26
The Poser Interface 26
 Rearranging the Workspace 26
Getting Up to Speed 31
Working with Multiple Views 32
 Changing Views 32
 Project: Using Multiple Views Efficiently 34
Using Parameter Dials 38
 Facial Morphs 39
Camera Basics 44
 Emulating Real-World Photography 44
 The Camera Controls 46

Introduction to the Animation Controls 52
 Using the Basic Animation Control Panel 55
Creating a Basic Figure Animation 58
 Movement Study 60
 Project: Creating a Lifelike Figure Animation 63

Chapter 3 Deformers ..**71**
Making a Character Your Own 72
Modifying Basic Characters 72
 Using Built-In Controls 72
Magnetic Personalities 77
 Creating a Droplet Animation 79
 Dueling Magnets 81
 Magnets That Characterize 83
Catch the Wave 85
 Pattern Play 86
 Project: Build a Turbulent Environment 90

Chapter 4 Character Development**93**
Characterization 94
Taking a Stance 94
 Building the Stance 95
 Playing Hide and Seek 100
 Final Positioning Notes 101
Poser: The Next Generation 102
 Changing Victoria's Appearance 103
Mix 'n' Match 108
 PROP-rietary Systems 109
 Introducing the Hierarchy Editor 111
 Project: Creating a Prop Person 113

Chapter 5 Image Is Everything**119**
Map to Success 120
Map Types 122
 Modifying an Image Map in Photoshop 123
 Making the Bump Map 130
 The Transparency Map 134
Getting Deep into Texturing 138
 A Look at Deep Paint w/Texture Weapons 138
Animating Materials 140
 Project: Changing a Character's Appearance 141
 The Texture Map 141
 The Bump Map 146
 The Heroine Unveiled 148

Part II Advanced Techniques

Chapter 6 The Setup Room .. **153**

Dem Bones . . . 154
 Bone Basics 156
 Using Existing Bones 159
Structurally Speaking 163
 File Types 163
 Meshing Up 166
 Project: Build a Character and Add the Bone Structure 168
 Creating a Centaur 168

Chapter 7 Parental Controls .. **177**

A Parenting Guide for All of Us (Even If You Don't Have Children) 178
Parental Guidelines 179
 Pure Magic 179
 Magical Mystery Tour 183
Pointing, in This Case, Is Polite 187
 Lights, Camera . . . Point! 187
 Pointing Pointers 189
Mixing Features 192
 Project: Pointing at the Parent 193
 Some Minor Enhancements 198

Chapter 8 Lighting Tricks and Techniques **201**

Let There Be Light 202
Light Terminology 203
Basic Light Setups 204
 Modifying the Default Lights 206
 Using Spots to Set the Scene 210
Light Effects 213
 Shadow Play 213
 Total Eclipse of the Sun 215
 Project: You Light Up Their Digital Life 216
 Kick Lights 219

Part III Motion and Web Integration

Chapter 9 Advanced Animation Modifiers **225**

The Movement Is upon Us 226
 First, a Pep Talk 226
The Animation Palette 227
 Everyone Knows the King of the Sea 227
Blurring Reality 237
 Creating a Motion Blur 237

I'm Walkin', Yes Indeed . . . 238
 Struttin' Their Stuff 238
 Walk This Way . . . 240
Capturing Motion 243
 Using BVH Files 243
 Project: Walking in Multiple Paths 245

Chapter 10 **The Art of Lip-Synch** ..**249**
The Sound of Silence 250
Face Value 250
 Study Your Face 250
 Sound Files 252
 Testing, One, Two, Three 253
Mimic-ing Reality 259
 Lip Service 259
 Project: Tweaking Your Animations 263
 Modifying Other Movements 264

Chapter 11 **Creating and Displaying Viewpoint Media****267**
A Clearer View 268
The Point of Viewpoint 268
 Sales 269
 Modeling the Clothes 276
 Viewpoint Export and Settings 280
 Project: Animated Interactivity 283
Some Final Notes 289

Chapter 12 **Creating Flash Animations** ...**291**
Flashing the World 292
Flash Basics 293
Props in a Flash 294
 Ballin' the Jack 294
 Project: Flashy Folk 298
 Low-Resolution Models 299
 High-Resolution Models 300
Flashes of Color 302

Chapter 13 **LightWave and 3D Studio Max Integration****305**
Export/Import 306
Base Animations 306
 It's a Drag 306
 Project: Draggin' the Line (in LightWave) 310
 Project: Takin' It to the Max 315
Final Thoughts 317

Chapter 14 The Full Python ..**319**

Uncoiling Python 320
Python Primer 320
 Object-Oriented Scripting 321
 Variables 323
 Strings 328
 The String Module 331
 Lists 334
 Tuples 336
 Dictionaries 337
Poser Objects 338
 Making a Doughboy 339
Building a GUI 340
 A Greeting Button 341
 Creating a Button That Affects Geometry 343
 Project: Building a Corridor or Time Machine 348

Appendix A Resources ...**359**

Appendix B The Ricks Effect ...**363**

Index ..**369**

Foreword

A Letter from Steve Cooper, President, Curious Labs

It's a pleasure to add some introductory words to Rick's newest book. Richard Schrand has been a vocal supporter of Poser and Curious Labs long enough now to almost be considered family. He's been included in a number of internal discussions related to product development and beta testing. We include him because he brings his knowledge of our tools, of the market, and of the users needs into those discussions. I'm confident that readers of this book will build a great understanding about Poser and Pro Pack from Richard's insights and words.

Pro Pack evolved from our need to bring advanced functionality to Poser without creating a version of Poser that would be either too complex for our existing user base to appreciate, too expensive for price-sensitive pockets, or too targeted with features that only the most advanced users want. Pro Pack isn't for every Poser user, but it is the best solution if you're looking for a way to integrate animated Poser scenes into LightWave or 3D Studio Max, export Poser scenes as Flash for animated Web content, or create 3D characters for the Web via our Viewpoint Experience Technology exporter. Pro Pack also allows advanced users and modelers a streamlined process for setting up new custom figures, a multicamera view pane for offering four unique views of your project, and a new Python interface that allows you to automate virtually every operation inside Poser, or even develop custom exporters to conform Poser data to be whatever you need it to be.

Although the Pro Pack transforms Poser 4 into a powerful production tool, for those that don't use Pro Pack, Poser remains a viable, actively supported tool, which enables personal creativity. The key to Poser's success is the empowerment that rich content combined with intuitive controls yields. Our users tend to include Poser in a mix of products, each with its own learning curve, each with unique functionality. What Poser provides is virtually instant character animation capabilities. As users' skills evolve over time, they may use less of the existing pose, figure, and animation libraries and more of their own customized animations and modified figures, but from the moment they opened the box, they were able to create with Poser. Pro Pack is merely a way of expanding that experience with a bridge between other applications and end uses for Poser's ready-to-go content.

Poser and Pro Pack are our flagship products and our purpose at Curious Labs. We are proud of each, and proud of what they enable of users to create. Every day, we see inspiring new examples of Poser art or animation, or hear about incredible projects made credible with our easily mastered tools. We make tools that empower artists, and that feels right. We know our mission is on track when we hear confirmation from artists like Richard Schrand about his new book on Poser and Pro Pack. We know the world is interested in learning about our tools, and that Richard is just the person to pass along the knowledge. Good luck with your projects. Happy Posing!

—Steve Cooper
 President, Curious Labs, Inc.
 www.curiouslabs.com

Foreword

A Letter from Chad Smith, DAZ 3D

When Larry Weinberg and Steve Cooper (then at MetaCreations) first talked to us (then at Zygote Media Group) about providing Poser-ready models to be included in Poser 3, we approached it as we would any other custom-modeling project. Through creating the new figures for Poser 3, however, we became skilled with the process of optimizing models for Poser, and after we were done with that project we immediately went on to release a collection of plug-in content CDs for Poser. Within the next year, we opened an online Poser store and began our ongoing tradition of posting a new free Poser model every week.

Later, while discussing the new content for Poser 4, we were excited to hear about the development of new capabilities such as conforming figures, full-body morph targets, and transparency mapping. It became more apparent than ever that the potential and need for additional Poser content were endless. At the same time, with so much do to, it also became obvious just how much more we needed to devote our resources to Poser development. Our initial plans for the creation of the next-generation Poser figures that would utilize Poser's new capabilities eventually evolved into the "Millennium" figures, Victoria and Michael. Then, at the end of 2000, we formed DAZ Productions to focus our Poser-related development and marketing efforts.

Which brings me to where we are now. Much like Curious Labs is composed of the former MetaCreations Poser development team, DAZ 3D employs those who have been developing, marketing, and supporting Poser-ready models for over three years at Zygote. In both cases, this means much more than "same people, new name." Strongly believing that Poser and its user-base are worthy of our undiminished attention, we are excited to continue working in tandem with our old friends at Curious Labs.

Now with the release of the Poser Pro Pack, we are thrilled to have new limits and new markets for our collection of the highest quality Poser products available. Our experience with production for the TV, feature film, and gaming industries makes us even more pleased to see Poser arise as a contender these areas. Also, with the expanding and diversifying customer base that the Pro Pack is helping to promote, we anticipate many opportunities to continue to lower our prices and expand our libraries (with our own and brokered items).

We are especially pleased with the publication of *Poser 4 Pro Pack f/x & Design*. Not only are we excited for its value as a resource for learning how to get the most from the Pro Pack itself, but also for learning how to get the most from the newer, more sophisticated models we are producing for this evolving product and its users.

Specifically, Poser users can look forward to the continued development for and of our Michael and Victoria models, which are quickly becoming the standard figures for artists interested in pushing the limits of Poser. For the future, we plan to release many very cool new products, publish a few inspiring animations, and sponsor some exciting promotions. We at DAZ 3D look forward to this journey together with you.

—Chad Smith
 Product Development Manager
 DAZ Productions
 www.daz3d.com

Introduction

Welcome, Poser protégés one and all.

With your purchase of the program and of this book, you have officially become a member of an extremely loyal and active community that is constantly pushing the envelope of 3D animation. Poser aficionados, those who have been using this cutting edge program for the past few years, will tell you that the program is probably one of the most misunderstood 3D tools on the market. Beneath its seemingly simple exterior lies a powerful production tool that can literally fit any need you, as a hobbyist or professional, have.

With the ability to export models in popular 3D file formats such as DXF, 3DS, OBJ, and others, users quickly began to learn how to integrate the Poser character models into their favorite modeling programs, such as Ray Dream Studio, Bryce, Vue d'Esprit, Cinema 4D, Pixels 3D, and others. They found that integrating into other programs gave them the ability to upgrade the look of the models for a more realistic, less Ken and Barbie-esque appearance.

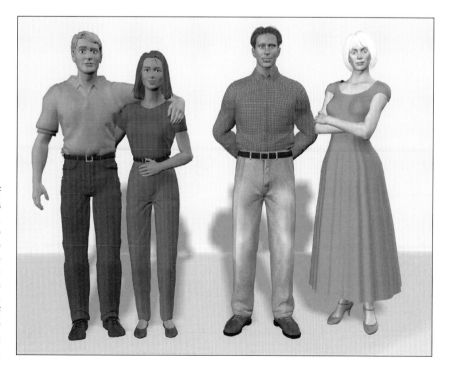

This figure shows an example of just how far the humanoid figures have come in the past few years. The main Poser male and female characters are on the left and the advanced male and female characters, Michael and Victoria are on the right. The latter two are available for sale online from DAZ 3D, the Poser division of Zygote Media. Notice how much more realistic the two models on the right look.

Poser's latest incarnation, Poser Pro Pack, adds some of the most anticipated and surprising features ever to be released in one upgrade. This book will take you on a guided tour of these features and help you understand—through tutorials and projects—how to get the most of the Poser Pro Pack.

Who this Book Is For

Whether you are new to the program or a veteran, you will find something useful in this book. I will assume, though, that you have a basic working knowledge of Poser, including how to place models onto the workspace, switch between the various model groups, open the main animation controls, and change views using the various on-screen tools and the workspace pop-up menus. If you are not familiar with these basic procedures, refer to the Poser user manual before delving further into the book.

The Novice Poser

If this version of Poser is your first exposure to the program, you're in for a treat. Throughout these pages you'll learn everything you'll need to know to get up and running quickly. I'll answer many of the questions newbies ask as they begin their explorations.

The Intermediate Poser

Within these pages you'll gain a better understanding of the advanced features of the program—everything from setting up cameras to emulate photography techniques to modifying lights to cast realistic shadows and elicit emotions. You'll also gain a better understanding of the advanced animation controls and techniques that will add realism to your files.

The Advanced Poser

Yes, there's even something here for you, too. With all the additions to the program—from generating Flash motion files to scripting using Python—you'll learn how to take Poser farther than it's ever gone before. You'll discover how to incorporate your files into LightWave [6] and 3D Studio Max. And you'll discover what all the excitement is with Viewpoint Experience Technology (VET).

So as you can see, there's something for everyone in this book, no matter what your experience level.

You'll also get a look at some of the great artwork that many of today's Poser pros are creating. The color studio will give you a great idea of how impressive Poser images can be, as well as help get your creative juices flowing.

How This Book Is Organized

Here's a quick look at the topics discussed in the book so that you can quickly move to the area you're most interested in.

- *Chapter 1: New to the Pack*—This chapter gives a quick overview of the newest features of the Poser Pro Pack.

- *Chapter 2: Making Poser Your Own*—For those who are new to the program, this chapter will be the first stop on your road to discovery. Here you'll learn about the new viewports, and how to work with the various controls for the camera, lights, and animation timeline.

- *Chapter 3: Deformers*—Discover the power of the Wave Deformer and Magnets. In this chapter, you'll learn how to use these two features to not only modify models in interesting ways, but also to create exciting animations.

- *Chapter 4: Character Development*—Learn how to pose your figures realistically—work with multiple models and position them so that they look natural. You'll also discover the finer points of element positioning and why careful placement so important for the final result.

- *Chapter 5: Image Is Everything*—In this chapter, you'll get hands-on experience creating original texture, transparency, reflection, and bump maps using existing templates.

- *Chapter 6: The Setup Room*—This chapter really begins to delve into the new, advanced features of Poser. Here you'll learn how to add bones to characters you create.

- *Chapter 7: Parental Controls*—No, this doesn't deal with ways to keep your children from accessing things you don't want them to. In this chapter you'll discover the best ways to do everything from basic parenting of one element to another, to making eyes and other body parts follow objects as they move across the screen.

- *Chapter 8: Lighting Tricks and Techniques*—Learn how to create realistic images and elicit mood through the proper setup of lights in your scenes.

- *Chapter 9: Advanced Animation Modifiers*—Learn how to use the advanced animation controls, and add motion blurs to your animation.

- *Chapter 10: The Art of Lip-Synch*—While lip-synching could have been included in Chapter 9, synching mouth movement to audio is probably the most difficult part of figure animation and thus deserving of its own chapter. Here, learn how to properly use phonemes, and discover the awesome third-party program, Mimic, that generates lip-synch files directly within Poser.

- *Chapter 11: Creating and Displaying Viewpoint Media*—Discover Viewpoint Experience Technology (VET) and how to best set up your files for premium Web presentation.

- *Chapter 12: Creating Flash Animations*—This chapter presents another highly anticipated addition to Poser. Discover the best ways to export everything from props to advanced characters as SWF files.

- *Chapter 13: LightWave and 3D Studio Max Integration*—The excitement is really building with this great new feature. Learn how to import your figure animations directly into these two high-end modeling programs.

- *Chapter 14: The Full Python*—With the addition of Python scripting capabilities, programmers can now write scripts to emulate everything from the most basic animations to highly complex effects such as hair or clothing blowing in the wind. This is a "Python primer" with real-world examples of basic scripts and explanations of why they are written the way they are.

- *Appendix A: Resources*—Here you'll find a comprehensive list of some of the most popular Poser-related sites on the Web. Many sites offer free content for Poser, while others provide low-cost, high-end models.

- *Appendix B: The Ricks Effect*—Learn about a brand new technique, discovered during the course of writing this book, that allows you to simulate glowing objects without special lights or image maps.

What You Need to Use This Book

Poser is a cross-platform program, which means you can use it either on a PC or Macintosh computer. Poser is a large program, though, especially as you add models to your collection. My copy of Poser takes up almost 3GB, so a large hard drive is highly recommended.

The base system configuration is as follows:

- *PC*—Minimum 250mHz Pentium with at least 160MB RAM (the more the better); 10GB hard drive; CD-ROM

- *MAC*—Minimum 250mHz with at least 160MB RAM (the more the better); a G3 processor is highly advantageous, with a G4 optimal; 10GB hard drive; CD-ROM

What's on the CD-ROM

There's a ton of great material on this book's CD-ROM. Included are demos of Poser and Deep Paint 3D w/Texture Weapons, free models provided by DAZ 3D, Dedicated Digital, Ken Sisemore, and Robert Whisenant, animated files that correspond to chapter projects, texture maps, and much more.

Time to Become a Member of the Poser Pro Pack

Okay, I've been rambling on for too long now. What you really want to do is to dive right in and begin discovering. So let me close by saying I appreciate your purchasing this book and hope you find it useful. The book is by no means intended to be a replacement for the Poser user manual but, rather, as an adjunct that you will hopefully keep handy as you delve deeper into this great program. So let's move along and discover what new features have been included with the Poser Pro Pack.

Part I

Poser Basics

Chapter 1

New to the Pack

This chapter gives a quick overview of what's new in the Poser Pro Pack; it also acts as an introduction to Poser if you are new to the program. Experienced users will also want to look at this chapter to get a feel for what the new features are.

Poser Preview

In the beginning, way back in 1996, when Poser was first introduced by MetaCreations, many 3D modelers looked at it with disdain. That's because it came with approximately 100 prebuilt models and didn't really give 3D purists the ability to create their own characters or add their own bones to their original creations. But Poser was initially created as a visual aid. With it, the graphic artist could quickly create designs and layouts with three-dimensional humanoid and animal models. The characters were very plastic looking, but they served a definite purpose. Those users who looked at the program from a nonjaded perspective, as I did, saw the potential for so much more.

An email list was created for users to share their tips and tricks. The list was moderated by the Poser production team, who actually listened to what was being said. With each subsequent upgrade, we found our suggestions being implemented. Throughout this time, folks were creating Web sites where users could exchange models and textures, read tutorials, and literally sate their insatiable desire to expand the quality of the images they were creating.

One of the great things about Poser is that you can create content for it with outside programs such as Carrara, Ray Dream Studio, 3D Studio Max, Cinema 4D, and others. Users began creating clothing, accessories such as glasses and shoes, new hair styles, props, and more for use on and with the models. Each model comes with its own template like the one shown in Figure 1.1, making it fairly easy to create new textures and, subsequently, new looks for each of the models. And then, when Poser included the ability to add transparency maps to the templates, all reality broke loose. Transparency maps are what make realistic models like Michael and Victoria possible. (Michael and Victoria are next-generation Poser characters that are for sale at DAZ 3D, the new Poser arm of Zygote Media.)

In 1999, MetaCreations sold off its interest in all its products in order to focus on its MetaStream technology, which is a visual delivery method for the Web (and will be discussed in Chapter 11). Many wondered what the future of Poser would be. That was answered about nine months later with the creation of Curious Labs. Run by many of the same people who were instrumental in the program's success at MetaCreations—including the creator of the program, Larry Weinberg, and the program manager (now company president), Steve Cooper—Poser Pro Pack represents the first major upgrade to the program under the new corporate heading.

What's so different between the old and the new? Let's look at a list of the differences before moving on to more detailed explanations:

- The workspace has been totally redesigned to give you the ability to work in ways that are more comfortable to you.

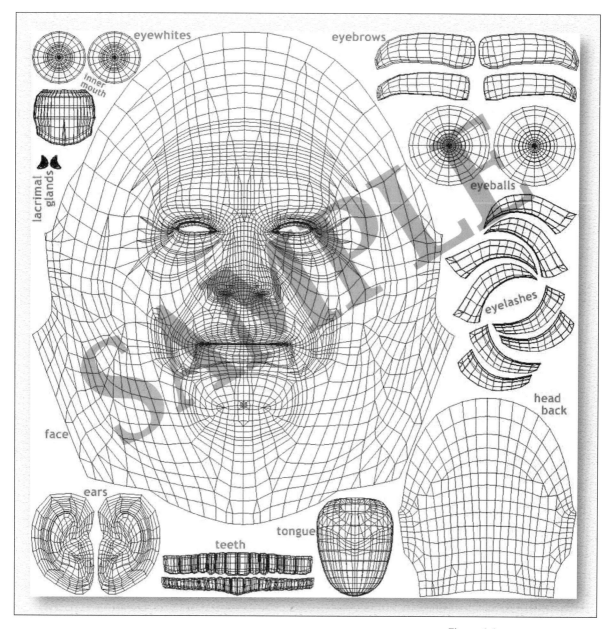

Figure 1.1

An example of a figure image map.

- There are new export features that make Poser even more useful to you as a designer and animator.

- You can now set up characters you design for animation by adding bones.

- If you create Flash files for the Web, you can now add 3D characters to your animations.

- You can create more realistic motion effects with the blur feature.

- Everything can be animated, all the way down to the materials assigned to your image elements.

Note: Throughout this book, I have tried to use the models that are included on the Poser Pro Pack CD-ROM and featured on this book's CD-ROM. In some cases, though, I used models available for sale from companies such as DAZ 3D and Dedicated Digital. If you don't have those particular models, you will need to use models you have in your collection. Ninety-nine percent of the time, any model you have will be appropriate for the projects and tutorials.

- You can create scripts using one of the easiest programming languages known to "computerkind."

Curious Labs could very easily have released the Pro Pack as Poser 5. But, as you can see, they didn't. If you want to have some sort of version number assigned to it, the Pro Pack would be version 4.5 or 4.989; although, in actuality, this upgrade is officially version 4.2.

Additions in Depth

In this section, I'll give you the details about the upgrade so you can share in the excitement of those who have used the program for years.

Viewports

Throughout its life, Poser has lived with the eclectic user interface designed by Kai Krause. It is both visually intriguing and beautiful but exceptionally functional, as you can see in Figure 1.2. There was one sticking point in the interface, though: the single-screen workspace. Yes, you could switch between different camera views via a pop-up menu, but the workspace retained its singular appearance.

Figure 1.2

The inimitable Kai Krause user interface design. The look is retained in the Pro Pack, but it has been enhanced in many ways.

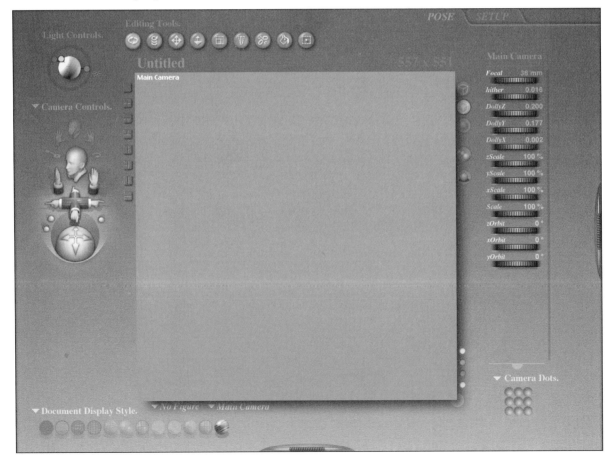

Notice the icons to the left of the workspace. Each of these icons, seen in Figure 1.3, represents a workspace layout. By clicking on them, you can set up your modeling environment in the way that is most comfortable.

Let's look at the different layouts from which you can choose. These are shown with each window's default view settings (following an explanation of the default views, I'll show you how to change the individual views to suit your needs):

Figure 1.3
A closer look at the workspace layout icons to the left of the workspace.

- *Single Window selector*—The top layout button is the single-window selector, the default window that appears when you start the program.

- *Quad view*—This selection gives you four different angles to work with. These include—clockwise from the upper left—the Front, Top, Right, and Main camera views. Figure 1.4 shows this layout.

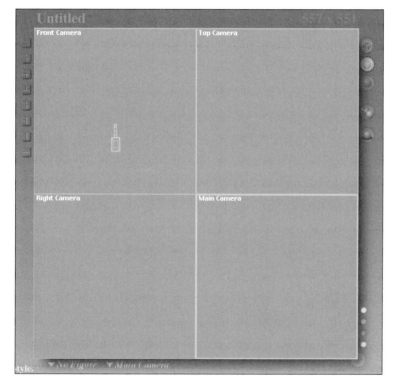

Figure 1.4
The Quad layout.

- *One Up/Two Down view*—Shows the Face, Left Hand (LHand), and Right Hand (RHand) cameras. Figure 1.5 shows this layout.

- *Two Up/One Down view*—Shows the Face, Dolly, and Main cameras. Figure 1.6 shows this layout.

- *One Left/Two Right view*—Shows the Right, Top, and Main cameras. Figure 1.7 shows this layout.

- *Two Left/One Right view*—Shows the Top, Front, and Main cameras. Figure 1.8 shows this layout.

Figure 1.5
The One Up/Two Down layout.

Figure 1.6
The Two Up/One Down layout.

Figure 1.7
The One Left/Two Right layout.

Figure 1.8
The Two Left/One Right layout.

Figure 1.9

The Vertical Dual layout.

- *Vertical Dual view*—Shows the Face and Main cameras. Figure 1.9 shows this layout.

- *Horizontal Dual view*—Shows the Top and Main cameras. Figure 1.10 shows this layout.

With these views, you have the ability to see changes you make from many different angles at one time without having to manually switch between them.

You aren't locked into those default views. You can change them by clicking on a viewport name. This brings up a view pop-up menu, which you can see in Figure 1.11. Select the view you want by moving your cursor over the view name, and pressing and holding down the mouse button.

Working with Multiple Panes

To get used to the multiple viewports, you'll place a model on the workspace and make a quick modification to it:

1. The first thing to do is switch to the Quad View mode by clicking once on the workspace layout icon that shows four screens.

2. Place the Business Man model on the workspace. To look at these four views (seen in Figure 1.12) in previous versions of Poser, you would have had to switch back and forth between the individual windows via the pop-up menu.

Figure 1.10
The Horizontal Dual layout.

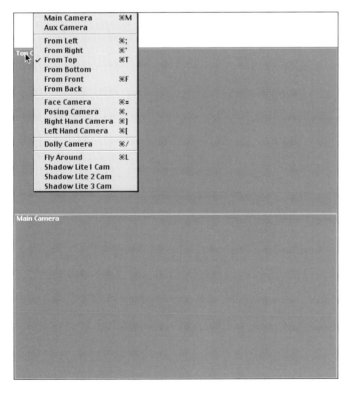

Figure 1.11
Changing which camera is
assigned to each viewport is as
simple as clicking on the
viewport name to bring up this
pop-up menu.

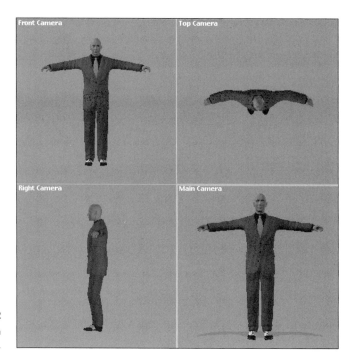

Figure 1.12

The Business Man model seen in the Quad View mode.

3. Select any body part in the Main viewport. In my case, I chose the fore-arm. Using the Parameter Dials, bend the arm to 1.000. All four viewports reflect the change you made.

4. Now click once on any of the viewports to make it active. You'll know it's the active viewport because of the red border that surrounds it. When you select a particular viewport, you can use the camera controls to the left of the workspace to change the orientation of the image.

Unfortunately, you still cannot truly use Poser in a dual-monitor setup. This means that you should have as large a monitor as possible so you can give yourself a larger area to work with by expanding the workspace to its largest possible size. You can, however, work around this limitation by working in the single-view mode when you need to make changes to tiny areas of the model, and then switching back to one of the multiple views to quickly see how your different elements are lining up with each other.

In Chapter 2, you'll work more extensively with the multiple viewports, switching between views in order to modify various elements in your scenes.

New Compatibility Features

Those of you who are into 3D modeling are going to love the new compatibility features associated with Poser. With this version, you can animate characters and props (individually and together), save the file, and then import them into two of the most popular 3D modeling programs with all animation and texture information intact.

Prior to this, you could save a model in one of the formats such as DXF, OBJ, or 3DS, import it into a modeler, and add it to a scene you've created. But to add your animated files to scenes created outside of Poser, you needed to do one of two things: save the scene you built in your modeling program as an image file and place it as a background image in the Poser program, or superimpose the rendered animation over the created scene in programs such as Final Cut Pro, Adobe Premiere, or Adobe AfterEffects. Those days, for some of you, are over.

Both of these solutions had inherent problems. In the first case, the characters would need to move in place or from one side of the frame to the other because you sure weren't going to get the still image to move. In the second instance, if you were creating a ground-based scene with a character moving through uneven terrain, you had some massive planning to do before merging the files. If you made a mistake, your character would look like he was defying gravity. So the best conditions for merging two animation files were when you were creating space or underwater scenes.

LightWave and 3D Studio Max

If you own LightWave 6 or 3D Studio Max, you need worry about the above problems nevermore, as Edgar Allen Poe so aptly put it. The Pro Pack comes with plug-ins for LightWave and 3D Studio Max so you can import your PZ3 files.

When you install the Poser Pro Pack, you'll be prompted to install the LightWave plug-in. Figure 1.13 shows this screen. If you have the program, select the correct version and click OK. It will automatically be installed in the LightWave plug-in folder.

Figure 1.13
You'll be prompted to install the LightWave plug-in after the Poser Pro Pack has been installed.

Importing to LightWave

Here's what you do to make sure that LightWave recognizes your saved Poser file:

1. Create a scene in Poser Pro Pack. Figure 1.14 shows two of the new characters included with the PPP. I call this Sugar Daddy.

2. Save the scene as a Poser document. (Boy, I can really state the obvious, can't I!)

3. In LightWave's Layout program, add the Poser plug-in. You should refer to your LightWave documentation if you don't know how to add plug-ins to the program. When you have installed it, you'll be asked

Note: More than likely, you'll need to quit Poser before opening LightWave due to memory considerations. I'm using LightWave [6.5], so if you're using an earlier version, your screen might look different from the screenshots shown here.

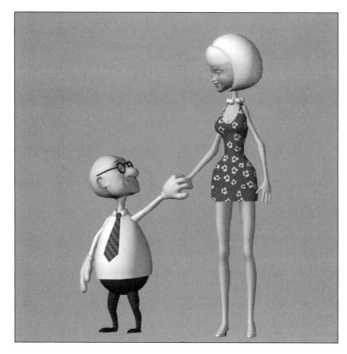

Figure 1.14
Here are two of the new characters included with the Poser Pro Pack in a scene I call Sugar Daddy.

Figure 1.15
This screen will appear while you are installing the Poser plug-in.

to find the Poser.dta file. Figure 1.15 shows this screen. Navigate to this file, which is located in the main Poser folder. You need to assign the DTA file in the Poser folder so LightWave can read documents with the .pz3 extension.

> **Note:** The Poser plug-in works only in the Layout program, not in Modeler.

4. Next, choose File|Import Scene In LightWave. When the file selector screen comes up, select Show: All Documents in the Load Scene dialog box (as shown in Figure 1.16) and then locate your saved Poser .pz3 file.

Figure 1.16
You need to tell LightWave to look for all files in order to import your Poser file.

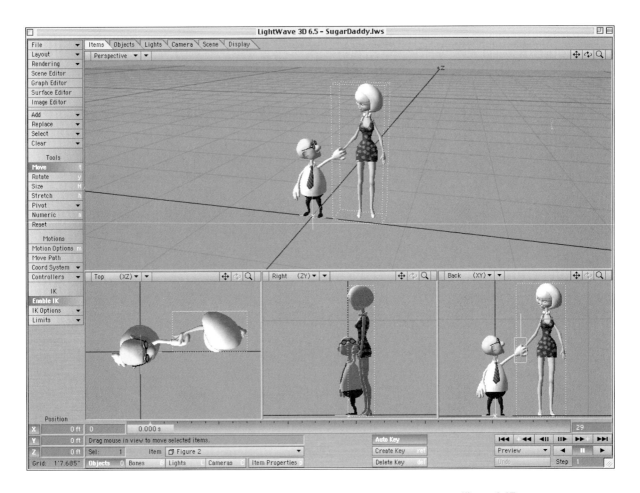

5. Your Poser file, whether a simple posed character or an animated char-acter, will appear on the workspace to be included in your scene, as shown in Figure 1.17.

You can also save your Poser projects in LightWave's .lwo format by selecting File|Export|LWO.

Setting Up 3D Studio Max

If you are working on a PC and have 3D Studio Max installed, use the Max Plug-In installer to place the Poser plug-ins in your version of Max. Then fol-low these steps:

1. Click the Geometries button and select either Object Type (for Poser props), Name and Color (for Poser figures), or Scene Creation (for Poser scenes). Figure 1.18 shows the Geometries selection panel.

2. You need to navigate to the folder where the appropriate Poser files are. Then all you need to do is select the element you want and click OK. The element you selected will appear on the workspace, as shown in Figure 1.19.

Figure 1.17
Sugar Daddy and his friend ready for inclusion in your scene.

Figure 1.18
The Geometries selection panel with the three Poser import choices.

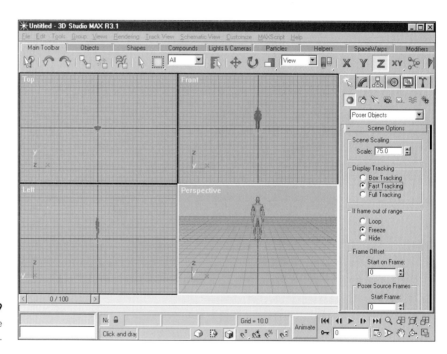

Figure 1.19
The chosen Poser element on the 3D Studio Max workspace.

It's important to note, especially for new users of Poser, that if you are importing props, you need to find the files that have the .pp2 extension. Figures have a .cr2 extension. Scenes have the .pz3 extension. The names of inappropriate files—those that don't conform to the type of Poser element you want to import—will appear grayed out in the list in the Load Scene dialog box.

Viewpoint Experience Technology

A couple of years ago, MetaCreations introduced a Web display technology called MetaStream. With this technology, designers could use programs such as Canoma to create 3D content that, when saved and incorporated on a Web

page, allowed visitors to interact with the file. If they had the plug-in, they could rotate and zoom in and out from the image to get a look at the entire model. Viewpoint Experience Technology (VET) is, basically, the latest incarnation of this technology.

There are limitations to this technology that are essential for you to know prior to using it. You can learn more at Viewpoint's Web site, **www.viewpoint. com**, and in Chapter 11.

Using VET

It's a fairly simple process to save your still images or animation files in Viewpoint Experience Technology format.

1. Place a character on the Poser workspace, such as our sugar daddy character. Don't worry about posing him right now; just place him on the workspace.

2. Choose File|Export|Viewpoint Experience Technology. The VET Media Player Format Export box seen in Figure 1.20 appears. For this exercise, assign a destination path and give the file a name. Click the Save button to save the file.

Figure 1.20
The VET export screen.

Once saved, the file can be added to your Web site. It's important to note that visitors to your site will have to have the VET VMP plug-in installed in their browsers. What's VMP? The Viewpoint Media Player, which is available at **www.viewpoint.com.** It's a good idea to make sure you place a link to Viewpoint's site on your Web page that contains the VET file or files so that people who don't have the plug-in can easily download it.

As you may have noticed, I said that you can save animations as *VET files*. These animations can trigger certain events from your site. In Chapter 11, you'll learn how to create and save animation sets as VET files for use on the Web.

The Setup Room

On the Poser workspace, there is a new tab, seen in Figure 1.21, that transports you to the Setup Room. This is an awesome addition to the program and has the potential of becoming an integral part of your Poser production process.

Figure 1.21
The tab that transports you to the Setup Room is located in the upper-right corner of the screen.

What is the Setup Room? In a nutshell, it gives you the ability to create all new characters that are ready to be animated in the main Poser work area. You can't pose models in this area; it's strictly there to give you the ability to assign bones to a modified or new model.

Note: In Chapter 6, you'll learn how to create and bone characters using both the Pose Room and Setup Room.

Dem Bones, Dem Bones . . .

Before you rush over to Chapter 6, you need to get a basic feel for the Setup Room. There are two ways to work in this area.

Setup Room #1

To work in the Setup Room, you can follow these steps:

1. Place a character on the workspace inside the Poser Room (the new name for the main workspace). Then click the Setup tab in the upper-right corner of the screen.

2. As shown in Figure 1.22, you'll see the model and a bone structure on the main workspace in the Setup Room. This is a base bone structure that can be modified by you, the bone specialist.

Setup Room #2

Here is another way to work in the Setup Room:

1. Without placing a figure or a prop on the workspace, click the Setup tab to enter the area.

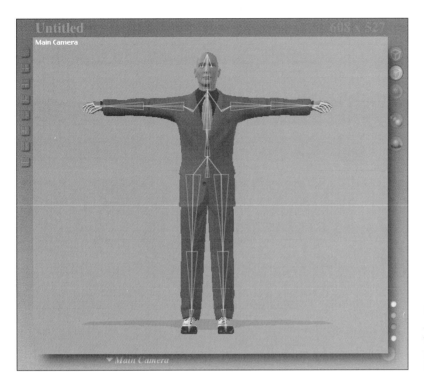

Figure 1.22

Just as if you were using a high-tech X-ray machine, you can view Poserdude's bones in the Setup Room.

Figure 1.23

The Bone tool, which is used to modify or create bone structures for your models.

2. Select the Bone tool, the location of which can be seen in Figure 1.23. You can now create a new bone structure by drawing it out on the workspace.

What can you use this for? How about adding bones to a sphere or cone prop to make the sphere or cone prop bendable? You could add bones to shoes or other elements to bring them to life. Why, you could even create a composite character using props and different body and clothing elements in a mad scientist-like experiment.

Flash-y Animations

Along with Python (introduced later in this chapter), the ability to export Flash files would very well make this upgrade a worthwhile purchase even if nothing else was changed. Anyone who has worked with Macromedia's Flash program, and those who have begun using Adobe's LiveMotion, knows that it is difficult to create humanoid 3D animations in these programs.

Lately, Flash 3D has been a hot topic with developers and end users alike. And Poser gives you a head start in incorporating true 3D content to your Shockwave (SWF) files generated by Flash and LiveMotion.

Note: An SWF file is included in the Chapter 1 folder of the CD-ROM that accompanies this book, so you can see how Poser Flash files look. You'll need the Flash Player to view the file. You can download Flash Player for free from **www.macromedia.com**.

In Chapter 12, you'll work with this feature, learning the best ways to set up your files for optimum quality. Right now, though, I'll give you an idea of what it takes to create an SWF file.

Flash File Formatting

In the Pose Room, place any of the Poser characters on the workspace. I'm using the new Minnie character, one of seven new character models bundled with the Poser Pro Pack.

1. Using the basic pose controls, create an interesting pose for Minnie.

2. Choose Animations|Animation Setup and change the Frame Count to 1, rather than 30. Refer to Figure 1.24.

Figure 1.24
Change the Frame Count to 1 because you'll render only one frame in this "animation."

Figure 1.25
Select the Flash Animation (.swf) setting from the drop-down menu in the animation setup panel.

3. Next, choose Animations|Make Movie. In this panel (shown in Figure 1.25), select Flash Animation (.swf) from the drop-down menu.

4. Click the Flash Settings button to bring up more controls for your file output parameters. Again, you'll learn the best parameters for different model types in Chapter 12.

5. Click OK, name the file, and then assign a place to store it when prompted to do so. Don't worry when the image on the screen looks horrid as it does in Figure 1.26 as the rendering starts. The final file won't look like this.

Learning to create Flash animations for the Web or for presentations is ultimately in your best interest as a designer or as a Web hobbyist. It's probably safe to say that there is no computer on the face of the planet that does not have the Flash plug-in stored on it. So, by learning and using the Flash export feature, you'll be joining a worldwide community and offering some great content that other Flash developers will be envious of.

2D Motion Blur

Take a close look at images that depict action or speed created in almost every 3D program, including Poser, and you'll notice that one thing is missing. What is it? The natural blurring that takes place as an object moves quickly from one place to another. These images all seem to have been taken by a camera using high-speed film. But now, with the Poser Pro Pack, you can use the 2D Motion Blur feature to add that extra element of motion to your renderings. Figure 1.27 shows an image that uses this new feature.

In Chapter 9, you'll discover the best ways to set up and utilize 2D Motion Blur.

Figure 1.26

As your file renders, the image on screen takes on a rather frightening look. This has nothing to do with how the final file will look.

Figure 1.27

The 2D Motion Blur feature gives this image that extra sense of motion.

Material Animation

You now have the ability to animate materials inside of Poser. That means you can create a planet, add an image layer of clouds, and have those clouds animate over time. You could create flowing water simply by animating the materials assigned to an elongated block. Or you could have dark hair turn gray to show aging.

You'll learn more about animating materials in Chapter 5.

Python Scripting

As I said earlier in this chapter, if the Flash export capability and Python scripting were the only two elements included in this update, the cost of upgrading from Poser 4 to the Poser Pro Pack would be well worth it.

Why? With Python scripts, you can add unprecedented control to your characters, props, and other models; you can add extra functionality to the program by creating plug-ins that fill a need; you can even simulate real-world effects that are available only with the most high-end programs—and that, most of the time, come as a third-party plug-in at added cost.

What are some of these effects you can create? Anything from collision detection—where props or characters bump into each other and then bounce realistically off each other—to making hair and clothing appear to be blowing in the wind. This latter script would be extremely long and complicated, but for Python aficionados, it is definitely doable.

In Chapter 14, you'll get a course in Python scripting so that, if you are unfamiliar with this programming language, you can see not only how easy it is to work with, but how quickly you can put your ideas into reality. There are also scripts on the CD-ROM that have been written expressly for this book by some of the people who were instrumental in creating the Poser Pro Pack.

Moving On

As you can see, there is an awful lot of exciting enhancements with the Poser Pro Pack, and each will be discussed in depth throughout these pages. You'll want to take your time, work through the various projects, then expand upon them to create your own inimitable style. And at the back of the book you'll find a comprehensive list of Web sites that provide free and/or low-cost content for Poser.

Once again, for all of you who are new to Poser, welcome to the community. For the rest of you—whether you have used Poser for a while or are considered power users but have yet to upgrade to the Pro Pack—enjoy this tour of the great new features and get out there and purchase the update. You won't regret it.

So, let's move on. In the next chapter, we'll begin truly working with Poser Pro Pack. Chapter 2 will be especially relevant for those of you who are new to the program, but even seasoned users will find something of interest because you'll begin working with the new workspace features and discovering the little details to creating lifelike animations.

Chapter 2

Making Poser Your Own

In this chapter, you'll set up the program to fit the way you work. You'll learn how to reposition controls and work with the new multiple viewports. New Poser users will become familiar with the workspace, and experienced users will become comfortable with basic workspace changes.

One View No Longer Fits All

Throughout the life of Poser there has been one constant—a single viewport for the workspace. Although other 3D applications provided users with multiple viewports (usually top, right or left, front, and an interactive camera view), Poser steadfastly maintained a one-view-fits-all layout. To change viewports, users would click the drop-down menu to the left of the workspace and select a new camera view, of which there were more than a dozen. This is no longer the case. Poser now has various multiview options, each of which can be assigned any of the numerous views individual users are most comfortable with.

There have also been some minor modifications made to how you access those numerous camera views. Instead of using a drop-down menu located off the workspace, you can now click the view title directly in the workspace window to make your visual changes.

In this chapter, you'll get a quick overview of how to work with the new Poser workspace, as well as how to utilize the new features to quickly prepare your scenes and animations.

The Poser Interface

There is one thing about Poser—it doesn't limit you to a set layout. The graphical user interface (GUI) is completely customizable, enabling you to set up your workspace as you like rather than forcing you to redefine the way you work.

Rearranging the Workspace

When you first start up the program, it opens to its default setup, which is shown in Figure 2.1. This layout is pretty much the one most people are accustomed to seeing and working with. But many people forget that each element of the interface can be moved anywhere on the screen and that you can save your new layout so that it appears every time you start Poser.

Follow these steps to rearrange the workspace elements:

1. With Poser running (it sure wouldn't be prudent to make changes to the interface with the program closed), click once on the default figure in the workspace and press your Delete key to remove it from the screen. Poser will boot up faster if it doesn't have to load a model when starting up.

2. Move your cursor over the Editing Tools heading on the workspace and click and drag the item up and to the left.

3. Repeat Step 1 to relocate the camera controls (shown in Figure 2.2) and the light controls to the right side of the screen.

4. Finally, move the workspace and the other controls so they are positioned as you see in Figure 2.3.

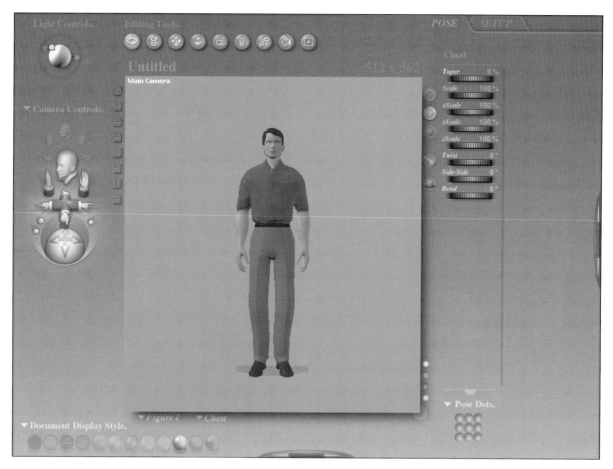

Figure 2.1

The default interface when Poser is first started. Almost every aspect of this layout is modifiable.

Figure 2.2

The camera controls on the way to their new position.

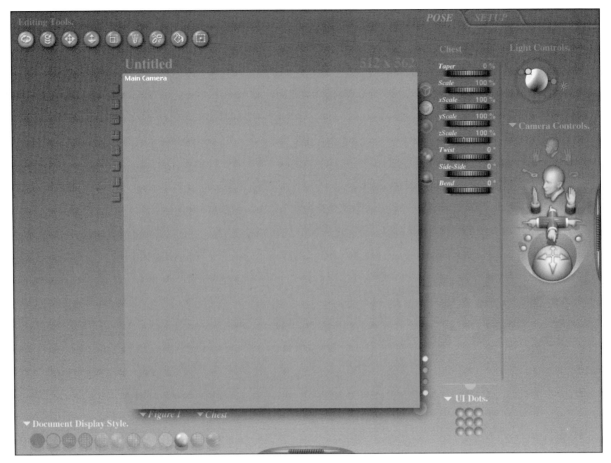

Figure 2.3

All the controls in their new positions.

Figure 2.4

The Preferences controls.

5. Choose Edit|Preferences to bring up the Preferences control window seen in Figure 2.4. Click Launch to Preferred State under Document Preference, then click Set Preferred State, and then click OK.

Quit the program and the restart it. The changes you made will become the new default setup, so you can always begin with the controls where you like them. Of course, as you can see in Figures 2.5 and 2.6, you can position these controls in completely different areas of the screen so they are in the position you most like, or you can revert to the factory state by using the Preferences controls to reset them.

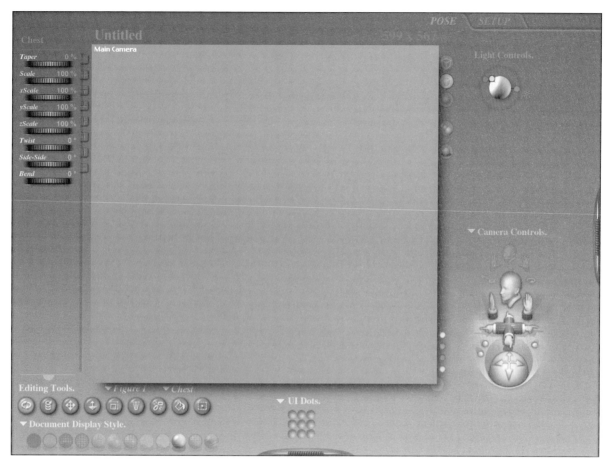

Figure 2.5
A second example of how the
Poser controls can be positioned.

An Undocumented Modifiable Element

Another on-screen element can be changed, but this change is an undocumented one. Some consider this an Easter egg—one of those neat little tricks that don't have any real effect on the workings of the program but are fun to discover.

Notice the outline figure graphic on the workspace. Figure 2.7 shows the default Poser Pro Pack graphic, which has been modified so you can see it better. This figure appears to be fixed to its location, but it can be moved. You can also change the graphic.

To modify the default graphic, follow these steps:

1. Place your cursor over the graphic and click and drag it around the screen until it's in a position you like.

2. Now either right-click (PC) or Option+click (Mac) the graphic. It will change to another figure. There are approximately 10 images you can choose from, which you can see in Figure 2.8. Continue to click until you find the one you like.

Horizontal, Vertical, On, or Off

You can quickly change the horizontal and vertical alignment of both the Editing Tools and Document Display Style buttons by right-clicking (PC) or Option+clicking (Mac) the respective title. Double-clicking any of the tool titles will make the tool icons disappear. Double-clicking the title again will make them reappear (on a Mac, this is called a *window-shade effect*).

Figure 2.6
Another example of how the Poser controls can be positioned.

Figure 2.7
Poser Pro Pack's Easter egg. You can move this graphic to another position on the screen or change the graphic altogether.

Getting Up to Speed

Another control panel you are going to want to be aware of is the Document Display Style panel, located (originally) in the lower-left quadrant of the screen (see Figure 2.9). When you work with more advanced models, or as you add additional models on the workspace, the program begins to slow down. It matters not how much RAM you have installed. It's just the nature of the

Figure 2.8
A compilation of the different figure graphics you can choose from to decorate your workspace. This image has been modified so you can see the graphics more clearly.

Figure 2.9

The Document Display
Style panel.

beast. By selecting a style from the Document Display Style panel, you can increase the speed in which the screen redraws by changing the way your model appears on the workspace.

Working with Multiple Views

As I said at the beginning of this chapter, one of the main changes in the Pro Pack is the multiple views feature. Although Poser aficionados have become used to working with the single view, they have quickly welcomed this change with open arms.

> **Note:** I recommend that you have a large monitor so that you can maximize the workspace. When you change to multiple views, the screens can become rather small.

Changing Views

Changing views is a simple matter. All you need to do is click one of the buttons to the immediate left of the modeling workspace. Each of these buttons shows the view style you are selecting. Refer to Chapter 1 for a complete list of these viewport options.

Follow these steps to change views:

1. Open the model shelf and place the Casual Man model located in the People subdirectory of the Figures area on the workspace. The People subdirectory is what opens by default when accessing the model shelf.

2. Click the Quad View button (the first one under the single port button—which returns you to the default workspace view). As you see in Figure 2.10, the workspace will be cut into quarters, giving you four views of the scene.

> **Note:** The model shelf is located to the right of the screen and contains the models you have in your collection. If you do not know how to access this area, refer to the Poser documentation that ships with the program.

3. Notice that one of the windows is outlined in red. This indicates that the viewport is the active one. What this means is that you can make changes to the figure in that viewport and see those changes reflected in the other viewports.

4. You can make another viewport active by clicking it once . You can now make changes to the model in the newly selected viewport (shown in Figure 2.11).

Changing Cameras in Individual Viewports

No matter which workspace layout you use, you can change the cameras associated with each viewport. To do so, follow these steps:

1. If you have changed to another workspace layout, select the Quad view.

2. Click once in the lower-left viewport to make it active (the red border will appear around it).

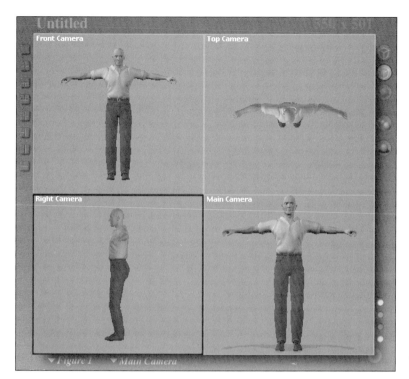

Figure 2.10

A look at the Casual Man model in the Quad view.

Figure 2.11

The active viewport on the workspace has been changed; the border indicates which viewport is active.

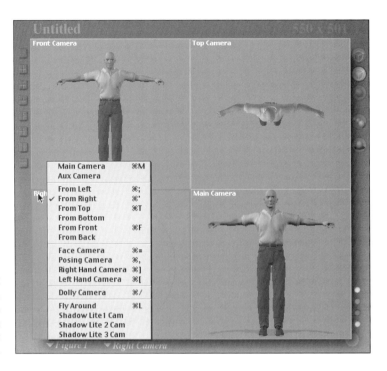

Figure 2.12

The various camera views can be selected via this pop-up menu. Each of the viewports allows you to access this menu via the view title.

3. Click and hold the mouse button down on the view title to bring up the view selection screen seen in Figure 2.12.

Each element is modifiable in each of the viewports. The other viewports will update automatically no matter which one you are working in. When you utilize the multiple views, it becomes much easier to position multiple elements so they interact with each other correctly.

Using Multiple Views Efficiently

To get a feel for how easy it is to use multiple views to position multiple elements, you'll be working with two of the Pro Pack's newest models, Bertha and Barney. These models are called *low-polygon* models, meaning their *geometry* (the mesh that makes up the 3D model) is not highly detailed. Low-polygon models are perfect for creating *avatars*—on-screen representations of people—for games and chat rooms. They are also easily translated to Flash files, which will be discussed in Chapter 12.

Follow these steps to work with Bertha and Barney:

1. Choose File|New or use the Command/Control+N key combination to create a new document. If you haven't quit the program between the last tutorial and this, you'll be asked if you want to save your changes to the document. Click No. A new, blank workspace will open. (The blank workspace will only appear if you set up your program to open that way, as discussed under "Rearranging the Workspace.")

2. In the model shelf, select Figures. Open the Pro Pack submenu and select the Barney character. Once he is on the workspace, click once on Bertha and at the bottom of the model shelf (seen in Figure 2.13), click the button with the double checkmark. If you were to double-click a second figure, you are telling the program you want to replace the one on the screen with this new selection. A window will appear that asks if this is really what you want to do. Clicking the double checkmark button tells Poser you want to *add* a new figure to the scene, rather than replacing the one already there.

3. If it isn't already selected, select Quad view.

4. Notice how the two models are in the same location (see Figure 2.14) on the workspace. You will want to change this so that they are standing side by side. (The next section of this chapter will go into detail on posing characters using the parameter dials.)

Figure 2.13

Use the double checkmark button at the bottom of the model shelf to tell Poser to add a second model to the scene.

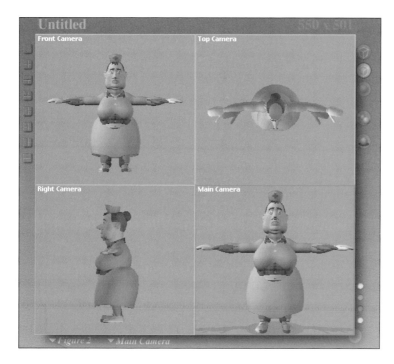

Figure 2.14

When you add a second model to the workspace, it will be placed in the exact same position as the first, often causing overlapping like you see here.

5. At the bottom of the workspace window, notice that Figure 2 is selected in the leftmost tab. You can select a different model, be it a figure or prop (hair, some clothing models, prop elements such as the ball) by clicking the tab. Figure 2.15 shows the current figure pop-up menu this action activates.

Figure 2.15

The current figure pop-up menu, activated by clicking the element tab at the bottom left immediately below the workspace.

6. The tab immediately to the right of the current figure tab lets you choose different scene elements and specific parts of a model. Figure 2.16 shows the current element pop-up activated and the body part submenu that appears. For now, select Body from this menu.

Figure 2.16

The current element pop-up menu, with the body-part submenu selections open. Here you can choose specific parts of a model to modify.

7. Activate Figure 2 in the current figure pop-up if you changed the active figure in Step 5. Then, in the current element pop-up, select Body. Change the xTran parameter located in the Parameters list by clicking and dragging the xTran Parameter dial to the right until Bertha is standing next to Barney, as you see in Figure 2.17.

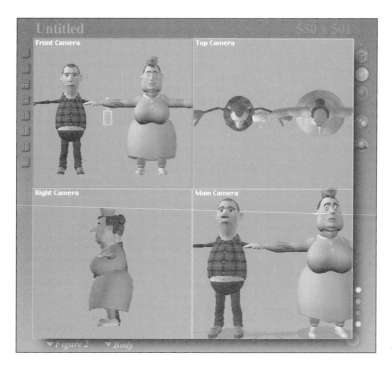

Figure 2.17
Barney and Bertha are positioned to stand next to each other.

8. Select another viewport. Change this viewport's camera to Top. Or, if you already have a viewport with the Top camera assigned to it, select it. Move Bertha by dragging the zTran parameter dial until she is standing ahead of Barney, as in Figure 2.18.

Note: It can often become difficult to simply click an element on a model and have the right element actually selected, especially when the element you want is located directly behind another model element. Using the current element pop-up menu makes the selection process much easier.

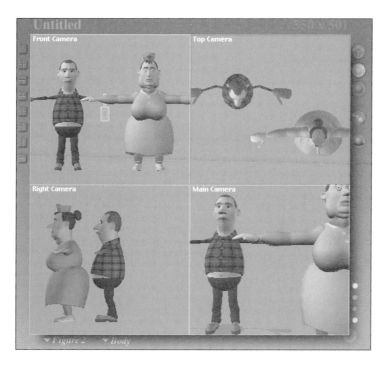

Figure 2.18
Bertha takes the lead in their extremely slow race.

Cameras and the Spacebar

When your cursor is on the workspace, holding down the spacebar when a tool is active affects the camera positioning. In other words, if the Rotate tool is selected, the camera will rotate; if the Move tool is active, the camera moves left, right, up, or down. Bottom line: the spacebar affects the positioning of the scene in the workspace.

Once you have finished, return to the single-frame workspace (the top view selector button). Prior to this version, positioning characters meant you had to switch camera views over and over again.

Using Parameter Dials

Often, you can use the various tools to quickly position or pose an entire figure or an element on a figure. But to make precise changes, or to make small modifications to an element's position, rotation, or bend, you need to use the parameter dials located immediately to the right of the workspace.

The parameter dials control the various morph parameters that are assigned to an individual model and to the various elements that make up that model. One of the great things about Poser is that it gives you the ability to create new morphs for a model, and by visiting sites such as **http://renderosity.com**, you can find additional morphs to give you even more control over your characters.

Morphs assign positive and negative attributes you can use to change everything from the positioning of a character's fingers or mouth to its overall size. These changes can be subtle, as you see in Figure 2.19, or extreme, as shown in Figure 2.20. Extreme changes can have a decidedly negative effect on your model; notice the changes to the arm in the Figure 2.20, seen in the close-up view in Figure 2.21.

The next section will give you a feel for working with the parameter dials in Poser. There's no difference between the way these dials work in the Pro Pack and the way they work in earlier versions, but it doesn't hurt to refresh your memory on their use, especially in conjunction with the pop-up menus beneath the workspace.

Figure 2.19
Subtle changes using morph targets can make a standard model look like a totally different model.

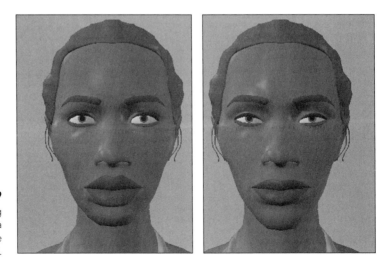

Figure 2.20
By turning parameter dials too far, you can make elements of a model look extremely strange.

Figure 2.21
The close-up view of the changes to the arm of the model shown in Figure 2.20.

Facial Morphs

One of the best ways to familiarize yourself with the paramater dials is to work with the face dials. You have to use almost every dial associated with some facial elements to get a realistic expression. This is especially true with the mouth; smiles can look extremely fake if you don't use all the dials. Here's how to make a realistic smile in the Poser Pro Pack:

1. With a new document open, place the Casual Woman on the workspace.

2. If you have set up the program to open to a multiple view by default, switch to single view because you don't need to see any other angles for this exercise. Switch to the Face camera so you have a close-up of Posette's face. (Posette is the unofficial nickname for the female Poser character.)

3. Let's go ahead and add some hair now. In the model shelf, select Hair from the shelf categories. It will open, by default, to Hair Types. Select Female Hair 2 from the list by double-clicking it. Within a few moments it will appear on the workspace in the correct position on the model's head.

4. As you move the cursor over elements in your scene (body parts, props, etc.), they will highlight to give you a visual cue as to what will become active when you click the mouse button. Upon clicking on that element, the highlighting will change to give you another visual cue that that particular element is ready to be modified. Click once on the model's face; make sure it is highlighted as Figure 2.22 shows before you click it. (Note that you can also select the head from the current element pop-up.)

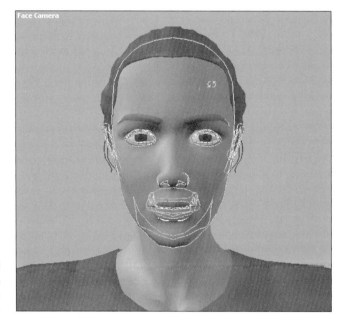

Figure 2.22
Each element will be highlighted when you move the cursor over it.

5. The first thing you'll do is give Posette a basic smile because she has too bland a look on her face in her default pose. (Refer to Figure 2.23 as you work through this section). Change the Smile dial to 1.300. You can do this in one of two ways. Either click and drag the dial underneath the appropriate morph to the right (dragging left will give you negative values, in this case creating a frown), or double-click the dial to bring

Figure 2.31
The 25mm focal length.
Notice the slight warping of
the shoulders, beginning to
give an appearance of the
use of a fisheye lens.

- *25mm*—This lens begins moving into the macro lens/fisheye lens realm (see Figure 2.31).

These focal lengths, when used in conjunction with the animation controls, can add some fantastic cinematic effects to your work. You can create a scene where the central figure stares into the camera while the background recedes into the distance. You can give the illusion of a figure leaning in toward a concave piece of glass, warping the form as it leans closer to the camera. But, before we get into advance animation techniques, it would be a good idea to get a feel for how the camera controls work and what they mean.

The Camera Controls

Now let's look at the controls at your disposal. You can either use the model you modified earlier, or you can create a new document and place a different character on the workspace. One way or the other, you need to have a character on the workspace so you can see the camera effects when you begin to change the focal length. Refer to Figure 2.32 for the following definitions.

Figure 2.32
The basic camera control dials.

- *Focal*—Assigns a focal length to the lens.

- *Hither*—Fixes clipping that might occur as you change focal length. *Clipping* is the disappearance of portions of the model because the camera has "moved into" it. By using the hither control, you can modify the lens of the camera to reveal the clipped area again without changing the feel of the image. The hither control is extremely sensitive, so work in small increments when using it.

Figure 2.29
An example of the 50mm focal length.

- *50mm*—This is another good portrait lens that can be used for many mood-style images, such as those that have high-contrast lighting (see Figure 2.29).

- *100 to 150mm*—Good for group shots, these lenses draw objects together, making them appear closer to each other than they really are (see Figure 2.30).

Figure 2.30
An example of the focal length set at 150mm.

Camera Basics

Another important part of creating more realistic looks for your models is setting up the cameras as they would be set up in the real world. Using the model you just modified, you'll return to the Face camera viewport and look at how different lens settings can help you achieve a look that reflects actual photographic lenses.

Emulating Real-World Photography

The lens settings in Poser have always been extremely accurate in their emulation of their real-world counterparts. Unfortunately, for most beginning and intermediate users, they are the most overlooked controls in the program. Modifying the focal length of a camera gives you so much creative power that, once you begin to really work with lenses, you will wonder why you've ignored them in the past. (I often use the term *lens* when discussing focal length because, when you purchase a new lens for a camera, you don't ask for a 35mm focal length; you ask for a 35mm lens.)

Some knowledge of what lenses are used in any given situation is a must. You can find tons of information on photographic techniques on the Web and at your local library, and it would definitely behoove you to take some time to learn what lenses are used for what results.

Basically, though, you can follow these guidelines:

- *35mm*—This focal length (or lens) is perfect for portrait work. It correctly captures the true dimensions of the subject without warping surrounding objects such as shoulders, hair, and neck (see Figure 2.28).

Figure 2.28

An example of the 35mm focal length.

Figure 2.26

Our woman now has a more natural smile, except for her eyes, which are just a bit too intense.

15. What you haven't done is reposition her eyelids. Right now, it almost appears as if she is trying to bore a hole through you. Change Blink Right to .131 and Blink Left to .040.

Other models, especially the higher-resolution Michael and Victoria models, have even more parameters to help you create realistic expressions, including wince morphs for both eyes. But for now, instead of creating a model with a smile that looks like the forced grin on a fashion doll, you have created something more natural, as shown in Figure 2.27.

Figure 2.27

A side-by-side look at the smile that was just created, as seen in the Face camera and the Main camera views.

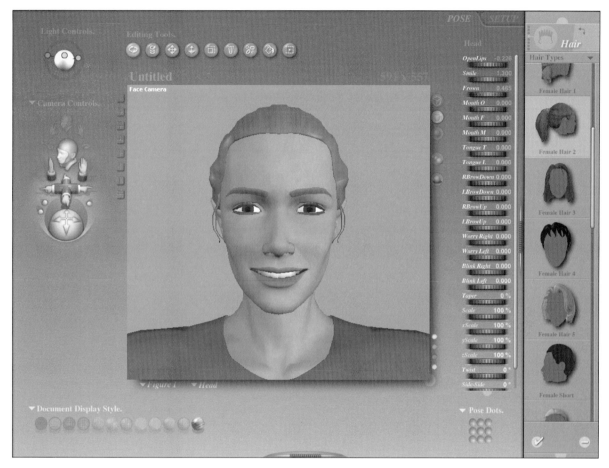

Figure 2.25

When you add a touch of a frown to the smile, the corners of the mouth don't appear so unnaturally peaked.

You now have a more realistic smile of greeting. Not the type your mother might give after not seeing you for 10 years, but definitely one that shows friendship and has an "I'm glad to see you again" feel.

To complete the look, you really need to work on the eyes and eyebrows, which, luckily, are part of the head morph selections. Again, you are working from the base set of morphs that come with this particular model. You can find other morphs that can be added to this base list to increase modeling functionality.

11. Below Tongue L is the start of the eyebrow and blink dials. You'll begin with RBrowDown. Change it to -.400.

12. For LBrowDown, change the setting to -.105. One thing you do not want to do is make left and right settings the same. This produces an unnatural look because no face is symmetrical and no movement is perfectly reflected on both sides of the face.

13. Change RBrowUp to .350, and leave LBrowUp at its default 0.

14. Use the next two dials, Worry Right and Worry Left, to add the finishing touches to the eyebrows. Change Worry Right to -.258 and Worry Left to .236. Posette should look similar to Figure 2.26.

Parameter Settings

Value: 1.300

Min Limit: -100000.000

Max Limit: 100000.000

Name: Smile

Sensitivity: 0.01831

Graph Cancel OK

Figure 2.23
(Left) Numerous dials give you complete control over different facial elements.

Figure 2.24
(Right) By double-clicking a parameter dial, you can access the Parameter Settings window where you can set numerous parameters for the particular morph you are working with.

up the Parameter Settings window seen in Figure 2.24. Type in the new value in the Value field. The smile this value creates kind of reminds me of when you try to tell a really poor joke and the people give you a false smile to make you feel better. We'll fix that in the next step.

6. Change the setting on the OpenLips dial to -.226.

7. Next, change Frown to .465. Yes, that's right; you want her to frown a little. It makes the smile a bit less like the Joker's smile. View the results in Figure 2.25.

8. Notice that when you changed the Frown setting, the model's mouth became a bit too wide. You'll begin working on that by changing the Mouth O parameter to .286. Yes, you're opening the lips again, but that will be fixed shortly.

9. Change the Mouth M setting to .140.

10. The next parameter, Tongue T, is an important one. It has as much to do with the realism of a smile in Poser as any other dial. Move this one back and forth a bit to see how it affects the overall appearance of the mouth, but make the final setting for this morph -.300.

The Parameter Dials

Take a moment to study the parameter dials. You should always check the names associated with the dial. If the names that appear above each dial do not indicate the parts you want to work on, you'll need to go back to the workspace or current element pop-up to change the selection. Next, look at all the dials associated with the head; everything from head type to eyelid position is under your control.

- *DollyZ*—Moves the camera in and out on the z-axis. Picture the camera on a pedestal (tripod). This dial rolls that pedastal toward and away from the subject.

- *DollyY*—Moves the camera up and down along the y-axis. In the real world, this is known as pedestaling up and down.

- *DollyX*—Moves the camera left and right along the x-axis. In the real world, this is called trucking.

- *xOrbit*—Literally rolls the camera on the x-axis, as if it were on a circular track.

- *yOrbit* —Rolls the camera on the y-axis, as if it were on a circular track that loops over and under the subject.

- *zOrbit*—Rolls the camera on the z-axis, as if it were on a circular track that envelopes the subject from front to back.

You'll also notice the graphic interface for the camera controls that are, by default, located to the left of the screen. These graphic controls, for the most part, emulate the numeric controls for the selected camera. Many people use this set of controls for basic moves, but for fine tweaking of camera position and movement, you will want to use the actual numeric values.

Note: When cameras other than the Main camera controls are selected, the xOrbit, yOrbit, and zOrbit change to Roll, Pitch, and Yaw.

Working with Focal Lengths Part 1: Portraiture

To really see how the focal length affects your image, use the model you have on the workspace and follow these steps:

1. Select the head and change the following parameters:

 - Twist: 25
 - Side-Side: 5
 - Bend: 0

2. Open the current element pop-up and choose Camera|Face Camera, as shown in Figure 2.33. Its parameter dials become active.

3. Change the Face camera's Yaw (zOrbit) setting to 25.

4. Select the model's right collar by clicking it. Change the Bend setting to 10.

5. Now select the right shoulder and change its bend to 36.

6. Repeat Steps 4 and 5, changing the Collar and Shoulder bends to -10 and -36, respectively. If you used positive numbers for the left side of the model, you would raise the elements rather than lower them. Posette should now look like what you see in Figure 2.34.

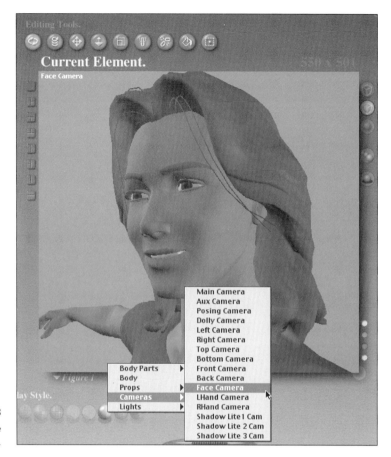

Figure 2.33

The path to selecting the Face camera.

Figure 2.34

The Casual Woman model ready for her camera test.

You now have a good example of how the 25mm lens warps the image. The model's left shoulder appears to be rather thick in comparison to the rest of her body seen in the image. This is part of the fisheye effect the shorter focal lengths produce.

7. Change the view to Main camera so you can better see what's going to happen. You'll begin by shortening the Focal value so that the model becomes extremely distorted, as shown in Figure 2.35. The setting I used for this image is 10mm.

Figure 2.35

Selecting an extremely short focal length massively distorts the model.

8. Now change to the Face camera and change the focal length to 35mm. First you'll notice that the model's face fills the screen. By assigning a higher value to Focal, you have zoomed in on the subject. From the Editing Tools panel, select the Translate In/Out tool, and while holding down the spacebar on your keyboard, zoom out slightly so more of Posette can be seen. Notice how her left shoulder looks more natural at this focal length.

9. Change Focal to 50mm. Again, you've zoomed in and her face has taken on a slightly wider look. But the dimensions of her face are still well within normal visual accuracy.

10. Use the Translate In/Out tool to zoom out a bit so you can see her shoulders.

11. Notice that, although she appears a bit "thicker" (Figure 2.36), her natural dimensions have remained even.

Figure 2.36
The Casual Woman, although still proportionally accurate, is beginning to gain a little weight.

Working with Focal Lengths Part 2: Multiple Characters

To show how the focal length truly affects the appearance of an image, especially when there is more than one element in the scene, you'll create a new document. Make sure you have Quad view selected, and do the following:

1. Open the current element pop-up beneath the workspace, and open Props. From the Prop Types, choose a ball, a box, and a cone, and place them on the workspace. Position these elements in the following manner (working from the last element placed to the first):

 - Cone: Change xTran to .212 and zTran to -.411.

 - Box: Change xTran to .050 and zTran to -.087.

 - Ball: Change xTran to -.090 and zTran to .223.

2. Switch back to the single view and, using the Translate/Pull and Translate In/Out tools along with the spacebar, position the elements so they appear as shown in Figure 2.37.

3. Select Main camera from the current element or pop-up. Set Focal to 25mm. (If you have been double-clicking the parameter dials to bring up the Parameter Settings window and changing the values numerically, for the rest of this section, drag the Focal dial instead so you can best see the focal changes in action.)

Figure 2.37

The props as they should appear on your workspace.

4. Change the focal length to 35mm by dragging the Focal dial to the right. Notice how everything begins to squeeze together.

5. Now, using the dial again, change the focal length to 100mm. It's almost beginning to appear as if the three elements are side by side.

6. Finally, change Focal to 150mm. This is a perfect example of depth of field (DOF), a technique used by cinematographers and still photographers since the dawn of filmmaking. Switch to the Quad view (Figure 2.38) and you'll see that the three props haven't changed position; it's just that the combination of focal length and DOF have created an illusion of close proximity.

7. To see how changing focal length and DOF affects humanoid figures, return to the single view and reset all parameters by choosing Edit|Restore|All. Select each of the props and remove them from the scene.

8. Place the Casual Man on the workspace and change his position to yRotate -8, xTran .212, zTran -.411.

Figure 2.38

By changing the focal length, depth of field is affected, drawing the elements in the scene together.

Note: When all parameters are restored, the positions of each element will return to their default 0, making them overlap each other as they did when you first placed them in the workspace.

9. Next, place the Casual Woman figure on the workspace. Remember to click only once on the model and then use the Create New Figure button (the double checkmark) at the bottom of the model shelf; otherwise, she will replace the Casual Man. Leave her in the default position.

10. Select the Main camera, and change Focal to 25mm. This focal length will give you the best possible differentiation when you change the focal length in the next step.

11. Change Focal to 150. Notice how the Casual Man character seems to be right behind the Casual Woman, touching her back as in Figure 2.39.

12. Drag the Focal dial to the left and watch how the two characters become separated when the focal length is reduced. Focal lengths between 35mm and 50mm will give the most realistic appearance.

Introduction to the Animation Controls

As I stated earlier, the focal length of a selected camera can be animated just like every other element in a scene. As with virtually every 3D program, animations are created by assigning key frames along a timeline and making changes to the various elements' parameter settings at those key frames. Poser then takes that information and figures out where all the modified elements would be positioned between the key frames, giving the sense of motion.

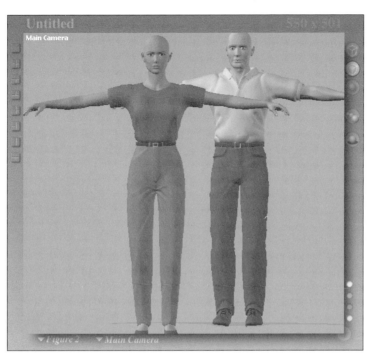

Figure 2.39
Because of the depth of field, the Casual Man seems to be directly behind the Casual Woman.

Figure 2.40
The basic animation controls.

As you can see in Figure 2.40, the basic animation controls are rudimentary. But don't let that fool you. Poser has all the controls you need to set up your basic animations. Starting from the left, the controls on the Basic Animation control panel are as follows:

1. *VCR-style control buttons*—From left to right:

 * *First Frame*—takes you back to the first frame of your animation

 * *End Frame*—takes you to the last frame of your animation

 * *Stop*—stops the animation during preview

 * *Play*—plays a preview of the animation

 * *Step Back*—moves you back one frame at a time

 * *Step Forward*—moves you forward one frame at a time

2. *Loop*—Located directly beneath the control buttons. Click Loop to turn looping on or off. If looping is turned on, the animation preview will replay over and over until you stop it.

3. *Frame number fields*—The first (left) number indicates which frame you are currently viewing. The second (right) number tells you how many frames are assigned to the actual animation.

4. *Timeline bar*—The bar directly beneath the frame number fields lets you quickly toggle from frame to frame. Click , hold over the triangle, and drag it left or right (depending on its location along the line) to view your animation.

5. *Key Frame control buttons*—From left to right:
 - *Previous Key Frame*—takes you to the previous assigned key frame
 - *Next Key Frame*—takes you to the next assigned key frame
 - *Edit Key Frames*—opens the advanced animation control screen (The advanced animation control screen will be discussed in detail in Chapter 9.)
 - *Add Key Frames*—assigns a key frame to the animation
 - *Delete Key Frames*—removes key frames from the animation

6. *Skip Frames*—When Skip Frames is activated, frames will be skipped during animation previews. Sometimes this helps alleviate undo slow-down because Poser doesn't have to calculate as many frames during the preview.

Notice in the frame number fields that the animation is set to 30 frames by default. By default of whom, I'm not sure. (Okay, bad pun. Sorry.) This emulates the basic frame rate of film or video, with 30 frames equaling one second (:01). Actual frame rates are 29.95 frames per second (fps), but that .05fps differential is fairly inconsequential unless you are actually preparing animations for broadcast or film.

It's important to know the fps rate in your animation, because it will affect how well your files are played back over the Web, if that is how you will be showing your creations. Here is the general rule of thumb when it comes to frame rates:

- *30fps*—Good for film and video. If you are asking people to download your animation for viewing with QuickTime, RealPlayer, or Windows Media Player and want the smoothest possible playback, this is the frame rate to use.

- *15fps*—This is a good frame rate for delivery directly on a Web page.

- *12fps*—This is the best frame rate for smooth Flash/Shockwave animations.

Other considerations you need to keep in mind when creating animations that will be delivered via the Internet include number of colors, audio type (stereo or mono), and length.

Using the Basic Animation Control Panel

With that short technical discussion out of the way, now it's time to put your newfound knowledge to work. In this section, you'll use the two models (Casual Man and Casual Woman) from the section "Working with Focal Lengths Part 2: Multiple Characters" and animate the depth of field using the Basic Animation control panel:

1. Reset the Main camera focal length to 35mm and make sure the Basic Animation control panel is open so your screen looks like Figure 2.41.

Figure 2.41

The workspace is set up to create the first animation.

2. Move the triangle on the timeline bar all the way to the right so the frame number field reads 30 of 30. Click the Add Key Frames button to set a key frame. Why did I tell you to do this when you haven't made any changes? In this animation, you'll watch the depth of field go from normal (35mm) to high (150mm) and then back again. The animation will also loop, so by making the start and end points of the animation identical, you'll have a smooth looping effect that makes the characters look as if they are moving in and out.

3. Move the timeline bar to the center of the line so the Frame number field reads 15 of 30. Or you can double-click the first numeric frame field and type in the frame number.

4. Change Focal to 150mm and click Add Key Frames.

5. Make sure Loop is selected and click the Play button to watch your animation.

You'll notice a swinglike effect as the camera's field of view (FOV) changes. That's okay. It's correctable using advanced animation techniques you'll learn in Chapter 9. For now, just focus on how the two characters seem to draw into and then recede from each other.

Figure 2.42

Poser turns your on-screen elements into base primitives when you're previewing an animation so that the preview runs as smoothly as your computer will allow.

Rendering the Animation

In order for Poser to give you a fairly smooth playback, it transforms the on-screen elements into base primitives, as you see in Figure 2.42. To get the full effect of what you did in the tutorial in the preceding section, you will want to render the file.

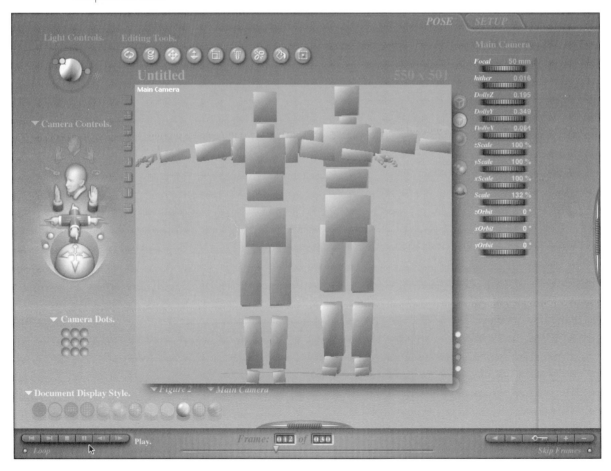

Here's what you need to do to render the animation:

1. Choose Animation|Animation Setup from the pull-down menu at the top of the screen.

2. Frame size is extremely important. The larger the size of the image, the larger the file will be—and animation files can be huge. Change the width to 200 and the height to 200, which will make the rendered animation a manageable size. Leave the rest of the settings as they are and click OK. The workspace will change to the size you assigned, which is normal.

3. Next, choose Animation|Make Movie (Command/Control+J) to bring up the movie parameters window seen in Figure 2.43. Here you can name the movie (which, for this section, you'll leave at its default, Untitled), select the type of animation file you want it saved as (Sequence Type), and set other parameters for the output file. You won't make any modifications to this screen for this tutorial, so just go ahead and click OK.

Figure 2.43
The Make Movie window. This is the third of four steps for setting up your animation output.

4. When you click OK, the Compression Settings screen appears (Figure 2.44). In this screen, you can set the type of compression used, how many colors will be assigned to the file, and the quality of the video. For now, though, keep everything as it is and click OK.

5. You'll now be asked where to save your file. Once you set the save path, click OK to render the animation.

6. When the rendering is complete, the video will open in a new window (Figure 2.45) where you can play it back.

Changing the Playback Speed

You'll see that the file plays back pretty quickly. You actually want it to be slower so you can see what is happening. Here is how to do that:

1. Choose Animation|Animation Setup and change the frame rate to 10. This will extend the duration of the animation to 3 seconds.

Figure 2.44
The Compression Settings window. This is the final setup screen; the next step is to save your animation file.

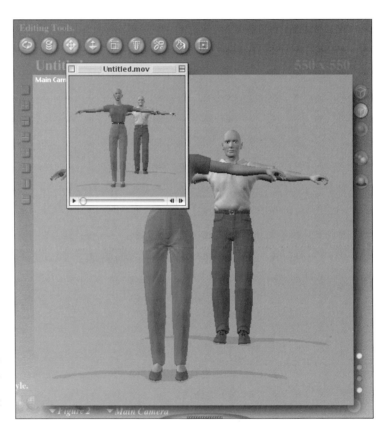

Figure 2.45
The rendered video track appears over the Poser workspace so you can see how it looks without closing down the program.

2. Cycle through the Animation|Make Movie windows and overwrite your original animation file.

3. Playback is slower now, giving you the ability to see the FOV changing.

Creating a Basic Figure Animation

Animating such things as the FOV is pretty simple. Where the complexity comes in is when you're working with humanoid models. As you discovered earlier in the chapter, when you're animating a human figure, you must

make small changes to numerous elements if you want to make movement seem natural.

Full-figure animation entails an eye for small details. Remember science class? Remember learning that for every action there is an equal and opposite reaction? Well, that has probably never seemed as true for so many as it does when dealing with figure animation. This is because, for every movement one body part makes, there is movement in the opposite direction for another body part— or series of body parts.

Take, for example, walking. When we move one leg forward, the rest of the body doesn't remain in place. As that leg moves, the hip on the opposite side shifts downward. The shoulders rotate slightly. The opposite arm swings out while the arm on the same side as the forward-moving leg swings back. The shoulders tilt slightly. The head bobs a bit. The toes of the moving leg tilt upward slightly.

One of the biggest mistakes in animation occurs when people animate hand movements—in particular, wrist twists. Unfortunately, most humanoid models that are set up to be animated allow you to twist the wrist. This is physically impossible. Don't believe me? Hold your arm out to your side and try to twist just your wrist. It can't be done. It isn't set up to rotate; it can bend up and down and (slightly) left and right along the perpendicular plane, but it can't rotate. Rotation occurs from the twisting of the forearm, which also causes the upper arm to twist in relation to the movement.

Yet when this impossible movement is assigned to the model, it can actually work in your favor. Because the "skin" of the model is not as stretchable as real skin, being able to rotate the wrist slightly can help offset mesh anomalies such as tearing or skin polygons cutting into each other, giving an unnatural fold to the offending area. So, although a real wrist can't rotate, being able to make it do so on your model can help alleviate problems that crop up because of limitations of today's technology.

Another thing that modelers do that isn't natural is make both sides of a model exactly the same. This is what causes many figures to look fake or doll-like. No face is truly symmetrical, and no body is either. One eye is slightly lower than the other. The mouth doesn't rest in a true horizontal line; one side droops slightly in relation to the other side. This is why if you took a photograph of a face looking straight at the camera and then cut it in half the left and right sides would look different when viewed separately. Also, breasts (both male and female) differ from right to left. One side might droop a little more, or it might be smaller than the other. Hips are not perfectly aligned; one juts out a little more than the other. Legs are not the exact same length. Neither are arms. These differences are slight and not readily apparent upon casual observation. But we intrinsically see them, and although we don't necessarily know why, we notice when something is amiss. It all happens subconsciously, but it happens.

This subconcious observation of asymmetry is also why, when you view an image created in Poser or any other 3D application, you can either get a sense of total reality or experience that twinge that tells you something isn't quite right. You might not be able to discern exactly what's wrong; you just have that uncomfortable feeling that something is different.

It's especially important to know and understand the concepts I discuss above when dealing with Poser characters. The creators of the program have given us the ability to add incredibly lifelike figures to scenes we create. But they have also given us the challenge of modifying these figures so that they possess that subliminal posture that screams out, "Hey! Look at me! I'm a real person stuck in a computer-generated image!"

Movement Study

To demonstrate what I just discussed, open a new scene in Poser and place the P4 Nude Woman on the workspace. You're going to change the position of the right arm (which is the arm on the left side of the screen as you look at your monitor). Switch to the single view (if need be) and make sure you're viewing the model via the Main camera. Then zoom in on the figure so you see the arm from the shoulder to the fingertips. Now you'll look at the wrong way to twist the arm, and the right way:

1. First, one wrong way. Select the right hand by either clicking it or selecting it from the Body Parts list in the current element pop-up.

2. Change the Twist parameter to -90. As you can see on your screen and in Figure 2.46, the skin of the forearm twists unnaturally, squeezing together a bit and causing a slight crease to appear.

Figure 2.46

Twisting the wrist causes an unnatural appearance in the forearm.

3. To see this even better, select the right forearm and change Twist to -53. Notice how the upper forearm and wrist look like taffy twisted into a corkscrew, as in Figure 2.47.

Figure 2.47
When the forearm is twisted, the unnatural twisting of the skin around the wrist is even more prominent.

4. Return the hand and forearm to their default resting position of 0.

5. Select the right shoulder by clicking the upper arm. Change the Twist setting to -8.

6. Now select the right forearm element and change the Twist setting to -30. You can see almost immediately how, by changing the Twist settings so the right shoulder and right forearm elements complement each other, the rotation of the arm is much more natural.

7. Twist the right forearm a bit farther, changing the setting to -45. Everything still looks natural. When you compare your arm with the arm on the screen, you'll see that the arm on the screen is very true to life, reflecting the way the hand would be positioned relative to the forearm and how the forearm would be positioned relative to the upper arm/shoulder area. You could now bend the wrist forward and backward by changing the Bend settings or move it side to side (slightly) by changing the Side-Side settings. You don't want to assign a Side-Side setting of more than +/-9 degrees or it will look very unnatural and hurt like crazy. (Just try it yourself!)

Another Look at Natural Placement

Let's look at one more example of natural placement. This time we'll focus on the eyes, so switch to the Face camera.

1. Use the rotation trackball to rotate the scene to screen left so the female figure is rotated about 45 degrees.

2. Select the head and change the Twist setting to 12. She'll still be staring off to screen left as in Figure 2.48, but this is what you want.

3. Use the Translate In/Out tool to zoom in so the head fills more of the screen. Other than that, positioning of the figure on the workspace isn't important to this section.

Figure 2.48

The final position for the head.

4. Click the left eye (the one on your right) and change the Side-Side setting to 10 and the Up-Down setting to 4. Or, depending on the positioning of your model, position the eye so the pupil appears to be pointed directly at you.

5. Before you make this look real, select the right eye and set its Side-Side and Up-Down settings to the same as the left eye's settings.

If you look closely at this setup, something will seem amiss. Notice how the left eye is pointed at you but the right eye seems to be a little lazy and is pointing over your shoulder. For the eyes to focus, the muscles that control movement allow the eyes to work separately. If you look in the mirror and change your head position, you'll see that your eyeballs are not in the same position.

6. To make the eyes appear more realistic, change the right eye's Side-Side settings so the eyeball is turned inward more. The setting for the model shown in Figure 2.49 was changed to 15. Now you have a woman who truly looks as if she is focused on you.

Again, this might seem to be a small tweak, but it dramatically increases the reality of the image.

Figure 2.49
The eyes now appear more natural, even though the settings for them are very different.

Creating a Lifelike Figure Animation

Now that we have gone through the process of positioning the model realistically, put your knowledge into practice. In this project, you'll pose the figure and create an animation of it standing up from a kneeling position. Start this project by creating a new document and placing the Casual Man model on the workspace. Make sure you have Main camera selected for the single view. You'll switch over to multiple view layouts later in the project.

To create a lifelike figure animation, follow these steps:

1. Select the Casual Man's hip and, with the Translate/Pull tool, move the hip downward until the figure's knees are even with the ground plane, as shown in Figure 2.50. Ground shadows can really help in the placement of elements, so choose Display|Ground Shadows to turn this feature on if it's not on already.

2. Select the right thigh. Using the parameter dials, change the bend to -79.

3. Next, switch to a multiview. In this case, choose One Left/Two Right view (fourth from the bottom). Make sure the screens are set up as you see in Figure 2.51.

4. Make the Right camera view active. Select the right shin and change the bend to 98.

Note: To help in your positioning of leg elements in this project, choose Figure|Use Inverse Kinematics and deselect the right leg and the left leg. Inverse Kinematics (IK) gives you the ability to move multiple objects, such as the foot, calf, and thigh, as one unit, although when you need to modify individual elements it can hinder the process.

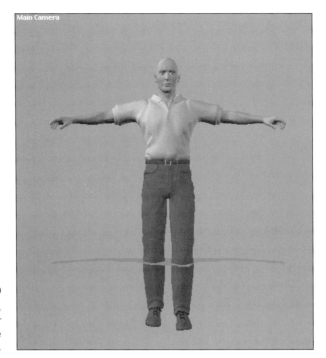

Figure 2.50

With ground shadows turned on, you can better position your elements relative to the ground plane.

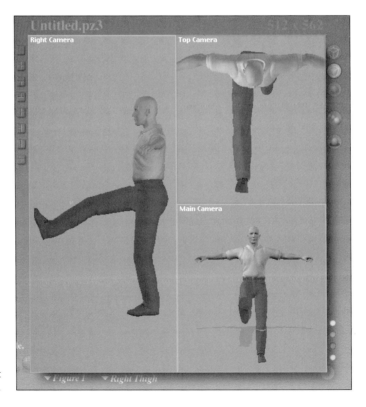

Figure 2.51

Set your multiport view so that it looks like this.

5. Select the right foot. Change its bend to 12. If you need to, set Twist and Side-Side to 0.

6. Then select the right toe and change the bend to -22. The right leg is now positioned correctly.

7. Move to the left leg and make the following changes:

 - *Left Thigh*—Twist: 16, Side-Side: 0, Bend: 9

 - *Left Shin*—Twist: 0, Side-Side: 0, Bend: 81

 - *Left Foot*—Twist: 0, Side-Side: 0, Bend: 33

 - *Left Toe*—Twist: 0, Side-Side: 0, Bend: -44

 The pose should now look like the pose in Figure 2.52.

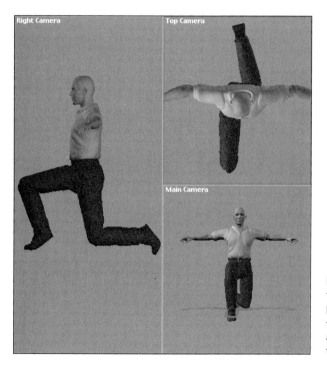

Figure 2.52
The Casual Man is now in his kneeling position. Notice how the slight twist to his left thigh adds an extra bit of realism to the pose.

Now it is time to pose his upper body. You'll start with his abdomen and work your way up.

8. Select the abdomen (his stomach) and set Twist to 24 and Bend to 30.

9. Next, select the chest. You'll tinker with reality slightly by twisting this area to 4. You'll also bend it very slightly—to 5.

10. Select the right collar. Change its parameters to the following settings:

 - Twist: -18

 - Bend: 13

 - Front-Back: 25

11. Activate the right shoulder. Change its parameters as follows:

 - Twist: -11

 - Front-Back: 4

 - Bend: 24

12. Move to the right forearm. Change its parameters to the following:

 - Twist: 36

 - Side-Side: 5

 - Bend: 61

13. And, finally, change the right hand parameters as follows:

 - Twist: -8

 - Side-Side: 8

 - Bend: -5

As you look at the pose now (see Figure 2.53), you may be wondering why the forward foot is up on its toes rather than flat against the floor. This animation will start just as the model begins to push himself up to a standing position. His right arm and hand have been positioned to give the look of pushing off from the knee, which is how this action would realistically take place.

Figure 2.53
The pose, midway through the setup.

So now let's finish the initial pose.

14. Select the left collar. Change its parameters as follows:

 - Twist: 10

 - Front-Back: -15

 - Bend: 13

15. Here are the parameters for the left shoulder:

 - Twist: 13

 - Front-Back: 17

 - Bend: -62

16. Change the left forearm parameters to the following settings:

 - Twist: 0

 - Front-Back: 0

 - Bend: -61

17. And for the left hand, change the parameters to these settings:

 - Grasp: 25

 - Twist: 0

 - Side-Side: -8

 - Bend: -1

18. Select the neck. Change Twist to 12.

19. Finally, select the head and use these parameters:

 - Twist: 13

 - Side-Side: 8

 - Bend: 18

Normally, when someone is standing up like this, the left hand would be touching the ground to help with the push off, which, in Poser, would be an extreme pose and would start tearing the mesh and causing weird deformations. (Go ahead. Give it a try.) The other option would be to have the left hand gripping or pushing off from an object such as a chair or table. This project, though, is designed to show you how to create a pose and animate it, so some creative license is being taken. The position for the left arm and hand in Figure 2.54 are pretty natural for what we have made so far.

From here, open the timeline bar and select Frame 30, which will be the ending frame. To simplify matters (and I always like to simplify things whenever I can), choose Edit|Restore|Figure to return the model to his default pose. Then, pose his arms so they are down by his side, as shown in Figure 2.55. An easy way to do

Figure 2.54
The left arm is in its most natural position based upon the scene as it is here.

Figure 2.55
The end pose for the standing animation.

this is to pose one arm and, once you're satisfied, choose Figure|Symmetry|Left To Right or Right To Left. This will mirror the left and right sides of the body.

All that's left to do now is to click the Play button to see how the animation flows.

Moving On

There are still more things that could be done to this animation to make it even more realistic. Right now, the model moves a little too smoothly from the kneeling to standing positions. Also, in reality, he would use his right hand to push off of his knee, so an interim pose would need to be added to make this happen. In addition, you didn't change his facial expression, so his bland default look doesn't reflect his action. Keeping an eye out for small details in order to create more realistic poses and animations is discussed more fully in Chapter 4.

In the next chapter, you'll continue working with the base Poser characters and learn some of the other ways you can control their appearance. You'll also discover how the new generation of Poser characters gives you the ability to create extremely interesting looks and animations.

Chapter 3
Deformers

In the worlds of television, film, and animation, character development is synonymous with revealing information on a character's background and personality. This holds true in Poser as well, but with one added element—modifying a character's physical appearance. In this chapter, you'll learn how to do that in several specific ways.

Making a Character Your Own

Of all the things Power Poser Users (PPUs) like to do, modifying a character to fit their specific needs is probably number one. PPUs create new morph targets for facial elements, body types, and basic functionality—to give themselves the ability to curl a model's toes, for instance. They change parameters so that noses can grow wider, eyes can change shape, lips can be pouty or thin. They modify the shape of the skull so they can give a character a heart-, square-, or round-shaped head. They add morph targets, which lets them create horns or ridges or fins. Many of these changes are accomplished by taking the model into another program such as LightWave [6], 3D Studio Max, Ray Dream Studio, Carrara, or Cinema 4D. Working with models in those programs is beyond the scope of this book, but if you're interested, there are numerous books and many tutorials on the Web that will help you. The focus of this chapter—and this book for that matter—is how to do this type of work directly within Poser. And that's what you're about to do.

In this chapter, you'll learn how to change a Poser character's general appearance by using the built-in Height selections and then changing the dimensions on particular body parts so they match the character's changed height. Then you'll discover the power of Magnets and Wave Deformers and create some sophisticated animations (drawing from what you learned in Chapter 2) by using these program features.

Modifying Basic Characters

In this first section, you'll work with the basic Poser 4 characters that come with the program. These are the default characters that appear when you open the model shelf and select Characters upon first booting up the program. The base Poser models have been around since the birth of the program, although they have been modified to meet users' demands as new versions of Poser have been released. Among the changes to the models is the addition of more articulated hands, allowing you to create more sophisticated poses and animations. Controls for some of the parameters mentioned in this chapter's introduction—head and eye shapes, for instance—have been added, alleviating the necessity to build them yourself. Even so, no figure will fit every need, and that's where this chapter comes in.

Using Built-In Controls

An often overlooked area of Poser is its built-in figure controls, which are located in the pull-down menus that appear at the top of the screen when you move your cursor into that area. These controls let you change the overall visual structure of the character, giving you the ability to quickly create a base cartoon character or superhero. This is how it is accomplished:

1. For the first example, place the Business Man character on the workspace and leave him in his default pose. You need to make sure that Body is selected from the current element pop-up at the bottom of the workspace.

2. Choose Figure|Figure Height. As you can see in Figure 3.1, you are given a number of choices, each of which will affect the overall appearance of the selected character.

Figure 3.1

The Figure Height list. When assigned to the character, these choices can dramatically affect its appearance.

3. At this point, Ideal Adult is the selected setting. But that's not what you want. Let's say what you want to create is a modern-day hobbitlike character who has escaped its Tolkienesque world and assimilated itself into modern society. (How else could I explain a hobbit wearing a suit?) To begin, change the Figure Height setting to Baby. As you can see in Figure 3.2, this changes the entire body structure.

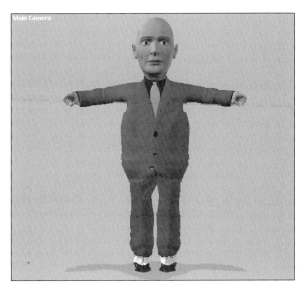

Figure 3.2

Changing the Figure Height setting to Baby gives a decidedly strange look to the Business Man model.

4. Use the Move X And Y control to zoom in on the model. You can zoom in by clicking on the tool and dragging downward. Dragging up will zoom out from the character. You will also need to use the Translate/ Pull tool to position the character in the center of the workspace. Place the cursor anywhere in the viewport except on the model itself, then hold down the spacebar and click and drag upward on the workspace.

5. Select the Business Man's head.

6. Change the xScale and yScale settings to 125%. Then change the zScale setting to 110%. Figure 3.3 shows a front and side view (using the Face and Main camera views in the vertical dual layout) of the hobbit-like executive.

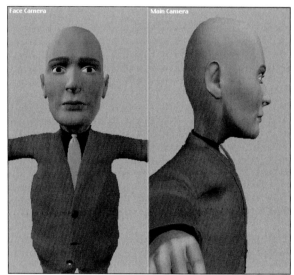

Figure 3.3
The character's head has been enlarged on the x-, y-, and z-axes.

7. Select the neck. Change the Scale setting to 115.

8. Notice the pinched look where the neck and shirt collar meet. This is partly caused by the Adam's apple, but the shirt collar area is still too tight. This needs to be fixed; he really doesn't need to be choked by an extremely tight collar. To fix this, select the chest area, shown high-lighted in Figure 3.4, and use the Taper parameter dial to widen out the neck. Change the Taper setting to -14.

9. Now that you've fixed the shirt collar, change back to a single view in the workspace and position the model via the Translate/Pull + spacebar combination to reposition the camera so that the right hand becomes the focus (see Figure 3.5).

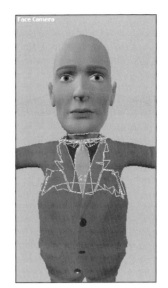

Figure 3.4
The chest area of the model is selected in preparation for using the Taper dial to fix the shirt collar so it doesn't look like it's choking the model.

Figure 3.5
Making an initial check of what the hands look like by zooming in on the right hand in the Main camera viewport.

10. The hands need to be enlarged. This will be a multipart process because the first change will affect the look of the fingers as well as the hand. Select the right hand. Change xScale to 140, yScale to 132, and zScale to 147. Notice in Figure 3.6 how this change made the first segment of the fingers (the segment that melds with the hand itself) appear to be out of shape with the rest of the fingers.

11. The first thing to do to correct this is to change the Taper setting of the hand to -32. Then you can fix the first segment of each finger and the thumb. The following list includes the settings to use for each segment. Refer to Figure 3.7 as you change the digits so you can make sure your

Figure 3.6
After making the initial changes to the hand parameters, the fingers look like overstuffed sausages.

Figure 3.7
The finished hand.

Note: The finger segments are numbered outward from the place where they meet the hand to the tip, so the segments for the index finger, for example, would be named Right Index 1, Right Index 2, and Right Index 3, with the latter being the tip of the finger.

hand looks like the one I have modified. Also, pay special attention to the name of the finger/thumb element; it should always be <**finger name**> 1, meaning segment 1 of the finger.

- Right Thumb 1

 Taper: 54

 Scale: 132

- Right Index 1

 Scale: 132

- Right Mid 1

 Taper: 65

Scale: 122

xScale: 95

- Right Ring 1

Scale: 132

- Right Pinky 1

Taper: -94

Scale: 138

xScale: 113

Making the Opposite Sides Match

Now it's time to make the left hand match the right hand. But you don't have to go through the process of changing the settings for each of the elements on the left hand. Here's a quick and easy way to make the left side match the right side of the model:

1. Choose Figure|Symmetry|Right To Left.

2. The screen you see in Figure 3.8 appears. Normally, you would click No if all you want to do is match one side to another after moving the parts into position. But you haven't changed the positions of body parts; you've changed the joint parameters. In other words, you should click Yes.

Figure 3.8

Poser will ask if you want to copy the joint zone's setup. When you're matching changes in the shape or size of an object, you should click Yes.

3. Changes will automatically be made to the left hand so it matches the right hand perfectly.

By applying these steps to modify different elements such as the feet and legs, you can create some interesting characters, like the one you see in Figure 3.9. Figure 3.10 shows a montage of the unmodified Business Man character with the different body heights assigned to it. These base settings can give you a head start toward creating your own unique 3D models for use in comic books— whether in print or online—and interesting additions to scenes.

Magnetic Personalities

Another way to modify a character or model (be it animal, alien, or prop) is through the use of Magnets. The Magnet Deformer is an interesting modifier because you can assign it to a portion of an object and it distorts just that portion. This distortion can be extremely slight, or it can be taken to extremes

Figure 3.9
The hobbitlike Business Man in his finished state. All you need to do now is add a special image map to give him more of a "hobbity" appearance—such as hair on his hands and hair on his head.

Toddler Child Juvenile

Adolescent Ideal Fashion Model Heroic

Figure 3.10
A montage of the unmodified Business Man character with the other seven different Figure Height settings that can be assigned to him.

and really cause some problems with the mesh of the model. It takes some time to get used to working with Magnets, but it's an investment that can pay off immensely.

You can also assign multiple Magnets to an object. This gives you even greater control over the manipulation of the model. Plus, the modifications can be made over time in an animation.

Basically, a Magnet affects a certain portion of a model's mesh. The scale dials, on the other hand, affect the entire mesh that makes up the model. So, instead of scaling the entire forearm of a character, you can scale just the upper portion of the forearm and leave the rest of it untouched. Here's a quick animation to show you what I mean.

Creating a Droplet Animation

Before working with Magnets on a complex model, you'll look at what it took to build the simple droplet animation found on the CD-ROM.

Follow these steps to build a droplet animation:

1. Open a new file in the Poser Pro Pack. Go to the Props model shelf and open Prop Types, if it is not already open. Select the ball prop.

2. The first thing you'll do is assign a Magnet to the ball prop. Make sure the prop is active, then choose Object|Create Magnet. A Magnet will appear on the ball prop, as shown in Figure 3.11. Notice that there is a circle surrounding the ball. This is the area of influence for the Magnet, called the Mag Zone in the elements pop-up menu. The Mag Zone, the Magnet itself, and another element, the Mag Base, all work in conjunction with each other to create the modifications.

3. Select the ball prop and move it to the top of the workspace, as shown in Figure 3.12. As you move the ball prop, the Magnet, Mag Zone, and Mag Base will move, too.

Note: All of the droplet animation tutorials in this chapter can be built in either Poser 4 or in the Poser Pro Pack.

Note: The Create Magnet option will not be available if a prop or element has not been selected on the workspace, because the Magnet must be assigned to a particular element of a model.

Figure 3.11
A magnet has attached itself to the ball prop. The white circle surrounding the ball prop is the Mag Zone, which is highlighted here so you can see it better.

Figure 3.12
The starting point for the ball animation.

Figure 3.13

The repositioned Mag Zone will now affect only the top portion of the ball prop.

Note: Droplet.mov (Mac) and droplet.avi (PC), found in the Chapter 3 folder on the CD-ROM, show a simple animation using the Magnet tool on a ball prop.

4. The Mag Zone determines which area of the associated element or prop is affected by the Magnet. Because it's centered around the ball prop, changing the Magnet parameters at this point would affect the entire prop. You want it to affect only the top portion. Select the Mag Zone by clicking it, and using the Translate/Pull tool, move it so the bottom edge includes only the top portion of the ball, as you see in Figure 3.13.

5. As you learned to do in Chapter 2, open the Basic Animation control panel. Change the animation length to 120 frames.

6. Go to Frame 40 and move the ball down to the middle of the workspace.

7. Next, select the Magnet and move it up so the top of it is against the top of the workspace, as shown in Figure 3.14. Click the Add Key Frames button to set a key frame at this position.

Figure 3.14

The Magnet has been positioned at the top of the workspace. Notice that when the Magnet is moved away from the ball prop, the top of the ball stretches out.

8. Go to Frame 80. Move the ball down to the bottom of the workspace. If you have Ground Shadows turned on (Display|Ground Shadows), align the bottom of the ball with the ground shadow. Move the Magnet back up to the same position it was in back in Frame 40. Set another key frame.

9. Go to Frame 120. Move the Magnet down until it disappears off the bottom of the workspace. This causes an indent in the top of the ball.

10. Select the ball prop and change xScale to 400 and yScale to 16.

11. Select the Magnet again, and this time using its parameter controls, change the yTran setting for the Magnet to -5.

12. Again, using what you learned in Chapter 2, create the animation.

Without a Magnet, this would have been impossible to create using the xScale, yScale, and zScale dials because the entire prop would have been stretched, not just a portion of it. Give it a try to see what I mean.

Dueling Magnets

The preceding example is pretty simple. But it illustrates the power inherent in the Magnet feature. As was mentioned, you can assign multiple Magnets to an object and have them affect different regions of the mesh. Once again, so that you can really see what happens, you'll create a short animation, this time using more than one Magnet on the object:

1. Create a new document and place the ball prop on the workspace.

2. Assign a Magnet to the ball, and move the Mag Zone to the top portion of the model—basically positioning it as you did in the preceding tutorial.

3. Select the ball prop again and assign another Magnet to it. This time, move the Mag Zone indicator to the right so it's positioned as you see it in Figure 3.15. Repeat this process two more times. Position the Mag Zones as they are in Figure 3.16.

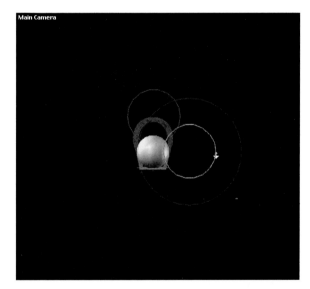

Figure 3.15
The second Magnet is assigned to the ball prop, and the Mag Zone should be positioned to the right of the ball as you see here.

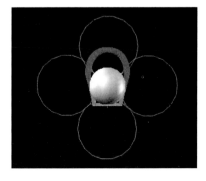

Figure 3.16
Four Magnets are now assigned to the ball. Their Mag Zones are set up to look like a four-leaf clover.

4. In the Animation Control panel, change the length of the animation to 50 frames. Go to Frame 50 and set a key frame so that the first and last frames are identical.

5. Now go to Frame 10 and select Mag 1 from the elements pop-up. Use the parameter dials to move it to the following position:

 * xTran: .256

 * yTran: .379

6. Select Mag 2 and change its position as follows:

 * xTran: -.739

7. Set a key frame at Frame 10 and move to Frame 20. Return both Mag 1 and Mag 2 to their original positions (making the xTran and yTran settings 0), and select Mag 3. Change its parameters as follows:

 * xTran: -1.329

 * yTran: -1.359

8. Select Mag 4 and make the following position changes:

 * xTran: 1.433

 * yTran: -1.306

9. Add a key frame to this frame (Frame 20). Then move to Frame 30. Instead of resetting the xTran and yTran settings for Mag 3 and 4, rotate and scale them. For Mag 3, change the following settings:

 * Scale: 600

 * yRotate: -120

 * xRotate: -85

 * zRotate: 193

10. For Mag 4, change the settings as follows:

 * Scale: 600

 * yRotate: 67

 * xRotate: 109

 * zRotate: 77

11. Finally, go to Frame 40 and change Mag 1's settings to the following values:

 * xRotate: 79

 * zRotate: 24

Note: In the current elements pop-up under Props, you'll see four sets of Magnet groups listed. This pop-up will be extremely important through the rest of this tutorial. Using it will be about the only way you can accurately select the Magnet you want to use, because all four Magnets are placed over each other.

- xTran: -.250
- yTran: 1.400

12. Change Mag 2 to the following positions:

 - xTran: 1.777
 - yTran: 1.612
 - zTran: 1.764

Create a new animation and play it. (This movie is named warped.mov [Mac] and warped.avi [PC] in the Chapter 3 folder on this book's CD-ROM.)

Magnets That Characterize

I'm sure you've all seen science fiction movies in which some sort of alien creature inhabits a body or a character goes through a transformation and his skin bulges in different places. In films, this is accomplished in one of two ways. The first is through the use of bladders that are placed on an actor's skin. Small tubes run from these bladders and people off-camera pump air into them. The second way is through 3D animation, using programs such as LightWave, 3D Studio Max, and Maya.

With Magnets, this effect can be created in Poser as well. And, as you've discovered, the effect can be animated. As is true of any effects, time and preparation are essential to success. The following tutorial will give you a good start in creating an effect like this; you can then modify it to suit your needs. This, again, will be done as an animation so that you can render it and see exactly how the effect looks:

1. For this tutorial, you'll use the Casual Man model and work on his forearm.

2. Select the right forearm and then switch to the Posing camera. Zoom in on the arm so it fills the workspace, as shown in Figure 3.17. I also used the rotation trackball to rotate the view and see the upper side of the forearm better.

3. With the right forearm selected, create a new Magnet. Move the Mag Zone so the bottom barely touches the forearm. You will need to use the rotation trackball in order to position this correctly. Figure 3.18 shows the Mag Zone placement.

4. Select the Magnet and change its zScale setting to 10. This makes the Magnet very thin, which is what is needed for this effect. The Mag Zone is what actually tells the Magnet which part of the mesh to affect. Because of this, you must do two things to create this effect: Move the Magnet up so it pulls out the area, and then move the Mag Zone so different areas of the forearm are affected.

Figure 3.17
You should zoom in on the right forearm so it fills the workspace as you see here.

Figure 3.18
The Mag Zone should be positioned so it barely touches the forearm.

Note: Because the Mag Zone actually selects the area the Magnet will affect, you do not have to physically move the Magnet over that area.

5. Change the length of the animation to 60 frames. Set a key frame at Frame 60 so the animation will end at the same place it started. Go to Frame 15 and change the Magnet's yTran to 1.65. So you can really see what happens, move the magnet farther than you normally would for more realistic animations.

6. Select the Mag Zone. Move to Frame 45. Move the Mag Zone on the xTran to -.292. This will place the Mag Zone around the wrist area. Then change the yTran to .679 so the Mag Zone is inside the wrist mesh. Figure 3.19 shows the positioning.

Figure 3.19
The Mag Zone has been moved so that it now affects the wrist area.

Animate the file and see how it looks. The armbug.mov (Mac) and armbug.avi (PC) files are available in the Chapter 3 folder on this book's CD-ROM.

Catch the Wave

There's another modifier that you have at your disposal: the Wave Deformer. This modifier acts in much the same way as the Magnet Deformer. Wave Deformers, though, can be used for larger areas, such as land masses.

After you have placed an object on the workspace, choose Object|Create Wave. Figure 3.20 shows the Wave and the Wave Zone on the workspace. It looks kind of like a sheet blowin' in the wind, doesn't it?

Figure 3.20
This is a look at the Wave Deformer and the Wave Zone associated with it.

Figure 3.21
The parameter settings for the Wave Deformer may seem rather scientific, but they shouldn't cause you any undo distress—even if science wasn't your strong suit in school.

Figure 3.21 shows the parameter dials associated with the Wave Deformer. Don't let the scientific nature of the names of the dials frighten you. The parameters are basically mathematical representations of natural phenomena. I am sure most of you have seen an audio waveform at some time or another. The peaks and valleys are graphic representations of the sound at that point in time. Poser's Wave Deformer operates on the same theory.

To get a feel for what this Deformer does—how it can affect an item it is assigned to—you must actually deform something.

Pattern Play

One of the best uses for the Wave Deformer is to create interesting patterns on a prop. The patterns can emulate land masses or geometric shapes that add interest to an item a character might be holding. Begin by placing a cylinder prop on the workspace and then deform it as follows:

1. Resize the cylinder by changing the yScale setting to 25. This will reduce the height of the prop.

2. Choose Object|Create Wave to assign a Wave Deformer to the cylinder.

3. Move the Wave Zone up so that changes you make to the Wave Deformer will affect only the upper-third portion of the cylinder. Refer to Figure 3.22 for the placement of the Wave Zone. Notice that as you reposition the Wave Zone, it affects the shape of the top of the cylinder.

Note: As the Magnet does, the Wave Deformer includes a Wave Zone that determines which portions of a model are affected by the changes you make.

Figure 3.22
Correct placement of the Wave Zone to affect only the top portion of the cylinder.

4. Select the Wave Deformer. Then change the Wave settings to the following values:

- Phase: .472
- Amplitude: .016
- Wavelength: .370
- Stretch: -.064
- Amp Noise: .222
- Freq Noise: .222
- Sinusoidal: .471
- Square: .444
- Triangular: 1.0
- Turbulence: 3.0
- Offset: -.136

You have created a sand dollar that should look like the one in Figure 3.23—a very thick sand dollar, but a sand dollar nonetheless. With the proper texturing, which will be discussed in Chapter 5, you can really make this look like a photorealistic sand dollar.

Figure 3.23
A sand dollar-like pattern has been created on the top surface of the cylinder.

Land Ho!

You'll do one more thing with the Wave Deformer before moving on. One of the most common uses for this feature is to create the look of rolling hills or wavy water. This can be done as follows:

Figure 3.24
The resized box prop.

1. Create a new document and place a box prop on the workspace. Change the box's xScale and zScale settings to 600 and the yScale setting to 2. This will give you a thin square like the one you see in Figure 3.24.

2. Assign a Wave Deformer to the box. Notice how it warps the prop immediately upon being assigned.

3. Change the Wave parameters to the following settings:

 - Amplitude: .146

 - Amp Noise: .252

 - Freq Noise: .210

 - Sinusoidal: .892

 - Square: .219

 - Triangular: .266

 - Turbulence: .500

 - Offset: .324

Note: Don't worry about the dark gray swatches you see within the warped box prop. That is merely the ground shadow showing through where the warped areas dip below the ground shadow. If this bothers you, choose Display|Ground Shadow to turn this feature off, as I have done in my example.

4. As you can see in Figure 3.25, the box looks somewhat unusable. But it really isn't. Select the Wave Zone and note the yTran setting (it should be .050 if you haven't already begun playing with it). Using the yTran parameter dial, rotate the dial slightly—very slightly—to the right, stopping every so often to look at how it affects the warping of the mesh. Return the yTran dial to .050, then repeat this process, moving the dial to the left this time and noting what happens. When you're finished, once again return the yTran setting to .050.

Figure 3.25
At first glance, the settings assigned to the Wave Zone make the box prop look unusable. But that really isn't the case.

5. The purpose of this tutorial is to show how you can create a land mass. But what has been done so far sure doesn't look like land. To change that, you'll resize the box prop itself. Select the box prop via the elements pop-up and change the xScale and zScale settings to 2000. No, that's not a typo. Notice how your box now looks like rolling hills, as in Figure 3.26.

Figure 3.26
After you drastically resize the box prop, notice how it looks like rolling plains.

With the proper texturing and color, this could look like a scene from Ireland or like a desert. Choose File|Import|Background Picture and place a JPEG, PICT, or TIFF image you've created of a cloud- or star-filled sky to add more interest.

Go ahead and save this file so that you can use it for the following chapter project. Don't change any of the settings you have assigned to this prop.

Note: As a reminder, I always like to make the first and last frames identical so that, if I decide to make a looping animation, it will loop smoothly and elements won't jump when the loop occurs.

PROJECT Build a Turbulent Environment

As I mentioned earlier, you can animate Wave Deformers just as you can animate Magnet Deformers. In fact, you can combine the two for some really exciting animated effects, such as the earth going through massive upheavals. That's what you'll create in this project:

1. The first thing to do is open the timeline (if it isn't already). Change the length of the animation you're about to create to 60 frames. Then move the timeline bar to Frame 60 and add a key frame.

2. Return to Frame 1.

3. Because a Wave Deformer is already assigned to this prop, you need to assign a couple of Magnet Deformers. Select the Box prop and then choose Object|Create Magnet.

4. You'll need to do some major resizing of the Magnet, but you don't want to affect the Box prop yet. Use the Move X And Z control to zoom out so you can see the entire mesh, and then do the following:

 • First, select Mag Zone 1 from the elements pop-up. Move it upward so it is away from the box prop.

 • Select the Magnet and move it upward.

 • Resize the Magnet by changing xScale to -14, yScale to -3500, and zScale to 74. The extremely large number in the yScale is more for visual effect than anything else; this way, you can see the Magnet better.

 • Lower the Magnet so it is against the box prop again (change yTran to 0) and then move it to the position you see in Figure 3.27.

Figure 3.27
The resized Magnet in position on the box plane.

- Select the Mag Zone and move it back to its original position (yTran should be 0).

5. Zoom back in using the Move X And Z control so your ground plane refills the workspace. Now it's time to animate.

6. Go to Frame 7. Select the Magnet and move it to yTran: -10. Add a key frame.

7. Go to Frame 10. Select the Wave Zone and change its yTran value to .060.

8. Move to Frame 25 and move the Magnet to yTran: -3 and the Wave Zone to yTran: .047.

9. Time to render. The ground will gradually return to its original position between Frames 25 and 60, which is what you want it to do in this instance. Set the frame size of your movie to 320×240 in the animation setup screen. In the Make Movie window (Animation|Make Movie), name your animation groundturb, change the Quality setting to Current Render Settings, and click OK. Change the settings in the Compression Settings screen to Millions Of Colors and High Quality, then render the file.

Note: You could also add more Magnets to the scene, placing them in different positions and setting them at different sizes so that other points on the mesh are affected.

Note: A rendered movie (groundturb.avi [PC] and groundturb.mov [Mac]) is included on the CD-ROM in the Chapter 3 folder.

Moving On

As you can see, the power contained within the Magnet and Wave Deformers is truly awesome. And, when used in conjunction with each other, they can add indefinite possibilities for special effects built directly in Poser. By adding a character or series of characters to the scene you just created and animating them to react to the environmental upheaval, you can make some fantastically eye-catching movies without leaving the program.

And speaking of characters, there is much more you can do with them in Poser. In the next chapter, you'll discover more advanced ways of modifying your Poser characters. This is a precursor to moving into the realm of the Poser Pro Pack's many new and advanced features.

Chapter 4

Character Development

There is much more to character development than posing a model. In this chapter, you'll discover how to work with multiple characters to create realistic scenes and how to mix and match model parts to create your own characters.

Characterization

When you create any type of art, what brings it to life? Is it the subject or the setting? Those are two elements that help. But what really brings a scene to life is the conveyance of a universal truth. Basically, that's a highfalutin way of saying that a scene has to contain that special something that everyone can relate to. It's not enough to simply place props and characters into a scene. If you really think about it, it's easy to create a street scene: Place some buildings and props on the workspace, position them, and light the scene so that it looks real. The tricky part is adding people and animals and posing them in a way that adds to the illusion of a bustling metropolis. If the characters don't meet the audience's perceived sense of reality—if an arm is swinging too high in midstride or a face isn't posed just right—your scene can turn from realistic to fake extremely quickly.

We are both helped and hindered by our complete understanding of how a person looks when faced with different situations. We're helped because every day of our lives we are experiencing input that tells us what a certain stance or expression means. We're hindered because many of the small nuances in stance and expression are so ingrained in our psyches that, without necessarily knowing what is amiss, we can sense that something isn't quite right in an image. If the characters you add to a scene aren't responding to each other in what the audience senses to be a natural manner, you have undermined the credibility of your work.

Poser comes with a number of predetermined poses, although many of them will need to be modified heavily before a realistic scene can be created. That's not to say that the poses aren't any good; they are perfect for giving you a head start with a minimum of fuss. But I've found over the years that it's best to start from scratch; it's actually less time consuming that way.

In this chapter, you'll be working with multiple characters and discovering how even the slightest change in a single element of a model can turn your work from the standard to the extraordinary. It often takes stepping back from the monitor to really study what you are doing from a distance, but the effort can be well worth it.

Note: This chapter will utilize both the standard Poser figures and the advanced Michael and Victoria models that are sold at **www.daz3d.com**. You don't need to purchase these models, but you will not be able to do some of the more intricate facial modifications that are discussed later in this chapter if you do not have them.

Taking a Stance

Working with Poser, or with any 3D application for that matter, makes you quickly realize that you need to really watch what is happening around you. In other words, you need to become a people watcher and train yourself to look for those little nuances that make the subliminal gestures we all make transmit a message. Nowhere does this become more important than when two people are interacting with each other. In this section, you'll use these observed nuances to create a scene in which the Casual Man and Casual Woman models are holding a conversation.

Building the Stance

The first thing to do is place one of the models you'll be using on the workspace. Assign basic starting stance settings to the model and save the pose you have created into a new Pose subcategory. Follow these steps to get started:

1. First select the Casual Man model and put him on the workspace.

2. This is a time when the multiple screen setup really comes in handy. Switch to the One Up/Two Down layout (third choice from the top). Assign the Main camera to the top viewport, the Left camera (listed as From Left) to the lower-left viewport, and the Top camera (listed as From Top) to the lower-right viewport. Reset the views so they are positioned as shown in Figure 4.1. Now is a good time to save your file. Give it a descriptive name, such as confab.pz3.

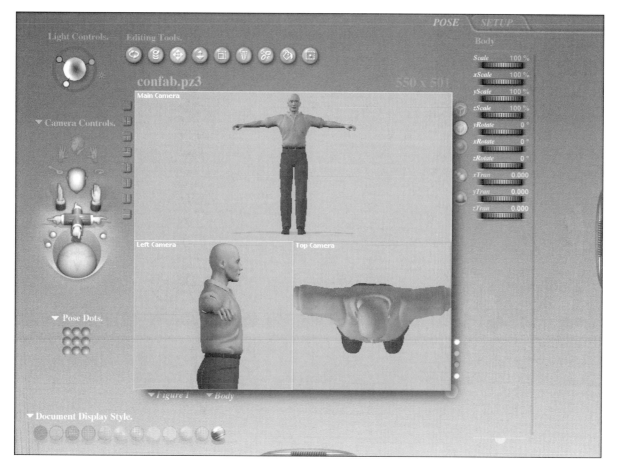

Figure 4.1

The workspace set up for the initial phase of posing the Casual Man.

3. Select the Casual Man's right collar. You can use any of the viewports to select this element. If you look at the models carefully, they are basically in the military position with shoulders back, chest out—not very natural for the common person. So change the Front-Back setting of the

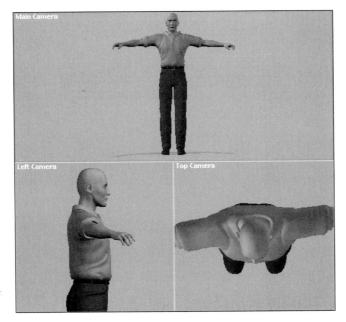

Figure 4.2

The right collar has been moved forward, giving a more natural appearance to the placement of the shoulder.

right collar to 18. This centers the shoulder with the middle of the neck, which is a more natural position, as you can see in Figure 4.2.

4. Choose Symmetry|Right Arm To Left Arm so that the left side of CasMan (as I'll call him from now on) is the same as his right side. You will notice that I'll use the Symmetry option to make changes to elements that need to be the same for both sides of the model.

5. Next, select CasMan's chest. He's still swaybacked, and that needs to be fixed. Change the Bend parameter to 4. It doesn't take much to fix the sway, as you can see in Figure 4.3.

6. What makes his look somewhat unnatural now is the position of his neck and head. This area is leaning too far forward. Select the neck and change its Bend value to -3. Then select the head and set the bend to 0. At this point, save the file—just in case.

7. Time now to fix his stance. Select his right foot and make the following changes:

 • xTran: .023

 • zTran: .055

8. Change the Left camera viewport to the Posing camera. Rotate and zoom in on CasMan's feet as shown in Figure 4.4. First, no one's feet, when they are standing in a casual position, point straight forward. Nor do they pronate (twist inward) or isopronate (twist outward). This twisting only occurs while walking; that's why the heels of your shoes

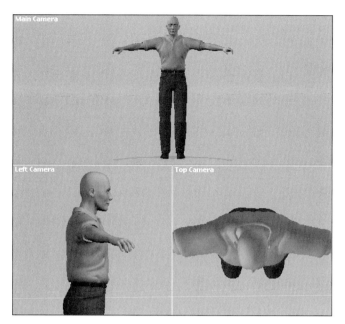

Figure 4.3
Small corrections to body parts can have a big effect on the appearance of the model. By making a small change in the chest position, you can eliminate the sway in CasMan's back.

Figure 4.4
The Posing camera viewport has been shifted so that CasMan's feet are the center of attention.

wear down more on the inside or outside. Look at the parameter dials for the right foot and notice how the foot is twisted (-6 for the right foot, 6 for the left foot). Change the Twist setting to 0 for both feet.

9. Select the right foot and make the following changes:

 - Side-Side: 20

 - Bend: 1

10. Select the left foot and change its Side-Side setting to 6.

11. Next, change the bend of both the right and left toes to 9. You'll end up with the feet looking like they do in Figure 4.5. Now you have them in a much more natural position.

12. Select the left foot again and move it back by changing zTran to -.022. Once again, this would be a good time to save your file and return to the single-view mode.

At this juncture, you have a choice to make. Because you now have a pose in which the body parts are set up naturally, you can save it to the Poses drawer so you don't have to repeat this initial setup every time you place a new character on the workspace. I suggest that you create a new subcategory called My Natural Poses and save it into there, by clicking the plus symbol button at the bottom of the Pose shelf. Call this pose Natural Stance.

Adding a Second Character to the Scene

CasMan is now set up and ready to have someone to talk with. Next you'll add the Casual Woman model to the scene, assign the saved pose to her, and make

Figure 4.5

After small changes are made to the positions of each foot, CasMan's stance is more natural.

the final modifications to each character so they look like they're in the middle of an interesting conversation:

1. Before placing CasWoman on the workspace, move CasMan into a new position. Select Body from the current elements pop-up menu and make the following setting changes:

 - yRotate: 90

 - xTran: -.208

2. Now place the Casual Woman on the workspace. Make sure you click the Create New Figure button (the double checkmark button) so she doesn't replace the Casual Man model.

3. Open the Poses drawer and assign the pose you just created to her by double-clicking on the Natural Stance pose. Then position her as listed here (refer to Figure 4.6 to see how your screen should look):

 - yRotate: 90

 - xTran: .208

4. The models need hair. The Telly Savalas and Sinead O'Connor looks just don't make it for this scene. I chose Male Hair 2 and Female Hair 1 for the respective models. Make sure to click the appropriate model to make it the active one before assigning the hair to it, otherwise the selected hair could go on the wrong model (an interesting look for each character, but again, not what is needed for this image). Figure 4.7 shows the coifed models in their starting positions.

5. Return to the same multiview setup you had earlier (One Up/Two Down) and position the viewports so that you can see both figures.

6. CasWoman will be holding a soft drink in her right hand. Knowing this, change her right side settings as follows:

 - Right Collar

 Bend: 19

 - Right Shoulder

 Twist: 22

 Front-Back: 14

 Bend: 60

 - Right Forearm

 Bend: 84

 - Right Hand

 Bend: 23

7. These settings are close to what will be needed for her left arm, which will be crossed over her stomach, with her hand cupping her upper arm (the right shoulder of the model). So choose Symmetry|Right Arm To Left Arm to duplicate the arm positions. Then all you have to do is make small adjustments to the various left arm parts.

8. Change the left arm/shoulder settings as follows:

 - Left Collar

 Twist: -8

Figure 4.6
(Left) CasMan and CasWoman are almost ready to talk with each other.

Figure 4.7
(Right) The chatting characters with hair added.

Bend: -19

Front-Back: -18

- Left Shoulder

Twist: -35

Front-Back: -21

Bend: -57

- Left Forearm

Twist: -7

Side-Side: -27

Bend: -105

- Left Hand

Twist: -6

Side-Side: -8

Bend: -5

If you change to the Posing camera and reposition it, you will see that you have a fairly natural upper-torso pose. No, the hands haven't been fully positioned yet—the fingers of the left hand need to be cupping the upper right arm, and the Grasp parameters for the right hand need to be set. But when it comes to the arm positions, you're pretty well set.

A woman's stance would be different from a man's. The center of gravity is different, women's postures are different, and accepted societal norms have led to the way a woman positions her legs in comparison to a man. This means the right leg should be changed because it's in a masculine position. To change the leg position, simply select the right foot and change the zTran setting to -.043. You can now save this pose to the Poses subcategory you created.

Now you can finish the pose on your own. The CasMan should be reaching out to hold the CasWoman's upper arm. His other arm should be positioned so that it looks like his hand is in his pocket. Unfortunately, there is no actual pocket in the pants, so you need to create the illusion of a pocket with a hand in it. You'll need to do some touch-up work in a program like Adobe Photoshop to not only smooth out the edges where the hand and hip meet (Figure 4.8), but to paint in the illusion of the pocket bulging.

Playing Hide and Seek

As you begin to make these changes, it can become difficult to move around and find camera positions where one figure doesn't block out another. That is easily correctable with a great feature: Hide Figure. By selecting one of the figures, in this case CasWoman, and choosing Figure|Hide Figure (Command/Control + H) as

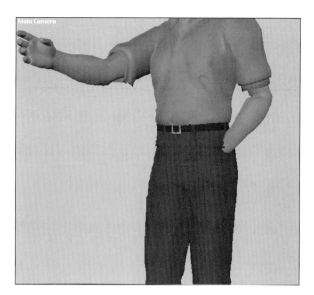

Figure 4.8
This is the hand and arm position to give the appearance of the hand being in his pocket. Some touch-up work in an image editing program is needed to smooth the ragged edges where the meshes intersect.

shown in Figure 4.9, you can make the model invisible until you want to see it again. When you've positioned the elements on your selected model and you're ready to see the other elements again, choose Figure|Show All Figures to make them reappear on the workspace.

Final Positioning Notes

After positioning CasMan's arms, you'll also need to change his xTran position so the two characters are close enough to touch but far enough apart that they aren't invading each other's space. Figure 4.10 shows the final position.

Figure 4.9
The path to hiding elements in a scene.

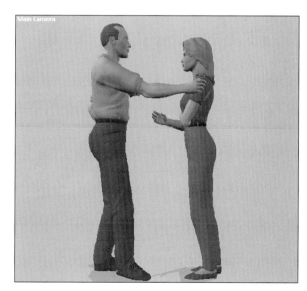

Figure 4.10
CasMan's final arm positions.

Another thing to realize is that, when two or more people are in conversation, bodies rarely face each other head on. There is a slight twist in the waist that subliminally tells the other parties that they are not being blocked from leav-

ing. Usually it's only in a confrontational situation that bodies face each other directly. This means you will want to twist the torsos of one or both of the characters to give them a less-threatening position.

There are other slight nuances. The head almost never tilts up or down so that it's perfectly aligned with the other person's head. The head will tilt, but the eyes will finish out the focus on the other person. And at least one or the other person's head will be tilted or turned to the left or right at any given time. The eyes will more than likely remain focused on the other person's eyes, but the heads will not remain pointed at each other.

To finish out the scene, use the tips you've learned in this and the "Using Parameter Dials" section of Chapter 2 to position the characters so they're looking at each other and to give them natural expressions. You will also want to work on positioning the fingers of CasMan's right hand and CasWoman's left hand so that they more naturally hold the arms they are touching. Figure 4.11 shows the models in their final stances, with all elements modified. Make sure you note the different stances and the nuances discussed in the previous paragraphs and how they add to the realism of the poses.

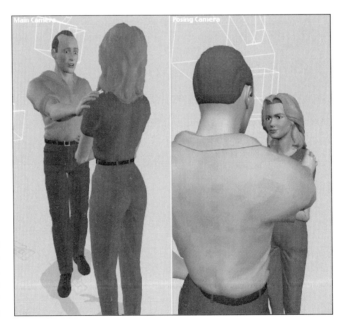

Figure 4.11

The Vertical dual view port setup lets you compare the subtle differences in each character, which adds to the realism of the scene. These two look as if they are really having a conversation.

Poser: The Next Generation

After working with the main Poser characters that come with the program, you'll notice that, especially on the head element, there are a limited number of parameter dials. This is somewhat of a drawback because it makes you have to work harder to design a realistic expression. There are dozens of people in the Poser community who have created new parameter settings, called morph targets (MTs), that can be added to that specific model's list of dials to help in this area. These MTs are available either for free or for a low cost, and **www.renderosity.com** is a

good place to start a search for them. Other Poser folks have created all new characters whose bases are built upon the P3 and P4 models in Poser. One of the most notable is the UltraMorph Woman and UltraMorph Man models offered for free from **www.renderosity.com**. These two models were created by a person who calls himself Confucius.

There are also two extremely advanced models that are sold by Daz 3D, the Poser division of Zygote Media Group. They are basically the highest standard available for Poser at this time unless you build a character of your own in a 3D modeling program such as LightWave, 3D Studio Max, Pixels:3D, or Carrara (to name a few). These two models add a great deal of functionality to your work, and because of this, I want to spend some time showing you how they can add extraordinary realism to your scenes. For an initial look, turn to the first page of this book's color section for a side-by-side comparison of the standard Poser models and Michael and Victoria. In the following pages, I'll show you how one model can be made to look like hundreds of different people.

Changing Victoria's Appearance

Because the same settings are used for both Michael and Victoria, what you'll see (or work with if you have the models) in this section is how versatile these characters are. I will be using the standard Vicki Map2 character for this section. If you have the model, go ahead and load it onto the workspace now. If you don't, and have been wondering what the fuss about these models is all about, follow along so you can find out:

1. Upon loading the Vicki Map2 character, switch to the Face camera. (Because this model is, as most models in Poser are, a nude character and it's a family book . . . well, enough said.) Figure 4.12 shows a rendered image of the Vicki/Victoria (sounds like a movie title, doesn't it) character.

> **Note:** You will notice throughout this section that Victoria, Vicky, and Vicki are used interchangeably. As the folks at DAZ 3D upgraded the model, they needed a way to help their technical support people easily differentiate between the upgrades as they spoke with users. So, the original model is Victoria. The first update is called Vicky. And the second update is called Vicki. By the time this book is in your hands, DAZ 3D will have released an updated version of the Victoria model, called Victoria 2, which has added even more modifiable elements to the character.

Figure 4.12
A rendered look at Victoria as seen in the workspace. No lights have been adjusted for this image.

2. Change the Face camera's focal length to 35mm so you have a more natural appearance to work with.

3. Select the head and notice all the extra parameter dials associated with it in comparison to the P4 models. Figure 4.13 shows the dials. These extra settings allow you to change the entire appearance of the model to the point where it will look like a completely different character.

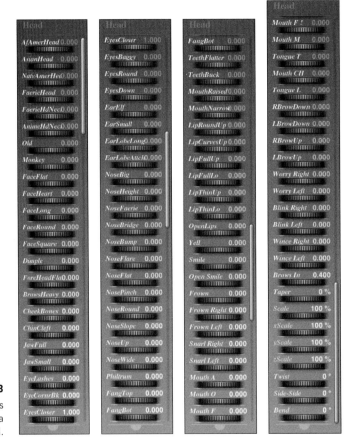

Figure 4.13

The parameter settings associated with the Victoria model's head.

4. As is true with other models, it's important to make slight changes to many different parameters so that you don't ruin the overall mesh. For instance, you can make Vicki a bit older by using only the Old setting. Image 4.14 shows Vicki as she might appear in her late 30s or early 40s. The setting for this is .500. Figure 4.15 shows how she looks with a setting of 1. As you can see, the mesh is beginning to have an unnatural look to it, especially around the jawline. Figure 4.16, on the other hand, shows the effect of changing the settings too dramatically. The setting here is 1.5. So, as you can see, just using one parameter dial to achieve an effect is definitely not the way to go.

Figure 4.14
(Left) Vicki as she might appear in her late 30s or early 40s.

Figure 4.15
(Right) Vicki is starting to show some unwanted warping of the flesh.

Figure 4.16
By changing an individual parameter too dramatically, the element is adversely affected.

5. To make Victoria/Vicky/Vicki age more realistically, start by changing the Old dial to .500.

6. Change the FaceLong setting to .17.

7. Next, change FaceRound to -.55. This gives the appearance of the skin tightening.

8. Many older people, due to the "ravages of time," have dimples that are more apparent than they would be on younger people, either because of more pronounced wrinkling or because the muscles have broken down slightly in that area. So change the Dimple setting to .37.

The Gravity of the Situation

As you age, your face gets longer as the flesh stretches, due to the effects of gravity, as do your ears. In fact, the effects of gravity over the years pulls everything down. The flesh also tightens around the skull as the skin loses elasticity. You need to focus on these effects as you age your models.

9. Cheekbones are a bit tricky to work with. If you overdo this setting, not only can it look as if the skull has changed shape, it can actually mess up the way an image map looks on the character, with unnatural highlights causing a discernable differentiation between color graduations. But cheekbones become more pronounced on many people as they age. In this case, change the CheekBones setting to .15—very, very slight. Figure 4.17 shows how the model should look at this point.

Figure 4.17
The aging process is starting to take effect in a very natural way. Compare this picture with Figure 4.12 to see how these small changes have affected the model's look.

10. Next, you need to add some puffiness to the eyes. Change the EyesBaggy setting to .6. Again, too large a change can have an adverse effect on the way the model looks, as you can see in Figure 4.18. What you see in this figure is a setting of 1.0.

Figure 4.18
An example of making the eyes too baggy. Notice the unnatural change from one portion of the image map to the other.

11. The eyes also need to be moved down as the skin pulls tighter. Change the EyesDown setting to .567.

12. Lengthen the ear lobes (EarLobeLong) to .364.

13. Now it's time to move onto the nose parameters. "Tighten" the skin by changing the following parameters (pay particular attention to how each of these changes affects the model and adds to the look of tightening skin):

 - NoseHeight: -.19

 - NoseBridge: .534

 - NoseBump: .5 (Turn the camera angle so you can see the model from the side as you make changes to this setting.)

 - NoseFlare: -.048

 - NoseUp: -.445

14. Next, you'll lower the mouth slightly. Change MouthRaised to -.341. Other changes to the mouth should be as follows (refer to Figure 4.19 for comparison):

 - LipFullUp: -.874

 - LipFullLo: -.420

 - LipThinUp: .424 (This adds some wrinkling to the upper lip.)

 - LipThinLo: .073

 - OpenLips: -.053

Figure 4.19

Now you see the changes to the nose and lips to increase the signs of aging.

15. Finally, as the years wear on, the corners of the mouth lower. This is what makes a person look like she's frowning when her mouth is at rest. To emulate this, make the following changes:

- Smile: -.140

- Frown: .090

- Frown Right: -.045

- Frown Left: -.028

As you can see in Figure 4.20, Vicki now looks to be in her mid to late 50s or very early 60s. Figure 4.21 shows some other examples of how drastically you can change this model's appearance to create original characters for your scenes.

Figure 4.20
A rendered look at Vicki as signs of aging set in. If you compare this image with Figure 4.12, you'll see how these subtle changes to the parameter dials give her a mature appearance.

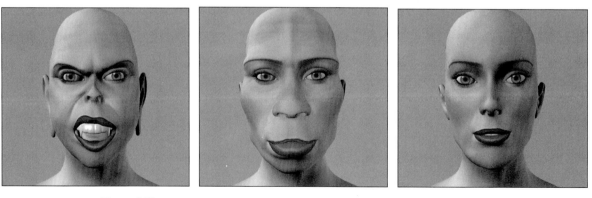

Figure 4.21
Different looks for the Victoria model. From left to right, VicAlien, VicFoot, VicModel.

Mix 'n' Match

And speaking of creating entirely new characters, one of the hottest aspects of Poser is the ability to mix and match elements from different models to create entirely new ones. Expect to spend some time on these modifications; as is true

of any modification process—like those you've already worked on—patience is truly a virtue.

You can mix and match everything: props with props, props with bodies, and bodies with body parts. In this section, you'll get an introduction on how to do just that, and then I'll show you how to create an entirely new character using different model elements.

PROP-rietary Systems

The first thing you'll do is create a new character out of different prop types. This is a precursor to what you will learn in Chapter 6, where you'll add bone structures for easier animation of the elements. You'll be using the base prop types to build an original character. Or maybe I shouldn't say it's a character. To come up with the idea, I got down on the floor with my twin boys and watched them build things with their wooden blocks. I have to admit, I didn't see what they saw in their finished project, but it didn't matter because what they built was real to them. So, with that said, what you'll build now is as real to me as that block structure was to them (in other words, this is going to be a crazy section, so bear with me as best you can):

1. Start by placing a cylinder prop on the workspace. This will be the torso for the character. Change the yTran setting to .396 so it's positioned slightly above center on the workspace.

2. Add a second cylinder and move its yTran setting to .280. The two elements should be positioned as they are in Figure 4.22.

3. Select the torus prop, position it at yTran: .389, and scale it down to 36 so it fits between the two cylinders.

Figure 4.22

The starting position for the two cylinders of the prop creature.

4. Select the torus prop two more times. Make the following size and position changes:

 - Both

 Scale: 50

 zRotate: 90

 yTran: .460

 - First Torus

 xTran: .059

 - Second Torus

 xTran: -.061

5. Select a fourth torus, scale it down to 64, and change its yTran setting to .278. Your creation should now look like Figure 4.23.

Figure 4.23
The torso and connectors in place.

6. Place a ball prop on the workspace, scale it up to 127, and change the yTran to .172. This will be the repulser control that makes it float over the ground.

7. Place a cone prop on the workspace. Change zRotate to 90, xRotate to -90, xTran to -.053, and yTran to .456. Then change yScale to 149. Repeat these settings with another cone; only for this one, change xTran to .053.

8. The last step is to place one more ball on the workspace and change the yTran setting to .505 so that it becomes the head. At this point, as you can see in Figure 4.24, you could make a nice little logo element out of this potpourri of prop parts.

9. Save the file and call it floatbot.pz3.

Figure 4.24
All the elements are placed and positioned for this rather strange creation.

Introducing the Hierarchy Editor

Now comes the fun part. You have the elements placed on the workspace, but they are nothing but separate parts that have no unifying structure. If you rotated one element at this stage, no other element would move in conjunction with it. In this section, you'll discover how to bring everything together into a cohesive whole. That is where this journey will now take you.

Figure 4.25 shows the Hierarchy Editor. You can access it by choosing Window|Hierarchy Editor. This window gives you a visual cue as to what elements make up both a placed model and the entire scene. It shows the elements in a scene to which a model is linked, the parent element (which controls the other elements), and the child elements (which are controlled by the parent element). This parent/child relationship is extremely important because it sets the initial parameters for what affects what as changes are made.

Notice how all of the elements you've placed on the workspace are listed. But at this stage, all of these props are what could be called parent objects. None has a controlling relationship to another. You'll also notice that, unless you have kept detailed notes as you placed each prop into the scene, it's kind of difficult to tell which is the top cylinder and which is the bottom cylinder or which torus you are selecting. Fortunately, the Hierarchy Editor gives you the ability to change the name of each element to something more descriptive. Click a name once and a text box in which you can type a new name for the element appears. If you double-click the name, the window you see in Figure 4.26 appears. Here you can control many different aspects of the prop. You can also access this screen by choosing Object|Properties or using the Command/Control + I key combination. As you can see in Figure 4.27, I have given each prop a more distinctive name.

Note: To learn about what all can be done via the Hierarchy Editor, refer to the Poser 4 user manual.

Figure 4.25
The Hierarchy Editor is an extremely powerful tool you can use to set the relational structure of elements in your scene.

Figure 4.26
The Prop Properties window.

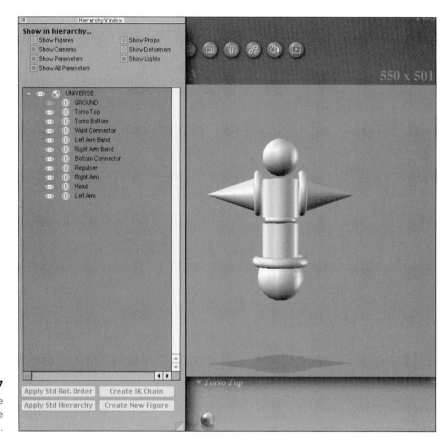

Figure 4.27
Each element in the scene
has been given a more
descriptive name.

In this next tutorial, you'll create a hierarchical structure with a parent object
that will affect the movement of all other objects associated with it. Here's how:

1. The Torso Top will be the main parent. All other objects will react when it
is moved. Click and drag each of the other elements in turn and place
them on top of the Torso Top listing in the Hierarchy Editor. Once you do
this, a plus symbol appears to show that there are children assigned to
the object. Clicking the plus symbol opens the list, which you see in Fig-
ure 4.28. You can also change the order in which the children elements
are listed by dragging an element to another location.

2. Make the Left and Right Arm Band elements children of the Left and Right Arm elements respectively.

3. Click the Create New Figure button. This tells Poser that you have created a new model and it should be recognized as such.

With that accomplished, you can add this little darlin' to the Props section. Create a new folder called Original Props, or place it in any existing folder. Also, if you open the Materials Editor after saving it, you'll see each of the prop elements that make up this model, as shown in Figure 4.29. By selecting the individual elements, you can assign materials, colors, transparencies, and more to the elements.

Figure 4.28
The Hierarchy Editor lists what is assigned as child elements.

Figure 4.29
The elements that make up the model you just saved become available in the Materials Editor for assigning of colors or textures.

Creating a Prop Person

Creating prop creatures is one thing. But what about assigning props as part of a character, replacing body parts with either props included in Poser or props you created on your own? Yes, that's possible, too. In this project, you'll play doctor and remove a character's leg and replace it with a peg leg that will be made from a cylinder and a cone prop. The props will then be parented to the leg. This project involves the use of the P4 Nude Man model. The genitalia feature will be turned off because this is a family publication.

Follow these steps to create a prop person:

1. Place the P4 Nude Man model onto the workspace and select the left shin.

2. This element, as well as the foot and toes, should be invisible. After selecting the particular body part, choose Object|Properties (Command/Control + I) to bring up the Element Properties window, shown in Figure 4.30, which is similar to the Prop Properties window you saw in Figure 4.26. Click Visible to make the element invisible. Also turn

Figure 4.30
Even though you have made an element invisible, Poser will still see it as part of the model, so it can still cast a shadow. When making an object invisible, also make sure Casts Shadow is turned off.

┌─ Element Properties ────────────────

Internal Name: lShin

Name: [Left Shin]

☐ Visible ☑ Bend

☐ Casts Shadow [Add Morph Target]

 [Cancel] [OK]
└──────────────────────────────────────

off Casts Shadow. If you don't, the invisible leg will still cast a shadow. The only element that should create a shadow is the peg leg.

3. Repeat this process for the left foot and the left toes. Your workspace and model will now look like Figure 4.31.

Figure 4.31
The amputation part of the project is completed. Poor guy.

4. Go to the Prop Types section of the Props model shelf and select the cylinder prop. Change the Scale settings to the following values:

 • Scale: 60

 • Yscale: 64

5. Position the cylinder in the following manner. The results should look like Figure 4.32.

 • xTran: .034

 • yTran: .188

 • zTran: .020

Figure 4.32
The cup of the peg leg in position on the model.

6. Place the cone on the workspace and change its parameters as follows. Figure 4.33 shows what it will look like.

- Scale: 51
- yScale: 389
- zRotate: 180
- xTran: .033
- yTran: .196
- zTran: .020

Figure 4.33
Our piratical hero has sharpened his peg leg to a lethal point.

7. Open the Hierarchy Editor. Notice the list now. Every element of the P4 Nude Man model is listed, along with each parent/child relationship. Scroll all the way down to the bottom. This is where the cylinder (cyl_1) and the cone (cone_1) are listed. Change their names to Cup and Peg_Leg respectively.

8. The Peg_Leg element needs to become a child of the Cup element, and the Cup element needs to become a child of the Left Thigh element. Move the Peg_Leg element onto Cup in the Hierarchy Editor. Then move Cup onto the Left Thigh listing. Don't worry if you can't see it because the screen is too small. Drag the element to the top of the window and it will begin scrolling. After you set the hierarchy, you will probably have to reposition the peg leg a bit. This is an anomaly within the program.

9. Click Create New Figure and then close the Hierarchy Editor.

10. Now open the Properties window again and choose Set Parent. In the Choose Parent window seen in Figure 4.34, scroll down to Left Thigh and click it once to select it. Click OK. Then click OK again in the Properties window. Before you reposition elements, such as the thigh, remember to turn off Inverse Kinematics in the Figure|Use Inverse Kinematics menu.

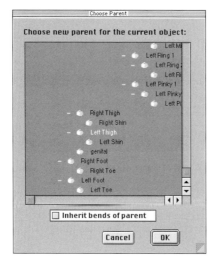

Figure 4.34

Use this window to set the Left Thigh element as the parent to the peg leg prop.

11. Now select the left thigh and move it around. With some creative texture mapping and some appropriate clothing (a naked pirate is not exactly a scary pirate!), you have yourself a fun new character to add to your scenes.

Moving On

With this knowledge well in hand, you can definitely begin to create new and exciting characters. You will also want to check online resources to discover how to modify Poser characters in other 3D programs so you can build everything, including clothes (your first priority should be making some clothing for that naked pirate!), hair, and new body elements.

This and the preceding chapters provided you with a quick overview to help you get up to speed in Poser if you are new to the program or have only used it for a short time. From here, you'll begin to move into more advanced areas. In the next chapter, you'll learn how to modify and create image maps for both the default Poser characters and the advanced characters like Michael and Victoria.

Chapter 5

Image Is Everything

*Posing your models correctly is important, but so is
the ability to add character through the use of image,
transparency, and bump maps. In this chapter,
you will discover the basic techniques utilized to
create high-quality maps for your models.*

Map to Success

If you have used Poser for even a little bit of time, I am sure you have seen image maps on the Internet—and you've probably downloaded some. There are dozens of artists who either provide these maps for free via sites like **renderosity.com** or for fairly low cost. The maps incorporate artwork that has been created in programs such as Adobe Photoshop, PhotoPaint, CorelDRAW, or Deep Paint 3D and Deep Paint 3D w/Texture Weapons, and many also incorporate photographic images that allow the artists to call the maps photorealistic.

Many, if not most, of these maps are built using images of unwrapped meshes, called *templates* (pronounced "tem-plet" or "tem-playt," depending on whom you talk with). Figure 5.1 shows a template for the P4 Nude Woman model. What you are looking at is the actual mesh of the model. The mesh has been flattened out, which allows you to paint on it with the confidence that, when the finished map is assigned to the actual model, it will be correctly positioned on the model. Although this description is simple, it's pretty accurate.

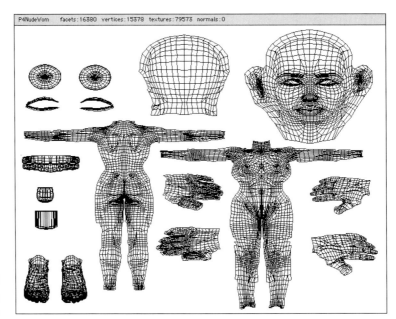

Figure 5.1

A sample of a template for the P4 Nude Woman model.

Many of these templates even list the various elements, so you'll know which part of the model is which. Without these lists, it can be difficult when you have models with numerous parts to tell which element of the model you are working on. Figure 5.2 shows the DAZ Charger model flattened using a program called UVMapper. As you can see, without some sort of defining text, it is difficult to tell what each element represents. However, UVMapper gives you the ability to select elements by their names by going to Select|Group (Figure 5.3) or Select|Material (Figure 5.4).

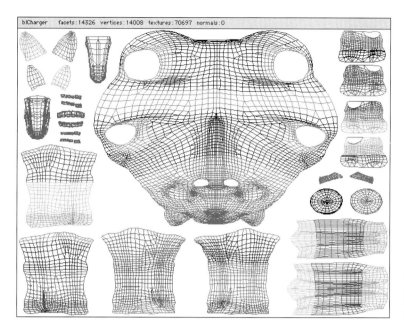

Figure 5.2
A sample of a complicated mesh. It is difficult to tell what each model element is.

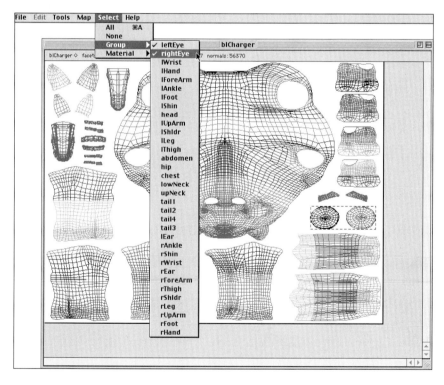
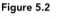

Figure 5.3
The path to selecting an individual or group of elements. This menu helps you better visualize where the correct texture should be added and where it will appear on your model.

Many of the higher-end modeling programs like LightWave and 3D Studio Max give you the ability to create mesh templates directly in the program. Other programs don't. Plus, many of the models you might download from the Internet don't include templates. In that case, UVMapper will create a template for you. UVMapper can be downloaded free of charge from **www.uvmapper.com**.

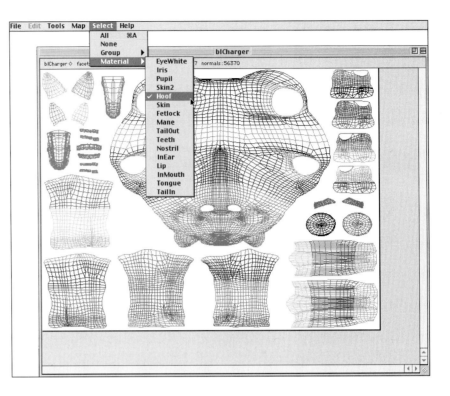

Figure 5.4

The path to selecting Materials. This menu helps you better visualize where the correct texture should be added and where it will appear on your model.

Many of the people who build image maps are true artists who have mastered the complexities of creating lifelike imagery. Most studied fine art and are talented painters. But this doesn't mean that if you aren't artistically inclined you can't create some fantastic image maps to use on your models and to share with the Poser community. That is what this chapter is about: showing you how you can create these maps even if you aren't artistically inclined. You'll discover how to use programs like Photoshop to create textures and transparency and bump maps, which will provide you with the basics you can build upon.

Map Types

The first thing to understand is what each map is and how each is used in conjunction with the others. The best way to learn about these maps is, of course, to go out and purchase a second copy of this book (for which I'd be eternally grateful!) and keep it permanently opened to this chapter.

There are three different kinds of maps:

- *Image maps*—These are the maps that contain the color information for the model. They provide the base look to the model, be it the patterns for clothing, the color of the skin, any blemishes you might add, and so on. (See Figure 5.5.)

Figure 5.5
An example of an image map.

- *Transparency maps*—The ability to make objects or portions of objects transparent was introduced in Poser 4. This has led to some fantastic effects, such as realistic hair. On a transparency map, anything colored white is opaque, whereas black is transparent. Transparency falloff is created through the use of shades of gray. (See Figure 5.6.)

- *Bump maps*—These maps, usually grayscale (meaning they are black-and-white images), give rough, textured looks to models and model elements. The white areas of these maps are high points and the black areas are low points. (See Figure 5.7.)

When these three image maps are used in conjunction with each other, your model or model element takes on a more realistic appearance when rendered.

Resolutions for Image Maps

The higher the resolution of the image map, the more detail will be added when the image is rendered. A good base image map size is 1200×1200 pixels for a low-end high-resolution map.

Modifying an Image Map in Photoshop

The best advice I can give to aspiring texture makers is to start simple. Don't try to create a human texture right off the bat. Begin with something like clothing and get a feel for the process. Then start moving up to building textures for organic characters. In this section, you will create a T-shirt texture and bump map for the P4 woman. In fact you will create a couple of them.

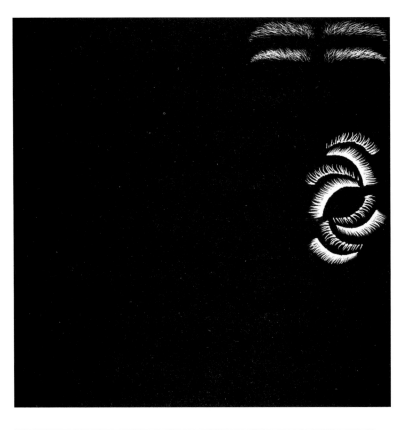

Figure 5.6
An example of a transparency map.

Figure 5.7
An example of a bump map.

To begin your foray into fashion design, follow these steps:

1. In Photoshop, or the image editor of your choice, open the femTshirt.jpg or femTshirt.pict image from the Chapter 5 folder on this book's CD-ROM. Once it is open, create a new layer.

2. When you're working with textures, only the areas where you see the mesh will be translated to the model. All of the white space outside of the mesh is not recognized by Poser. So you can legally color outside of the lines without losing grade points. The active and inactive areas are indicated in Figure 5.8.

Note: The following tutorials involve working in Photoshop 6. The techniques will be the same for any similar program, but you will need to make adjustments for tool names, locations, and so on if you are using a different program.

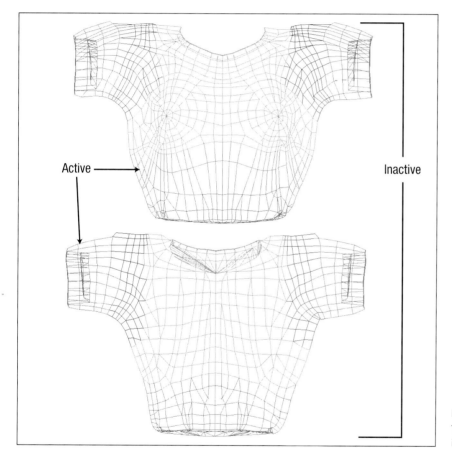

Active

Inactive

Figure 5.8
This image shows the active and inactive areas in a template file.

3. With a T-shirt texture on a template such as this, you can safely fill in the entire layer. But, to get used to working with different elements, use the Lasso tool and draw around the two mesh areas of the image. Fill these areas with a deep blue color. Your template will look like the one in Figure 5.9.

Figure 5.9

The T-shirt mesh area has been outlined and filled with a deep-blue color.

4. Now, here comes the biggest trick to making seamless textures. The front and back areas of the mesh are mirrored. This means that any pattern you create on the front will have to be flipped on the vertical axis to match up correctly with the other side of the shirt. Refer to Figure 5.10 to get a better idea of what I'm describing.

5. To best visualize what happens, make a new layer and, using the Rectangular Marquee tool, make a vertical rectangle and fill it with yellow as shown in Figure 5.11.

6. Lower the opacity of the shirt color layer (which should be Layer 1), duplicate the layer with the vertical stripe, and move it so that it corresponds with the same points of the mesh of the T-shirt back—only on the opposite side of the image. Refer to Figure 5.12 to better visualize this.

7. Now choose File|Save As and save this file as femTshirt1.jpg. Then open Poser. From the Clothing-Female section of the Figures model shelf, select the Women's T model. Assign your newly created JPEG image to the shirt in the Surface Material screen and then render the image. You will notice that the inside edge of the stripes match up, but the outside edges don't (refer to Figure 5.13). Why is that?

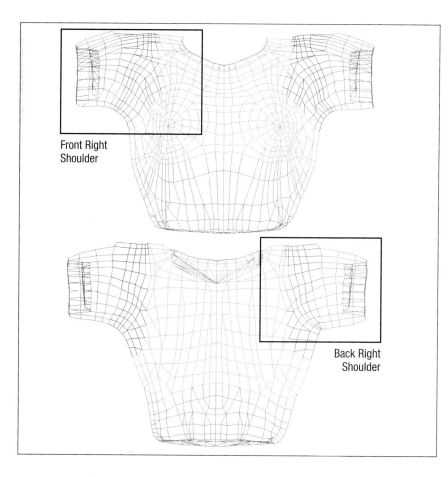

Figure 5.10

The right shoulder for the front of the shirt and the back of the shirt are on opposite sides of the mesh.

Front Right Shoulder

Back Right Shoulder

Figure 5.11

A vertical rectangle created on a new layer and positioned on the right shoulder.

Figure 5.12
The duplicated stripe is placed into the correct position on the back side of the mesh so that it aligns properly with the stripe in the front.

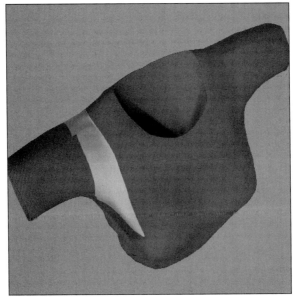

Figure 5.13
Even though their dimensions are the same, an anomaly in the mesh prevents the stripes from matching up perfectly at the seam.

Fixing the Anomaly

The stripes don't match up perfectly because the curve to the mesh causes a slight resizing of the model. This can easily be fixed back in Photoshop. Here's how to do it:

1. Select the layer that contains the stripe on the back.

2. Choose Edit|Transform|Distort and move the upper-right corner of the back stripe inward so it looks like what you see in Figure 5.14.

Figure 5.14
The upper-right edge of the stripe has been moved inward.

3. Choose File|Save As and save the file as femTshirt2.jpg. In Poser, assign this new image to the T-shirt model and render the image again. You will see the shoulder edges line up perfectly, as they do in Figure 5.15.

You might need to change the stripe a couple of times until you get the top edges to line up on the model correctly. By doing this, you get a good idea as to why high-quality image maps can take some time to make. It's the small details that separate the good from the great. So take your time and experiment, and try not to let too much frustration into the equation.

Figure 5.15
With that slight change to the back stripe, the two sides of the image map align perfectly.

Making the Bump Map

Now that you have the stripe lined up correctly, you can make it puff out some, as if it were a strip of leather or shiny vinyl. Before doing that, though, save your layered file as tShirtdesign.psd, making sure to retain the layers. This way, you won't accidentally overwrite the original mesh image. Then do the following:

> **Note:** Unlike in previous versions, Poser no longer converts bump maps to a special file for Poser to read correctly.

1. Convert the image to grayscale (Image|Mode|Grayscale). Be sure you select Don't Flatten when prompted. Turn off the two stripe layers so all you're left with is the T-shirt image.

2. Using the Magic Wand tool, select the T-shirt portions of the image and fill them with white. Remember, white represents the high points in a bump map, and you want the body of the T-shirt to be the high point. Turn off the Background layer so you can see your shirt better, as in Figure 5.16.

3. Select the T-shirt parts with the Magic Wand tool and choose Filter|Texture|Texturizer. On this screen, seen in Figure 5.17, choose the following settings:

 - Texture: Burlap
 - Scaling: 55
 - Relief: 1
 - Light Dir: Top Left

 This will give you a very light texture that is barely discernable. That's okay because, with T-shirt material, the material's texture is not readily apparent unless you look at the shirt closely.

4. Now make the two stripe layers visible. They'll be a grayish color, which is okay for now. That will be changed shortly. What you'll create now is the slight inward ridge that would appear when the shiny vinyl material is sewn onto the shirt. To do this, make a new layer between the shirt layer and the front (top) stripe layer. Then select the Airbrush tool and a small, soft-edged brush. With the newly created layer active, draw an outline around the outer edge of the stripe, as seen in Figure 5.18. It doesn't have to be a perfectly straight outline because the material would not naturally have a perfectly even indentation.

5. Next, using the same layer, select the Airbrush tool and draw an outline for the back stripe.

6. You don't want the indentation to be too deep, plus you want some of the material bump to show through this ridge, so change the layer opacity to 45%. Figure 5.19 shows a close-up of the front stripe and how the indentation layer should look.

7. Now you will work on the stripes. First, merge the two stripe layers. Select this newly merged layer and fill it with white, making sure that Preserve Transparency is selected. Use the Magic Wand tool to select the two stripes. Choose Select|Modify|Border and create a 2-pixel border.

Figure 5.17
The Texturizer screen in Photoshop, with the bump settings selected.

Figure 5.18
The base indentation for the front stripe.

Figure 5.19
By reducing the opacity of the indentation layer, you allow the texture to show through, as well as guarantee that the indentation itself isn't too deep.

8. Create a new layer with the selection still active, choose Edit|Fill, and fill with the foreground color (as long as it's black). Once it's filled, deselect the selection and choose Filter|Blur|Gaussian Blur. Assign a 2-point blur to the borders and then change the opacity for this layer to 45%. As you can see in Figure 5.20, this gives a puffed appearance to the stripe.

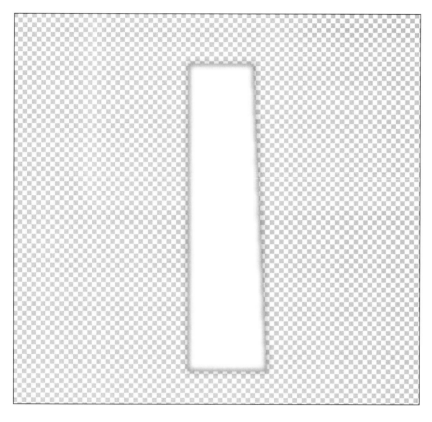

Figure 5.20
After you complete Step 8, the stripe will have a puffed-up appearance.

9. You can now add some folds in the stripe so it looks like crunched-up leather, or you can leave it smooth. I did the former by duplicating the stripe layer, selecting the stripes, choosing Filter|Render|Clouds, then changing the layer opacity to 40%.

10. Choose File|Save As and save this image as femTbump.jpg. Then use the Save As function again to save this bump file and its layers as a layered PSD file.

11. Start Poser and open the Surface Material screen. In the Bump area, select the femTbump.jpg image and then render it. This is a nice, subtle effect. To make it less subtle, you can go back to your layered bump file and change all the shadow layers to 100%. Figure 5.21 shows what this would look like on the model.

Figure 5.21
The bump map as seen in close-up on the T-shirt model.

The Transparency Map

Transparencies are, as bump maps are, created using a black-and-white image. The black areas are completely see-through, and the white areas are totally opaque. Transparencies can be used to create rips in clothing, turn a sleeved shirt into a sleeveless shirt, or in science fiction scenes, create holes in flesh to reveal robotic appendages under the surface, among other things. With practice, you can even simulate hanging threads and strands of hair. In this section, you will use the same layered grayscale file you just made to turn the sleeved T-shirt into a sleeveless one. Here's how:

1. Either reopen or go back to the layered file you just saved as femTbump and make the stripe and stripe shadow layers invisible so that all that is left is the white T-shirt. If need be, refill this layer with pure white to remove the material texture.

2. Now make that layer invisible so that all you are left with is the template image.

3. Select the sleeve portions of the template, as shown in Figure 5.22, and then, after creating a new layer, fill these sections with black so your image looks like Figure 5.23.

4. Save this file as tTrans.jpg.

5. In Poser, go to the Surface Material screen and, in the Transparency Map section, choose this file. Set the Transparency Min and Transparency Max controls to 100. The Surface Material screen will now look like it does in Figure 5.24. Click OK.

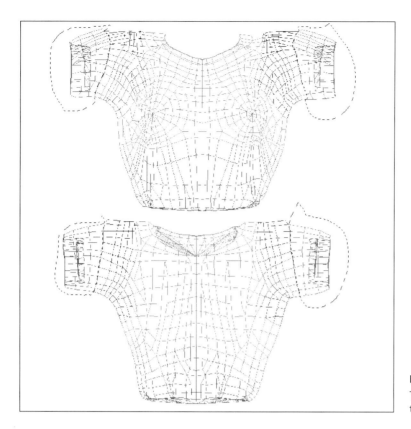

Figure 5.22
The selected mesh representing
the T-shirt sleeves.

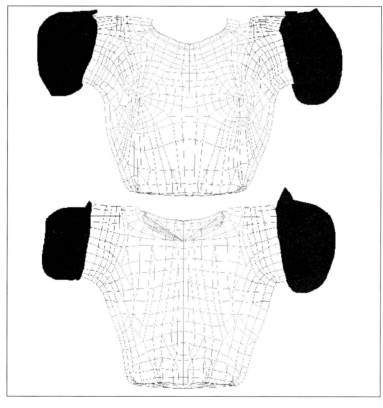

Figure 5.23
The selected areas filled
with black.

Figure 5.24

The Surface Material screen with all maps assigned and the Transparency settings in their correct positions.

6. With the transparency map assigned, the entire T-shirt will appear grayed out as it does in Figure 5.25. But that's okay. This is normal for an element that has a transparency map assigned to it. Render the file, and you will see that everything that has white assigned to the transparency map is seen, and the sleeve areas—the only areas that have black assigned—are see-through, as shown in Figure 5.26.

Figure 5.25

When transparencies are added to a model, the model on the workspace takes on a very weird appearance. This is perfectly normal.

Figure 5.26
The rendered shirt, sans sleeves.

Figure 5.27
Two looks for the same shirt.

To make the T-shirt look more realistic, you can modify the bump map to reflect seams at the edges of the modified sleeves, but for the most part, you now have a totally new look for the shirt. Figure 5.27 shows the T-shirt on the P4 Nude Woman before the transparency map is applied and after, so you have a better idea of what you just created.

Getting Deep into Texturing

For years, many 3D texture artists have been asking for the ability to paint directly onto a model because, with flat meshes, you can get unwanted stretching of the texture around curves and odd-shaped areas. There was one product a few years back that failed pretty massively (I won't mention its name, but many of you know what I am referring to), but a short while ago, another product was released that has many in the 3D community salivating because of its capabilities. This program, Deep Paint 3D, and its plug-in, Texture Weapons, gives artists the ability to paint not only on a two-dimensional unwrapped mesh via a plug-in that can be installed in Photoshop, but also directly on the model.

This next section will give you an overview of Deep Paint w/Texture Weapons capabilities. This is a high-end program, and it would take an entire book to explain its intricacies and do it justice. If you look at the texture provided by Catharina Przezak on this book's CD-ROM (in the Original Textures folder), or any of the textures that are for sale at **www.renderocity.com** (her company's site) or at **Renderosity.com**, you are looking at textures created in Deep Paint w/Texture Weapons.

A Look at Deep Paint w/Texture Weapons

This section will show you how you can use Deep Paint w/Texture Weapons to paint directly on a model rather than on projection maps or on flattened meshes.

The first thing to do after starting up Deep Paint w/Texture Weapons is to import a model. You can import various formats, including 3DS and OBJ. In this case, I'm using the Bigfoot model that comes free from DAZ 3D (located in the Models\DAZ 3D folder on this book's CD-ROM). The model I am using was exported from Poser in 3DS format.

You can also select the materials you want to import, if any are available. The Material Import screen, seen in Figure 5.28, is where this is accomplished.

The actual model that is opened on the workspace is seen in Figure 5.29. Many of the standard controls are available, including the control that allows you to zoom in to areas (Figure 5.30) for more precise work and the controls used to rotate the model to see it from various angles (Figure 5.31).

Figure 5.32 shows one section of the effects list. This list sets up the brush to lay down that effect as you paint. Figure 5.33 shows the Hair 2 effect painted onto a portion of the model. This image also shows the Human Skin feature assigned to Bigfoot's upper lip, cheeks, and forehead.

With Deep Paint and Deep Paint w/Texture Weapons, you have total control over all aspects of the paint brush and lighting, as well as other tools that affect the look of your model's exterior. Plus, you can paint on bump maps,

Note: As this book is being written, Deep Paint and Deep Paint w/Texture Weapons are PC-only programs.

Figure 5.28
The Material Import screen.

Figure 5.29
The model as seen after being imported.

Figure 5.30
You can zoom in to do highly detailed work on the model.

Figure 5.31
The model can be rotated a full 360 degrees so you can work on all sides.

create reflective areas, and more, all while assigning these effects directly onto the model. You then export the various maps you've created and import and assign them to the appropriate section of the model in Poser, LightWave, 3D Studio Max, Carrara, or other modeling programs.

Figure 5.32

The Skins, Fur, and Hair list and the various preset effects that are available to paint with.

Figure 5.33

The Hair 2 effect has been assigned to a portion of Bigfoot's beard. This is accomplished simply by painting on that particular area of the model.

Learning Deep Paint w/Texture Weapons will take some time, but if you are serious about creating photorealistic textures for your own use or to provide over the Internet, there is nothing else that even comes close to what can be accomplished in this program.

Animating Materials

New to the Poser Pro Pack is the ability to animate materials. Materials in this sense are different from texture maps—materials are the colors assigned to an object. So, over time in an animation, you can assign different colors to an

object and have it dissolve from one color to the next as the animation plays out. This feature is activated by clicking the Animateable button at the bottom of the Surface Material screen. Give this a try as follows:

1. Place a ball prop on the workspace and open the Surface Material screen.

2. Change Object Color to red. Leave the rest of the color settings on their default colors. Click OK.

3. Go to Frame 10 in the Basic Animation control panel. Open the Surface Material screen again and change the Object Color to yellow, Highlight Color to red, and Reflective Color to green. Click OK.

4. Go to Frame 20 in the Basic Animation control panel. Open the Surface Material screen again and change Object Color to blue, Highlight Color to yellow, and Reflective Color to red. Click OK.

5. Go to Frame 30 in the Basic Animation control panel. Change the colors to the colors you set in Step 3. Click OK.

6. Set up the animation settings as you want and animate your scene.

> **Note:** A sample animation called AnimatedColors is provided in the Chapter 5 folder of the CD-ROM.

Of course, you can add a bump and/or transparency map to the object to add some interest to the surface, and by changing light positions, you can create interesting effects. Plus, by utilizing the Ricks effect outlined in Appendix B, you can build some pretty awesome images.

Unfortunately, the Pro Pack doesn't allow for animated texture maps—yet.

PROJECT Changing a Character's Appearance

In this project, you'll build an original image map over a flattened mesh. Hopefully you've gotten a lot of the excitement out of your system from the texture creation power of Deep Paint, and you want to try your hand at modifying something more complicated. Chances are most of you have some sort of program that emulates Photoshop—or have Photoshop—so return to that program.

The Texture Map

For this project, you will work with the P4 Nude Woman texture map that is located in Poser in the Runtime\Textures\Poser 4 Textures folder. The file is called P4 woman texture.tif. The texture you're about to create is for a warrior woman who has just been in a massive battle. You'll start by creating the basic texture:

1. Open the P4 woman texture.tif file in Photoshop (or your image editing program of choice) and create a new layer. The first thing you will do is cover up the genitalia, because—well, this is a family book.

> **Image Creation Tip**
>
> I think by now you have discovered that painting an image map is not the easiest thing to do with a mouse or trackball. If you are serious about creating textures, you should consider investing in some sort of graphics tablet, such as a Wacom Intuos tablet.

2. Use the Lasso tool and surround the lower torso from the waist down, including the feet. Select a deep green color and fill this area in so it looks like Figure 5.34. These will be the tights your heroine is wearing.

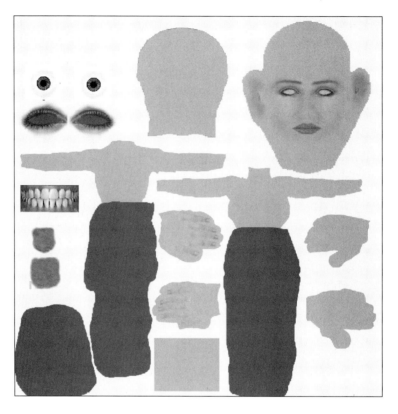

Figure 5.34
The selected areas of the mesh have been assigned a green color. These will appear as tights when assigned to the model.

3. Next you will focus on the hands. You need to make them dirty and scraped up. Start with the scrapes. Zoom in on the tops of the hands, which are located between the front and back of the torso. Change the color to a deep red, the settings for which are shown in Figure 5.35.

Figure 5.35
The color that was selected for the scrapes on the hands. Use these settings to assign the same color to your image.

Figure 5.36
The placement of the scrapes on the knuckles and around the fingernails.

4. Choose the Paint Brush tool and assign the Soft Round 5-pixel brush. Make a new layer and, using Figure 5.36 as a reference, bloody up the knuckles and the area around some of the fingernails.

5. Select Filter|Blur|Gaussian Blur and assign a radius of 1.5 pixels. Then change the opacity of the layer to 80%.

6. Time for some dirt. Choose a dark brown color and, with the same brush you used in Step 4, paint some dirt onto the hand. Make sure you do this on a new layer. Also, don't be afraid to go into the scraped areas to add some realism. When finished, choose Filter|Blur|Motion Blur, put the angle at 0, and set the Distance to 20 to smear the dirt patches around.

7. Choose Filter|Noise|Add Noise. Change the noise amount to 2.44, set Distribution to Gaussian, and select Monochromatic. Your image will now look somewhat like Figure 5.37.

8. Change the opacity of the dirt layer to 65%.

9. Make a new layer and dirty up the bottoms (palms) of the hands. Use the same settings you used in Steps 6, 7, and 8.

Figure 5.37

After you blur and add noise to the dirt layer, your model's hands will look somewhat like this (barring the differences in how you painted on the dirt).

10. Now it's time to work on the face. You're going to give her a black eye. Select an extremely dark purplish black and, on a new layer, paint around the bottom of the eye and onto the cheek area so your image looks like Figure 5.38.

11. Assign a Gaussian Blur of 3 pixels to this layer and set the layer opacity to 52%.

12. Select a green color and, on a new layer, add some green color to the bruise. Give it a Gaussian Blur of 6 pixels and set the layer opacity to 50%. Then merge the bruise layers.

13. Select the same red color you used for the scrapes. Then select the Hard Round 3-pixel brush and draw a jagged streak down the right cheek, as shown in Figure 5.39.

14. Use the Eyedropper tool and sample the skin color immediately outside the jagged scar you created. Around this scar, you need to create a puckered area that is slightly lighter than the actual skin color.

15. Finally, create a new layer and dirty up her face some. Use the same settings you used for the dirt on her hands. By the time you're finished, your heroine should look pretty messy and in much need of some heavy foundation to cover that big old bruise. Figure 5.40 shows how my finished model looked.

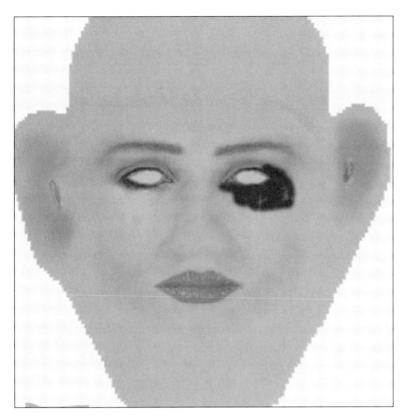

Figure 5.38
The preblended first layer of
what will become a bruised eye.

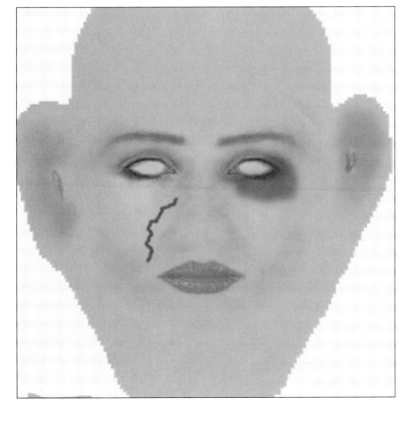

Figure 5.39
A jagged scar running down your
heroine's right cheek.

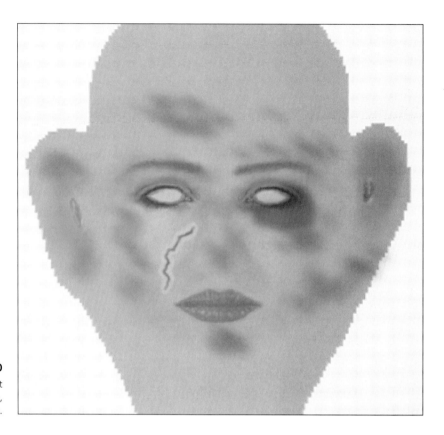

Figure 5.40

This character needs a good, hot shower to ease those sore, aching muscles.

16. Save the layered file in the native Photoshop format and then choose File|Save As and save this file as heroineTexture.jpg.

The Bump Map

Now it's time to create the bump map. With the layered Photoshop file open, do the following:

1. Create a new layer over the background layer and fill it with white. You will also want to change the image to a grayscale image.

2. Make all the layers invisible except for the tights layer. With Preserve Transparency activated, fill the tights with white and then choose Filter|Texture|Texturizer. Choose Canvas and change Scaling to 86 and Relief to 2.

3. Open the Motion Blur panel and set Angle to -90 and Distance to 9 pixels.

4. Select the layer that has the scraped knuckles. Create a new layer directly above it and then select the Pencil tool and white for the color. With the smallest pencil point, begin dotting around the exterior and,

in places, the interior of the scrapes. Assign a .5-pixel Gaussian Blur to this layer and change the Blending Mode setting to Screen.

5. Select the black-eye layer and create a new layer over that. Choose a light gray color and, with the Paint Brush tool, paint a light area over the bruise.

6. Blur this layer using a Gaussian Blur setting of 3.5. Leave the opacity at 100%.

7. Create a new layer immediately above the scar layer. Use the same light gray color and, with the smallest brush size, paint an edge around the scar. Then select the Lasso tool and select the middle to outer pixels of this edge, as shown in Figure 5.41. Assign a Gaussian Blur of 2 pixels.

Note: The layered Photoshop files I created during this project are included for your use in the Chapter 5 folder of the CD-ROM.

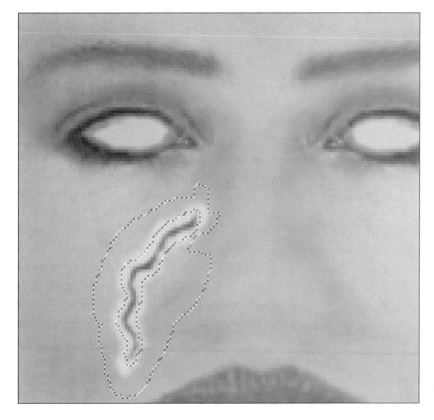

Figure 5.41
A bump has been created for the puckered area of the scar.

8. If, like me, you kept the background layer on so you could see your work against the actual texture map image, make that layer invisible now and activate all the other layers except for the dirt layers. This is your bump map. Save it as heroineBump.jpg and get ready to view how the bump map looks when assigned to the model.

The Heroine Unveiled

Now it is time to assign the image and bump maps you created to the character. I have also used a female tunic costume model from DAZ 3D's Tunic Pack. If you don't have this model, you will need to use another to cover the character's upper torso. Topless heroines were virtually nonexistent in the time period you're re-creating. Anyway, open Poser, place the P4 Nude Woman model on the workspace, and do the following:

1. Select a shirt for her to wear. Open the Surface Material screen. Select Figure 1 and click the Texture Changes Apply To Entire Figure button. Then load the heroineTexture.jpg image as the texture map.

2. In the bump map area, load the heroineBump.jpg image.

3. Switch to the Face camera and render the scene. Your heroine's face will look similar to what you see in Figure 5.42.

Figure 5.42
A close-up of the heroine character's face.

I have also positioned the heroine character in a combat-like pose. Figure 5.43 shows this wider shot so you can get a better feel for how the textures you created for the tights and hands appear on the model.

With some more tweaking to the image map, you can create pockmarks in a character's skin, blemishes, and much more.

Figure 5.43
A full shot of the mapped heroine.

Moving On

As you can see, creating textures, even nonphotorealistic ones like the one you just made, is rather time consuming. Textures are not something you create in a couple of minutes. Many people spend days and weeks on their image and bump maps. But as you can also see, the effort can be very much worth the amount of time you put in.

Now it's time to move on to some of the new additions to the Poser Pro Pack. The first stop you will make is at the Setup Room, where you can add bones to figures you create inside of Poser or in modeling programs such as LightWave, 3D Studio Max, and Ray Dream Studio. I'll see you there.

Part II

Advanced Techniques

Chapter 6
The Setup Room

One of the hottest additions to the Poser Pro Pack is the ability to set up bone structures directly in the program. In this chapter, you'll be introduced to this feature and discover how to create objects you can animate.

Dem Bones . . .

Anyone who has created a 3D model and wanted to animate it knows about *bones*. To put it as succinctly as possible, bones in 3D modeling programs act exactly like the bones in our bodies; they control our movements. By properly assigning bones to a model, you can control the way various parts of the model twist and bend. Of course, if these bones are not assigned correctly, they can do some very strange things to your model, such as creating holes in the mesh or deforming the model or element so drastically it's no longer recognizable. The Pro Pack offers a new feature called the Setup Room, which you can use to create and assign bones to a model. I'll start off this chapter with a quick explanation of what bones are and how the Setup Room differs from the Hierarchy Editor you worked with in Chapter 4.

Bones can be assigned to virtually any type of object that you want to make move. This can be anything from the simplest dancing box to a highly complex humanoid character. The trick to using bones is to make sure their parent/child relationship is set up correctly. The bone structure relationship (the hierarchy) is important, but so is the position for the starting (or resting) setting for a particular bone and the setting for the bone's maximum movement allocation. These settings are called the Rest Position and Rest Rotation parameters. In Poser, these are assigned via the parameter dials you've been using throughout this book.

Figure 6.1 shows you what a P4 model's bone structure looks like when the model is brought into the Setup Room.

<div style="float:left; width:30%;">
Note: In this chapter (and throughout the rest of the book), I will be referring to the Pose Room and Setup Room to differentiate between the main Poser workspace (the Pose Room) and the bone setup area (the Setup Room).
</div>

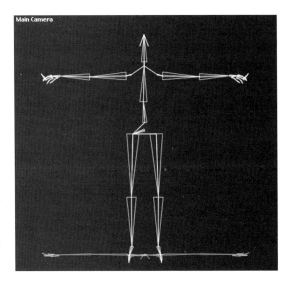

Figure 6.1

The bone structure of the P4 Nude Woman as viewed in the Setup Room. I have made her invisible so that you can see the actual bones assigned to the model.

The piano model seen in Figure 6.2 is an articulated prop that was offered as a freebie from the Daz 3D site. Its bone structure as seen in the Setup Room, shown in Figure 6.3, is much simpler. An articulated prop, by the way, is a

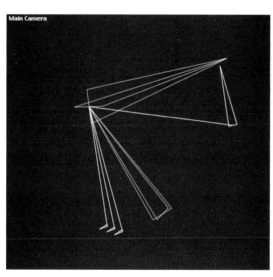

Figure 6.2

An example of an articulated prop. Various parts of this model have movement parameters assigned to them.

Figure 6.3

The bone structure for the piano model as viewed in the Setup Room.

nonstatic prop; in other words, it has movement parameters set to various parts of it. In the case of this piano, the lid can be closed and the pedals can be moved up and down.

Think of a bone as a type of magnet; it is attached to a specific part of the model—just as the Magnets and Wave Deformers in Chapter 3 were—giving you the ability to change the appearance of the mesh.

Bone Basics

To understand bone setup, it helps to remember that bones play off each other. An individual bone assigned to, say, the upper area of a model will affect the entire model. So a single bone would make the entire model tilt forward. But on the other hand, if you drew out two bones that attach to each other at the model's midpoint, moving one or the other will affect only the area where that particular bone is. Give this a try, starting with the single bone scenario:

1. Place a box prop onto the workspace. Change the yScale setting to 500 and the zScale setting to 40, creating a long, narrow box. Open the Prop Properties window (Command|Control + I) and change the name of the box to Monolith.

2. Click the Setup tab. You will receive the message you see in Figure 6.4. You definitely want to click OK. You can't assign bones to a model if it isn't turned into a figure. This is how Poser differentiates between a static prop and one that is considered *articulated*, meaning it has moving parts.

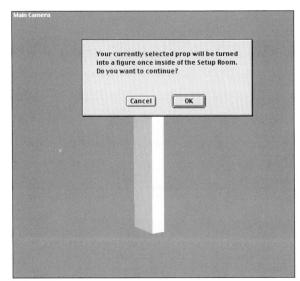

Figure 6.4
Turn your prop into a figure by clicking OK when this screen appears.

3. Select the Bone Creation tool, which is the last tool to the right in the Editing Tools panel, as seen in Figure 6.5.

4. Click and drag from just above the top of the box to approximately the middle of the model (refer to Figure 6.6).

Figure 6.5
The Bone Creation tool is located in the Editing Tools area (the tool on the far right).

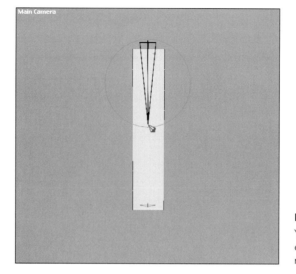

Figure 6.6
You should draw the bone so it extends to approximately the middle of the Monolith.

Figure 6.7
Use the Element Properties window to set the properties for the bones in your scene.

Figure 6.8
The Group Edit window.

5. With the bone active, choose Object|Properties to bring up what is now called the Element Properties window. Notice in Figure 6.7 that the window includes an Internal Name field and a Name field. It's often not a good idea to change the internal name; it's based on the bone's numerical placement and it gives you one more representation of the element's overall bone structure. But you can comfortably change the name of the bone itself. I named this bone Monolith_Upper. (I have a habit of using initial caps when I name objects. This is not necessary, so feel free to use upper- or lowercase letters.)

6. Select the Grouping tool, which is immediately to the left of the Bone Creation tool. The Group Edit window, seen in Figure 6.8, appears.

7. This is a very simple model and demonstration, so at this juncture it's not necessary to go into detail regarding this window. You'll learn more about it at the end of this chapter. For now, simply click the Auto Group button. Then close the Group Edit window.

Return to the Pose Room. In the current element pop-up menu, under Body Parts, you will now see Monolith_Upper listed. When it's selected, the controls for that bone become active in the Parameter Dials area. But because the single bone affects the model the same as if you just chose Body from the current element pop-up, you aren't going to get a lot of use out of this setup. In the next section, I'll show you how to build a more useful setup.

Adding a Second Bone to the Monolith

As I mentioned earlier, adding a second bone to the model will make it easier for you to modify the Monolith:

1. In the Setup Room, select the Bone Creation tool. At the end point of the original bone (Monolith_Upper), draw out another bone. The second bone will begin at the middle of the Monolith and end at the bottom of it, as shown in Figure 6.9. Rename this new bone Monolith_Lower.

Figure 6.9
The second bone is drawn from the end of the first bone to the bottom of the Monolith object.

2. Click the Grouping tool. In the Group Edit window, click Auto Group.

3. Go back to the Pose Room and select Monolith_Lower by either selecting it from the current element pop-up menu or clicking on the lower half of the Monolith model. Play with the x-, y-, and zRotate dials and x-, y-, and zTran dials to watch your model bend and twist.

If, as you play with the dials, the model actually breaks in half instead of bending smoothly, go back into the Setup Room, reassign names to the bones, and then, instead of clicking Auto Group in the Group Edit window, click Weld Group. This will tell Poser that this model should be welded together and, thus, bend without breaking.

You can make the bone sections shorter and add more of them to the Monolith model to give you more control over the way the model bends, twists, and turns. Take some time to experiment before moving on to the next section of the chapter. You can also view a short animation I have saved as both a QuickTime (jump4joy.mov) and AVI file (jump4joy.avi) in the Chapter 6 folder on the CD-ROM. This animation uses the Monolith model with four bones added to it. The positions of these bones are shown in Figure 6.10.

Figure 6.10
By adding more bones to an element, you can obtain greater control over it as you create poses or animations.

Using Existing Bones

You don't have to create entirely new bones when you're creating a new model in Poser. You can combine existing bones with your creation. This can sometimes speed up the building process when you're making structures that are more complicated. In this section, the model you will create isn't very complicated at all—if you close your eyes real tight, click your heels together three times, and then reopen your eyes, it might look like a suitcase, but it will give you a good idea as to how you can combine prop elements and merge them with a prebuilt bone structure.

Follow these steps to build a model using existing bones:

1. Create a new document and place a box prop on the workspace. Resize the box to the following dimensions:

 - xScale: 150

 - yScale: 50

 - zScale: 150

2. Add a second box prop and change its scaling as follows:

 - xScale: 150

 - yScale: 150

 - zScale: 50

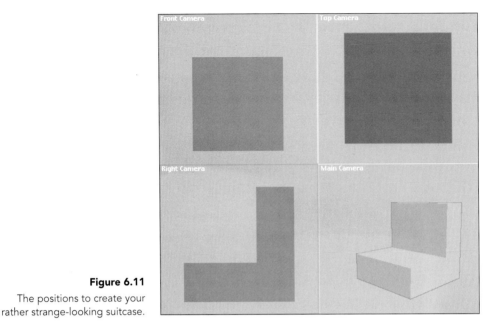

Figure 6.11

The positions to create your rather strange-looking suitcase.

3. Switch to a Quad view and position the second box primitive as it is positioned in Figure 6.11. Here are the actual numerical values for this position:

- xTran: 0

- yTran: .0

- zTran: -.050

4. Rename these elements so that the bottom box is called Bottom and the top box is called Top. (Pretty creative names, if I do say so myself.)

5. Open the Hierarchy Editor and move the Bottom box element onto the Top box element so that the latter becomes the parent object. The Hierarchy Editor will now look like Figure 6.12.

6. In the Hierarchy Editor, click the parent object (Top), then click the Create New Figure button. In the New Set Name window, name the new model Suitcase and click OK. A new figure will be created and saved in a subfolder called New Figures in the Figures model shelf. (Don't worry, you can get rid of the Suitcase model after this tutorial is completed—unless, of course, you really love it and want to use it over and over again.)

7. Now create a new document, but don't save the file you are closing. Then reload the saved Suitcase model.

Set Parent

You can assign a parent to an element by selecting the one you want to be a child, opening the Properties window, and clicking on the button called Set Parent. Navigate to the element you want to be the parent, click it, and then click OK.

Figure 6.12

The Bottom element is now the child of the Top element, as seen in the Hierarchy Editor.

8. Go to the Setup Room. There will be two bones already assigned to the model. These are the base bones that let you rotate and resize the model. Click them individually and use the Delete key to delete them.

9. Open the model shelf. You're going to import a preexisting bone structure to assign to the Suitcase model. In this case, go to the Figures subshelf and choose the Poser 2 Lo shelf. Select the Nude Man P2 Lo figure and his bone structure will be brought into the scene.

10. Delete all the bones except for the left thigh and left shin bones so your screen looks like Figure 6.13.

11. In any of the camera views on the Quad layout, select the left shin bone. Move your cursor to the bottom tip, where it will turn into a circular icon. This is one of the two control points for the bone (the other is at the top of it). These control points allow you to reposition the bones in the workspace. Drag the control point of the bone so it is flush against the front edge of the bottom segment of the Suitcase, as shown in Figure 6.14.

Figure 6.13
Only the left thigh and left shin bones should be left on the workspace after deleting the other bones associated with the Nude Man P2 Lo figure.

Figure 6.14
The bottom tip of the left shin bone is positioned flush against the front edge of the Suitcase model.

Note: If you click in the middle of a parent bone, the parent bone and the child associated with it will move. If you click and drag in the middle of a child bone, the child bone will be repositioned and the parent bone it's attached to will be stretched.

12. Using the four views in the Quad layout, position the bones so they are centered in the Suitcase model as shown in Figure 6.15.

13. Rename the bones Lid and Storage, and then open the Group Edit window by clicking the Grouping tool. Click Auto Group and go back to the Pose Room. Now you can select the elements and open and close the Suitcase.

You will also notice that all the parameters that were set up for the P2 character, most notably the rotation controls, are still intact. Because you used an existing bone structure in this project, all the settings that were assigned to those particular bones were retained.

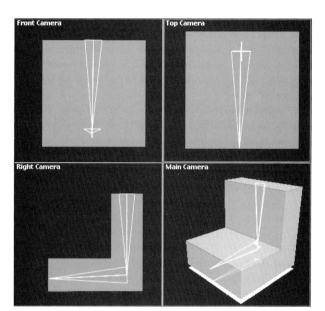

Figure 6.15
Position the bones so they are centered in the model.

Structurally Speaking

This is the perfect time to stop for a moment, sit back and relax, pour some fresh coffee, and talk about hierarchy in more detail. Although we have already used the Hierarchy Editor, I'll focus on it in this section to help you understand it better.

So far you have worked with creating models directly within Poser by combining primitive shapes and then taking them into the Setup Room to add rudimentary bone structures. But I would be remiss if I didn't take this into the other realm of model creation—custom figure creation in other programs. No, this isn't going to lead into a step-by-step tutorial on building a humanoid or animal character because that, in itself, can take up an entire book. What this section will cover is that point after the character has been built and what needs to be done to make the hierarchical structure work within Poser and the Poser Pro Pack.

File Types

Every Poser character or articulated prop is made up of a CR2 and OBJ file. These two files are used for both PCs and Macs. Model files for use with the PC also contain an RSR file. There usually is a texture file (or series of texture files) that comes with the model as well. Here are brief descriptions:

- *CR2*—These are the geometry files that Poser needs to display the model on the workspace, including how an element bends and twists and how it affects other elements in the hierarchy when this happens. For the model to display correctly, its corresponding OBJ file must be installed in the proper location.

- *RSR*—This is a Windows resource. It is a separate file that the Windows version of Poser needs to read various resources assigned to the model.

Note: To convert a hierarchy file to one that Poser can read, choose File|Convert Hier File and navigate to your text document.

- *OBJ*—In a way, there are two different OBJ files. The first is the associated geometric hierarchy file that Poser needs to recognize the .cr2 file and display the model on the workspace. The second is a common 3D model format that most 3D applications—including Poser—can export and read.

- *PHI*—This is a file needed for the PC format and contains the hierarchical and color information for that particular model. When converted for the Mac, the PHI file is combined with the CR2 file. (*PHI* stands for *Poser Hierarchy*).

To get a feel for what the hierarchical text file for a model might look like, break it down line by line where necessary for better clarification. (Remember, this file is generated after a model is completed. Popular modeling programs that many Poser users use to build models are discussed in this chapter under "Meshing Up.")

Examining the Hierarchy File

The first thing that has to appear on any PHI file is the file locator, which tells Poser what it's looking for and where that item can be found. This line appears at the top of the page. Here is a sample locator:

```
ObjFile :Runtime:Geometries:boney:BoneyMaronie.obj
```

This line tells Poser that the OBJ file is located in the Runtime folder, which is located in the main Poser folder. Subsequently, it is then stored in the Geometries subfolder in a sub-subfolder called boney. The model name is BoneyMaronie. So, when you're accessing that model in the model shelf (be it a prop or a character), you'll notice a pause between the selection and the model's appearance on the screen. During that pause, Poser is searching for the correct OBJ file based on the locator line and then reading the hierarchical structure of the model.

Now to the hierarchical information—or the tree of life, as it were:

```
1 body yzx
   2 neck yzx
      3 head yzx
         4 reye zyx
         4 leye zyx
   2 chest zyx
   2 rshoulder yxz
      3 rarm xyz
   2 lshoulder yxz
      3 larm xyz
   2 waist zyx
   2 hip zyx
   2 rleg zxy
      3 rfoot zxy
```

```
    2 lleg zxy
        3 rfoot zxy
ikChain rleg rfoot
ikChain lleg lfoot
```

Although the part names for this fictitious model make sense, the lines look a bit confusing, don't they? You see information for the body, neck, head, eyes, chest, shoulders, arms, waist, hip, legs, and feet. Also included is Inverse Kinematics (IK) information for the appropriate body parts.

It's easiest to think of this as a family tree, with parents and children listed in descending order.

First, the numbered lines represent the parts of the model that must be listed exactly as named. Following each name is the order of rotation for that element. For many elements, the twist parameter should be listed first because it is the most common movement for many body parts. In the case of line 1, the body twists on the y-axis and bends on the z- (forward/back) and x-axes (left/right). Because of this, y should go first. This way, the most common movement control is the first encountered as you move down the list in the Parameter dials.

These numbers also represent the parent/child relationship. The element in line 1 is the parent of all the other parts. The elements in lines with the number 2 are children to the element in line number 1; elements in lines with the number 3 are children to the elements in the line 2 that precedes them, and elements in lines with the number 4 are children to the elements in the line 3 that precedes them. So what this means is that, when the element in line 1 is moved, everything else moves, too. When the element in line 2 is moved, any elements in corresponding lines 3 and/or 4 are moved as well. If you twist the neck, therefore, the head and eyes will move in the same direction because they are the neck's children. If you move the head, the eyes will move with it because they are children to the head.

So what does "ikChain" at the bottom of the list mean? IK helps you pose a character more realistically. For instance, it is natural that when you twist your hips, your thighs also move. With IK turned on, the body parts are repositioned as they normally would move. You will often want to turn the feature off so you can make incremental adjustments to the individual elements though. IK produces the basic positioning; to add that final element of realism, tiny tweaks need to be made to (in this example) the twist of the thigh and final positions of the shin and feet. To turn off IK, choose Figure|Use Inverse Kinematics and deselect the appropriate elements.

It is a good idea to add this ikChain assignment information to the end of the PHI file so that you have the ability to turn the feature on or off if you so desire. It's better to have it than not, in other words.

Meshing Up

Poser pros use numerous 3D modeling applications to build their models. These models include everything from full-fledged characters to clothing to props. Again, taking you through a full modeling process would fill up an entire book. There are dozens of wonderful books that cover the intricacies of 3D modeling on the market, and you will want to obtain those that focus on the program you might happen to use. Here, though, is a list of the most popular programs that many of the modelers use:

- *Ray Dream Studio*—This venerable program, although no longer produced, was made by MetaCreations, the same company that originally developed and marketed Poser.

- *Carrara*—This program, basically a blend between Ray Dream Studio and Infini-D, was also originally developed and distributed by the same company as Poser. It is now being handled by Eovia (**www.eovia.com**), allaying user's fears about its future.

- *Cinema 4D*—There is a very strong user base for this program. Its high-end tools make it an excellent choice for modeling. There is also a email discussion list that you can join, the Poser-Cinema list, by going to **groups.yahoo.com/group/poser-cinema**. You can also find out more about the program at **www.maxoncomputer.com**.

- *Pixels 3D*—A Mac-only modeler that has many high-end features. You can find out more about this program at **www.pixels.net**.

- *Hash Animation:Master*—Another superb application that creates seamless models that can work extremely well in Poser. You can find out more about the program at **www.hash.com**.

- *3D Studio Max*—The most popular 3D modeling application for the PC. This is a high-end program that is used by professionals in the television and motion picture industries. Plus, with the Pro Pack's plug-in, there is unprecedented integration between the two programs. Find out more about 3D Studio Max at **www.discreet.com**.

- *LightWave [6]*—Another high-end professional package that is used for television and motion picture production. This cross-platform application is considered one of the tops in the industry, and, as is true of 3D Studio Max, Pro Pack's plug-in provides unprecedented integration between the two programs. Find out more about LightWave at **www.newtek.com**.

With that as some background, you will want to open one of the OBJ or PHI files in your collection using a text editor program such as SimpleText or Word and take a good close look at them. Study how they are structured. A full CR2, OBJ, or PHI file (depending on which you open in your text editor) can get

extremely complicated. I have seen some 100-page files, depending on the complexity of the model. For instance, the Business Man.cr2 model file for the default Poser character is 35 pages when opened in Microsoft Word. Why? Take a look at this code snippet from the model:

```
actor BODY:4
   {
   name     GetStringRes(1024,1)
   off
   bend    1
   dynamicsLock    1
   hidden    0
   addToMenu    1
   castsShadow    1
   includeInDepthCue    1
   parent UNIVERSE
   channels
     {
     zOffsetA zOffset
       {
       name GetStringRes(1028,38)
       initValue -0.00771635
       hidden 1
       forceLimits 0
       min -100000
       max 100000
       trackingScale 0.004
       keys
         {
         static  1
         k  0  0
         }
       interpStyleLocked 0
       staticValue -0.00771635
       }
```

You can see where the model creator has assigned minimum (min) and maximum (max) settings for the movement of the element. Each body part and each axis have similar parameters set. And when you consider that there can be hundreds of individual body parts on a model—each segment of a finger (for all 10 fingers), the forearm, the shoulder, the collar, and so on—you can see how this file can grow. Again, the preceding example is from the CR2 file that is stored in the Runtime\Libraries\Character\People folder.

This knowledge can help you as you look at the Hierarchy Editor window and try to decipher how each element in the model is associated with the others. I suggest that you take some time and open the OBJ, RSE, CR2, and other files associated with a model to see exactly how they are laid out. If you want to build articulated models of your own, this is the perfect way to start.

PROJECT Build a Character and Add the Bone Structure

Now that you have a good feel for hierarchical structures and some working knowledge of the Setup Room, you can try something a bit more complicated. In this section, you'll return to the Pro Pack (or to Poser 4) to get a more advanced feel for the Setup Room. You will use the techniques you learned in Chapter 4, combine them with what you've discovered up to now in this chapter, and then add to that knowledge. In this project, you'll combine two different figures and then modify the bone structure.

Creating a Centaur

First, you will work on creating the mythological centaur—part man, part horse. Of course you could also make it a centaurette—part woman, part horse—if you like, or even a centaur-toddler, which would be part child and part horse. Although the centoddler (as I prefer to call it) is not part of written mythology, there had to be centbabies, centoddlers, and centeenagers hidden away somewhere. Otherwise, where would the centaurs and centaurettes have come from? Anyway, which one you will make is up to you. This will work for any of these characters provided you make some slight modifications.

1. Load the Poser 4 Nude Man model on the workspace. Using what you've already learned, open the Hierarchy Editor and make everything from the hips down invisible, as you see in Figure 6.16.

Figure 6.16
Some days, you just feel like half the man you used to be.

2. With Body selected in the current element pop-up, Choose Figure|Figure Height|Heroic Model.

3. Go to the Animals subcategory in the Figures model shelf and add the horse to the scene. Make the Upper Neck and Head segments invisible.

4. Change the zTran setting for Figure 1 to .152. When you switch to the Quad view, your model should look like the one in Figure 6.17.

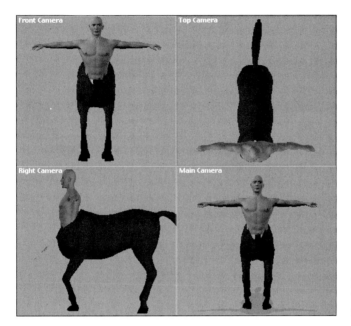

Figure 6.17
The beginning stages of the centaur.

5. Next, make the following changes to Figure 1's (the man's) body:

 - SuperHero: .524

 - Scale: 121

 - yScale: 114

 - yTran: .062

 - zTran: .178

6. Following this, select the chest area of the horse figure and change the zScale value to 114. This will give the model a look much like the one you see in Figure 6.18.

7. Next you need to make the horse body a child of Figure 1. Choose Figure 2 from the current figure pop-up (the one on the left beneath the workspace), and Body from the current element pop-up. Choose Figure|Set Figure Parent to bring up the window you see in Figure 6.19.

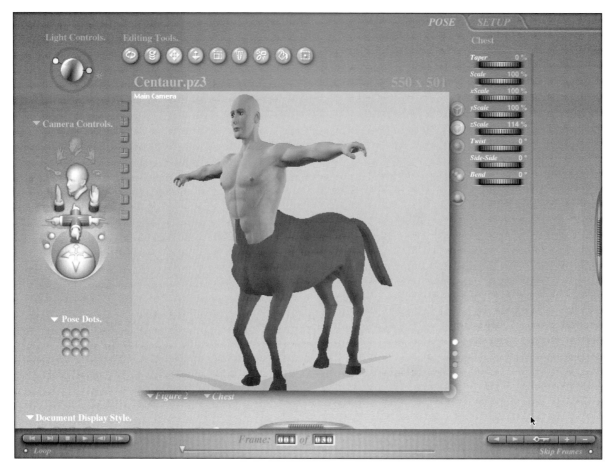

Figure 6.18

The heroic figure and the horse body have been sized to fit nicely together.

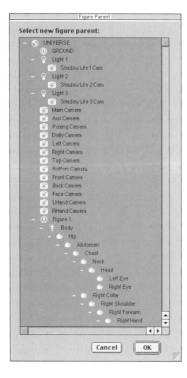

Figure 6.19

The Figure Parent window.

8. Click the Body element for Figure 1, then click OK.

9. At this point you can do one of two things to merge the horse's chest and the human's abdomen. You can make some minor adjustments to the zScale setting for the horse's chest so that it covers the bottom of Figure 1's stomach. Or, you could select the Hip element for Figure 1, choose Object|Properties, and make the hip visible. If you do the latter, your centaur figure would look like the one in Figure 6.20.

Figure 6.20

The human figure's hip has been made visible, which gives a more connected look to the centaur character elements.

10. If you open the Hierarchy Editor, you'll see that the horse (Figure 2 and all its elements) is listed as a child to Figure 1. Also, you can select Figure 1 and Body and change the x-, y-, or zTran setting. Because the horse body is the child, any positional changes you make to the human torso will affect the horse portion as well.

Congratulations. You have now created a centaur character.

If you want to reuse this character, as well as create a specialized bone structure, you'll need to create a new figure and store it. Currently, the figure you built is still seen as two separate models by Poser. Because of this, if you select

Body under Figure 1 in the Hierarchy Editor window and then click Create New Figure, you would create a new figure, but the existing bone structures for both the human and horse models would be left in place. Likewise, you can click the Add Figure button in the Figures model shelf and save the grouped character to one of the subcategories by clicking the Whole Group button seen in Figure 6.21. This, again, leaves the bone structure in place for both the human and animal figures you've combined. However, if saved in this manner, the two bone structures will conflict and make any posing you want to do extremely difficult.

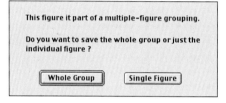

Figure 6.21
Use the Whole Group button if you have combined multiple elements and are saving the file as a new model.

The second, and best, way to save your new character, is to export the file and save it as an OBJ file. When you do this, you are basically creating a nonarticulated prop. The bone structure will be removed, and the finished model will be, when brought back in, a static model ready to have bones assigned to it. Poser will see the two elements—the human and the horse—as one unit.

To save this new character as an OBJ file, choose File|Export|Wavefront OBJ. Navigate to the folder in which you want the file to be saved and then save it. In my never-ending quest for highly creative file names, I called this model centaur.obj. There is no need to make any other settings changes. After you save the model, if you open the folder in which you saved it, you'll see the OBJ file and an MTL file. *MTL* stands for *Material Texture Library*; the MTL file stores the color information assigned to the elements of the associated OBJ file. You don't have to worry about doing anything with the MTL file. It will automatically be read when you import the OBJ file.

Adding the Bones

Note: To change memory allocation for programs running on a Mac, click once on the main program icon, go to File|Get Info|Memory, and type in a new number in the Preferred Size text field.

Now you have the centaur built and you're ready to get down to adding the bones. That is exactly what you will do in this section. Before starting this part of the project, make sure you have plenty of RAM assigned to Poser; otherwise, your computer could crash. As with virtually every other modeling program, the more memory you can assign to Poser, the more efficiently it will run. With PCs, the optimum memory allocation will be taken care of for you; with a Mac, you will need to assign the maximum memory allocation in the program's information window.

To add the bones, follow these steps:

1. With a new document open, choose File|Import|Wavefront OBJ. Navigate to the folder in which you stored the centaur.obj file. When you select the file, the screen in Figure 6.22 appears. The only change you should make here is to select Place On Floor so the bottom of the model is positioned on the floor.

Prop import options
- ☑ Centered
- ☐ Place on floor
- ☑ Percent of standard figure size: 100.00
- ☐ Offset (X, Y, Z):
- ☐ Weld identical vertices
- ☑ Make polygon normals consistent
- ☐ Flip normals
- ☐ Flip U Texture Coordinates
- ☐ Flip V Texture Coordinates

[Cancel] [OK]

Figure 6.22
The OBJ prop import options screen.

2. Click the Setup Room tab, then click OK in the Prop Will Be Turned Into A Figure message screen. Inside the Setup Room, switch to the Quad view. Your screen will look like Figure 6.23.

3. The first thing you'll add are bones for the human portion of the model. Using the same techniques you used earlier in this chapter (see the section "Bone Basics"), select the P4 Nude Man figure so that its bone structure is placed on the workspace, as shown in Figure 6.24.

4. Before doing anything else, get rid of the hip, legs, and feet bones. You'll keep everything from the waist up. Your screen should now look like the screen in Figure 6.25.

5. Select the bottommost bone and, with the Translate/Pull tool selected, move it so it is centered inside the Man torso on the model. And here's where practice and perseverance pay off. You need to reposition the bones so that they align with the correct mesh. The most tedious part of this is working on the hands and the various finger joints. Take your time. Move around in the different views. Switch to the Left or Right Hand cameras when needed. After doing this with a few models, the process will become much quicker. When you are finished, your human bone structure should fit within the human portion of the character. The model and bone structure should look like Figure 6.26.

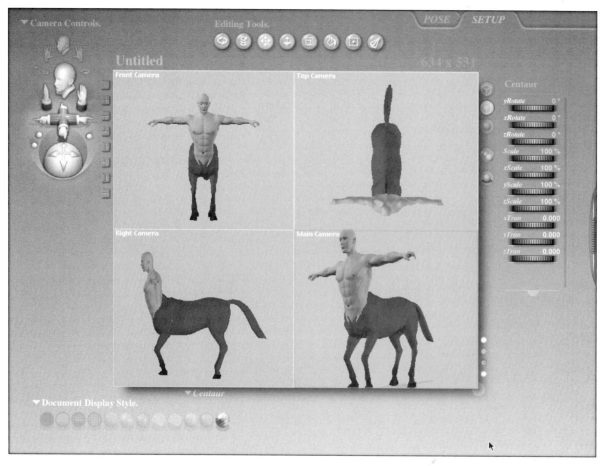

Figure 6.23
The centaur seen in the Quad view in the Setup Room.

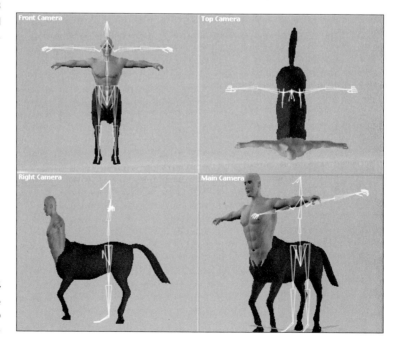

Figure 6.24
The bones from the P4 Nude Man model added to the Setup Room workspace.

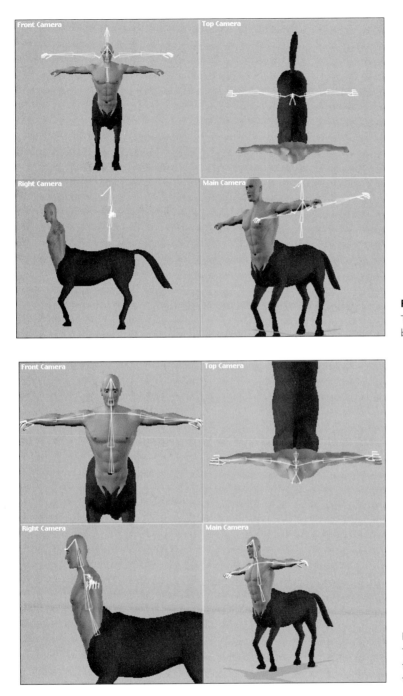

Figure 6.25
The upper part of the Man bone structure.

Figure 6.26
The bones have been positioned for the humanoid portion of the model.

6. Now select the horse model in the Animals section of the Figures model shelf to import the horse model. Remove the head, ears, and both neck sections from this bone structure. As you did with the bones in Step 5, place these bones into their proper position.

7. After the bones are positioned as you want them, click the Grouping tool and then click Auto Group. Go back to the Pose Room and have fun with your centaur.

Note: The nice thing about using bones from an existing model and modifying them for the same model is that you don't have to worry about renaming the bones to match the body parts.

You can now repeat this process to make the aforementioned centaur family consisting of the centaurette, the centson, centdaughter, and centbaby.

Moving On

Now you have the model, you've boned it, and it's ready to be added to any scenes you create. But wait—the texturing on the creation is anything but photorealistic. That's where programs like Photoshop and Deep Paint 3D With Texture Weapons come in handy. As you learned in Chapter 5, you can import your model into Deep Paint and paint the textures directly on the model, or you can integrate Photoshop with the Deep Paint plug-in to do some marvelous texturing. Be sure to save that OBJ file you created and used in the project in this chapter because you can open it in UVMapper by Steve Shanks, create a template, and work directly in Photoshop if you don't have Deep Paint on your system. (This valuable free utility can be downloaded from **www.uvmapper.com**.)

It's time now to move on to other features that will make your Poser animations really stand out. In the next chapter, you'll discover the power of features such as parenting and the different ways it can be used. See you there.

Chapter 7

Parental Controls

We all become attached to things, and your Poser people are no different. In this chapter, discover how parenting objects, combined with the Point At feature, can liven up even the most common scene.

A Parenting Guide for All of Us (Even If You Don't Have Children)

As you continue to build scenes within the Poser 4 Pro Pack, they will gradually increase in complexity. Instead of simply posing a single character, you'll advance to two, three, or more, depending on the amount of RAM you have in your computer and how much of that RAM can be allocated to the program. And as you create these increasingly intricate scenes, you will want your characters to react to something either offstage (out of the scene) or in the scene itself. It can become rather tedious to manually reposition model parts so they realistically do this. Hence, parenting and the Point At controls come into play.

In the context of this chapter, *parenting* is somewhat different from what it is when it's discussed with hierarchy (covered in Chapter 6), yet it is also very much the same. Poser gives you the ability to parent objects to other objects, giving you the freedom to focus on your image rather than on the miniscule adjustments of numerous elements. You can, for example, parent a prop to a body part—say a ball to the hand—so that, as you reposition one, the other moves with it. Of course you would want to make the hand the parent; if you made the ball the parent, any positional changes you made to the ball would affect the entire figure or a particular element, depending on how you set up the parent/child relationship. With the proper parenting setup, you can create realistic magic effects, fun sports-style scenes, and much more.

Then there is the Point At feature. With this control, you can make one object always align itself with another. For example, you can parent the eyes of a character to a prop in the scene. If that prop is moved to another location, the eyes will be automatically repositioned to remain focused on that prop. So, in reality, the Point At feature is another form of parenting, but instead of physically relocating in relation to the parent object, the element rotates while staying in place.

Imagine the following scene: A child is learning to juggle. She starts with one ball, arcing it from one hand to the other to begin getting a feel for how to do it. As the ball moves from hand to hand and then falls to the ground when she misses the toss, her eyes follow it closely. If you were to animate this element by element, you would have to position the ball and each of the eyes at different key frames. As you positioned the eyes, you would have to make incremental changes so they appear to be pointed at the ball. If you apply the Point At feature, all you need to do is move the ball prop and the eyes will follow.

In this chapter, you'll begin by using the parenting feature to create an animation, and then you'll work with the Point At feature. By the end of the chapter, you'll combine parenting and the Point At feature to build a fun animation.

Parental Guidelines

I'm sure the late Dr. Spock (not to be confused with Mr. Spock of *Star Trek* fame) never had any idea that *parenting* would evolve into a common term for computer animation. His guide to raising children was a mainstay in homes around the world for decades. In it, he laid out guidelines for becoming the best parent a person could be based on a generation's norms. When it comes to 3D animations, you want your animation files to be the best they can be when you're utilizing the parent/child relationship function.

Pure Magic

The best way to get a feel for how creating a parent/child relationship can simplify your life is to create an animation with parented elements. In this section you'll create a magician performing the floating ball trick. Disclaimer: The following gives absolutely no prestidigitator's trade secrets away.

I will be using DAZ 3D's Stylized Business Man character and a ball prop. To add interest to the scene you could use DAZ 3D's Stage model, which many Poser users may have because it was one of the company's weekly free model give-a-ways. If you do not own this prop, you can find it at the DAZ 3D store for just under $8. The Stylized Business Man model is also available there. If you don't own it, substitute any model you would like for this tutorial.

Positioning

The first thing to do is position the prop in the scene:

1. Whether you have the stage prop or not, place the character model of your choice on the workspace. Then select the ball prop and place it on the workspace.

2. Resize the ball by changing the Scale setting to 50. Then change the x-, y-, and zTran settings so the ball is aligned with the character's right hand, approximately in the position you see in Figure 7.1. Be sure to switch to the Right Hand camera so you can make sure the ball is correctly aligned with the hand. Save the file as magic.pz3.

Who's the Parent Here Anyway?

Now comes the reason you saved the file. As I mentioned, with the wrong parent setup, the effect you are trying to achieve would not be possible. Follow these steps to find out why:

1. Select the Hand element from the current element pop-up (you can also select it by clicking it in the workspace). This is the element that will be the child for this example.

> **Note:** Whenever you're positioning a prop—such as a sword or cane in a hand, or the ball prop in the tutorial— that is to be associated with a character, you want the figure that will be holding or interacting with the prop to be in its default resting position. This resting position is the one the character is in when you place it onto the workspace. When the character is in the resting position, you can position the prop object correctly prior to making any changes. Taking this step really helps speed up the process.

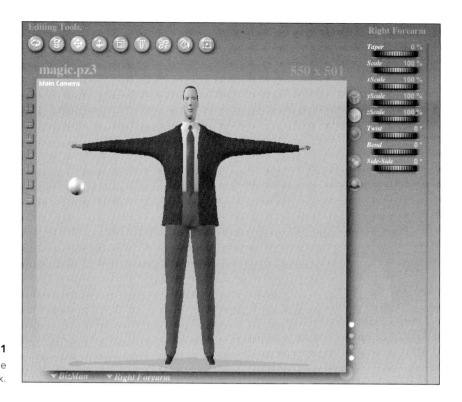

Figure 7.1
The ball prop in position for the magic trick.

2. Choose Figure|Set Figure Parent, which brings up the Figure Parent window seen in Figure 7.2. The Figure Parent window is similar to the Hierarchy Editor window, except it shows only the nonselected elements in the scene so you don't accidentally parent a part of a model to itself or to another element in the same model. That would cause undo stress on the model.

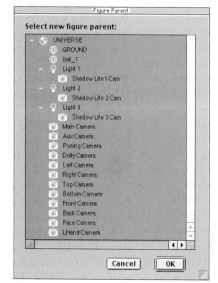

Figure 7.2
The Figure Parent window.

3. Select ball_1 from the list and click OK. This assigns the ball as the parent. Any positional changes you make to it will affect the entire character figure. If, for example, you change the rotation values for the ball to the following, the entire figure will move with it so that every-thing appears on the workspace as shown in Figure 7.3:

 - yRotate: 54

 - zRotate: 30

 - xRotate: -21

 A change to the ball's Scale setting will affect the figure's scaling as well. You can see this in Figure 7.4.

Figure 7.3
Changing the rotation settings for the ball also moves the parented figure.

With what I discussed in Step 3 in mind, choose File|Revert so Poser will return to the last saved version of the file, which is why I told you to save the file earlier.

Prestidigitation

With the original file open again, you'll assign a parent to the ball. The method you'll use this time is slightly different from the method you just used:

1. Select the ball prop and choose Object|Properties (Command/Control+I) to bring up the Prop Properties screen.

Figure 7.4

Changing a parent object's scale settings also affects the scaling on the child object.

2. Click the Set Parent button to open the Choose Parent window. Scroll down and select Right Hand. Click OK, and then click OK again in the Prop Properties window. The ball, which is floating freely in space, will now move whenever the hand is repositioned. Figure 7.5 shows this amazing feat of magic.

Figure 7.5

Presto! Chango! An amazing feat of magic performed by our friendly neighborhood magician.

Select the right hand and move it around to see what happens. Then prepare to move on and make a short animation.

Magical Mystery Tour

The amazing floating ball is not that spectacular when it's a still image. To really make the audience's eyes pop out in sheer amazement, you have to show it being manipulated in space.

In this section, you'll create an animation in which the magician makes the ball mysteriously move about of its own volition:

1. Open the Basic Animation control panel at the bottom of the screen and change the length of the animation file to 240 frames. This animation will run at 30 frames per second (fps), which means the final length will be 8 seconds.

2. Set the parameters for the right arm as follows:

 - Right Collar

 FrontBack: 12

 - Right Shoulder

 Twist: -14

 Bend: 29

 FrontBack: 70

 - Right Forearm

 Twist: -55

 Bend: 24

 Side-Side: 11

3. Choose Figure|Symmetry|Right Arm To Left Arm to mirror the right arm's position. Figure 7.6 shows the basic look.

4. Here's the fun part. Even though you have parented the ball to the right hand, you can still move the ball around freely without affecting any other element on the workspace. Use the x-, y-, and zTran dials to move the ball so it's centered between the magician's hands as in Figure 7.7.

5. The final element to change is the head position. The character should be looking at the ball, concentrating on it, forcing it to do his will through the sheer power of his brainwaves. So, select the head and change the Bend setting until he looks as if he is looking at the ball. I used a setting of 25 for the position shown in Figure 7.8.

Figure 7.6

(Left) The Amazing MagicMan is ready to begin amazing you.

Figure 7.7

(Right) The ball should be centered between the character's hands at the start of the animation.

Figure 7.8

With the magician now staring at the ball prop, you're ready begin animating.

6. Select the right forearm. Go to Frame 25 and change the forearm settings so the forearm moves away from the ball. Do the same with the right shoulder. Then select the ball prop and move it back so it's close to its original position. Reposition the left arm so your frame looks like Figure 7.9 and click the Add Key Frames button to assign a key frame.

7. Go to Frame 100 and move the right arm so it's underneath the ball. Reposition the ball so it's centered on the magician. Reposition the left arm any way you would like. Figure 7.10 shows the way I positioned it and how Frame 100 looks.

Figure 7.9
The position for the magician at
Frame 25 of the animation.

Figure 7.10
A look at Frame 100.

8. Make changes to the figure by moving the right forearm up at Frame
 110 and then back down at Frame 120. Bend the hand at these key
 frames so the ball remains centered on the character's tie.

9. Go to Frame 140. Select the right shoulder and change its Twist setting
 so the arm rotates outward. Also change the head position so he con-
 tinues to stare at the ball. Figure 7.11 shows this frame.

10. At Frame 160, move the magician's left arm inward so it looks like it
 does in Figure 7.12.

Figure 7.11

Frame 140 of the animation as the magician moves the ball away from his body.

Figure 7.12

Showmanship is everything when it comes to performing magic.

11. Continue to make changes to the scene at Frames 180 and 250. Save your file again and then render it. A copy of the animation I made is in the Chapter 7 folder on this book's CD-ROM (magic.avi [PC] and magic.mov [Mac]). I also included a Flash animation (magic.swf) of the same file.

I believe some explanation should be given regarding my not providing detailed movements for you to follow in the preceding steps. You're at the point now that you should begin producing your own original animations, and this is a good one to work with so you can experiment and see how your changes affect the overall movement of the modified elements and their children.

Also take a look at how I made the movements of the left arm appear to affect the movement of the ball, especially near the end as the right arm twists around so the ball moves upward. With some preplanning, you can purposely add these subliminal elements that add an extra touch of reality to your animations.

Pointing, in This Case, Is Polite

And now we turn to the Point At feature. In many ways, it's extremely similar to the parenting function, but it has uses that distinctly separate it. Point At actually gives you some wonderful control over such things as lights and cameras, which you could spend hours setting up without it.

With Point At, you can point a selected item toward another object in the scene. For example, you can assign the Point At function to a light, and if you move the light to a different location, it will always point to its assigned element. Or, if you move the assigned element to a different spot in the scene, the light will rotate so that it remains pointed at it. In the next chapter, you'll be working with lights and learning advanced techniques to make your scenes look more realistic. You have already worked with the cameras. But in this section of the chapter, you'll work with both as you discover how the Point At control works.

Lights, Camera . . . Point!

Setting up any scene requires patience. You don't just go in, click a few buttons, and end up with an award-winning image. Many of the images you may have seen at the DAZ 3D site, or on **Renderosity.com** or any user's personal site, often took hours or weeks to build. So, if you consider the investment in time, you realize how painful it can be if, as you modify your image, you also have to keep tweaking the positioning of the lights and cameras in the scene. That's where Point At truly comes in handy. You will want to have the workspace set up in the Quad view for the following tutorial:

1. It makes no difference what kind of model you place in the scene for this. I'll be using the Bigfoot model that DAZ 3D has provided for this book's CD-ROM, found in the Models\DAZ 3D folder (the Bigfoot model is shown in Figure 7.13).

2. You need to add a new light to the scene. At this point, you won't remove lights or do any modifications to them; you'll do that in the next chapter. Unless you moved it, the Lights panel is located in the upper-left corner of the screen. Click once on the Create Light button shown in Figure 7.14. A new light is placed onto the workspace, and a new light indicator is added to the Light Controls as seen in Figure 7.15. You will need to use the Move X And Z control to zoom out so you can see the light on the workspace.

Figure 7.13

(Left) The Bigfoot character seen here is provided on the CD-ROM that accompanies this book.

Figure 7.14

(Right) You can use the small icon that looks like a light bulb on the right side of the Lights Controls to add lights to the scene.

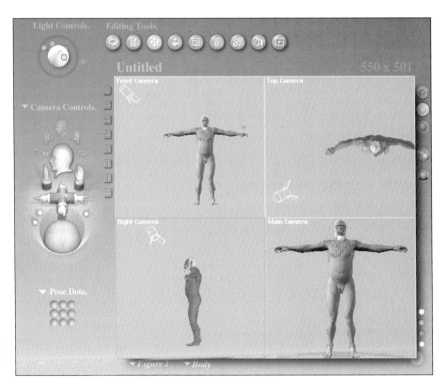

Figure 7.15

The Light Controls shows a new light indicator, and the new light can be seen on the workspace.

3. This new light is pointing downward and toward the back of the scene. It's also spilling onto the model at the hip area. In this position, it could be used as a fill light—the type of light that illuminates parts of a scene other than the subject—after some modifications. But this is not what you want. With this light still selected, choose Object|Point At, which brings up the Select A Scene Element window seen in Figure 7.16.

Figure 7.16

The Select A Scene Element window associated with the selected light and the Point At command.

4. As with many similar windows, the Select A Scene Element window lists each element that is in a scene in a hierarchical structure. Choose Head from the list of items by clicking it once. Before clicking OK, though, notice the None button at the bottom of the window on the left. If you should decide that you don't want the light to point at anything, return to this screen and click the None button and the Point At setting will be turned off. When you click OK, the light points at Bigfoot's noggin.

5. Use the x-, y-, and zTran dials for Light 4, the default name given to the light, to move it around the workspace. Notice how, no matter where you move the light, it will always point at Bigfoot's head. Figure 7.17 shows the repositioned light.

If, on the other hand, you moved Bigfoot's head, the light would remain in position. It does so because the light is still pointing at the head as a whole, which is what you told it to do.

Pointing Pointers

When you select the Point At feature and assign it to an element, a new Point At dial appears in the parameters area, which automatically defaults to its maximum of 1.000 (see Figure 7.18). By changing the setting on this dial, you can, over time, quickly create movement toward a specific object.

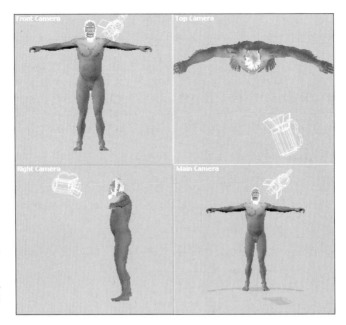

Figure 7.17
As you move the light around on the workspace, it will always point at the spot it was assigned to point at.

Figure 7.18
The top parameter dial, Point At, appears after the Point At feature is assigned to an element in your scene.

The Point At dial is extremely important. Depending on the position of the object at which an element is pointing, it can initially wreak havoc with the position of the element. To see what I mean, do the following:

1. Place any model you like on the workspace. The model shown in Figure 7.19 is the Casual Girl with the Girl's Pig Tails hair. The model has had the Fairy Dance pose from the Creative Pose Sets assigned to it, which is a subset of the Poses shelf.

Figure 7.19
The Casual Girl practices the dance steps she learned in her ballet class.

2. Switch to the Vertical Dual layout. If needed, assign the Face camera to the left pane and the Main camera to the right pane, and then reposition the cameras so your workspace looks like Figure 7.20.

Note: The default lights will not have Point At included in the parameter list unless you go into the Light Properties panel and change the light type to Spot.

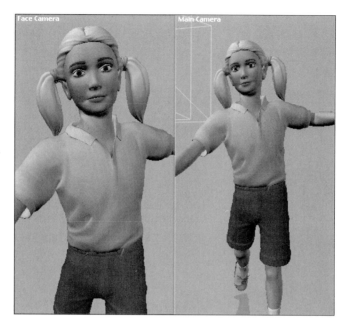

Figure 7.20

With this dual-pane setup, you can easily select the elements you want and see the effect of the Point At feature when it is assigned to those elements.

3. Select the right eye. Choose Object|Point At and choose Right Hand from the Choose Actor window. When you return to the workspace, you'll notice that the right eye has moved dramatically (seen in Figure 7.21), and only the white of the eye is showing. The position of the hand in relation to the right eye causes the eye to rotate pretty heavily.

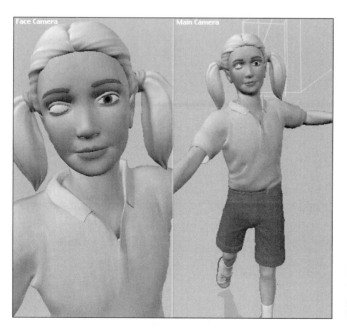

Figure 7.21

The initial position for the eye is unacceptable and needs to be fixed.

4. To get a feeling for where the pupil disappeared to (what its positioning really is), select the head and choose Object|Properties. Turn off the visibility by deselecting Visible in the Element Properties window. As you can see in Figure 7.22, what you are left with are the eyes floating in space, and you can see that the pupil is pointed directly toward the hand. This tells you how you need to rotate the eye so the pupil is visible.

Figure 7.22
By making the head element invisible, you can see that the pupil is pointing directly at the hand based on its positional relationship to the eye. An indicator has been added to show where the right eye's pupil is located in this image.

5. Make the head visible again; then reselect the right eye. Change Point At to .175.

6. Select the left eye, set Point At for the right hand, and then change the Point At setting to .125. Figure 7.23 shows the starting position for both eyes.

Note: A video file called eyeanimation.wav (PC) and eyeanimation.mov (Mac) is included in the Chapter 7 folder on the CD-ROM. It shows the final animated output of this tutorial.

If you have to modify the positioning of the eyeballs when using the Point At feature, why not just change the eyes' positions manually in the first place? Here's why. Open the Basic Animation control panel and go to Frame 30. Select the right shoulder and change the Front-Back setting to 79 and the Bend setting to -18. The eyes will automatically move to continue looking at the hand. This saves you from having to change positions for two more elements (left and right eye), ultimately saving you time in your overall animation setup.

Mixing Features

Until now, you have worked with both parenting and the Point At feature separately. The true power for animation lies in using both in conjunction with each other. Combining these two features can cut down on your animation setup times drastically—usually by two-thirds or more—because you don't

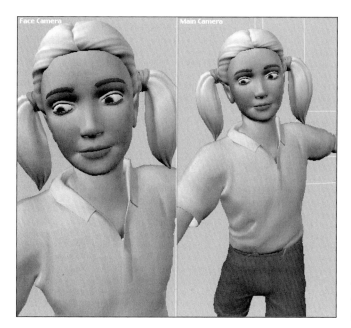

Figure 7.23
The starting positions for the eyes after the Point At parameters have been modified.

have to worry about making changes for as many elements as you build your movies. In this section, you will discover what a timesaver these two features are when creating a movie file.

PROJECT Pointing at the Parent

Parenting can be used to help you easily move an element in a scene and automatically move the child object at the same time. Point At helps with the positioning of an element in relation to another element on screen. Although parenting and the Point At feature both help in setting up a scene, their true reason for existence is for animation. In this project, you will combine the two features to create a short animation quickly and efficiently.

As mentioned under "Lights, Camera . . . Point," DAZ 3D has provided its Bigfoot model on the book's CD-ROM (in the Models\DAZ 3D folder). If you haven't already, load it into Poser.

To use parenting and Point At to create an animation, follow these steps:

1. Create a new scene and place the Bigfoot model in it. Using techniques you learned in Chapters 1 through 6, pose him in a crouching position as he is in Figure 7.24. Save the new pose in the Poses section of the model shelf in any Poses subfolder you would like, and then select Body from the current elements pop-up menu. Move him to xTran -230, yTran -.338, and yRotate 14. There will be a boy moving across the scene bouncing a ball. Bigfoot will be watching him.

2. Place the Casual Boy model into the scene. Be sure to give him some hair from the Hair shelf.

Note: The boy will glide across the scene for this project; I'll discuss motion and creating walk cycles and walk paths in Chapter 9. The purpose of this project is to show how the Point At and parenting functions can be used in a more complicated scene.

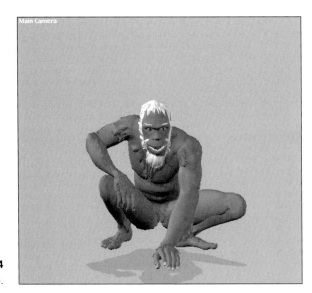

Figure 7.24

Bigfoot in his crouching pose.

Figure 7.25

The ball has been positioned under the boy's left hand.

3. Add the ball prop to the scene and position it under the boy's left hand, as shown in Figure 7.25.

4. Open the Hands submenu in the model shelf. Select Cupped from the Basic Hands section and assign it to the boy's left hand.

5. Select the ball prop and make the boy's left hand its parent. Remember that, as you do this, the boy is Figure 2 in the list; otherwise you might parent the ball to Bigfoot.

6. Select the boy's body, rotate him on the yRotate dial to -90, and then change his left arm segments in the following manner:

- Left Collar

 Bend: -11

 Front-Back: -15

- Left Shoulder

 Twist: -1

 Front-Back: -27

 Bend: -50

- Left Forearm

 Twist: 33

 Side-Side: 34

 Bend: -28

7. Select the boy's body again and move him off the right side of the workspace by changing the xTran setting to approximately .652. I say "approximately" because your workspace dimensions might be different from mine, depending on your monitor size and settings. Just make sure he and the ball are not visible on the screen.

8. Choose Bigfoot's head. Choose Object|Point At and click the ball prop, which will be listed as a child to Figure 2's left hand, as shown in Figure 7.26.

Figure 7.26

The ball prop is listed as part of the boy's left hand in the hierarchical listings.

9. As you can see in Figure 7.27, ol' Biggie's head is pointed rather strangely. The head's center point is pointing at the ball, making the top of his head the area that is pointing at the prop. Change the Point At parameter to approximately .065, effectively tilting his head upward to a more natural position like that in Figure 7.28. You could also set a key frame at Frame 1 if you would like.

Figure 7.27
In this position, Bigfoot is going to get a massive crick in his neck, which will probably put him into a bad mood.

Figure 7.28
Ah! That is much more comfortable.

10. In the Basic Animation control panel, change the overall length of this animation to 120 frames.

11. Move the triangle of the Timeline bar to the last frame of the animation. Select Figure 2 and Body, and move the boy from offstage screen right to offstage screen left using the xTran dial to do so.

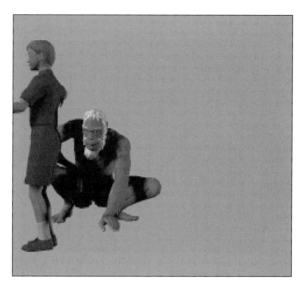

Figure 7.29
This is how Bigfoot's head should look on the last frame of the animation.

12. Select Bigfoot's head. Change the Point At dial to 0 and Twist to -2. Refer to Figure 7.29 for the positioning.

13. Assign a new key frame to Frame 120.

You are probably asking yourself why you went through the trouble (if that is what you want to call it) of assigning Point At to Bigfoot's head if you are going to have to reposition it at the start and end points of the animation. Although it will become clear shortly, the main purpose was so the head will bob up and down as the boy dribbles the ball across the scene. This way, you don't have to manually make the changes to Bigfoot's head.

Also, because the ball is parented to the boy's hand, the only parameter that you will have to set as you make changes to the various key frames between 1 and 120 is to move the ball on the yTran and xTran. The xTran comes into play because you will also want to move the boy's hand up and down according to the ball's position to make it appear as if he is dribbling the ball. Doing this will change the ball's xTran position, so you will need to make small corrections.

14. Go to Frame 12. Change the Bend setting for the boy's left hand to -27.

15. Change the ball's yTran setting to .093 and xTran setting to -.058.

16. Go to Frame 30. Change the Bend setting for the boy's left hand to 27. Then change the xTran position of the ball prop to -.037.

17. Move to Frame 50. Change the Bend setting for the boy's left hand to -17.

18. Change the ball's positioning as follows, then set a new key frame:

- xTran: .414

- yTran: .115

- zTran: -.069

19. At Frame 70, make the following changes:

 - Left Hand

 Bend: 34

 - Ball

 xTran: .275

 yTran: .405

 zTran: -.009

20. At Frame 90, the ball and the boy's left hand will be off screen as you saw in Figure 7.29, which means the positioning of the ball and left hand is not important. But to make sure that movement occurs as the boy moves from Frame 70, change the ball's yTran setting to-.002. This is an arbitrary number because, again, the ball is off screen by then. Set a new key frame at this point and then preview the animation by clicking the Play button on the VCR-like controls on the left side of the Basic Animation control panel.

Pay particular attention to Bigfoot's head. It will bob up and down slightly as the ball moves. Save this scene you just made and call it dribble.pz3. After you work with walk paths in Chapter 9, you might want to come back to this scene and add a walk path.

The completed animation is included on this book's CD-ROM in the Chapter 7\ Bigfoot folder (bigfootwatching.avi for PC; bigfootwatching.mov for Mac). I saved this file at 15fps rather than 30fps so that you can get a better look at the way Bigfoot's head moves very naturally, thanks to the Point At function.

Some Minor Enhancements

In real life, when the ball hits the ground, physics states that it would compress slightly as its forward momentum abruptly stops, meaning the bottom of the ball would flatten, and the rest of the ball would compress as the trajectory is interrupted and changed. By changing the yScale setting for the ball at each key frame you set, you can simulate this natural phenomenon, either realistically or in a cartoonlike fashion.

Moving On

Throughout this chapter, you discovered how parenting and assigning the Point At feature can expedite your work flow, allowing you to focus on the main action in the scene while ancillary movements are made automatically for you. Some minor adjustments still have to be made, but they are less involved than if you were making changes to numerous elements at each key frame.

So far throughout this book, you've also discovered how small—some might say miniscule—changes to different parts of the models can enhance the reality of your scenes and your animations. This also includes the type of lens, or focal length, you assign to the rendering camera. But Poser includeds one more aspect you can use to add a final touch that will separate your scenes from the norm. That aspect is the lighting.

In the next chapter, you will discover how lighting affects mood and how it can be used to emulate real-world scenes, and you'll get a feel for why you need to throw away the main lighting and literally start from scratch.

Poser 4 Pro Pack
Studio

*The Poser 4 Pro Pack Color Studio shows samples
of many of the techniques discussed throughout the book,
as well as some fantastic artwork contributed by Poser
artists from around the world.*

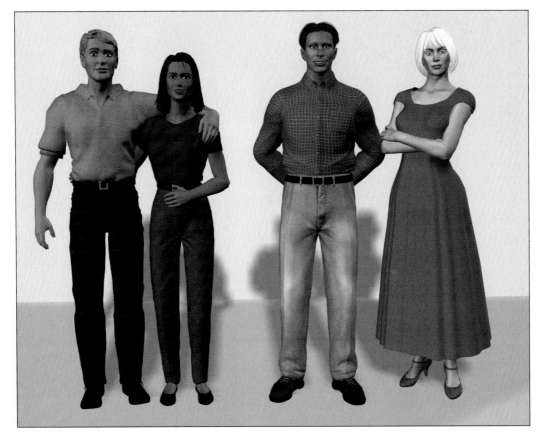

A comparative look at the standard Poser characters (left) and the new characters available online (DAZ 3D's Michael & Victoria, right) that add a new level of realism to the program.

This original artwork by the author (left) uses Poser characters and props to create the cover of a program for a Broadway-style musical performed in Myrtle Beach, SC. A modification on the *Rock and Roll Heaven* image (right) was also used on a CD cover.

Camera angles (discussed in Chapter 2) are important for conveying emotion in an image. All three models here have the same expression, but each image has a different camera angle, which conveys three different emotions. The images, created by the author, use the Michael character with Catharina Pzrezak's "Richard" texture, which is provided on this book's CD-ROM.

Another illustration of how camera angles can add interest to an image. This image shows the last frame of an animation included on this book's CD-ROM.

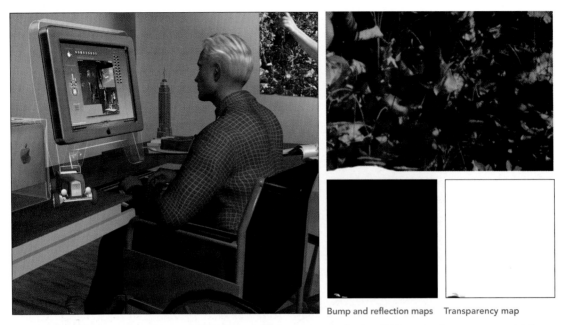

Bump and reflection maps Transparency map

Entire scenes (like this one) can be created inside Poser. The poster on the back wall (shown in close-up, upper right) used a very small transparency map and bump and reflection maps (which are discussed in Chapter 5) to simulate creases on the bottom edge. This scene, created by the author, was rendered entirely in the Poser Pro Pack.

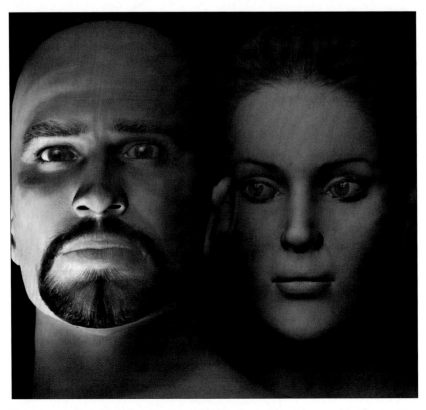

This image by the author shows advanced lighting techniques (discussed in Chapter 8) when using multiple characters, as well as a portrait lens setting (discussed in Chapter 2) to help achieve emotional content.

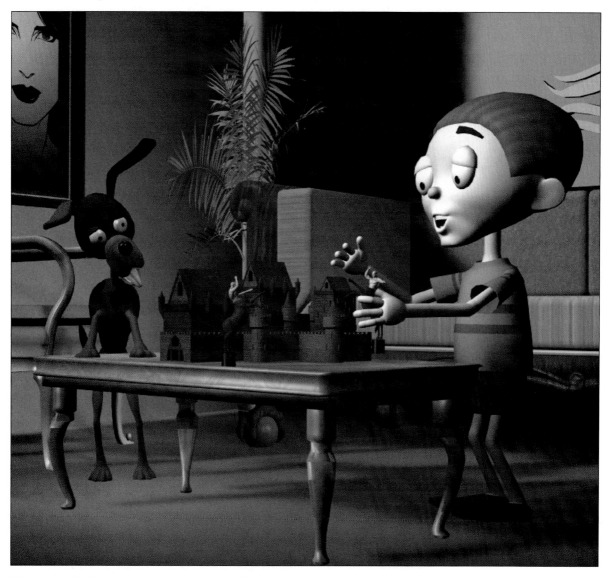

This scene, called *Storming the Gate*, was rendered by the author entirely in the Poser Pro Pack. The image uses numerous free props from **http://renderosity.com**, plus the DAZ 3D boy and dog models and castle prop. The centaur playing pieces were created by parenting a cylinder prop to the DAZ 3D Centaur character, saving it as an OBJ file, then reimporting it into the Poser Pro Pack. Parenting techniques are discussed in Chapter 7. The image also shows the results of using multiple lights and props.

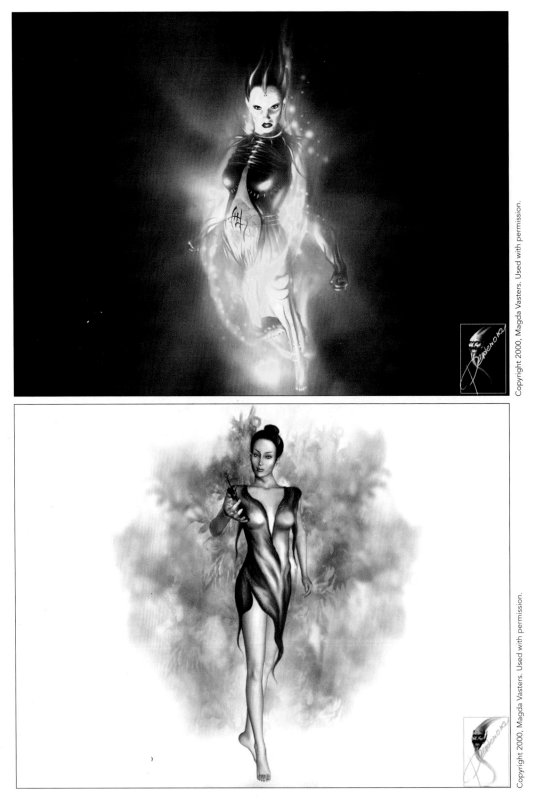

These images by Magda Vasters show the high-quality work that can be done using Poser and posting in Photoshop. The artist calls these images *Farenia* (top) and *Pure Beauty* (bottom).

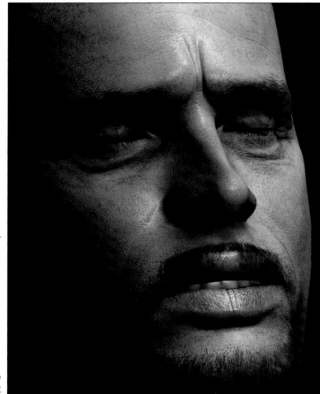

Catharina Przezak's images, *Angst* (top) and *Contemplation* (bottom), show the realism that can be achieved using the Poser Pro Pack with the Michael and Victoria models. These images also show advanced lighting techniques, which are discussed in Chapter 8. Catharina creates portrait scenes entirely in the Poser Pro Pack, using the Face camera with a focal length of 256 and a soft shadow on one spotlight. She sets the shadows for all other lights in the scene to 0.

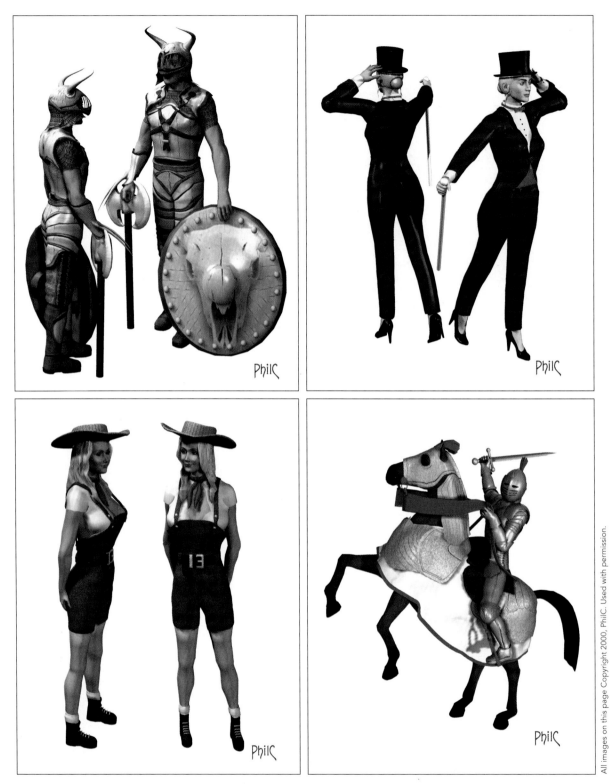

Many Poser artists focus on creating textures, props, and conforming clothing for Poser models. Artist Phil Cooke created the clothing and props on the models shown here.

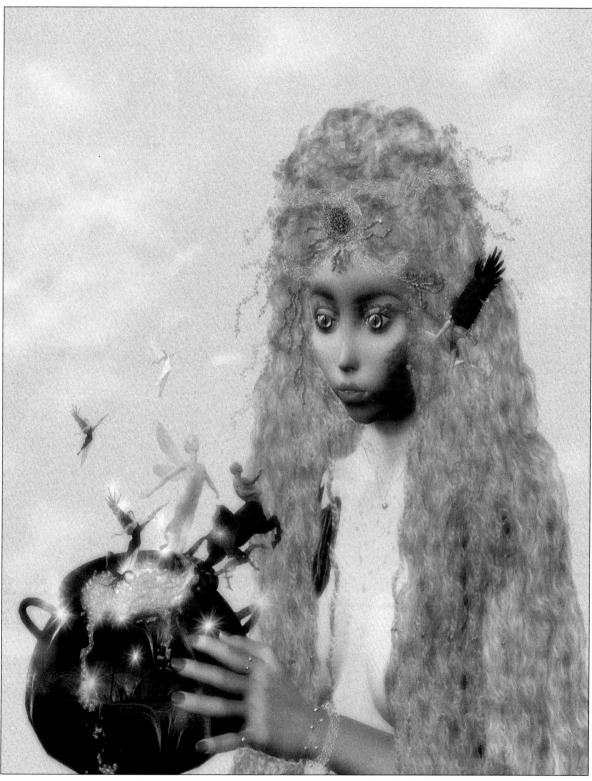

Fairies are a popular theme for Poser artists. This image by Willow DaNaan, called *Magic*, shows advanced postproduction work with Poser characters.

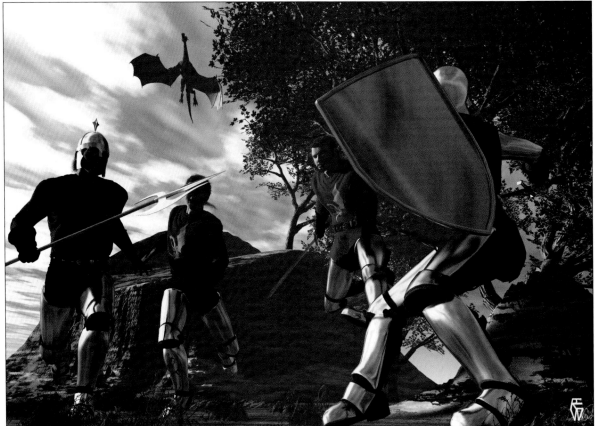

This image, called *Ironic*, by Robert Whisenant, shows interesting results that can be achieved with Poser characters and programs such as Bryce 4 and Vue d'Esprit. In the artist's words: "Creating the image started out as an exercise for using more dramatic camera angles in my work. I had purchased the knight from Zygote [now DAZ 3D] and wanted to incorporate it into another image. I also had the DAZ 3D dragon and thought it a good idea to use this figure at the same time. The atmosphere used is a variant of the Realistic Sunset\Copenhaugen preset. The trees are a combination of the yellow and red maples that also come with Vue d'Esprit."

Keith Ahlstrom created this image to show that artists can produce sophisticated images in Poser with minimal postproduction editing. Once the basic image was created in Poser, the rendered output was brought into Photoshop 6 for the final detail work. In Photoshop 6, the artist cleaned up the hair, added the lettering, adjusted the lighting, and filtered the image to smooth the details.

Ken Sisemore's comic book series, *Jack*, uses Poser figures exported to Bryce and Photoshop. In the artist's words: "The characters used in my comic are created from base figures in Poser, which are then clothed and textured and equipped with whatever props or extras they will be using. They are then posed and exported. I load all the elements into Bryce and construct the final scene. Afterward, I touch up whatever images need work and add them to the page layout in Photoshop, and finalize it with text." The comic can be downloaded in PDF format from Chemical Studios (**www.chemicalstudios.com/jack**).

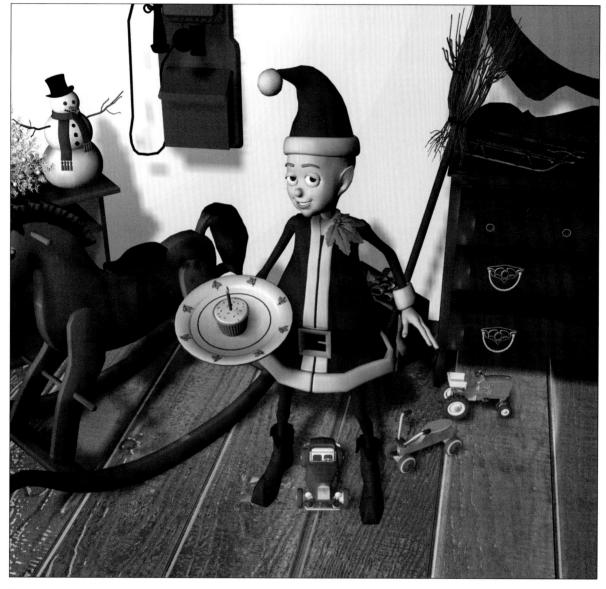

By including numerous props, placing the camera in an unusual position, and modifying the way shadows are rendered, you can add a lot of realism to your scenes without ever having to leave the Poser Pro Pack. This image by the author was set up and rendered entirely in the Poser Pro Pack.

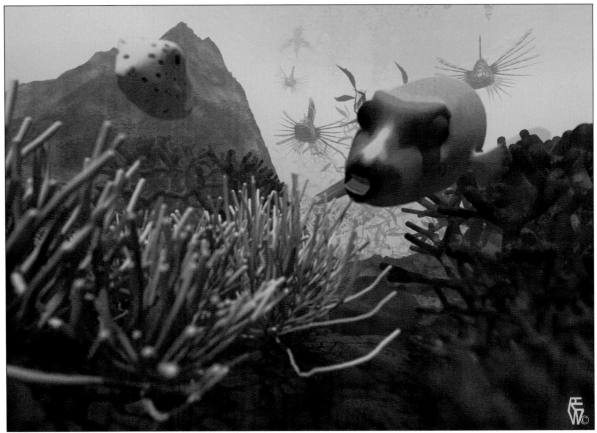

Underwater scenes are popular with Poser users. Using Poser and programs like Bryce 4, Vue d'Esprit, and World Construction Set, virtual oceans, rivers, and lakes team with life. Robert Whisenant created the boxfish model seen here for this book. The model is included on the book's CD-ROM.

Poser 4 Pro Pack Studio

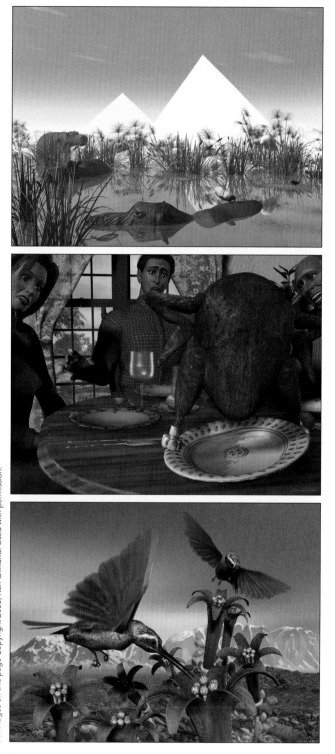

All images on this page Copyright 2000, Ken Gilliland. Used with permission.

These three images—*Hippos in Denial* (top), *Turkey Day* (middle), and *Wildflowers* (bottom)—show how diverse and humorous scenes can be created in Poser. Ken Gilliland constructed these original images in Poser and Vue d'Esprit. *Wildflowers* is a still from an animation included on this book's CD-ROM.

This image, created by the author, shows a Poser 4 character rendered in LightWave [6]. Chapter 13 covers integrating Poser characters to LightWave.

Part III

Motion and Web Integration

Chapter 9

Advanced Animation Modifiers

Using Poser's advanced controls, you can create intricate animations, including multiple walk paths, that can then be exported to programs such as LightWave and 3D Studio Max. Plus, new features in the Pro Pack add an extra semblance of realism to your animations.

The Movement Is upon Us

Designing eye-catching still images is a joy unto itself. But after a while, virtually everyone wants to delve into the world of digital animation. Much of what has been discussed in this book ultimately deals with animation in one form or another, although until now you have worked with only the basic animation tools. In this chapter, you will work with advanced features that give you full control over your animations, giving you the ability to tweak every element in a scene so it turns out the best that you can make it.

As you have discovered, the processes for posing and placing characters and elements in a scene—as well as creating detailed texture, bump, and transparency maps—are anything but fast. You need to sweat out the small details and take time to study what you are building to make sure everything flows together correctly—all of which takes time. Many a 3D artist will spend weeks putting her scenes together. Then she'll spend up to a couple of days (depending on the intricacy and size of the rendered file) waiting for the scene to render. In other words, becoming a 3D artist takes perseverance.

First, a Pep Talk

You also need to check your frustration level at the digital door when you build your scenes. What does that mean? It means that you need to know your limitations and learn how to offset them by focusing on your strengths. Not everyone can do everything that is involved with 3D modeling. And nowhere is that more apparent than in the entertainment industry, which has been both a boon and an obstacle for many aspiring artists. Ads for 3D software make it appear as if you will become the best modeler in the world the second you open the package and load it onto your computer. Some companies would have you believe that, when you buy their 3D software, you will immediately be able to create world-class textures or audio files. That could almost lead you to believe that, by having all those programs, you will instantly be able to create the next *Star Wars*, Disney's *Dinosaur*, or *Terminator* movie. But the reality is that very few people can do it all. I'm not disparaging either you or the companies. The companies are just marketing their products; they need to convince buyers that the product gives them the tools they need to make highly sophisticated models or textures once they learn how, and that they aren't limited to lower-end results. The user, though, will always be limited by knowledge and skill.

Consider the movies coming out of Hollywood these days. We see awesome computer-generated effects in almost every feature film—*Gladiator* used advanced particle systems to create large crowds in the computer-generated coliseum; a specially written program was used to create the hair effects for

the title character in *Stuart Little*. You might even be thinking that you can find out what program was used, buy it, and create the same effects, but consider this: A studio such as Skywalker or Industrial Light and Magic will hire over one hundred specialists to create what you see on the screen. Some of these effects artists specialize in creating character models, while others are experts at scenery. Others are specialists in creating the bones. Still others are fine artists who can create realistic image, bump, and transparency maps. Then there are the lighting specialists and the compositors who bring the models in and make them work with the environment that has either been built on a computer or has been shot on film.

Frustration levels can run high when the average person (myself included) finds it difficult to create certain aspects of a scene—be it a prop, a conforming figure, or an image map. That's why there are people who are more than happy to help out and provide elements that might not fall into your area of expertise. And this is the reason you should not allow frustration to get in the way of your creativity, and you shouldn't think that you don't measure up to the talent of others. I encourage you to take the time to practice and hone the area that most interests you.

Poser, of course, makes it much easier to add humanoid, animal, and fantasy creatures into scenes you build in other programs like LightWave and 3D Studio Max. Building organic creatures is the most difficult part of modeling, with bone creation the second most difficult. After that, it's creating realistic motion for animations. And that's where this chapter comes in. You can create awesome animations using the Poser Pro Pack, and you can also import prebuilt motion files designed specifically for your Poser models. In this chapter, you will not only learn how to animate within Poser, you'll discover another program that works in conjunction with Poser to create motion files.

The Animation Palette

You know about the Basic Animation control panel in Poser. But, as I discussed in almost every chapter so far, there are advanced controls that give you more precise modifiers for each element in your scene. In this section, you'll take a look at the Animation palette and how it works.

Everyone Knows the King of the Sea

Begin by placing the dolphin contained in the Animals section of the Figures model shelf (this model comes with Poser 4). Then:

1. Open the Basic Animation control panel and move the playhead to Frame 30.

2. Add a key frame to Frame 30 and return to Frame 1.

3. Choose Window|Animation Palette (Shift+Command/Control+V). Another way to access this window is by clicking the Key symbol (Edit Key Frames) in the set of key frame controls to the right in the Basic Animation control panel.

If you follow Steps 1 through 3, the Animation palette seen in Figure 9.1 appears. It's a floating palette, which means you can move it anywhere on the workspace that you would like. This is where a multiple-monitor setup can help you out, because you can move the floating palette onto the second monitor, allowing you to better see the workspace. Figure 9.2 shows the Animation palette in a single-monitor setup. To make modifications when you're using this configuration, you'll need to resize the window and move it around so it's not blocking the workspace and the element you're modifying. Figure 9.3 shows the Animation palette in a dual-monitor setup.

Figure 9.1
The Animation palette.

You will see two tabs at the top of this window: Key Frames and Animation Sets. Start with the Key Frames tab. Starting at the top of the window, there are three indicators (see Figure 9.4):

- *Rate*—The overall frame rate of your animation, which, by default, is 30fps

- *Time*—Where you are in the animation timewise

- *Frame*—Which frame you are on

Clicking Options opens a submenu (see Figure 9.5) that includes the following options:

- *Display Frames*—Displays time information in frames in the main work area (discussed momentarily).

Figure 9.2

The Animation palette expanded in a single-monitor setup.

Figure 9.3

The Animation palette in a dual-monitor setup. This setup allows you to move the window onto the other monitor so it doesn't block your view of the model(s).

Figure 9.4

The Rate, Time, and Frame indicators at the top of the Animation palette window. These are nonmodifiable areas.

Figure 9.5

The Options pop-up.

- *Display Time Code*—Displays time information as hours/minutes/seconds/ frames (00:00:00:00) in the main work area (which I will discuss below).

- *Loop Interpolation*—Quickly produces looping animations without duplicating frames. If you, for instance, have a 30-frame animation, you can turn on Loop Interpolation and make a change to the pose(s) at Frame 15, and Poser will automatically create the motion(s) from Frame 16 to Frame 30 that will ensure a smooth transition between Frame 30 and Frame 1.

- *Quaternion Interpolation*—Enables a mathematical technique that provides predictable in-between motions between each key frame you create. The difference between this and the base interpolation method Poser uses is that it interprets each frame using all three rotation settings at once rather than one at a time.

In the lower half of the Animation palette are three sets of VCR-like controls (see Figure 9.6).

Figure 9.6
The various VCR-like controls.

From left to right, they are as follows:

- *First Frame*—Returns to the first frame of the animation.

- *End Frame*—Takes you to the last frame of the animation.

- *Stop*—Stops playback.

- *Play*—Plays the animation.

- *Step Back*—Moves to the frame prior to the one you are on.

- *Step Forward*—Moves to the frame after the one you are on.

- *Previous Key Frame*—Moves back to the previous assigned key frame.

- *Next Key Frame*—Moves forward to the next assigned key frame.

> **Note:** You can access the Graph Display window without going into the Animation palette. Either choose Window|Graph or press Shift+Command/Control+G.

- *Show Graph Display*—Opens a graphic display, shown in Figure 9.7, of the selected element's animation settings. Within the Graph Display window you can choose what is affected as you modify the line via the pop-up menu seen in Figure 9.8. If you are modifying mouth movement in a lip-synch animation, the controls at the bottom right let you view the audio file's waveform. I'll discuss the Graph Display in more detail in Chapter 10.

Immediately below the graph area is a zoom control bar. Move the control to the left to zoom in on the display so you can see more details, or move the control to the right to zoom out and see more of the graph and quickly locate an area you want to work with.

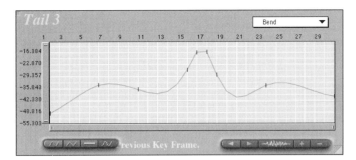

Figure 9.7
The Graph Display window, which is revealed when you click the Show Graph Display button.

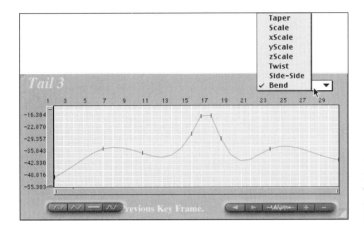

Figure 9.8
Select the parameters you want your changes to the graph to affect by opening the pop-up menu.

- *Add Key Frames*—Adds a key frame to the animation.

- *Delete Key Frames*—Removes a selected key frame.

- *Spline Section*—Changes to Spline interpolation. Spline interpolation places intermediate poses on a curve, allowing you to modify that curve with this setting.

- *Linear Section*—Changes the animation to a Linear interpolation. With the Linear setting, positional changes between frames are produced in equal increments.

- *Constant Section*—Changes the animation to a Constant interpolation. With this setting, there are no intermediate poses created between key frames.

- *Break Spline*—Stops the intermediate poses at that particular frame. You can use this to make sharp changes in direction, such as an insect abruptly changing direction in midflight.

Underneath these VCR-like controls are four radio buttons (from left to right):

- *Skip Frames*—Tells Poser to skip frames so you can see a rough draft of the animation.

- *Loop*—Turns looping on or off when you review an animation.

Note: Working with the Graph takes a lot of practice. This is another of those areas that predicated the discussion at the beginning of this chapter regarding not getting frustrated. The more you work with this feature, the better you will become at it. Don't become too impatient if you make some mistakes along the way. Once you get used to working in the Graph, the time you invest will seem well worth it.

- *This Element*—Tells Poser that changes affect only the element you have selected.

- *All Elements*—Tells Poser that changes affect all elements in the scene.

In the Element List and Frame Display area, shown in Figure 9.9, you select an element you want to modify by first clicking its name. Then choose the frame you want to modify by clicking the appropriate frame indicator next to the element.

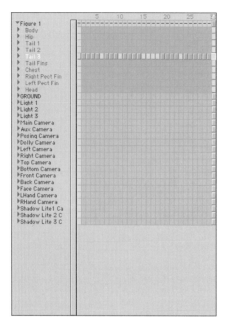

Figure 9.9

The Element List and Frame Display area of the Animation palette window.

Figure 9.10 shows the Play Range indicator, which is located immediately beneath the Element List and Frame Display area. The Play Range indicator shows the overall length of the animation. You can click and drag either end of this bar to lengthen or shorten the animation time.

Figure 9.10

The Play Range indicator. You can use it to shorten the length of the animation.

The Animation Sets screen looks like a watered-down version of the Key Frames window (which in effect it is). After you have made modifications to your animation, you can create a new animation set via the New button in the upper-left portion of this window. This way, you can name the animation you created and have it available from the Poses shelf for later use.

Now that you have been introduced to the controls, let's begin working with them.

Ever So Kind and Gentle Is He

With the dolphin still on the workspace, close the Animation palette and Graph Display window (if they're open) and return to the main workspace. You'll

make some basic changes to the dolphin and then modify them using the Animation palette and Graph Display window. Start by doing the following:

1. To Position the dolphin on the workspace, select Body from the current element selector and change his position as follows:

 * yRotate: 43

 * xTran: -.181

 * zTran: -.996

2. Move the timeline indicator in the Basic Animation control panel to Frame 15.

3. Select Tail 1 (shown in Figure 9.11) and change the Bend setting to 6.

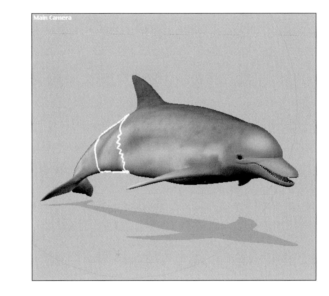

Figure 9.11
The first tail section on the dolphin model is located just behind the dorsal fin.

4. Select Tail 2 and change Bend to 20.

5. Select Tail 3 and change Bend to 13.

6. Select Tail Fins and change Bend to 20. Ol' Flip-meister (as I lovingly refer to him) should look like he looks in Figure 9.12.

7. Open the Animation palette. After resizing the window so you can see the workspace, select Loop Interpolation from the Options pop-up. Click the Play button to watch the animation.

8. Click Tail 1 in the elements list. Notice that there is a toggle switch immediately to the right of the element name. You can click it to expand the list and see the various parameters associated with the element. Figure 9.13 shows the expanded Tail 1 list.

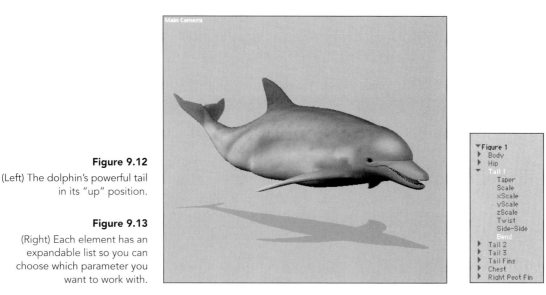

Figure 9.12

(Left) The dolphin's powerful tail in its "up" position.

Figure 9.13

(Right) Each element has an expandable list so you can choose which parameter you want to work with.

9. Now click Tail 2 and open the Graph. At Frame 15, which is indicated by the dark-green vertical line (the midpoint indicator), click the red line (the motion spline) and move it up to approximately 23.079, as shown in Figure 9.14.

Figure 9.14

Drag the motion graph line upward to increase the bend in the dolphin's Tail 2 section.

Note: For the exercises in this chapter I will assume you are working with a single monitor. If you have a dual-monitor setup, simply move the Animation palette to the other monitor and don't worry about resizing the window.

10. Select Tail Fins by clicking either the section in the workspace or the name in the Animation palette list.

11. Switch to Twist. You can either expand the functions list by clicking the toggle switch next to Tail Fins in the Animation palette, or you can use the pop-up menu in the Graph Display window.

12. Notice that the graph is a straight line extending horizontally from the 0 point. You didn't do anything to the Twist setting in the main workspace, which is why this is a flat line. Go to Frame 9 and move it up to the second horizontal grid line. Then go to Frame 17 and move it up to the fifth horizontal grid line (refer to Figure 9.15).

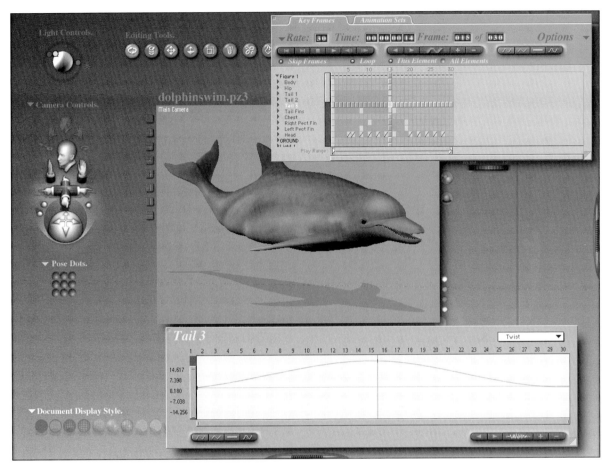

Figure 9.15

The position of the motion graph has been changed to make the dolphin slightly twist his tail fin as he powers through the briny deep.

13. Switch to Bend. At Frame 1, move the motion line downward to -22.500. This will more than likely force you to drag below the visible area. That's okay because a toggle bar you can use to scroll up and down will appear.

14. Select Right Pect Fin. In the Graph Display window, select Twist, and at Frame 11, move the motion line upward approximately one and a half grid spaces. Repeat this at Frame 20. Your motion line will look like the line in Figure 9.16.

15. Repeat this process for the left pectoral fin.

16. Select Head. Change Bend at Frame 17 to -3.502 in the Graph Display window.

17. Notice in the Animation palette that each change you have made is reflected in the time indicator area (seen in Figure 9.17) by an expanded green line that extends to where the most extreme part of the

Note: Depending on how you have set the view in the Graph Display window, the numbers listed might not appear exactly as noted in this section. Use the closest numeric value that is displayed on your graph.

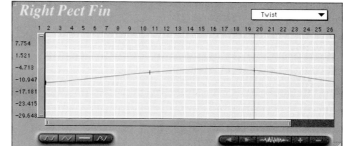
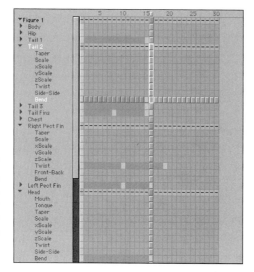

Figure 9.16
The modified motion line for the right pectoral fin.

Figure 9.17
Each change you make to the motion graph is reflected in the Animation palette timeline for the corresponding element. By expanding a particular element's settings, you can see how each parameter has been modified.

motion occurs. You can make frame-by-frame adjustments to the animation by clicking the start or end point of the element timeline, and dragging it to the left or right to change a starting point or ending point of the movement. (Unfortunately, the dorsal fin on this model is combined with the body; otherwise you could easily make the fin sway back and forth as Ol' Flip-meister cuts through the water. You can still change the twist settings for the body if you like.)

18. Select the head again if you clicked another area of the model. Expand the Element List in the Animation palette and select the mouth.

19. Make various changes to the mouth's motion graph and then, at the point of each change, click the Break Spline button. Your motion line will reflect the change by making sharp peaks at these points.

20. Close the Graph Display window and Animation palette windows and save your file as dolphinswim. Then render the animation file.

Note: My version of the first dolphin animation is included in the Chapter 9\dolphin_swim folder of the CD-ROM. This animation file also shows animated colors in lights. Animated colors and textures are discussed in Chapter 5.

There is still one thing that could make this animation competitive with the most advanced 3D animation program: *blurring.*

Blurring Reality

New to the Poser Pro Pack is the Motion Blur feature. It affects any moving object on the screen, so you need to be careful how you use it. Blurring is most effective when you want to show speed—as in the flapping of a bird's or insect's wings or in the swimming motion of a dolphin—because it helps simulate the natural phenomena of our eyes not being able to refresh quickly enough to keep everything in focus.

Creating a Motion Blur

Working with the Motion Blur function is pretty straightforward. Here is how to do it:

1. With the dolphinswim file open, choose Render|MotionBlur Document. The workspace will change to show you how Motion Blur will affect the current frame (in my case, and what you see in Figure 9.18, Frame 21).

Figure 9.18

A preview of the Motion Blur feature via the Render| MotionBlur Document selection.

2. Next, choose Animation|Make Movie (Command/Control+J) and click the 2D Motion Blur button. This activates the numeric settings field directly underneath the button. The higher the value, the more blur there will be. Because a dolphin's tail moves up and down fairly slowly, change the number to .250. Render this animation, calling it dolphinswimblur.

What you will notice when the animation is finished rendering is that areas that have a larger motion, such as the tail, will have a heavier blur than the fins or head. Without going into the mathematical equations used to simulate the effect (because you don't really need to understand the equation to actually use the Motion Blur feature effectively), suffice it to say that Poser will recognize larger movements and create a heavier blur on those parts.

You do need to be careful with a scene like the one with the boy and Bigfoot (which you created in Chapter 7). The boy will blur as he is moving across the screen, as will the ball. Almost equally, in fact. Bigfoot's head turn won't be as blurred because that movement isn't as broad. This can work to your benefit, though, because you can turn the focus to Bigfoot, almost making the boy and the ball appear to be slightly out of focus because of the motion. Just move the setting higher, from .750 to .9, and render the file to see what happens.

I'm Walkin', Yes Indeed . . .

Another great control included with Poser and the Pro Pack is the Walk Designer. It is an extremely powerful tool you can use to create a walk cycle that is automatically assigned to the selected character. Then, combined with the Walk Path creation tool, you can create intricate motion paths. First, you'll take a look at the Walk Designer to see how it is set up.

Struttin' Their Stuff

The Walk Designer is deceptive in that it's a small screen with relatively few controls, but its power lies in how you manipulate the controls. Take a moment to look at this window.

Choose Window|Walk Designer (Shift+Command/Control+S—which stands for Struttin' or Stride, I would expect). Figure 9.19 shows the Walk Designer window.

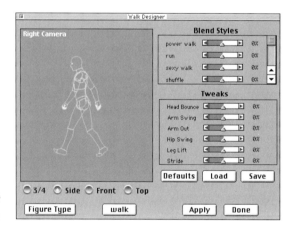

Figure 9.19
The Walk Designer window.

The controls for this screen are fairly straightforward. Starting from the left and working more or less clockwise around the window, they are as follows:

- *The Animation Window*—Here you can view how your changes affect the stride of your model.

- *Blend Styles*—By changing the settings for any or all of the selections (power walk, run, sexy walk, shuffle), you can create realistic or hilariously cartoonish strides. These controls affect the entire body.

- *Tweaks*—These give you extra control over various body parts (Head Bounce, Arm Swing, Arm Out, Hip Swing, Leg Lift, and Stride) and how they react to the body motion.

- *Defaults*—Clicking this button after you have made changes returns the controls to their default (0) settings.

- *Load*—Click this button to load predefined walk paths that you have saved.

- *Save*—With this button, you can save a walk that you particularly like.

- *View radio buttons*—Directly beneath the Animation window, the view radio buttons change the view in the Animation window to a 3/4 view (the default), a side view, a front view, or a top view. You will definitely want to use each of these as you build your motion file because anomalies might not be seen in a single view (such as an arm moving into the waist mesh).

- *Walk*—When you press this button, you can view how your changes look in the animation. When activated, this button changes to Stop.

- *Apply*—With this button, assign the walk you just designed to the character. A subscreen comes up to let you further define how the walk is assigned.

- *Done*—This button closes the Walk Designer window.

When you click the Apply button in the Walk Designer window, the screen you see in Figure 9.20 appears.

Figure 9.20
The Walk Designer's assignment screen.

In this screen you can set the following:

- *Start Frame*—Use this button to tell Poser where the walk animation should begin.

- *End Frame*—This button tells Poser where in the animation the walk should end.

Note: For the most part, you should leave the Start Frame and End Frame fields at their default settings because the default settings represent how many frames the walk you designed encompasses.

- *Figure*—If you have more than one character on the workspace, use this drop-down menu to tell the program which character you want the animation to be assigned to.

- *Walk In Place*—Use this setting if you don't want the character to follow a walk path or when you know the animation is going to be placed into LightWave or 3D Studio Max and assigned a walk path in either of those programs.

- *Cycle Repeat*—When you are assigning the walk animation to a character that is following a walk path, this setting tells how many times the character will repeat the walk cycle before stopping.

- *Always Complete Last Step*—If your overall animation ends before the last step is completed, or if you change the End Frame setting, you can tell the program to finish the step. This often creates a rather strange and unnatural hitch at the end of the walk cycle.

- *Transition From Pose At Path Start In ___ Frames*—This setting tells Poser how many frames should be played before the walk animation begins. Poser will then make any smooth transitions from the pose assigned to the character at Frame 1 and the start of the walk animation.

- *Transition To Pose At Path End In ___ Frames*—With this setting, you can tell Poser how many frames should be played after the walk animation completes. Poser will then make any smooth transitions from the last frame of the walk animation to the last pose assigned to the character.

- *Align Head To*—This setting is extremely helpful when you assign the character and the walk to a path, especially one that curves. As with the Point At feature, you can make the head turn in the direction of the path one step prior to the actual curve, at the end point of the path, or on a sharp change in path direction—if there is any.

I'll return to the Walk Designer tool in just a moment. But because I've alluded to walk paths and the way the Walk Designer can be linked to the path, I'll briefly describe the Walk Path creation tool so you can see how it works. After that, you will work with both the Walk Designer and the Walk Path creation tool to create a walk animation.

Walk This Way . . .

Having the character walking in place is perfect if you are going to do your final render in another program, but if you are planning to render directly in Poser, you will want to make a path the character will follow along. Here's how:

1. Choose Figure|Create Walk Path. This places a curvy line on the workspace as shown in Figure 9.21. (I have changed the background color for the workspace to black so you can see the walk path more clearly in the following images.)

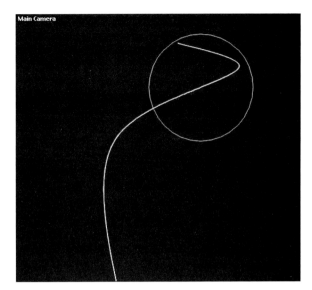

Figure 9.21
A portion of the walk path immediately upon being assigned to the scene.

2. You can modify the line by placing the cursor over it (the cursor will change to a crosshair icon). Click and drag the line to reshape it to meet your needs. Points are added along the line as you reshape it. These points are what the Walk Designer looks for when you assign Align Head To to the model.

3. Create a circular path like the one you see in Figure 9.22, then place a character on the workspace. In this case, I have chosen the Gremlin (shown in Figure 9.23) model that comes with the Poser Pro Pack. You will find out why I chose this character in just a moment.

Figure 9.22
The shape of the walk path as seen from the Main camera, which has been slightly tilted.

Figure 9.23
The Gremlin character has been added to the workspace.

4. Now open the Walk Designer. Gremlins, in my mind and from my vast experience as a Gremlin keeper, have very strange walks. Their legs are wobbly when they are in a standing position, because they actually prefer to move around on all fours—much like a chimpanzee—so their walk makes them look like they are somewhere in between highly inebriated and just shuffling along. To emulate this wobbly walk, change the Blend Styles as listed here:

- Power Walk: -32

- Run: 31

- Sexy Walk: -8

- Shuffle: 79

5. Change the Tweaks settings as follows:

- Head Bounce: 24

- Arm Swing: -39

- Arm Out: 55

- Stride: 8

6. Now click Apply, activate Align Head To (by clicking the button to the left of this setting), and select One Step Ahead from the now-activated Align Head To choices. Then click OK. It will take a few moments for the added frames and the frame information to be assigned to the character. After it has been assigned, click Done in the Walk Designer window.

Note: The settings toggles in the Walk Designer are extremely sensitive. Be very careful: Make sure you move the settings in small increments as you change them.

7. Click the Play button in the Animation palette window and watch your Gremlin do his thing. (A rendered movie file from this tutorial, called gremstride, is included in the Chapter 9/gremlin_movie folder on the CD-ROM.)

8. Return to the Walk Designer. The settings assigned to the Gremlin should still be set, but change Sexy Walk to 8. Click Apply and change the Align Head To setting to Next Sharp Turn. Return to the workspace and watch closely at how the Gremlin's head moves.

These two features, the Walk Designer and the Walk Path, when combined, provide you with some powerful animation tools. You can have characters weave in and out of the crowd in a party or crowd scene or set up a full animation for use inside a scene created in LightWave or 3D Studio Max.

Capturing Motion

As I mentioned earlier, there is a program that works in conjunction with Poser to create motion files. Poser and the Poser Pro Pack can import BVH motion files that are created using motion capture devices. Top studios use motion capture for video game characters, television, and movies. Basically, an actor puts on a special suit with sensors embedded at different points. These sensors are connected to a computer and read the changes in position for the associated body part. Suffice it to say, motion capture equipment pricing is out of reach for most of us, but the cost of BVH files created with this technology isn't.

> **Note:** A demo version of LifeForms 3.9 can be downloaded from the Credo Interactive Web site (**www.charactermotion.com**).

Poser and the Pro Pack come with a sampling of these motion files created by a company called Credo Interactive. Credo Interactive (**www.charactermotion.com**) produces and distributes an awesome software package called LifeForms and also has a CD-ROM compilation called Power Moves that contains over 500 motion files for use with Poser.

LifeForms 3.9, the most current version of the program, gives you the ability to design high-end motions for Poser characters (as well as 3D models you might build in LightWave, Max, Ray Dream, or other modeling software) without having to use the model itself. Figure 9.24 shows the LifeForms workspace. The upper-right quadrant is the area where you can modify the positioning of body parts. You can do this for a single character or a number of characters. You export the file in BVH format and then assign it to your Poser characters.

> **Note:** The motion files are located on the second CD-ROM included with the Poser 4 program. You can either import these files directly from the CD or copy the folder into your Poser root folder on your hard drive.

Using BVH Files

Because Poser and the Pro Pack come with BVH samples, I'll show you how they are assigned to a character:

1. Place the Casual Man character on the workspace and leave him in his default position.

Figure 9.24

The LifeForms 3.9 workspace, where all the controls you need for creating realistic motion files are provided.

2. Choose File|Import|BVH Motion.

3. Navigate to the Motion Files folder. Open the House Of Moves folder, and select mltpchh2.bvh. The screen seen in Figure 9.25 will appear, asking how the character's arms are aligned. Choose Along Z Axis. Then click Scale Automatically in the next screen that appears (Figure 9.26). If you receive a message that some elements aren't present, just click OK.

Figure 9.25

This screen will appear after you choose a BVH motion file. If you choose the wrong axis alignment, the model elements will be positioned incorrectly.

How are the arms aligned in this motion file ?

| Along X axis | Along Z axis |

Figure 9.26

Usually it is a good idea to always select Scale Automatically when adding a BVH motion file to a model.

Do you want Poser to attempt to scale this motion capture data automatically or leave it unmodified ?

| Don't do any scaling | Scale Automatically |

4. It might take a few moments for the motion file to load. This file has 218 frames, so a lot of information is being fed to Poser. Once the file is imported, click the Play button to watch the Casual Man practice his boxing technique.

Trying to build this animation by yourself could take hours or days in Poser, but will take a few hours in LifeForms. And, by using existing motion files and the Animation palette and Graph Display window, you can make minor or major adjustments to the animation and then save that file for use on other models.

Note: Click Scale Automatically unless you know how the scale settings for the motion file and the settings for the model itself differ. Always let the program do some of the "grunt work" for you when you can.

Walking in Multiple Paths

It's time to bring together all of the techniques you learned in this chapter. In this section, you will create multiple walk paths and then create a walk cycle and time it so that the characters don't collide. Start by creating a new document and then do the following:

1. Choose Figure|Create Walk Path. Switch to the Quad view and zoom the Top camera viewport out so you can see the entire path. Reposition the path as shown in Figure 9.27.

Figure 9.27
The new shape for the first walk path.

2. Create a second walk path and reposition it as shown in Figure 9.28.

3. Select Gramps from the Pro Pack model shelf and place him on the workspace.

Figure 9.28
The second walk path intersects the first, and the start point of the first path and end point of the second path are positioned so they are even with each other.

4. Open the Walk Designer window and make the following changes:

 • Blend Styles

 Shuffle: 96

 • Tweaks

 Head Bounce: 15

 Arm Swing: -24

 Arm Out: 44

 Hip Swing: -4

 Stride: -19

5. After clicking Apply, select One Step Ahead under the Align Head To setting. Click OK and then click Done. Figure 9.29 shows Gramps in his starting position.

6. Place Barney on the workspace and open the Walk Designer window. I know he's really violating Gramps's space (refer to Figure 9.30), but don't worry about changing his position right now. His position will automatically be changed when you assign him to the second walk path.

7. Click the Defaults button to return the walk parameters to 0. Then make the following changes for Barney:

 • Blend Styles

 Power Walk: 111

 • Tweaks

 Head Bounce: 63

 Arm Out: 44

 Hip Swing: 15

 Stride: 100

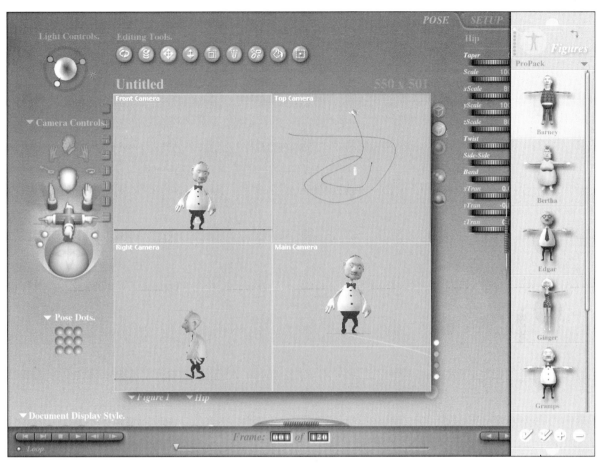

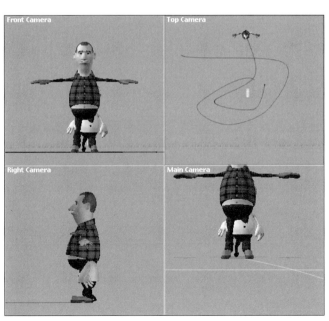

Figure 9.29

Gramps, with his walk designed, is shown in his starting position.

Figure 9.30

I've heard about invading a person's space, but this is ridiculous!

8. After clicking Apply, change the length of the walk to 130 frames. You'll see why in a moment. Then be sure to select Figure 2 in the Figure pop-up and Path_2 from the Path pop-up.

9. Select Transition From Pose At Path Start In ___ Frames and change the number to 10. If you don't, Gramps and Barney will literally walk through each other at the first path intersection. After you've done that, click OK and then click Done. Because Barney starts walking 10 frames into the animation, his animation would end 10 frames before he reaches the end of the walk path. By changing his animation length to 130, you have made up for this 10-frame discrepancy and he will make it all the way to the end of the path.

10. Notice in the Basic Animation control panel that the length of the animation has changed to 130 to reflect what you did to Barney.

11. Return to the single-window setup. If need be, switch to Main Camera view. Zoom out so you can see more of the animation—but not too far. You want to animate the camera to zoom as the animation progresses.

12. Go to Frame 103 and select Main camera from the current element pop-up. Change the DollyZ setting so that both characters are completely visible on the workspace.

13. Play back the animation.

My completed animation, which I called multipath, is in the Chapter 9/multipath_movie folder on the CD-ROM. In that animation, I changed the frame rate to 15fps so you can see the figures crossing by each other.

Moving On

There is one more animation technique—albeit probably the toughest one when it comes to 3D modeling—that I did not discuss. That, my friends, is lip synching. As you have discovered so far, animation can really be a blast, especially when you include multiple characters. But what about when you want those characters to talk with each other? That's what you'll work on in the next chapter. In addition, you'll learn about a fantastic product for the PC that can make your lip-synching chores a bit less daunting.

So follow me to Chapter 10 and get started creating lip-synch animations in the Poser Pro Pack.

Chapter 10
The Art of Lip-Synch

Another phase in the animation process is making your characters talk. In this chapter, you'll discover ways to create realistic lip-synchs directly in Poser and by using a program called Mimic.

The Sound of Silence

Until now, you have worked with animating full figures and cameras. That's all well and good if you want to create a silent movie—a la *Metropolis* by Fritz Lange—but eventually you will want to make your characters say something. It could be as simple as "Hello" or as complicated as the Gettysburg Address. Either way, though, you will need to create what are called *lip-synchs* (which stands for *lip synchronization*—or the process of matching lip movement with audio). Of all the animation specialties, creating lip-synchs is, in my humble opinion, the most difficult to master. There are many intricacies inherent in setting up the mouth positions, and they are even more demanding than emulating the correct posture of a character, which you worked on in Chapter 4.

There are two parts to creating lip-synchs. There is the actual modification of the mouth movements to correctly represent the vowel or consonant that is being spoken. And then there is the ability to read audio waveforms correctly. Within this chapter, you will learn about waveforms and gain a better understanding of what you are looking at when working with them. You will also discover why making the mouth move correctly is only the first step in building a realistic lip-synch animation.

Face Value

When you begin to delve into lip synchronization, your powers of observation become even more important, especially if the character who is speaking is the focus of the scene. I say "especially" because, although it may seem as if the speaking character should be the center of attention in an animation, that character could be in the background narrating—or acting as a commentator for—the action on the screen. If the speaker is in the background, the small details aren't as important because the focus won't be on the character. In that situation, you can take some creative license.

Poser and the Pro Pack come with a series of premade phonemes that can be assigned for the basic lip-synch. What are phonemes? In the case of Poser and other animation programs, *phonemes* are the basic mouth positions that represent specific sounds, such as *a*, *e*, *i*, *o*, and *u* as well as *th*, *f*, *ch*, and so on. These phonemes, shown in Figure 10.1, can be accessed by opening the Phonemes section of the Faces model shelf. As you'll discover, though, the position of the lips on the face is only the beginning of a realistic expression.

Study Your Face

Look closely at each of the images in Figure 10.1 and you will see that the eyes remain the same no matter what the phoneme. Now take a moment to go to the mirror. Take the book with you and make the sounds each of the phonemes represent. Pay particular attention to your eyes, eyebrows, and forehead and even the actual position of your jaw. Notice how everything changes to reflect the new position of muscles controlling your mouth.

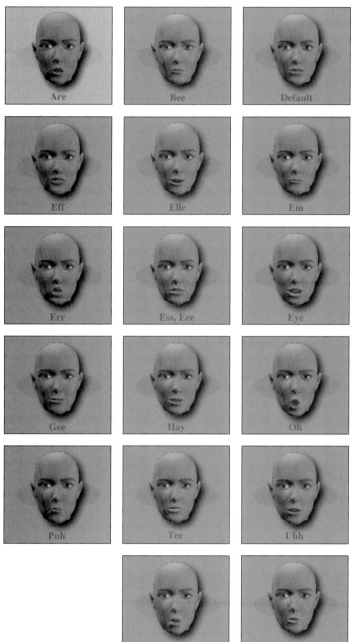

Figure 10.1
The predefined phonemes that are included in Poser and the Pro Pack.

Now add in the emotion factor. Take, for instance, the Hay (or *hey*) phoneme. Continue looking in the mirror and, while focused on your mouth, say it with the following emotions: happiness (as in "happy to see you"), urgency (calling out to someone from a distance), and then anger (seen in Figure 10.2). Notice that, although the center of your lips remains in a certain position—slightly open and puckered—the outer edges change. Do this again, but look at your entire face, especially your eyebrows and eyelids. Notice how, with each different emotional implication, the overall look on your face is affected.

Figure 10.2
A look at the face of
someone saying "Hey!" in
anger or consternation.

On top of this, the tilt of the head also adds to the emotional implication of the words. Using "Hey!" as an example, when it is said in an angry tone, the head will tilt slightly to the left or right, and usually it will dip downward somewhat (the Bend parameter). This movement not only visually shows the emotion behind the word, it is physically used to push the word out. Of course, the movement also comes from the diaphragm, which pushes in quickly to release a quick blast of air and is a contributing factor to the head movement.

The jaw position becomes especially important when you change from one sound to another. In most cases, the jaw will move to the left or right slightly. Everybody's jaw moves differently, based on their regional backgrounds and accents as well as the tone that is being conveyed. Look in the mirror again and say something like, "Hello. My name is <fill in the blank>." Watch closely as you form these words. Notice how, as you change from one sound to the next, the jaw will slightly (and in some cases not so slightly) move to the left and right. Often, it's a miniscule adjustment to the horizontal setting of the jaw, but when you say the words, "Now is the time for all good people to come to the aid of their fellow party goers," you will see more movement in the jaw placement.

These are the tiny—and not so tiny—details you need to be aware of if you want to convey realistic emotional content with your lip-synchs.

Sound Files

You can import WAV or AIFF files into Poser. WAV files are PC-native files, although Macs will play this file format as well. AIFF files, though, are more Mac-native than PC-native.

Audio editing programs view sound through *waveforms*, which are graphic representations of the sound file depicted as peaks and valleys. Figure 10.3 shows the waveform for the Test.wav file that is included in the Chapter 10\Audio_Files

Figure 10.3
An audio waveform for the Test file included on this book's CD-ROM.

folder on this book's CD-ROM. (A Test.aif file is also included.) The peaks represent where the audio is at its highest level, and the valleys represent the low points. When the line is flat, as it is at the very beginning of this waveform, it's called *dead air*—there is nothing to hear.

The waveform in Figure 10.3 is pretty simple because it represents only a voice. Simple waveforms are good to begin with because you don't have to deal with a complicated audio track and try to decipher what each peak and valley represents. As you can see in Figure 10.4, when you're working with a music file that includes singing and instrumentation, the waveform can become hard to read. So, by starting slowly and working with simpler sound files, eventually, you'll learn to identify what you're looking at when the files become complicated.

Figure 10.4
An example of a complicated waveform that represents a segment of a song.

Testing, One, Two, Three

In this tutorial, you'll examine what happens when you combine the various phonemes into an animation. Here you will add an audio track and work in the Graph Editor to make the base lip-synch actions.

Open Poser and do the following:

1. Import the Test.aif or Test.wav file (depending on which system you are using) from the Chapter 10\Audio_Files folder on the CD-ROM. Import the file using File|Import|Sound.

2. This audio file will take up 125 frames. Unfortunately, the Basic Animation control panel won't update to reflect this, so in that panel, change the total frame length to 125 frames. Click Play to listen to the audio masterpiece.

Note: As you work on creating lip-synch animations, you will need to stop often and play the audio track. Watch the frame indicator move across the waveform graph so you can get a feel for where key sounds take place.

3. Place any of the main Poser characters (preferably male because the audio file consists of a male voice) on the workspace. Save this file as testAudio.pz3.

4. Open both the Animation palette and the Graph Display window. In the Animation palette, expand the Head selection and click Lips. Your screen will now look like Figure 10.5—unless you are using a dual monitor setup, in which case you could place the Animation palette and Graph on the second monitor, leaving the workspace clear, as you see in Figure 10.6.

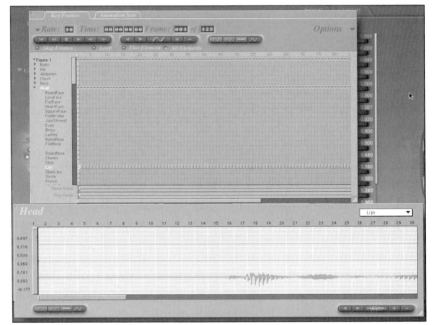

Figure 10.5

(Right) The Animation palette and the Graph Display window take up much of your workspace in a single-monitor setup.

Figure 10.6

(Below) The Animation palette and Graph Display window as shown in the dual-monitor setup.

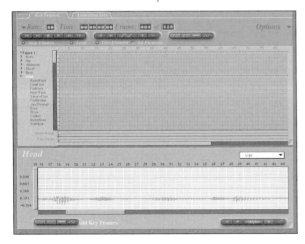 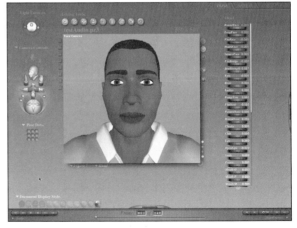

5. I will continue to work in a single monitor setup so that it will emulate what I expect is the setup most readers are using. Notice on the audio track that the first word begins inside of Frame 15. This is shown in Figure 10.7. So, in the Animation palette, click the number 15 at the top of the element section (indicated with a circle in Figure 10.8). A green indicator line will appear at Frame 15 in the Graph Display window as well. The junction of the frame and selected element is also indicated, as shown in Figure 10.9.

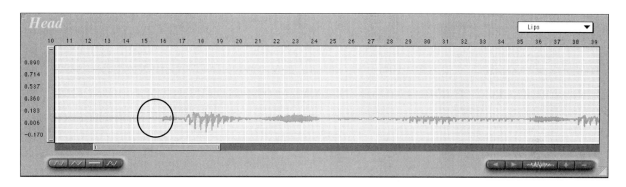

Figure 10.7
This circled section of the audio graph in the Graph Display window shows the start of the *t* sound in the word *test*.

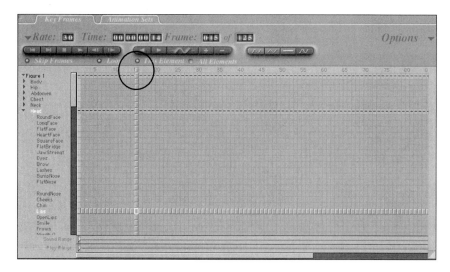

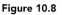

Figure 10.8
Frame 15 is chosen in the Animation palette by clicking on the number at the top of the element area.

Figure 10.9
The junction of the selected frame and selected figure element.

6. Move the Animation palette to any location on the screen until you can see your character on the workspace. Scroll the parameter dials until you can see the control for Tongue T. Change the setting to .092. This will make the model's lips part slightly.

7. Now open the Phonemes section of the Faces model shelf. Go to Frame 17 and assign the Ess, Eee facial pose.

8. The thing about this phoneme is that the corners of the mouth are turned downward. But if you actually said *ess* or *eee*, the corners of your mouth would be turned upward slightly. To better emulate this, change the Smile parameter dial to .406 and the Mouth O setting to .070. Your character should now look like the character in Figure 10.10.

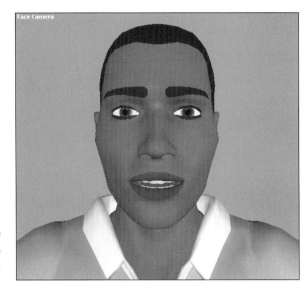

Figure 10.10

The modified mouth position to more realistically reflect the Ess, Eee phoneme.

9. Switch to Frame 23. This is the basic area where the last *t* in *test* occurs. Select Lips either from the pop-up menu in the Graph Display window or by clicking on the associated frame in the Animation palette. Change all mouth settings except for Smile and Tongue T to 0. Leave Smile at .406, but change Tongue T to -.010 and Frown to .192.

10. Go to Frame 26. This is where the word *one* begins. Assign the Whu phoneme at this frame. Again, this phoneme makes it look as if your character is frowning. Change the Smile parameter to .507 and reduce the Frown setting to .337 so your character looks more like the character in Figure 10.11.

Figure 10.11
The modified mouth position for the Whu phoneme.

11. Select Frame 31. This frame is the starting point for the *n* in *one*. Because there is no *enn* phoneme, the closest physically is Ess, Eee. Assign this phoneme to the frame. Close the lips slightly because they are parted just a little too much. This also brings the teeth closer together in a more natural position for the *enn* sound.

12. The *t* in *two* starts at Frame 35. But, if you notice that when you say, "Test one, two, three, four," the *n* in *one* and the *t* in *two* blend together. This is because the transition between the *t* and *oo* sounds are virtually simultaneous. So, at Frame 35, assign the Oh phoneme to the model. This is, as you can see in Figure 10.12, much too drastic an expression. So make the following parameter settings changes:

 • OpenLips: .360

 • Smile: .155

 • Frown: .337

 These settings make your model's mouth look like the mouth in Figure 10.13.

13. The *th* sound for *three* begins at Frame 38. Again, the transition between the *oo* in *two* and *th* in *three* is virtually nonexistent. There is no *th* phoneme, so you will need to create it yourself. Do this by changing the following settings:

 • OpenLips: -.695

 • TongueT: .092

 • TongueL: .313

 This will make your character's mouth look like it does in Figure 10.14.

Figure 10.12
(Left) This definitely shows an overemphasis on the *oo* sound.

Figure 10.13
(Right) The modified *oo* mouth.

Figure 10.14
The look for the *th* sound.

Note: The basic P4 models do not have a parameter dial that allows you to stick out the character's tongue. You could create a morph for this action if you would like, or you could look on the Internet to see if one has been created for the basic Poser models. Characters like DAZ 3D's Michael and Victoria do have these morphs included.

14. The *ee* sound begins approximately at Frame 44. Assign the Eee phoneme to that frame. You don't really need to worry about the *r* transition between the *th* and *ee* because that will be taken care of as Poser creates the in-between (tween) mouth positions.

15. The *f* in *four* begins at Frame 52. Assign the Eff phoneme at this frame.

16. Frame 54 is where the *oh* sound begins. Assign the Oh phoneme to this frame and change the mouth positions to the following settings:

 • OpenLips: .347

 • Frown: .264

17. At Frame 62, assign the Err phoneme. Set the mouth parameters as follows:

 - OpenLips. -.859

 - Smile: .200

 - Frown: .341

Note: You can view the first half of the animation by downloading the Rough1stHalfTest movie files from the Chapter 10\ LipSynch_Samples folder on this book's CD-ROM.

Repeat Steps 6 through 17 in order for the rest of the audio track, using the mouth positions, phonemes, and tips in this section. Do a rough render of the animation so you can get a feel for what you have just created. You will notice that some of the lip-synching is off and the mouth movements are exaggerated. Just go ahead and save this PZ3 file and put it aside for now; you'll come back to it to modify the animation at the end of this chapter.

Mimic-ing Reality

As you are quickly discovering, creating lip-synch animation is—to say the least—a tedious process. There is nothing easy about it. Patience and perseverance are the keys to success. For PC users, though, there is an alternative to creating lip-synch animations manually. It's a program called Mimic from LIPsinc (**www.lipsinc.com**), and it creates high-quality lip-synch animations quickly and efficiently.

Lip Service

When you first start Mimic, you are greeted with a number of controls that will determine the type of output the program will produce. Here is a breakdown of the elements on the Mimic screen (refer to Figure 10.15):

- *Links*—The column on the left includes links to the help files, LIPsinc's Web site, and email address. The latter two will work only if you have an open connection to the Internet.

- *Sound*—By clicking the folder icon, you can import your audio file into Mimic. The audio will be represented by a waveform.

- *Text*—In this area, the Use checkbox should always be selected. Type in the text for the audio file in the text box or import a text file by clicking the folder. Mimic will use this in conjunction with the audio file to create the animation.

- *FX*—This area is broken down into three sections:

 - *Fewer Keys*—When this option is activated, fewer key frames will be assigned.

 - *Move*—Select Head, Eyes, Eyebrows, and Blink to automatically add these motions to your animation.

 - *FPS*—Choose the frame rate for the outputted animation file.

Figure 10.15
The Mimic workspace.

A Tip for Mimic-ing Reality

Here is a suggestion for saving Mimic files that utilize the Head, Eyes, Eyebrows, and Blink settings. These motions are randomly assigned to an animation. This means that you could have Mimic create three or four files from the same audio file and each will look different—blinks will occur at different points along the timeline, head bobs will be in different places, and so on.

So create three or four different files from the same audio track and then render them in Poser. Save each render with a separate name. Use Premiere, AfterEffects, or Final Cut Pro and mix and match the various files so that you create the "perfect" animation with very little effort.

- *Output*—Select the path where the finished file will be saved. For the most part, you will want to leave this at its default path. The file will automatically be added to a Mimic shelf inside the Poses drawer in Poser.

Create a Mimic File

There is no great secret to creating high-quality lip-synch animations using this program. But there are some tricks you should utilize when building an animation for final output. Get started by following these steps:

1. Click the file folder icon in the Sound area of Mimic and import the Test.wav audio file you used in the "Testing, One, Two, Three" section earlier in this chapter. When the file loads, the waveform and the path to the file are listed in this area, as shown in Figure 10.16.

Figure 10.16
Mimic with your audio file loaded.

2. Click in the text input field in the Text area of the workspace and type in "Test wun, too, three, fore. Test wun, too, three, fore." No I didn't make any typos. The best way to get the most precise lip-synch motion from Mimic is to spell words phonetically. *One* could be spelled correctly or as I spelled it. In the case of the word *two*, Mimic might try to add a *w* to the lip-synch motion, which you don't want. Figure 10.17 shows the text added to the Mimic screen.

Figure 10.17
Now text has been added to the Mimic program.

3. Make sure you have Head, Eyes, Eyebrows, and Blink selected so that Mimic generates these movements with the animation. Then click the Generate Pose button in the lower-left portion of the workspace. The Save Pose File dialog box appears with the path for where the file will be saved filled in, as well as the file name, Test.pz2, as you see in Figure 10.18.

Figure 10.18
The Save Pose File dialog box for the Test audio file.

4. When the program is finished doing its thing, click the Launch Poser button to start Poser.

5. Place the Bigfoot model from this book's CD-ROM (found in the Models\DAZ 3D folder) onto the workspace. Then select the Mimic subfolder from the Poses drawer. The Test pose animation will be listed, as you can see in Figure 10.19. Double-click it to assign it to the Bigfoot model. When the screen seen in Figure 10.20 appears, click OK to have Poser extend the frames to fit with the animation.

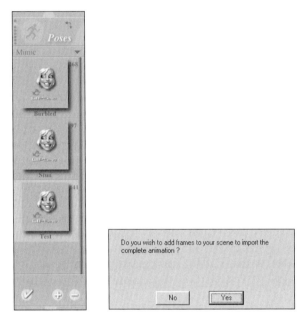

Figure 10.19

(Left) The saved motion file in the Mimic subfolder.

Figure 10.20

(Right) You definitely want to have frames added so the entire animation plays out.

6. Set up the animation output and save the animation.

You will notice that Bigfoot's mouth doesn't close, giving the lip-synch animation a very strange look. You can open the Graph Display window and make modifications to fix this. The reason I used this model as an example, though, is to show that not every model in your arsenal will perform correctly with lip-synch animation without heavy tweaking. Because of the different setups for models, some might not have the correct motion tracking capabilities.

Next, you'll assign this animation to a different character:

1. Open the Figures model shelf and select—for grins and giggles—the Business Woman model. Double-click her and have her replace Bigfoot. Do not keep Bigfoot's current proportions.

2. Rerender the animation, saving this as Test01.avi.

Now play that animation and you'll see a nearly perfect lip-synch. I say "nearly perfect" because there are some modifications that could be made to the head

position to put more emphasis at different points along the timeline. But even so, this one could be ready to show off to a potential client to show your prowess at making lip-synch animations.

PROJECT Tweaking Your Animations

For this project, you'll return to the file you created earlier so that all you Mac users (and I count myself as one) can join back in. Reopen the testAudio.pz3 file you built in the "Testing, One, Two, Three" section. It's time to fix some of the problems with it. Here's how:

1. Make sure the Graph Display window is open. Select the character's head so it shows as the selected item in the Graph Display window.

2. In the pop-up menu, select OpenLips. Notice how the graph's red line (the line on top) undulates across the key frames, as shown in Figure 10.21. You'll also see along the line little black vertical dashes that mark where assigned phoneme changes occur.

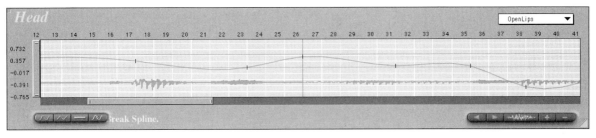

Figure 10.21

The undulating red line (on top) shows the opening and closing movements of the lips along the span of time.

3. Looking at the graph gives you a good idea of where extreme fluctuations occur in the animation. The first large fluctuation takes place at Frame 26. Click this frame in the Graph Display window. The scene will jump to that point in the animation.

4. Place your cursor on the red graph line. It will change to a vertical arrow with tips on both ends. This tells you that you can move the line up or down to change the setting for the OpenLips element. In this case, move it downward so it is fairly even with the highest point in the graph line prior to the start of the animation.

5. Make changes along the graph where you see the undulations peaking (or reaching their maximum point) beyond what the base height is.

6. Pay particular attention to Frame 50, which is between phoneme changes. You can still click frames and modify the graph even if there aren't vertical indicators there. And you definitely need to do it in this area. Look at Figure 10.22 to see why.

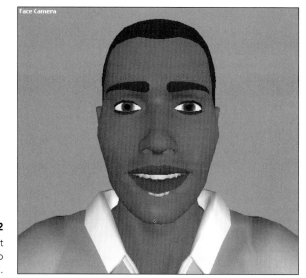

Figure 10.22
Ouch! Having your teeth pop out of your skin under your lips has to be painful.

7. Fixing the problem of the teeth poking through the skin requires selecting different elements from the Head pop-up. First, move the graph line down in the OpenLips category. Then switch to Frown. Notice how the graph line dips below the waveform? Move it upward at Frames 50 and 52 until the teeth are covered.

8. Once you have modified the graph as you like, rerender the animation to see how it looks. Keep it at low resolution—thousands of colors and medium quality—because this won't be a final version. If you're not happy with the way the lip-synch looks, go back and make adjustments to other areas of the animation until you are.

Animation Modification

Be prepared. The actual modification of the base lip-synch can take twice as long as setting up the base lip-synch itself. Again, and I can't say it enough, patience is the key to success.

Modifying Other Movements

The lip-synch should be set up as you want it now. But the problem is that the head is too static. You need to make the model's head bob and the eyebrows go up or down—both to place emphasis on a syllable or word—and you need to make the model blink once in a while. Do the following:

1. Listen closely to the audio file and listen for verbal emphasis on the words, such as the first instance of *one* and *four*. You'll work on the first instance of *four* first.

2. The first occurrence takes place at Frame 55. Select Bend from the pop-up menu in the Graph Display window. Move the red line upward about one segment. Click the Break Spline button. (Refer to Chapter 9 if you don't remember where this control is located.) Select Frames 54 and 56 individually and click Break Spline for each frame. Your red spline line will look like it does in Figure 10.23.

Figure 10.23
The modified and broken spline, which will make the head drop sharply.

3. Make your own modifications to the following dials along the timeline, practicing with different timeline positions to see how this affects the look of your animation:

- LBrowUp

- RBrowUp

- BlinkRight

- BlinkLeft

For the most part, where you believe the motions should occur is truly a personal matter. In the case of the LBrowUp and RBrowUp settings, don't be afraid to modify the graph line drastically. Or go to the actual parameter dials after choosing the frame you want to modify and change the settings there. Then refer back to the graph to make minor adjustments or to break the spline so the action is less fluid.

Moving On

Working with audio and creating lip-synchs takes practice. Even the most experienced lip-synch animator has to go through numerous passes before he or she is satisfied with the outcome. But, as you have discovered while working with phonemes, the graph, and Mimic, every tool you would ever need is at your disposal in the Poser Pro Pack.

Now it's time to look at (in the next chapter) a fascinating Web-based application called VET—Viewpoint Experience Technology. With it, you can create extremely high-quality interactive materials for display on the Internet.

Chapter 11

Creating and Displaying Viewpoint Media

*What began as the MetaStream technology
a couple of years ago has now evolved into the
Viewpoint Experience Technology (VET). In this chapter,
you will discover what it is and how you can create
VET files and integrate them into your Web sites.*

A Clearer View

For the past few years, Web developers have been looking for a high-quality method for displaying their clients' products—beyond the static photo, that is. *Interactivity* has become, in many senses, a buzzword within the development community, and many people have tried to develop ways to make their sites more interactive.

Back in the days of MetaCreations, just before the company divested itself of its software division, they introduced the MetaStream plug-in for Web browsers. This plug-in allowed Web site developers to create interactive elements for their sites. Visitors could move their cursors over an image and, by clicking the mouse button, move the image around in a full 360-degree arc. They could also zoom in for a closer look and out for a wider view. Bryce 4 and Canoma took advantage of this technology, allowing users to save their files as MetaStream files. Canoma, especially, used this technology to its (at the time) fullest capabilities. The program, which users could use to create full 3D objects from photographs, was the perfect vehicle for building and displaying interactive product previews on the Internet.

The problem was that the technology didn't yet meet the expectations. The resultant files were blocky; when you zoomed in, the photograph became grainy. But, as with all technologies, the initial steps had been taken. Then came MetaCreation's divestiture. What the company retained was the MetaStream technology. This has now become Viewpoint Experience Technology (VET)—and an entirely new and enhanced delivery method that is as far from the original MetaStream lineage as it can get.

The Point of Viewpoint

The main purpose of the Viewpoint technology is to allow a site's visitors to see an entire product, front and back, so they have a clearer view of what they are purchasing. Cars, clothing, and electronics can be displayed, for example. Potential customers can zoom in on, rotate, even change the colors of the images so they can purchase a product and know exactly what they are going to get. And because the browser plug-in is free, everyone who visits the site(s) can take advantage of this fascinating technology.

But where does this fit in with Poser? How can a feature that is basically built to create enhanced and interactive online catalogues be pertinent to what you as an artist create in the Pro Pack? Plenty. And that's what this chapter is about—giving you the ideas to help you provide unique interactive elements for your Web site. I will break down the uses for VET throughout this chapter so you can see how versatile the technology can be.

Note: Canoma is still available and can be found at sites such as Amazon.com. To learn more about Canoma and its varied uses, you can purchase the book *Canoma Visual Insight* (The Coriolis Group, Inc., 2000)—via the publisher's Web site (**creative.coriolis.com**) or from various online bookstores.

Note: As this book was being written, the Viewpoint media player was available for PC only. The Mac player was in beta testing, which means that, by the time you purchase this book, it should be available for download. Visit **www.viewpoint.com** to find out if the plug-in has become available.

Sales

There are two parts to this section. The first deals with creating a display that shows off an original model. The second uses Poser characters as models for T-shirt sales.

First, you will work on creating a display that shows off an original model:

1. The first thing you need to do is create the template for the model. This entails using UVMapper, a free utility program that was briefly discussed in Chapter 5. With UVMapper open, choose File|Open and navigate to Runtime\Geometries\Poser4Clothes\Shirts. Select the blmTShirt.obj file. Your screen will look like Figure 11.1.

Figure 11.1
The blmTShirt.obj file, unwrapped and ready for saving.

2. Repeat Step 1 and open the blmPoloShirt.obj file (refer to Figure 11.2). Then save both files.

3. Open these files in Photoshop 6 or whatever image editing program you use. Create a new layer and fill it with a light, sky-blue color. Refer to Figure 11.3 to see the RGB settings I used. Make sure you turn off Preserve Transparency when filling this new layer with color.

4. Open the Logo_Parts.ai file in the Chapter 11 folder on this book's CD-ROM. Drag the image from this file onto the blmTshirt image and place it as shown in Figure 11.4. Make sure the layer opacity for the color

> **Note:** I will be using Photoshop 6 throughout this section; if you use a different program, please refer to the user manual that came with it if you don't know how to re-create some of the effects that will be used in this section.

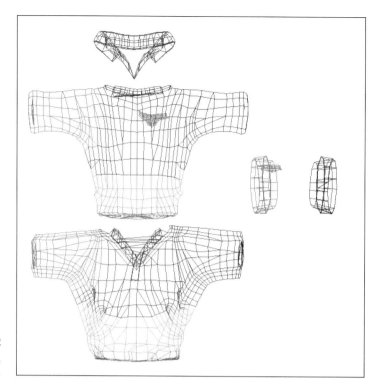

Figure 11.2

The blmPoloShirt.obj file, unwrapped and ready for saving.

Figure 11.3

The new layer for the Poser T-shirt map has been filled with a light, sky-blue color. Use the RGB values shown here to re-create it, then use the same color for the polo shirt file.

Figure 11.4

The logo has been placed and positioned on the front of the T-shirt.

Figure 11.5

Using Bevel And Emboss, you can give the logo a puffy appearance.

layer is turned down so you can see the flattened mesh underneath it for easier placement of the logo.

5. Choose Layer|Layer Style|Bevel And Emboss. Change the Size setting to 7 px (pixels) and Soften to 6 px, as shown in Figure 11.5. This will give a slightly raised appearance to the logo. Then click OK.

6. The next step is to choose Filter|Texture|Texturizer to open the Texturizer window, where you will assign the Sandstone texture with the following settings (refer to Figure 11.6):

 • Scaling: 100

 • Relief: 4

 • Light Dir (which stands for Direction): Top Left

Figure 11.6

The Texturizer window with the settings for the Sandstone texture that's being applied to the logo.

7. After clicking OK, use the Magic Wand tool to select everything outside of the logo. Choose Select|Similar to select the rest of the non-logo portion of the image, then choose Select|Inverse to invert the selection to include only the logo. Next, choose Filter|Blur|Motion Blur. Set the angle to 90 and the distance to 2 pixels. This gives a slight blur to the texture, re-creating the look of thread.

8. Return the opacity for the color layer (which should be Layer 1) to 100% and save the file as BlueT.jpg.

9. Place the logo onto the blmPoloShirt file. Resize and position it as you see in Figure 11.7. Repeat Steps 6 and 7 to give the logo a raised stitched appearance. Then save the file as bluePolo.jpg. Don't close this file yet.

Figure 11.7
The logo resized and positioned on the polo shirt.

10. Make the logo layer invisible. Then select Layer 1 (the color layer). Choose Filter|Texture|Texturizer and select Canvas. Change the following parameters:

 • Scaling: 50

 • Relief: 1

 • Light Dir: Top Left

11. Choose Image|Mode|Grayscale to turn this into a grayscale image. When asked, go ahead and flatten the file. Save this as shirtbump.jpg. Because you colored the entire layer with the light blue color, this bump map will work for both the T-shirt and polo shirt models.

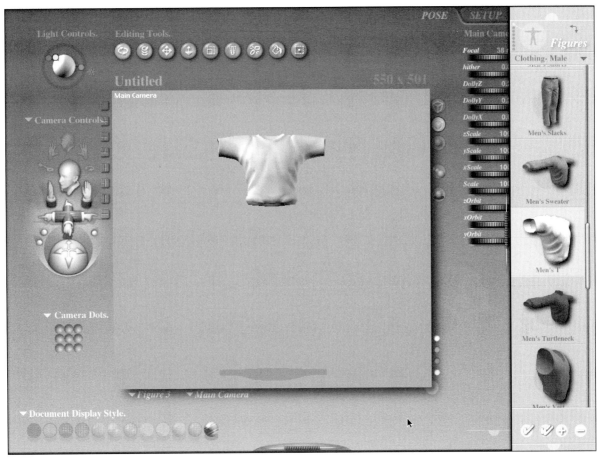

Figure 11.8

The Men's T-shirt is on the workspace ready to have the texture you just created assigned to it.

12. Quit Photoshop and open Poser Pro Pack.

13. In the Pro Pack, open the Clothing-Male section of the Figures model shelf. Place the Men's T on the workspace as shown in Figure 11.8. Make sure you select Texture Shaded from the Document Display Style buttons seen in Figure 11.9. If this set of buttons does not appear on your workspace, choose Window|Preview Styles to activate it.

Figure 11.9

Texture Shaded, which allows you to see the textures placed on your models, is located on the far right of the Document Display Style buttons.

14. Choose Render|Materials. Click the Load button in the Texture Map area of the Surface Material screen and select the BlueT.jpg file.

15. Click the Load button in the Bump Map area of the Surface Material screen and assign the shirtbump.jpg image to it. Then change the Strength setting to 20%. Figure 11.10 shows the files assigned to the Surface Material screen, and Figure 11.11 shows the texture placed on the model.

Figure 11.10

The files and settings for the T-shirt as seen in the Surface Material screen.

Figure 11.11

The image map can be seen on the model as long as you have Texture Shaded selected.

16. Do a quick render (Command/Control + R) to see how the shirt looks.

17. Choose File|Export|Viewpoint Experience Technology. The screen you see in Figure 11.12 appears. For now, leave the settings as you see in the image.

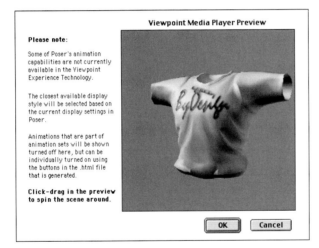

Figure 11.12
The Viewpoint Media Player
Format Export screen.

18. Next, name the file logotshirt.mtx and click OK. The Viewpoint Media Player Preview window appears next (shown in Figure 11.13). You can click and drag the image in this window so you can see how it will work on the Web page.

Figure 11.13
The interactive Viewpoint Media Player Preview window.

19. Repeat Steps 13 through 18 to create the polo shirt, seen in Figure 11.14. Because the polo shirt model has a brownish color, make sure you change all the model elements Object Color to white. This is done in the Materials screen.

20. If you have moved the camera around on the workspace by zooming in and rotating it, choose Edit|Restore|Camera to return it to its default position.

The reason you're restoring the camera is to prepare for the next part—adding a model for Viewpoint export.

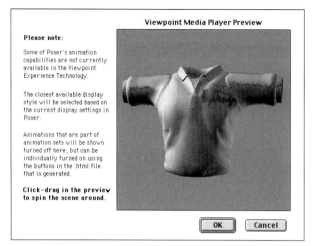

Figure 11.14

The polo shirt as seen in the Viewpoint Media Player Preview window.

Controlling the View

Before adding the human figure to model the shirt, you should take a moment to understand the controls that allow site visitors to manipulate the on-screen image:

- *Mouse button*—Rotates the image in the direction the cursor is moved.

- *Command/Control+mouse button*—Allows the viewer to zoom in and out from the image by moving the cursor up (zoom out) or down (zoom in).

- *Shift+mouse button*—Allows the viewer to move the image left, right, up, or down to reposition it.

These controls will not be apparent to visitors to your Web page—whether you import a Viewpoint file onto your page or have Poser generate an HTML document. So it is important to remember to add the mouse control directions to any page that holds a Viewpoint file.

Modeling the Clothes

Every advertiser and advertising agency knows that when it comes to showing off clothing, putting them on a human is the way to go. There is no other way to really let people see how an article of clothing looks when it's worn than to show it on an actual person. So in this section, you'll add a model to wear the polo shirt in your Viewpoint file:

1. Add the Men's Jeans to the scene by clicking the Create New Figure button.

2. Place the P4 Nude Man model on the workspace, being sure to click the Create New Figure button when doing so.

3. Select the shirt and use the Conform function by choosing Figure| Conform To. From the Conform To screen's pop-up menu, select the P4 Nude Man, who will be listed as Figure 1. Then select the jeans and use the Conform function on them. This conforms the clothing to the Nude Man model.

Figure 11.15

The male model is ready to be posed wearing the new company logo shirt.

4. Finally, add some shoes (I chose Cowboy Boots) and hair (I chose Male Hair 1) to finish dressing the model. Figure 11.15 shows the fully dressed character.

5. Now it's time to pose the newest supermodel, Van Nawhyte. Make the following changes to the body parts:

- Head

 Twist: 9

 Side-Side: 9

 Bend: 6

- Abdomen

 Twist: 14

- Right Collar

 Twist: 10

 Bend: 9

 Front-Back: -8

Mending Errant Meshes

There will be times when you place conforming clothing on a model, or different conforming elements such as the boots and pants, and parts of the underlying model show through. Unless you have transparency maps assigned to the outer elements—such as rips in pants—the best thing to do to correct this problem is to make the underlying element that is poking through invisible by selecting that element, choosing Object|Properties, and deselecting Visible.

- Right Shoulder

 Twist: 25

 Front-Back: -3

 Bend: 48

- Right Forearm

 Side-Side: 32

 Bend: 73

- Right Hand

 Bend: -10

6. Select Figure|Symmetry|Right Arm To Left Arm. This will position the left arm so it's in the same position as the right. But some minor corrections will need to be made:

- Left Shoulder

 Front-Back: -18

- Left Forearm

 Side-Side: -42

 Bend: -70

7. You will need to work with the fingers on the left hand so they look like they do in Figure 11.16. With his thumbs in his pockets, ol' Van's fingers would naturally be flattened out against his hip.

Figure 11.16

A close-up of the model's left hand. Use this as a visual guide for the repositioning of the fingers against his hip.

8. Now it's time to position the legs. For this part, do not turn off Inverse Kinematics because all the positioning will be accomplished by simply moving the feet. First, select Figure 1's right foot. (Selecting Figure 1's foot can be tricky because of the boot. If you click the foot element to select it, make sure Figure 1 is active in the current figure pop-up.) Then move it in the following manner:

 Twist: -6

 Side-Side: -54

 Bend: 3

 xTran: .007

 yTran: -.002

9. Move the left foot in the following manner:

 Twist: 4

 Side-Side: 3

 xTran: .015

 zTran: .104

10. Finally, you need to add some expression to Van's face. Switch to the Face camera and make the following parameter changes:

 Eyes: .829

 Frown: .365

 Tongue T: .250

 LBrowDown: .805

 RBrowUp: .088

 Worry Right: -.490

 Worry Left: -.302

11. To make Van look at the camera, select each eye in turn and make the following changes:

 - Right Eye

 Up-Down: -6

 Side-Side: -10

 - Left Eye

 Up-Down: -5

 Side-Side: -11

Figure 11.17
Van Nawhyte, your male supermodel, in his final pose. Have you ever noticed how no male model ever smiles?

12. Return to the Main camera. Your model should look like the model in Figure 11.17.

Viewpoint Export and Settings

Save your file as PoloModel.pz3 in preparation for exporting to Viewpoint. Choose File|Export|Viewpoint Experience Technology to bring up the Viewpoint Media Player Format Export controls seen in Figure 11.18.

Figure 11.18
There are a lot of controls to work with when exporting in Viewpoint Experience Technology format.

Look at the following controls:

- *Generate MTS/MTX Only* and *Generate MTS/MTX And HTML*—Select whether to have the Viewpoint files created so you can add them directly to your site or have an HTML document created so all you need to do is create a link to the finished page.

- *HTML Viewport*—Set the size of the image. The default size is 400×400 pixels. Usually it is not a good idea to go above 640×480 because of download speeds (remember—the average Web surfer connects via a 33.6 or 56.6Kbps modem) and making sure the image is completely visible to all size monitors.

- *Save Compressed*—Save a compressed file to help alleviate size issues that affect connection speeds and download times.

- *Use Wavelet Textures*—Use a compression method that reduces the number of colors to make the file size more manageable. Instead of creating sharp edges where the colors change, this compression method adds noise to simulate gradients.

- *Use Animation Sets*—Include an animated model in the saved file.

- *Ignore Camera Animation*—Ignore an animated camera.

- *Soft Edges In HTML Window*—Assign soft edges around the image window.

- *Image Quality*—Keep this between 60 (the default) and 80 to help keep file sizes manageable. You can increase this when creating smaller image files.

- *Geometry Quality*—Determine how smooth and realistic the image will be by making the geometry of the model more dense.

- *Scale Factor*—Determine how far you can zoom in or out on an image.

- *Broadcast Key URL*—The area where you type the license code assigned to the VET file. If you are using the VMP for professional use, you need to get a broadcast key for the file—VMP is not free for commercial use. Check the Viewpoint site to find out about how to obtain broadcast keys.

With that knowledge under your belt, export the PoloModel file by following these steps:

1. Activate Generate MTS/MTX And HTML.

2. Change the HTML viewport to 480×480.

3. Deselect Use Animation Sets, but keep Soft Edges In HTML Window selected.

4. Change Image Quality to 90 and Geometry Quality to 100.

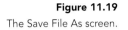

Figure 11.19
The Save File As screen.

5. Click OK, and on the Save File As screen, delete the .pz3 extension seen in Figure 11.19. When Poser generates the file, it keeps the .pz3 extension in the name. Remove it so that the file will load properly on your Web page. Dual extensions can wreak havoc on the display of images on the Web.

6. After previewing the file, click OK.

7. Next, view the generated HTML document. Close Poser and open your Web browser. Choose File|Open and navigate to your saved HTML file. You'll see that Poser has created a really cool page design, as well as logos and links to pertinent Web sites, much like what you see in Figure 11.20.

Figure 11.20
The male model, Van Nawhyte, on the generated Web page. I have zoomed in on him so you can see the soft edge effect assigned to the image.

What is interesting with Viewpoint technology, though, is that it's capable of accepting animated files yet retaining interactivity. In the following project, you will work with this capability as you create a fun little animation that shows off the power of VET.

PROJECT Animated Interactivity

In prior releases of Viewpoint technology—back in the days when it was called MetaStream—you created a static 3D image and all movement came from how the visitor manipulated the file. That was great for showing off clothing or a nonmoving product. But what if you had a client who was selling a new product called the Yo!Ball—a ball that acted as a yo-yo. (I know. How original.) A static image would be okay, but wouldn't it be great to show the Yo!Ball in action while still allowing people to zoom in and out, and rotate around it?

In this project, you'll create an animation, save it as a Viewpoint file, and then view the animation in your Web browser:

1. Create a new document in Poser and place the Casual Boy model on the workspace.

2. Next, choose the Child Hair from the Hair Types section of the Hair model shelf so your boy doesn't look like a prepubescent Kojak.

3. The Yo!Ball needs a string; otherwise, how would it return to the user? But string is a rare commodity in the world of Poser props, so you'll have to fake it. This method won't create a fully realistic string, but it's a good way to give the effect of having the string tied around a finger. Remember, the focus will be on the Yo!Ball product. So here's how to create a string. Select the cylinder prop and resize it in the following manner to place the string on the finger:

 - xScale: 8
 - yScale: 11
 - zScale: 8
 - yRotate: -4
 - zRotate: 14
 - xTran: -.270
 - yTran: .468
 - zTran: .009

4. With the cylinder prop still active, select Object|Properties, change the name of the prop to String, and click Set Parent. Make the Right Mid 1 (the first section of the middle finger) the parent. Use the RHand camera (as in Figure 11.21) to see how the string looks on the boy's finger.

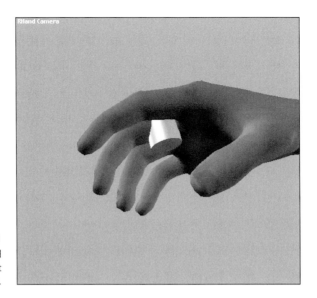

Figure 11.21

The "string" is positioned and made the child of the right middle finger.

5. Return to the Main camera and add a ball prop. Make the following changes to the ball:

- Scale: 35

- xTran: -.267

- yTran: .442

- zTran: .010

6. After the ball is positioned in the palm of the boy's hand and nested against the string, you will need to fix the fingers of the hand. Use these parameters:

- Right Thumb 2

 Bend: 53

 Side-Side: 3

- Right Thumb 3

 Bend: -25

- Right Index 2

 Bend: -1

- Right Index 3

 Bend: 16

- Right Mid 2

 Bend: -5

- Right Mid 3

Side-Side: -1

Bend: -1

- Right Ring 1

Bend: -10

- Right Ring 2

Bend: -20

- Right Ring 3

Bend: 15

- Right Pinky 1

Side-Side: 11

- Right Pinky 2

Side-Side: -8

Bend: -39

- Right Pinky 3

Bend: 15

7. Figure 11.22 shows the position of the ball prop in the hand. Save the file as YoBall.pz3.

Figure 11.22
The ball is now in position, resting comfortably in the boy's hand.

8. Reselect the ball prop, choose Object|Properties, and rename it YoBall. Set the right hand as the parent. What you have now effectively accomplished is parenting the "string" to one element of the hand and the ball to the hand itself so that both props will move when the hand position is changed. Save your file again.

Figure 11.23
Look out! The boy's ready to hurl the ball at you!

9. Change the boy's body and arms in the following manner so he appears ready to hurl the Yo!Ball (refer to Figure 11.23):

- Abdomen

 Twist: -20

- Left Collar

 Bend: -25

- Left Shoulder

 Twist: -1

 Front-Back: 6

 Bend: -50

- Left Forearm

 Twist: -1

 Bend: -21

- Right Collar

 Bend: 32

 Front-Back: -13

- Right Shoulder

 Twist: -22

 Front-Back: -53

 Bend: 2

- Right Forearm

Twist: -41

Bend: 72

- Head

Smile: .939

Twist: -24

Bend: 16

10. After saving the file, select the Yo!Ball prop and change its color to a yellowish gold. Then, in the Basic Animation control panel, go to Frame 30 and set a key frame.

11. Switch to Frame 15. Change the following settings so it looks as if the Yo!Ball is being thrown at the viewer:

- Abdomen

Twist: 39

- Right Collar

Bend: 4

Front-Back: 19

- Right Shoulder

Twist: -22

Front-Back: -23

Bend: 11

- Right Forearm

Twist: -41

Side-Side: -9

Bend: 35

- Head

Smile: .939

Twist: -32

Side-Side: 2

Bend: 5

- Yo!Ball

xTran: -.511

yTran: -.353

zTran: -.035

12. Because of the way these parameters were changed, you will need to check the animation and move the ball so it stays within the frame and attention isn't drawn to the fact that the string is not stretching out. The so-called string on the finger is merely used as a subliminal element; you know it's there, but you don't really pay attention to it.

13. Choose File|Export|Viewpoint Experience Technology. Save the file with the following parameters:

 • HTML Viewport

 Width: 350

 Height: 350

 • Image Quality: 70

14. Click OK and name the file YoBall.mtx. When the preview screen comes up, you'll see a rough estimation of the animation. Click OK to save the file.

15. The last thing to do is open your Web browser. Make sure you have the Viewpoint Media Player installed. If you don't, go to the link provided on the page, install the player, and then reopen your browser. Choose File|Open and browse to find the YoBall.html file. Figure 11.24 shows the animation in the browser window.

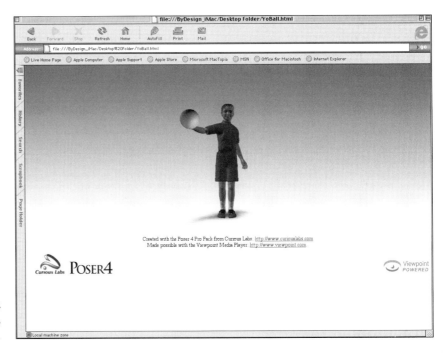

Figure 11.24

The Yo!Ball animation seen in the browser window.

Take some time to move the image around in the window. Rotate it, zoom out, and see how animation can enhance the entire Viewpoint experience.

Some Final Notes

You will definitely want to work with the lighting of your files using techniques you learned in Chapter 8. You can also animate the lights for some interesting effects, changing their positions and colors—something impossible to do in the old MetaStream format. With Viewpoint, static images are a thing of the past if you take some time to find ways to present your clients' products in a manner that makes the most of this technology.

Of course, there is one thing missing from the page you see in Figure 11.24. That missing element is descriptive text. You need to open the HTML file in your Web development program of choice—be it Adobe GoLive 5, Macromedia Dreamweaver 4, or one of the text editors—and add a description, links to an online store (if there is one), and phone numbers where people can call to order the product.

Moving On

The next big improvement introduced in the Poser Pro Pack is that the program gives you the ability to export in the Shockwave format. Millions of Flash developers have spent countless hours figuring out how to include 3D elements in their animations. But until now, realistic 3D characters have been almost impossible to build in Flash files. That's no longer the case. In the next chapter, you'll discover how you can create varied animations that can be directly imported into Macromedia Flash or Adobe LiveMotion. Plus, you'll discover exciting ways to wow your visitors by adding humans, animals, and 3D props to your Shockwave files.

Chapter 12

Creating Flash Animations

Since the latter part of 1999, the ability to include 3D elements in Shockwave files has been a hot topic. With the Poser Pro Pack, that ability has reached new heights.

Flashing the World

A new step in the process of Web animation is now at your disposal. Does that sound like the standard advertising hype you see in virtually every print ad and commercial? In this case, it's true. For years, Flash programmers have been coming up with creative ways to simulate the look of three-dimensional objects in their Shockwave animations. Usually, those 3D effects were merely vector graphics, which worked well for boxes, balls, and other proplike objects. But when it came to adding humanoid figures to the file, 3D effects became a study in frustration.

Flash programmers were frustrated because, to adequately include this type of art, an animation created in Poser, for instance, had to be saved as a series of JPEG or PICT files. The challenge then became making the final Shockwave animation small enough to load quickly. Thanks to the Poser Pro Pack, those days are over. One of the hottest topics since the announcement of the Poser Pro Pack update has been the inclusion of the Flash export function, allowing Flash designers to add jaw-dropping effects to their files—effects that will leave Flash developers who do not have the Poser Pro Pack in their design arsenal wondering how they were accomplished. Of course, it won't be long before word gets out and millions of developers add the Poser Pro Pack to their stable of programs, but until then, consider yourself among the few, the proud, the cutting-edge elite.

Sound improbable? Then consider this. Approximately 95 percent of the people who have access to the Internet have the free Flash player installed in their Web browsers. Those who don't—namely, those who access the Internet via WebTV or similar products—are not able to see the files because the hardware doesn't support it yet. But with the vast proliferation of the player, the audience is so huge that once word gets out about the Pro Pack's capabilities, Flash developers yearning for animated 3D figures for their productions are going to flock to the Poser fold.

Flash developers have grown in number as well. Two programs on the market focus solely on Shockwave (SWF) production—Macromedia Flash (now in version 5)—which started the "revolution"—and Adobe LiveMotion. Of the two, Flash has the stronger user base, but it definitely has a high learning curve. LiveMotion works well with other Adobe products—including GoLive 5, the company's premiere Web layout program—and has a fairly low learning curve. So what LiveMotion lacks in Flash's sophistication is made up for in the speed with which you can begin building your SWF files.

This chapter, though, is not set up to teach you Flash or LiveMotion. There are books on the market that focus solely on these programs, and you should probably find the one that best fits your needs to learn how to build completed SWF animations. This chapter is designed to help you export high-quality

animations for inclusion in Flash or LiveMotion. To this end, I will use both programs when talking about importing the Poser Pro Pack files, but I won't go into detail about how to create a finished Shockwave file.

Some of you might be saying, "That's good, because I don't own Flash 5 or LiveMotion!" You don't need to own the programs. What you are doing when creating a Shockwave animation in the Pro Pack is making a stand-alone file, the same type of file that you create when using either of those two programs. This means that, what you export from the Pro Pack is ready to be put onto your Web site if that is its final destination. You don't need to take the file into Flash or LiveMotion to prepare it for Web delivery. This means that you could very easily build your entire Shockwave animation without leaving the comfortable confines of Poser. So fear not, intrepid animator. You too can join the Flash revolution without making any other software investment.

Flash Basics

The popularity of SWF animations lies in the small file sizes, which decrease the time it takes files to load on the Internet. The files are small because vector graphics (non-resolution-dependent artwork) are used. With pixel-based files, such as those generated by Photoshop, the file size grows as the resolution is increased. Vector-based graphics remain extremely small because they are resolution independent. So when Poser converts a model or animation to Flash Shockwave format, it translates the image into a virtual vector graphic. The size of the generated file is determined by the number of colors and the length of the animation.

In Chapter 1, you got a quick overview of the Flash Export controls. Here, you will gain a better understanding of them—and a better understanding of how the type of model you use will affect your final output size. Here are the points you need to be aware of as you build your file in Poser and then save it in the Flash Shockwave format:

- *Length*—The longer the animation, the larger the file.

- *Image size*—Keeping the dimensions of your outputted files smaller will help keep the final animation size low. Screen dimensions of 400×400 pixels and lower are preferable.

- *Number of colors*—The more colors you assign to the outputted file, the higher the file size will be. You can go up to 255 colors, but usually 128 or fewer will suffice.

- *Frames per second (fps)*—The standard for smooth Shockwave animation is 12 fps, which is pretty much the default fps in Flash and LiveMotion. But 15fps is also acceptable. Anything over that will begin affecting playback and make the final file size too large.

Another concern is the size of your model's geometry. Models such as the Michael and Victoria characters are high-resolution models, meaning their geometry is more dense than, say, the P4 characters. This allows for a higher-quality rendering when you're creating an image in Poser or exporting to another 3D application, but it can slow down file generation when you're exporting to Shockwave. Extra care also has to be taken when using props that rely on transparency maps.

Included with the Pro Pack are a set of new, lower-resolution models—Gramps, Ginger, and others. These models and models such as the DAZ 3D Kids and Dog and Stylized Business people give you a high-quality output that isn't as detail oriented. These models make for wonderful characters to use in your Flash animations if you are not looking for photorealism.

Props in a Flash

The first thing you'll work on is creating a Shockwave animation that utilizes different props. Then you'll look at how the settings you choose will affect the final size of the outputted file.

Ballin' the Jack

In this animation, you will use the ball and cylinder props that will eventually create a jack. Here's how to do it:

1. With a blank workspace open, access the Basic Animation control panel and change the length of the animation to 60 frames. Also, double-click the workspace size display shown in Figure 12.1 to bring up the Set Window Size window seen in Figure 12.2. Change Width to 550 and Height to 501 so the settings you'll soon use will work properly.

2. Place a cylinder prop on the workspace. Change its Scale and Rotate settings to the following to create a long, thin cylinder that is lying on its side:

 • xScale: 50

 • yScale: 600

 • zScale: 50

 • zRotate: -45

 • xRotate: -90

3. Add a second cylinder. Scale this prop to the same dimensions as the first cylinder, then change the following settings so your screen looks like Figure 12.3:

 • zRotate: -45

Figure 12.1

By double-clicking the size indicator above the workspace, you will open the window that allows you to change the workspace display size.

Figure 12.2

The Set Window Size screen.

- xRotate: 90

- xTran: -.251

- zTran: -.857

4. Select Cameras|Main Camera from the current element pop-up and change its position in the following manner:

- DollyY: .299

- DollyX: .070

5. Place four balls onto the workspace. These will initially be placed off the workspace where they can't be seen. Here are the positions I used for this initial setup:

- Ball 1

 xTran: -.476

 yTran: .501

- Ball 2

 xTran: .607

- Ball 3

 xTran: -.192

 yTran: .723

- Ball 4

 xTran: .567

 yTran: .393

6. Move the timeline bar to Frame 15. Switch to the Horizontal Dual view and make sure one viewport is set to Top camera and the other is set to Main camera. Move the two cylinders in the following manner so their positions are the same as they are in Figure 12.4. When the cylinders are positioned, set a key frame:

 - cyl_1

 xTran: -.259

 zTran: -.413

 - cyl_2

 xRotate: 75

Figure 12.4
This is how the two shafts should look at Frame 15 of the animation. If you have Ground Shadows active, you will see that cylinder 2 is slightly raised.

7. At Frame 20, change the xRotate setting for cyl_2 (the top cylinder) to 90 so the two cylinders intersect. Set another key frame and save the file as jack.pz3.

8. Go to Frame 30. Change the positions of the balls in the following manner so the balls lock onto the ends of the shafts. Then set a new key frame:

 - ball_1

 xTran: -.273

 yTran: -.053

 zTran: -.423

 - ball_2

 xTran: .192

yTran: -.053

zTran: -.417

- ball_3

 xTran: -.273

 yTran: -.053

 zTran: -.874

- ball_4

 xTran: .176

 yTran: -.053

 zTran: -.865

9. Now move to Frame 50. Make the Main camera active and change its settings as listed here so your workspace looks like Figure 12.5. Then set another key frame:

- DollyZ: .409

- DollyY: .646

- DollyX: -.052

- xOrbit: -90

Figure 12.5
After you change the Main camera position settings, your workspace will look like this.

10. The last thing to do before creating the animation is to turn off the ground shadows so they won't render in the scene. Choose Display|Ground Shadows to deselect this function.

11. Now it's time to create the Shockwave file. As you learned in Chapter 1, choose Animation|Animation Setup and change the frame size to 550×501 to match the size of the workspace. Then change the frame rate to 12 and click OK. Because this won't actually be used for a real Web animation, you can leave the file dimensions larger than you probably normally would.

12. Choose Animation|Make Movie. Change the Sequence Type setting to Flash Animation (.swf) and click the Flash Settings button. For now, leave the number of colors set to 4 and deselect Draw Outer Lines. Click OK, then click OK again to make the animation. Because you have saved the file, the actual file name will be inserted in the Name field. So when prompted, just leave the name jack.swf as the file name.

13. Before checking the SWF file you just made, go back to the Make Movie screen and change the number of colors to 64. Save this file as jack2.swf. You're doing this so you can see the difference the number of colors makes in the size of the final animation. Figure 12.6 shows the file information screens from a Macintosh computer, with the first and second animations side by side.

Be Aware

Increasing the number of colors in a Flash animation will make the render time for the animation dramatically longer, effectively tying up your computer until the render is complete.

Figure 12.6

Comparing file sizes, you can see that there is a big difference between the 4-color animation on the left and the 64-color animation on the right.

You can use this technique for making animated logos or fun animations to show off your prowess as a 3D Flash developer.

PROJECT Flashy Folk

Exporting prop animations in Flash is a lot of fun. But to really make your Shockwave files stand out and make all those Flash folks go ga-ga over them, you want to include animals or humans in your scenes. In this project, you'll discover the differences between using low-resolution and high-resolution models so you can make your Flashy folk look as good as they can.

Low-Resolution Models

The first scenario you'll look at is working with low-resolution models. The star of this section will be Mick, the Teddy Roosevelt/Rough Riders-type character that comes bundled with the Pro Pack. Do the following:

1. Place Mick on the workspace. Move the timeline bar in the Basic Animation control panel to the last frame and create a new key frame. This way, the default pose he's in now will be the one he ends up in.

2. Move back to Frame 1. Using the techniques you've learned throughout this book, pose him so he looks somewhat like he does in Figure 12.7. This is the first frame of the Rough Rider's aerobics class.

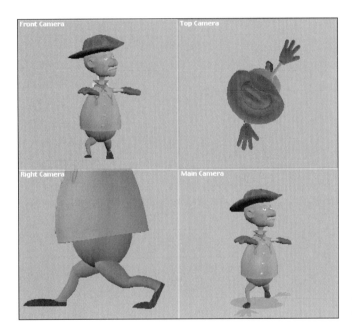

Figure 12.7

Ol' Mick begins his pre-turn-of-the-century aerobics exercise with this warm-up position.

3. Go to Frame 15 and change his pose so it looks like it does in Figure 12.8. Make a new key frame and then save the file as OlTimeAerobics.pz3.

4. Turn off Ground Shadows.

5. Time to animate. In the Animation window (Animation|Setup), change the frame size to 240×190, and the frame rate to 12.

6. In the Make Movie window, select Flash Settings. Change the number of colors to 16, and this time, leave Draw Outer Lines on. This creates an interesting animated outline effect, almost like a pencil test, when the file is rendered. Then go ahead and render the file.

7. Repeat Step 6 and change the colors to 128 in the Flash Export window. Then render again, adding the number 2 at the end of the name of the SWF file (OlTimeAerobics2.swf).

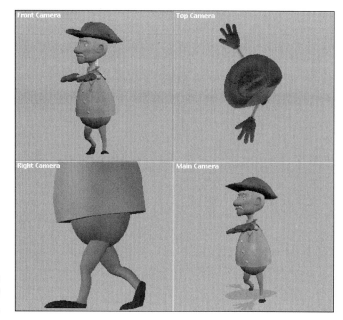

Figure 12.8
Mick's pose at the 15th frame of the animation.

Note: You'll find three SWF files of the low-resolution model animations on the CD-ROM in the Chapter 12 folder.

8. Render one more time, but this time, turn off Draw Outer Lines. Then view your three renders and compare the differences.

High-Resolution Models

Now you'll turn your attention to high-resolution models. For this section, I'll be using the Michael model (if you don't own the Michael model, use the P4 Casual Man or P4 Casual Woman model that comes with Poser). To replace Mick with the high-resolution model, follow these steps:

1. Select the model to replace Mick and double-click it. A screen pops up indicating you are about to replace the existing model with a new one. You want to do this, so click OK.

2. A screen like the one you see in Figure 12.9 appears. This screen lets you tell Poser to give the replacement figure the same pose as the original model (Keep Modified Geometries), to attach any props to the replacement model that were attached to the original model (Keep Props Attached to Figure), and to keep any changes you might have made with Magnets or Wave Deformers (Keep Deformers Attached To Figure). In this case, you don't want to repose the replacement model, so select Keep Modified Geometries and click OK.

3. Figure 12.10 shows the next screen that appears—the final one before the change takes place. Because Michael and Mick are proportionally different, do not do anything to this screen except click OK. It will take a few moments for the new model to replace the old one because Poser is transferring all the positional information for the different body elements to the new figure.

The current figure contains customized geometry.
Would you like to apply these to the new figure type ?

☐ Keep modified geometries
☐ Keep props attached to figure
☐ Keep deformers attached to figure

Cancel Figure Change OK

Figure 12.9
The screen that appears when you replace a model on the workspace. This important screen tells Poser what poses, props, and deformers from the original model should be attached to the replacement model.

Would you like to keep this figure's proportions through the figure change ?

☐ Keep current proportions

Cancel Figure Change OK

Figure 12.10
This screen asks if you want the new figure to have the same dimensions as the existing figure. Most of the time you will not want Poser to retain the existing dimensions.

4. Because the replacement model is so much larger than Mick, you will have to reposition the camera so you can see all of Michael.

5. Because the Michael character is not so cartoonlike, you will need to set your Flash settings differently than they were set with Mick. In the Make Movie window (see Figure 12.11), change Quality to Current Render Settings. Click the Render Settings button and make sure Antialias is turned off. Because of the way the transfer to a Flash-compatible file is generated—with lower color resolution and a semiconversion to vector-style art—Antialias will slow down the rendering process, though it won't give any discernable improvement to the image quality.

Note: I added the Wedge Cut Hair style to the Michael character. (This hairstyle is sold separately at DAZ 3D's site [**www.daz3d.com**]). Advanced transparency settings are used to simulate the look of real hair. You can see a sample of this hair in the "home office" scene on page 4 of the color section of this book.

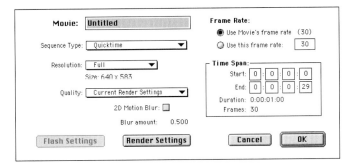

Figure 12.11
Change Flash settings in the Make Movie screen to correspond to the more sophisticated Michael model.

6. After leaving the Current Render Settings screen, click the Flash Settings button and change the number of colors to 128 (if it isn't still set at that). Also make sure that Draw Outer Lines is deselected.

7. Click OK to begin rendering the Flash file, but name this one ModTimeAerobics.

What if you had assigned a transparency to the file? How would that render in the Shockwave format? If you had set Quality to Current Display Settings in the Make Move window, transparencies would look extremely bad in the generated Flash file. Because you chose the Current Render Settings function, Poser will correctly read any transparencies that are assigned to an object and translate them correctly to the animation, as you can see in Figure 12.12. It is the same as when rendering a still image; the program will not read transparencies correctly if told to render using the current display settings.

Figure 12.12
A still from the ModTimeAerobics.swf file. Notice how, even with only 128 colors assigned, the hair—which has a strong transparency added to it—looks pretty realistic.

Flashes of Color

Although the process of exporting and saving a Flash Shockwave file is pretty straightforward, you have found out that, because of the way Flash files are saved, the most important part of the export setup is to determine the number of colors to use. Use the following as a guide as you are creating your Flash files:

- *4 to 63 colors*—Good for low-resolution or cartoon-style models.

- *64 to 128 colors*—A good median setting that provides clearer, more accurate renderings. This is good for low-, medium-, and high-resolution models.

- *129 to 255 colors*—Good for high-resolution models, but will noticeably slow down animations as the number of colors reaches the high end of Flash's color capabilities. Also makes extremely large animation files.

There is definitely a trade-off when exporting in Flash format. You won't get a photographic image because of Flash's color limitations. If you want to have photo-quality images, render your animation as an image series and import the individual frames into Flash or LiveMotion. Poser users had to do this prior to this export capability. This workaround, though, will also create large SWF files, which means increased download time before the file can be played on a browser.

Moving On

As you can see, exporting Flash animation files is really a boon to the Poser and Shockwave community. Now you can easily create small animations to highlight special areas on your Web site or use true 3D actors in your Flash animations. Again, this was virtually impossible—or should I say, inordinately difficult?—to accomplish prior to the Pro Pack.

And another new feature that has many users drooling is the ability to export models and animations that translate perfectly to LightWave and 3D Studio Max. In the next chapter, I'll give you a tour of how these plug-ins work and how they add one more level of sophisticated 3D realism to your work.

Chapter 13

LightWave and 3D Studio Max Integration

For those who have these two professional 3D modeling programs—LightWave and 3D Studio Max—adding Poser figures and animations has become as simple as clicking a button.

Export/Import

Have you ever tried to figure out how to add an animated Poser character to a scene you created in another modeling program, such as Bryce, Ray Dream, Carrara, Infini-D, or even LightWave or 3D Studio Max? Couldn't be done, could it? In fact, about the only way to really integrate a Poser animation into a scene created in one of these programs was to either render the scene you built and add it as a background image in Poser or blend the rendered animation files in programs such as Adobe Premiere, AfterEffects, or Final Cut Pro. This also meant that extra care had to be taken building the backgrounds and the walk path that was assigned to the Poser character.

With the Poser Pro Pack, you now have the ability to import your Poser figure or animation directly into LightWave versions [5.6] through [6.5] or 3D Studio Max versions 3.*x* and 4. This ability makes life much easier for all you animators. Merely save your animation as the native PZ3 file, and, after installing the appropriate plug-in, open the file directly in LightWave or 3D Studio Max.

In this chapter, you'll learn how to set up a figure animation and import it into these two programs. You'll discover how powerful the LightWave and Max plug-ins are and how much they can simplify your animating life. This chapter features two projects: one focuses on LightWave, the other on Max. You'll learn to build an animation, import it into the program of your choice (meaning whichever one you might have on your system), and render it.

The tutorials and projects in this chapter are not designed to teach you how to use LightWave or Max. Basic knowledge of the programs is needed, and it's assumed that, if you own either of these applications, you can do basic modeling in them.

There is a lot to cover, so let's get to it.

Base Animations

First I will show you how to build animations in Poser and save them for inclusion in Max or LightWave. You have spent dozens of hours practicing posing different models in Poser, so I won't go into great detail regarding element positions. From this point, you will want to study the accompanying images and use your knowledge to duplicate the figures' positions.

It's a Drag

The animation file you will create is that of a man dragging a rock across the workspace. Of course, the rock will be created in either LightWave or Max, whichever program you use, so for this tutorial, you will merely create the pulling motion animation.

To create the pulling animation, follow these steps:

1. Create a new document and place the Casual Man model on the workspace. It makes no difference as to what size you set the workspace,

> **Note:** Because of the intricacies of this type of action, the draggin files included in the Chapter 13 folder of the CD-ROM will be fairly simple. You can use the file to practice with or to use as a base for the final animation you create. You can also use the file to study the base positioning of the figure elements.

because, once you save the file and import it into LightWave or Max, you will import only the model and any motion information assigned to it.

2. Next, give him a head of hair.

3. Assign the Main camera to the single-view workspace or to one of the views if you are using a multiple-view layout.

4. Select Figure 1's Body element and move him backward by changing the zTran dial to 1.3. This will give you room to create the pulling motion.

5. Pose the Casual Man as you see in Figure 13.1. Take care to make minor adjustments to the shoulders, which are a very important aspect to an animation such as this. People use the shoulders and the back when pulling or dragging a heavy object, so it's necessary to reflect this in the positioning of the shoulder area.

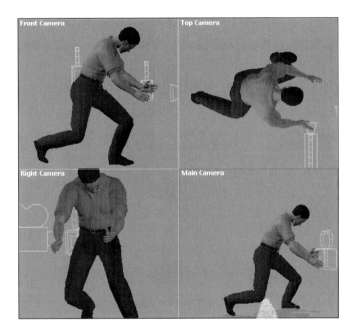

Figure 13.1
A look at the base starting pose for the dragging motion as seen in the Quad view.

6. Save the file as draggin.pz3.

Other points that you should look for in Figure 13.1 and as you create the pose are the head and neck positions, the hip twist, and the weight distribution for the feet based on the action being made at that point. In Figure 13.1. the model is shown in the position of bracing to pull on the rock. This means his head will be down and twisted slightly (look in a mirror and pretend that you are about to drag something heavy—you grimace and your head twists slightly in preparation). His hip will be twisted so there will be more weight on the front foot, and his shoulders will be slightly hunched.

7. Change the animation length to 90 frames.

8. Now you'll create some key frames for this pose, which is one he would use a couple of times as he drags an object. Create key frames at Frame 35 and Frame 70.

9. Move to Frame 23 and reposition good ol' hard-working Casual Man so he looks like he does in Figure 13.2.

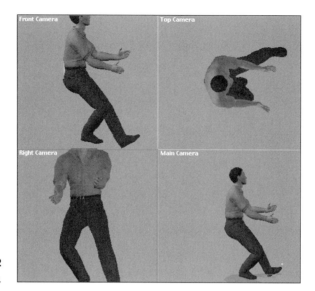

Figure 13.2
He works hard for his money.

Figure 13.3
(Left) The position at Frame 13.

Figure 13.4
(Right) The position at Frame 28.

10. Move the timeline bar, and at key points where the body positions get a little bit extreme, modify them so his movements aren't so broad. Figures 13.3, 13.4, and 13.5 show various positions along the timeline to give you an idea of the poses throughout the animation.

Figure 13.5
The character position at Frame 42.

Save the Animation File

If you are happy with this motion file you just created, you will more than likely want to save it for later use. To do this, follow these steps:

1. Open the Poses drawer and, from the pull-down selector, choose Add New Category.

2. Name the new library Original Animations and click OK.

3. Select this new category from the pull-down menu and click the + button at the bottom of the Poses shelf.

4. Give the set a name such as Dragging and click OK.

5. When asked if you want to include morph channels in the pose set (Figure 13.6), click Yes. You have actually created morphs from one position to another, so you definitely want to include them.

6. In the next screen, you'll be asked if you want to save a single frame or multiple frames. Because this is a multiple-frame animation, select Multi Frame Animation and, if necessary, change End Frame to 90 as shown in Figure 13.7.

Figure 13.6
Click Yes to include the morphs you created in the animation.

Figure 13.7
Make sure you select Multi Frame Animation and the correct number of frames when saving your original animation files.

Figure 13.8

The saved animation as seen in the Poses shelf. Notice the frame number indicator in the upper right, which shows the length of the animation.

Note: Chapter 1 gives a brief overview of the way LightWave needs to be initially set up to access a Poser file. For more details on the installation of the plug-in, which is installed at the same time as the Pro Pack, and the initial setup, refer to the *Pro Pack Introduction Guide.*

7. Click OK, and the animation will be added to the Poses shelf. In the upper-right corner of the icon, you'll see the number of frames the animation encompasses (see Figure 13.8).

8. Now that the animation is saved, you need to save the master Poser file again. Simply select File|Save (Command/Control+S) to make sure that you have saved the most recent version of it.

PROJECT Draggin' the Line (in LightWave)

This project uses Poser in conjunction with LightWave. Throughout this section, I'll be using LightWave [6.5] on a Macintosh computer—the program is virtually identical in both its Mac and PC incarnations, so there shouldn't be any differences platformwise. If you are using an earlier version of LightWave, you might need to modify some of the instructions to fit your version. For the most part, though, I will try to avoid using tools that aren't included in all versions of the program. However, I will assume that you already know where the basic controls in LightWave are located.

To create the draggin' motion, do the following:

1. Open Modeler and create a rock. Size doesn't matter at this point because you can resize the rock in Layout when you import it. Remember, the Pro Pack plug-in works only inside of Layout.

2. After making your rock, open Layout and choose File|Load|Load Scene. In the Load Scene window, make sure All Documents is selected in the Show pop-up, as shown in Figure 13.9.

Figure 13.9

All Documents must be selected in the Show pop-up for LightWave to recognize the saved PZ3 file.

Load Scene
Scenes
Name
Aviation
Benchmark
Characters
Computer
Electronics
Games
Show: All Documents
Cancel

3. Navigate to where you have saved the draggin.pz3 file and click Open. The Loading Scene window will appear, and shortly thereafter, the character will be placed in the scene. There are times when the color information for certain objects does not translate into LightWave correctly; this includes the hair texture, which, as you can see in Figure 13.10, has no texture

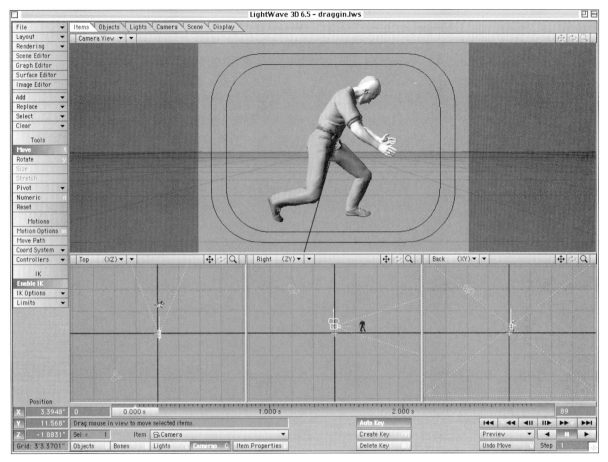

Figure 13.10

Sometimes color information doesn't translate well into LightWave.

map or color applied to it at all. A fix for this is likely to be in the works or might even be available at this time at the Curious Labs site, but for now, you can assign the colors you want to different elements.

4. To fix the hair, open the Surface Editor (seen in Figure 13.11) and notice how all the elements for the Poser figure are listed in the Surface Name panel. If you select Hair and then click the T (Texture) button next to Color to open the Texture Editor screen, you'll notice that Male Hair 1 Texture (see Figure 13.12) is assigned to the image and that UVMap is set to Poser UVs. If you change the hair color, you will want to remove the UVMap; otherwise, you will not get clean results, as you can see in Figure 13.13.

5. Choose File|Load|Load Object (or use the + key) to import the rock you created. As you can see in Figure 13.14, mine was rather—how shall I put this?—big. I don't think ol' Poser Dude is going to be pulling that one anywhere anytime soon.

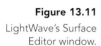

Figure 13.11

LightWave's Surface Editor window.

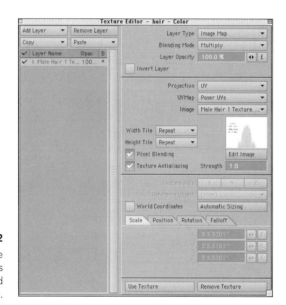

Figure 13.12

The Texture Editor screen. Notice that the Male Hair texture map is assigned to the hair element and that UVMap is set to Poser UVs.

Figure 13.13

If you change the hair color and don't remove the UVMap, your color results will more than likely not be what you want.

Figure 13.14
That's one massive rock. I think it needs to be resized.

Figure 13.15
The resized rock positioned between our hero's hands.

6. Resize the rock so it fits between the model's hands. Although it's still a mammoth piece of stone, as you can see in Figure 13.15, it will work for the purpose of this demonstration.

7. With the Rock option selected, open Motion Options and, in the Motion Options For Rock window, select Figure 1 as the parent item (see Figure 13.16). This way, any changes made to Figure 1 will affect the rock as well.

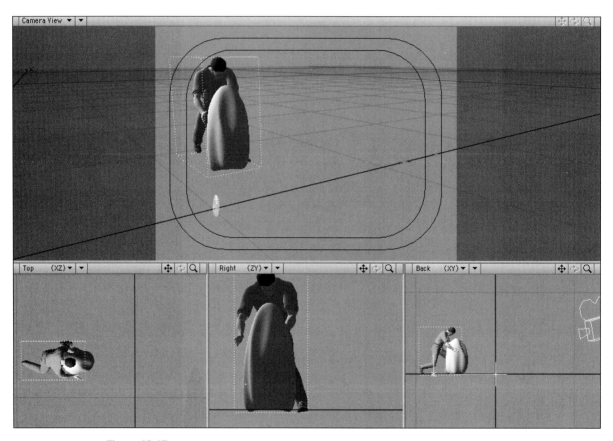

Figure 13.16

Figure 1 (our hero) is selected as the parent for the rock.

Figure 13.17

Figure 1 and the rock have been moved to a new location.

8. Select Objects and then Figure 1 from the Item pop-up. Move the timeline bar to the last frame of the animation and move Figure 1 to the left. Figure 13.17 shows the end position.

9. Select Make Preview from the animation controls (see Figure 13.18) to create a preview rendering of the animation.

As you view the preview, you'll notice that, because of the rock's fluid motion (because it's parented to the body), Figure 1's arms move through the material, as shown in Figure 13.19. First, the rock shouldn't move smoothly all the way through the animation; it needs to stop and then begin moving again as the character tugs on it for a second time. Find that errant frame (which should be around Frame 1.685s), reposition the rock, then do another preview.

With a little more work—some tweaking of the rock's position—you'll have a pretty cool little animation in LightWave using a Poser file.

Figure 13.18

Use Make Preview to do a quick test of the animation.

Figure 13.19

Amazing how that arm moves so easily through the rock, isn't it?

 Takin' It to the Max

Taking a Poser file into 3D Studio Max is slightly different from taking it into LightWave, but once it's imported, you have total control over the scene or file, just as in LightWave. In this section, you'll integrate the scene from the LightWave project into Max. After that's done, manipulating the animation and object positions is, in essence, no different than what has just been discussed.

To load the scene into Max, follow these steps:

1. Upon opening Max (after the Pro Pack plug-in has been installed, of course), make sure the Create panel is active (Figure 13.20).

2. Click the Geometry button shown (circled in Figure 13.21) and then select Poser Objects from the drop-down menu, as shown in Figure 13.22.

3. A button marked Scene *.pz3 appears. Click it and then click the Load File button (labeled "...") that appears. Refer to Figure 13.23 to see where these buttons are located.

4. Navigate to the draggin.pz3 file and click Open. Within a few moments, the file will load on the workspace.

Note: You can view the rough animation (pre-tweaking) in the draggin.mov (Mac) or draggin.avi (PC) file in the Chapter 13 folder on this book's CD-ROM.

Note: The images in this section show 3D Studio Max v3.1. At the time this book was being written, version 4 had just been released. Those of you who have upgraded will need to make the appropriate changes where the location of controls might be concerned.

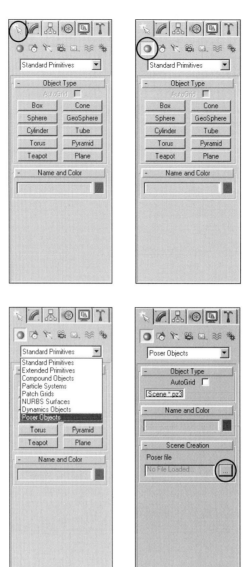

Figure 13.20

(Left) The Create panel (its tab is circled) should be active for Poser file selection.

Figure 13.21

(Right) You need to tell Max what type of file to load. In this case, click the Geometry button.

Figure 13.22

(Left) A drop-down list including Poser Objects appears after you click the Geometry button.

Figure 13.23

(Right) After you click Scene *.pz3 button at the top of the panel, the Load File button becomes active.

5. Next, set the animation parameters seen in Figure 13.24. Make sure you set the Starting Frame in the Poser Source Frames to Frame 0 and the Number Of Frames to 90 frame.

In the Chapter 13 folder on the accompanying CD-ROM, I have included the Rock.obj file shown in the "Draggin' the Line" project. You can now import it and position it as it was positioned in LightWave. Then simply create your animation as you normally would in Max.

Also, you should check the Curious Labs Web site (**www.curiouslabs.com**) to find out if the updated Max plug-in for v4 has become available. It should be there by now—or very shortly.

Final Thoughts

Both 3D Studio Max and LightWave are known to have powerful texture-creation engines. Between what you discovered in Chapter 5 and the texture maps that can be obtained free of charge or for low cost at Poser-related Web sites, you have more texture-creation power at your fingertips that ever before. Combining a texture map with Max's or LightWave's texture features, adding in radiosity, raytraced reflections and refractions, diffusion of lights, and volumetric lighting, you have the power to create extremely photorealistic scenes.

In fact, the last picture in this book's Color Studio (seen in Figure 13.25 in glorious black and white) was a test render created for a possible VHS/DVD/CD release. The Poser figure—which happens to be the Michael character with a P4 cowboy hat plopped on his head—was imported into LightWave. The lights were added and positioned so that the colors blend on the character's shoulder. It's a simple yet compelling scene that would have been difficult to accomplish prior to this because some of the advanced lighting configurations I used could previously be accomplished only in LightWave and Max.

Figure 13.24

Setting the start and end frames for the animation.

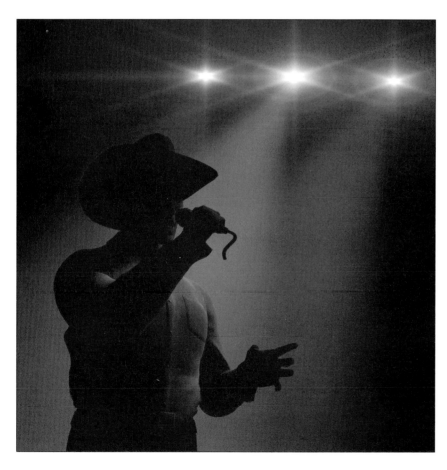

Figure 13.25

This image includes a Poser figure and prop imported into LightWave. The color version is in this book's Color Studio.

From this point, how you integrate Poser items into LightWave and 3D Studio Max is really up to you. I can guarantee that, within a very short amount of time, you're going to be seeing some awesome animations both on the Web and in the theaters. In fact, if you have ever had any doubt as to the power that lies within Poser (even before this interactivity between Max and LightWave), consider that Poser was used and seen prominently in television specials such as Tom Clancy's *NetForce* and such high-profile feature films as *The Matrix* (the scene where Neo was being taught Kung Fu—go back and take a look). Now, with the prevalence of Max and LightWave in the animation industry, I think we're on the cusp of a new level of Poser pioneering. And you can say you were there from the start.

Moving On

Even with the plug-ins discussed in this chapter, LightWave and Max can't do everything. No modeling program can. That's why you always read about special scripts and software that are developed by production companies to meet special needs for their projects. Now that scripting power has come to Poser via a programming language called Python Script.

In the next chapter, you'll get an overview of Python scripting with demonstrations of some of the key elements, and you'll build a few scripts that could prove useful to you in the near future.

Chapter 14

The Full Python

The Python scripting language is a powerful addition to Poser. With it, you can literally go under the Poser Pro Pack hood and create all new features and effects.

By Richard Schrand
and John Brugioni

Uncoiling Python

One of the most exciting new features of the Poser Pro Pack is the inclusion of the Python scripting interface. It allows you to greatly expand the functionality of Poser—from automating common tasks to designing advanced motion and collision-detection features. Learning a scripting language is a lot like learning a spoken language; there are rules of syntax that must be met in order for a script to run properly, and there are new words that need to become a part of your vocabulary. Entire books are available to help you learn these languages, so to try to do this in the space of one chapter would be futile. This chapter will give you an overview of Python and walk you through writing a basic script so you can get up and running. For this, I have enlisted a Poser Pro, John Brugioni, who has advanced knowledge of Python. He will begin his discussion in the "Python Primer" section.

Because of the nature of an explanation of programming languages, the bulk of this chapter describes the various elements that go into the Python language. Projects and tutorials are located in the latter third of the chapter. To benefit the most from this chapter, you should use a word processing package or a text editor as you follow along with the examples.

Note: Experienced programmers with knowledge of other scripting languages such as C/C++ will definitely want to look at how the Python language is written by scanning through the various examples in this chapter.

Python Primer

Python is an object-oriented interpreted language, which is also referred to as a *scripting* language, and you use the Python code to write *scripts*. These scripts are typically written in a text editor or Integrated Development Environment (IDE) and then run by the Python interpreter. Unlike C/C++, Java, and Fortran code, the Python scripts do not have to be compiled or processed before they are used. With compiled code, the human-readable commands are converted into binary code that can be executed directly by the computer. When Python scripts are run, the Python interpreter will compile the text script into an intermediate form called byte code. The byte code is then run by the Python interpreter program to execute the script. Thus, instead of being directly executed by the computer, the Python script is run by another program. As far as the programmer is concerned, the Python interpreter essentially runs the script directly from the user-written text file. The main impact for Poser users is that interpreted code will generally run more slowly than compiled code—although for most applications, the difference should not be noticeable. A secondary effect of using an interpreted language is that any errors in the script will go undetected until the script is run by Poser, at which point error messages will be printed in the Python console window that is opened in Poser when the scripts are accessed.

Note: I suggest you use a text editor such as BBEdit or BBEdit Lite to write your Python scripts; Microsoft Word or SimpleText should not be used. MS Word places various symbols into the document that can conflict with the code, and in Simple Text, errant tabs can cause the script to fail.

Note: When saving a Python script, always make sure you use the .py extension so your file will be recognized as a Python file.

Python is a powerful scripting language with straightforward syntax. It supports standard data types, several built-in structure types, basic looping and branching, file input/output I/O, math functions, system calls, and other stan-

dard programming language features. There is a cross-platform graphical user interface (GUI) capability using the Tkinter modules. Python is extendable by writing new modules in C or C++ and compiling them in scripting libraries and dynamic link libraries (DLLs) for Python to access. This allows Python to achieve relatively good execution speed for an interpreted language. The scripts are cross platform to the extent that any special extension modules used in the script are available for the target platform. Python is copyrighted but can be used and distributed freely, including for commercial use.

Object-Oriented Scripting

Object-oriented languages use constructs called *objects*. An *object* is a logical grouping of variables and the functions, also called *operations*, that work on and with the data contained within the object. In Poser, for example, a scene will have a certain number of figures in it. Each figure is represented by a figure object that contains data such as its name and references to its component actors and its display style. Its member functions act upon the data contained in the object. For example, the Figure objects in Poser have the following member function:

```
SymmetryBotRightToLeft()
```

This function copies the left-side parameters of the figure to the bottom right side. Objects are usually referred to as *instances* of a particular class. A class definition can be considered the blueprint used to construct the object.

The data and functions of an object are accessed in Python using the following notation:

```
object.variable
object.function()
```

For example, this simple script will print the name of the currently selected figure in a Poser scene:

```
import poser
scene=poser.Scene()
figure=scene.CurrentFigure()
print figure.Name()
```

The first line imports the Poser module, which makes the Poser interface functions and classes available to the rest of the script. The second line creates an object called *scene* that is a reference to the scene in Poser. The third line creates an object called *figure* that is a reference to the currently selected figure in the scene. The fourth line will get the name of the figure and print it. The one thing you will immediately notice is the use of the ., or dot, in the script. Thus, the command **figure.Name()** invokes the **Name()** function of the **figure** class,

Note: Samples of the scripts used in this chapter, as well as a few other demos you can use on your own, are included in the Chapter 14 folder on the CD-ROM. File names are indicated with each script sample. Refer to the Poser Pro Pack introduction guide for information on how to open scripts in the program.

of which **figure** is an object instance. The **Name()** function is technically referred to as an access or **Get** function and returns the name of the object as a string. Many of the functions encountered in object-oriented programming can be grouped as **Set** or **Get** functions. They either set (**Set**) a particular parameter of an object or get (**Get**) the value of a parameter. Most of the variables contained in the Poser objects are not directly accessible and must be obtained or modified through a **Set** or **Get** function.

The commands in the preceding script could also all have been combined to give a much shorter script:

```
import poser
print poser.Scene().CurrentFigure().Name()
```

This example also shows the hierarchical nature of the objects in Poser. It is good programming practice in Python, and most other languages, that you use the access functions directly rather than creating a separate variable if you are going to use a particular parameter only once, as in the preceding example.

Poser uses the standard dot notation, *objectName.memberName*, for accessing member variables and functions. There are no explicit pointers in Python and thus no reference or deference operators, such as *, &, ->, or their equivalents.

The keywords in the Python core as well as in the various imported modules are used to construct statements. *Statements* are commands or instructions that control the flow of the script and manipulate the data within it. *Syntax* is the grammar of a programming language. It tells how the statements and operations should be ordered and constructed.

Keywords are special words that the interpreter recognizes. The following identifiers are used as reserved words, or keywords, of the language, and cannot be used as ordinary identifiers. They must be spelled exactly as in the following list:

- and
- assert
- break
- class
- continue
- def
- del
- elif
- else
- except

- exec
- finally
- for
- from
- global
- if
- import
- is
- lambda
- n
- not
- or
- pass
- print
- raise
- return
- try
- while

When importing other modules, such as the Poser module, care must be taken not to use a name of a function, constant, or variable used in the imported module.

For a normal Python installation, it is possible to bring up an interactive shell or window. However, because of the way the Python interface is integrated with Poser, you can not bring up an interactive console or shell-type window. Print statements or errors will bring up a window in which text is displayed but text or commands cannot be entered (see Figure 14.1).

Most of the example scripts presented in this chapter can be composed in a text editor and placed in the Python directory or subdirectories of your Poser installation. They can then be run from File|Run Python Script.

Variables

The first thing to learn about any programming language is how it stores data. In Python, the two major data types are numbers and strings. A *string* is an array of characters such as *a*, *Z*, or *poser*. Inside the script the data will

Figure 14.1

The Python script window, in which statements or errors will be displayed.

generally be referred to by a symbol, called a *variable*. This fragment will take the value 10 and assign it to the variable *x*:

```
x=10
```

Performing a simple math operation will result in the variable *y* being assigned the value 15:

```
y=x+15
```

The equal sign in the preceding line is referred to as the *assignment operator*. The plus sign and other standard math symbols are also operators. The entire line is referred to as an *expression*. A valid expression does not have to have an equal sign in it and may not even involve numbers at all, as you will see in the section "Making a Doughboy."

Inside Python there are four basic ways of representing numbers:

- *Integers*—Whole numbers in the range -2147483648 through 2147483647.

- *Long integers*—Whole numbers designated with the suffix *L* (samples of long integers are shown in the list below). Long integers have unlimited range; their maximum size is subject only to the total available memory of the computer on which they're being used. They are useful for certain specialized applications for which you need very large numbers, such as cryptography.

- *Floating point numbers*—Have digits on both sides of the decimal point. Floating point numbers can also have an exponent. The exponent tells how many zeros are behind or in front of the decimal point. For example, the number 1 billion can be represented as 1000000000.0 or as 1.0e+9. The e+9 represents 10 raised to the ninth power (10^9) and indicates nine zeros before the decimal point.

- *Complex numbers*—A pair of floating point numbers, one representing the real value and the second representing the imaginary value.

The following are examples of the ways to integrate numbers in Python scripts:

- *Integers*—1, -1, 100000, 1073741824, -973418

- *Long integers*—1L, -1L, 100000, 34359738368L

- *Floating point numbers*—1.0, -1.0, 1.0e+5, 34359738368.0, 3.4359738368e+10

- *Complex numbers*—1+0j, 9+8.0j, 1.0+34359738368.0j, 1.0+ 3.4359738368e+10j, 3.0e+05 - 2.0j

Unlike in some other programming languages, the variables in Python do not have to have their type, such as float or integer, declared before they are used. Also, the type of the variable will switch based on its usage. An integer variable will become a float if it is assigned a float value.

There is a set of standard math operators in Python:

- + —addition

- - —subtraction

- * —multiplication

- / —division

- ** —exponentiation (x**y is x to the power y)

These operators have a precedence order, which is the order in which they are evaluated. This precedence (in descending priority) is as follows:

- Unary +, unary -

- *, /, %

- +, -

- Bitwise operators

- Comparison operators
- Logical operators

The unary operators are those that change the sign of a number. The next to be evaluated are the multiplication, division, and modulus operators. The modulus operator (%) returns the remainder of the division x/y. The addition and subtraction operators are next. Then come bitwise operators, which allow you to manipulate the binary bits of a number. The comparison and logical operators come last. The significance of the precedence is the order in which parts of an expression are evaluated. Consider, for example, adding 2 and 2 and then dividing the result by 4.

If you wrote

```
x=2.+2./4.
```

then x would have the value of 2.5. (Note that decimal points have purposely been included in this expression. If they were omitted, Python would treat all numbers as integers and the resultant value of x would be 2. Because the division operator has precedence over the addition operator, it is executed first.)

To get the result you want, you need to put the first terms in parentheses:

```
x=(2.+2.)/4.
```

The portion of the expression inside the parentheses is calculated first and the proper answer of 1 is obtained.

Variables do not need type declarations. Variables can change type upon assignment. Variables in Python are actually best thought of as references to an object. Variable names are case sensitive. Python uses the standard set of bitwise operators (see Python documentation for details).

Core Math Functions

Python has a set of core math functions, some of which are listed here:

- *abs(x)*—Represents the absolute value of a number.
- *cmp(x,y)*—Returns negative, zero, positive if x is less than, equal to, greater than y.
- *complex(real, [imaginary])*—Constructs a complex object.
- *divmod(x,y)*—Returns tuple of (x/y, $x\%y$).
- *float(x)*—Converts a number or a string to floating point.
- *int(x)*—Converts a number or a string to a plain integer.
- *len(s)*—Determines the length (the number of items) of a sequence object.
- *long(x)*—Converts a number or a string to a long integer.

- ***max(s)***—Returns the largest item of a nonempty sequence.

- ***min(s)***—Returns the smallest item of a nonempty sequence.

- ***pow(x, y [, z])***—Returns *x* to power *y* [modulo *z*]. See the explanation of the ** operator earlier in this section.

- ***round(x,n=0)***—Rounds floating point value *x* to *n* digits after the decimal point.

In addition to the core math functions, Python has a library of math functions as part of its standard distribution. To access functions in the library, you must first import the math module. Modules in Python act to contain additional operations, data types, and other functionality. The **import** statement is used to bring modules into Python. This statement, for example, will print out the number 1.0 (the **print** statement will be explained later in this chapter):

```
from math import *
x=sin(pi/2)
print 'x'
```

There are several ways to use the **import** statement. In the first line of the previous script the * after **import** tells Python to import all the functions and variables in the module. To import just the sin and pi, you would use this statement:

```
from math import sin,pi
```

You could also use this statement:

```
import math
```

If you use this form, you need to prefix all the function calls like this:

```
import math
x=math.sin(math.pi/2)
print 'x'
```

Why the difference? In the first example, Python imports all of the math module functions and places them into the global list of functions that are already available. The second example imports the math module essentially as an object. To access the functions of the math module, use the *object. functionName* form described earlier. This can be useful if you have two modules that have two functions with the same name but different functionality. Python is built upon modules, which allows you to extend the capability of the language to deal with almost any programming problem. The math modules include the following functions and constants:

- ***sqrt(x)***—Square root of *x*.

- ***hypot(x, y)***—Hypotenuse or Euclidean distance, sqrt(x*x + y*y).

- *cos(x)*—Cosine of *x*.

- *sin(x)*—Sine of *x*.

- *tan(x)*—Tangent of *x*.

- *acos(x)*—Arc (inverse) cosine of *x*.

- *asin(x)*—Arc (inverse) sine of *x*.

- *atan(x)*—Arc (inverse) tangent of *x*.

- *atan2(y, x)*—atan(y / x). (The difference between atan2 and atan(x) is discussed in the paragraph below.)

- *fabs(x)*—Absolute value of real *x*.

- *ceil(x)*—Ceiling (next highest integer) of *x* as a real number; for example, ceil(32.1) = 33.0.

- *floor(x)*—Floor (next lowest integer) of *x* as a real number; for example, floor (32.6) = 36.0.

- *pow(x, y)*—Same as exponentiation operator x**y .

- *exp(x)*—e**x

- *log(x)*—Natural logarithm of *x*.

- *log10(x)*—base-10 logarithm of *x*.

> **Note:** For the additional functions, refer to the Python documentation.

The **atan2** function is different from the **atan** function in that the **atan2** function will return a value in the range +/- π, which gives directions all throughout the range of 0 to 2π. The **atan** function returns only in the range +/- π/2 because it does not have the sign information that the **atan2** function has. The math module also defines the constants pi and e. Complex versions of most of these functions are available in the **cmath** module.

The **import** keyword acts as a combination of an include and a library link. How you invoke the import will determine the variable scoping.

Strings

Strings are sequences of characters. They can consist of one or more characters enclosed in single or double quotes, such as 'a', "a", "Poser Pro Pack". Strings can also be in double and triple quotes, which have special behavior with respect to newlines and tabs and for documentation purposes. In addition to the standard alphanumeric characters, strings can contain escape sequences that represent special characters like **newline** and tab. Escape sequences are also used to represent certain characters within a string, such as a set of quotes, that would otherwise be seen by the interpreter as being part of the statement instead of part of the string. The following list includes examples of these characters:

- \'—Single quote character

- \"—Double quote character

- \\—Backslash character

- \n—Newline

- \t—Tab

The newline, **\n**, sequence is probably the most commonly used in both print and writing to files. For example, if you do not include the **newline** code when you're writing to a file, the text will jam up all together on the first line.

In Python, strings can be created and added to, but you cannot add, remove, or replace elements. They are thus referred to as *immutable*. A number of functions within the string module will modify the elements, but these functions return completely new strings rather than changing the input string. You can access the member elements of a string using an index, as shown in the following script:

Note: The escape sequences in Python are similar, if not identical, to those used in C/C++.

```
s="Poser"
    print len(s)
    print s[0]
    print s[2]
    print s[len(s) -1]
    print s[-1]
    print s[-len(s)]
```

Running this script in Poser will return the results in the console window seen in Figure 14.2.

Figure 14.2
The console window with the script's result.

Strings and other structures in Python use zero-based indexing. Negative indices count backward from the end of the sequence, with no terminator \0 at end of the string.

If you consider a string as an array, list, or sequence of characters, you'll get the idea. The one point to remember is that the indexing is zero based, and the last character has an index of **len(s)** -1. The **len** function returns the number of characters in the string. Because the indexing is zero based, this value will be one more than the index of the last character in the string. You can also see that Python allows negative indices that start at the end of the string and count backward. The indexing is shown in Listing 14.1:

Listing 14.1 Indexing sample.

```
s   =       P               o   s   e   r
+ index   0               1   2   3   4 ( = len(s) -1)
- index  -5 ( = -len(s) )   -4  -3  -2  -1
```

There is no terminator \0 at the end of the string as there is in C/C++.

Slicing

A powerful capability in Python strings is *slicing*. Slicing makes it easy to extract portions of a string. The general syntax of slicing is **stringName[startIndex : endIndex]**. Building upon the script that gave you the results in Figure 14.2, here is an example of how slicing acts within a script:

```
s="Poser"
print len(s)
print s[0]
print s[2]
print s[len(s) -1]
print s[-1]
print s[-len(s)]
print "positive index slicing"
print s[0:0]
print s[0:1]
print s[1:3]
print s[0:len(s)]
print s[1:len(s)]
print s[1:len(s)-1]
print "negative index slicing"
print s[-len(s):-1]
print s[-3:-1]
print "go from index to end of string"
print s[2:]
print s[-3:]
print "go from start of string to index"
print s[:2]
print s[:-3]
s2=s[:]
print s2
```

When you run this script, you will get the first part of the results shown in Figure 14.3. Notice that, for slicing, the **startIndex** is included and the **endIndex** is excluded. Negative indices also work as can be seen. You can also go from an index to the end of a string by using **stringName[startIndex :]** or from the start of the string to an index by using **stringName[: endIndex]**. In addition, you can copy a string by using **stringName2 = stringName[:]**. As mentioned earlier, Python strings cannot be modified but they can be added to, which is referred to as *concatenation*.

If we add the following to the preceding script, you will see "Poser Pro Pack" printed out twice (again see Figure 14.3):

```
print"CONCATENATE AND MULTIPLY"
s2= "Pro Pack"
print s + " Pro Pack"
print s + " " + s2
```

Figure 14.3
The slice string results in a
dual printout.

Python strings can also be multiplied. This can be seen by adding this final
line to the script:

```
print s*8
```

The String Module

In addition to the string functions available as part of the Python core, there is
a standard string module that is included with Python. The string module
includes the following functions:

- *find (string, substring [, startIndex[, endIndex]])*—Finds the first occur-
 rence of *substring* in *string* within the range delineated by the optional
 parameters **startIndex** and **endIndex**. If the optional parameters are not
 used, the whole string is searched. Defaults for start and end and interpre-
 tation of negative values are the same as for slices.

- *rfind (stringName, substring [, startIndex[, endIndex]])*—Works like
 find but finds the last occurrence.

- *split (string[, separator [, maxsplit]])*—Returns a list of the words in a
 string. If the optional second string argument **separator** is absent or
 None, the words are found based on the white spaces (space, tab,
 newline, return, form feed) in the string, which are assumed to separate
 words. If **separator** is present and not **None**, a string to be used in deter-
 mining words is specified. If **maxsplit** is present, it represents the
 maximum number of splits to be returned. After the **maxsplit** splits oc-
 cur, the remainder of the string is returned as the last element of the list.

- *join (strings[, separator])*—Concatenates a list or tuple of strings with
 intervening occurrences of **separator**. The default value for **separator** is a
 single space character. It is always true that **string.join(string.split
 (string , separator), separator)** equals **string**.

- *lstrip (string)*—Returns a copy of a string without leading white space characters.

- *rstrip (string)*—Returns a copy of a string without trailing white space characters.

- *strip (string)*—Returns a copy of a string without leading or trailing white space.

- *upper (string)*—Returns a copy of a string with lowercase letters converted to uppercase.

- *lower (string)*—Returns a copy of a string with uppercase letters converted to lowercase.

- *replace (string, oldString, newString[, max])*—Returns a copy of a string with all occurrences of substring **oldString** replaced by **newString**. If the optional argument **max** is given, the first **max** occurrences are replaced.

Note that for these syntax definitions, the brackets denote optional variables as opposed to actual brackets in the call. These functions are accessed after an **import string** or **from string import ***, as in the following example:

```
import poser
from string import *

for figure in poser.Scene().Figures():
    print figure.Name()
    print upper(figure.Name())
    print lower(figure.Name())
```

I've introduced something new here, the **for/in** statement, which you will use in the next sections of the chapter. Also notice that I am now importing the Poser module and accessing the Scene and Figure objects within Poser. For now, you can use the preceding script, but be sure that you indent the lines underneath the **for** by one tab. If you load a figure, you'll get an output like Figure 14.4.

Figure 14.4

The result of the import string as it appears in the Python window.

Here is an alternative:

```
import poser
import string
for figure in poser.Scene().Figures():
    print figure.Name()
    print string.upper(figure.Name())
    print string.lower(figure.Name())
```

Here you can see that you need to prefix the command with the module name. As listed earlier, there are several functions in the math module for performing string-to-number and number-to-string conversions.

The **print** statement I've been using is very simple. It takes any comma-separated or concatenated strings, expressions, or variables that follow it, converts them as necessary to strings, and prints the output to the console window. In the preceding example, the **print** statement converted the integer output by **len(s)** into a string and printed it. For simple variables and structures, the output is relatively obvious. For objects, your output may be a little different; For example, the following statement will print out something like the output shown in Figure 14.5 (after you load one or more figures):

```
import poser
for figure in poser.Scene().Figures():
        print figure
        print 'figure'
        print str(figure)
        print repr(figure)
```

Figure 14.5
The output from the print statement.

The **print** statement tries to output the best representation of the object. What you are seeing is its type, Figure object, as well as its internal address. This can be useful when debugging so that you can see object type as well as tell if one object instance is the same as the other. The **str** and **repr** functions attempt to convert the object into a printable form. For many of the Poser objects, the results are the same. Enclosing the variable in backward quotes will generally give the same result.

It is also possible to create formatted output with the **print** statement. The basic syntax is **print** *stringWithFormatSequences* % (*variable1, variable2,… variableN*). The *stringWithFormatSequences* will look something like what you see in the following script (which will give the output shown in Figure 14.6). Note that line 4 has been broken to fit in the layout of the book, but normally would appear on one line.

```
intVariable = 3
floatVariable = 1.01
stringVariable = "Poser"
print "Formatted integer %d , float %6.3f and string %s " _
    % (  intVariable,  floatVariable, stringVariable)
```

Figure 14.6

A sample of formatted
output created by using a
print statement.

Note that the float is printed with three decimal places. The format sequences, **%d**, **%6.3f**, and **%s**, are replaced by the values in the variables in the list. The general syntax of the format is % [*name*] [*flags*] [*fieldWidth*] [.*precision*] *type* and is essentially the same as it is for C/C++. The name can only be used if the right-hand side of the % operator is a dictionary. The *flags* specifier includes the following operators:

- - —Puts padding, such as zeros or white space, to the right of the string instead of the left.

- + —Prints numbers with their signs.

- *0* —Acts as a single white-space character so that, when added to an operator such as % **f**, the first character of the number, if not a sign, will be a space.

The **fieldWidth** sets the minimum size of the field to be used when printing a number. The ***precision*** indicates how many digits to the right of the decimal point should be printed. The **type** includes the following parameters:

- *s*—String.

- *d*—Integer.

- *i*—Integer.

- *f*—Floating point number.

- *e*—Floating point number in scientific notation with small e, e+01.

- *E*—Floating point number in scientific notation with capital E, E+01.

- *%*—Adds a percent sign in the output; i.e., %% will print a % sign after the number.

For more details on the format specification, see the Python documentation.

Lists

Most programming languages support what are known as data structures. *Data structures* provide a way to organize a large amount of data. The Python core supports three built-in data structure types: lists, tuples, and dictionaries. *Lists* are essentially arrays, which can be multidimensional, whereas *tuples* are immutable forms of lists. *Dictionaries* are used to map one piece of data to another. Lists, strings, and tuples are referred to as *sequence variables* because they contain sequences of items. For Poser, the list is probably the most important structure because it is used in a large number of the interface functions.

Lists resemble strings in that both are sequences of items. Although strings are always sequences of characters, a list can contain any type of variable or object; you can even mix different types together in the same list. The elements can be other lists, allowing the formation of multidimension arrays, matrices, or other more complicated structures. The data in the list is referred to as *elements*. These elements are accessed in the same way as a string. The following string will give the output shown in Figure 14.7:

```
myList = [0.0, 1.0, 2.0, 3.3, 4.4, 5.5]
print myList[0]
print myList[1]
print myList[len(myList)-1]
print myList [1:3]
print myList[-2]
```

Figure 14.7
A sample output of a list program.

Although you access individual elements the same way you access strings, when slicing is applied, you will get a list back instead of the individual elements. Also note the **len** function works on lists in the same way it works on strings. To access the elements of a list within a list, use double brackets, as in **[index of list in list][index of element in list in list]**. The following string will print out 11 and 15:

```
myList = [5,"five", [11, 12, 13, 14, 15]]
print myList[2][0]
print myList[2][4]
```

A list can be initialized by setting it equal to some sequence of data (the first line in the following statements), by setting it equal to an empty list (the second line), or by allocating an empty list of a specified size (the third line):

```
myList = [5,"five", [0, 1, 2, 3, 4, 5]]
myList = []
myList = [None]*5
```

The first way is pretty straightforward and illustrates the flexibility of lists in Python. The second method will set up an empty list that data can then be added to. The third way allocates a list with five elements, all of which are empty. The difference between the second and third forms is that with **myList=[None]*5**, you could legally do something like this:

```
myList[0] = 5
myList[1] = "five"
myList[2] = [0, 1, 2, 3, 4, 5]
```

whereas with the second form, the list is completely empty and therefore the elements don't exist to be accessed. Attempting to do so will cause an error condition.

A number of functions that work on lists are very useful. They are summarized here:

- *list.append(value)*—Adds *value* as a new element at the end of the list
- *list.insert(index, value)*—Inserts *value* in the list at element *index*, the list size increases by one
- *list.sort()*—Sorts the list in ascending order
- *list.reverse()*—Reverses the elements of the list
- *list.min()*—Returns the minimum value of the list
- *list.max()*—Returns the maximum value of the list
- *list.remove(value)*—Finds the first instance of *value* in the list and deletes it
- *del list[index]*—Deletes the element at *index*
- *del list[startIndex, endIndex]*—Deletes the elements between *startIndex* and *endIndex*

In addition, the lists can be concatenated in the same fashion as strings are concatenated, using the +. As with strings, there are three other useful functions: **len (*list*)**, **max (*list*)** and **min (*list*)**. They return, respectively, the number of elements in the list, the largest element in the list, and the smallest element. These three functions also work with tuples, which will be discussed next.

Tuples

Tuples are similar to lists except they are immutable and, like strings, their elements cannot be modified. Tuples are not as heavily used in Poser as lists are. They are mainly used for several attribute returns and for certain geometry functions.

Tuples are created as follows:

```
myTuple = (5,"five", [11, 12, 13, 14, 15])
```

Note the use of parentheses instead of brackets, which are used with lists. Indexing and slicing are the same as with strings. Remember that the elements can only be read; they cannot be modified once the tuple is created. The **list** and **tuple** functions can be used to convert from tuples to lists and from lists to tuples; that is, **list ((1,2,3))** will yield a list from the tuple and **tuple ([1,2,3])** will give a tuple from a list. So if needed, you could convert the tuple to a list, modify it, and then generate a new tuple from the list.

Dictionaries

Dictionaries are the third built in-data structure type. Dictionaries are essentially arrays, but instead of using a number index, they use a *key*, which can be a string, a number, or a tuple that contains only strings and numbers. Dictionaries are maps/hash tables. Lists can not be used as keys because they are a mutable data type and only immutable types can be used as keys. Dictionaries can also be considered as maps because they take one piece of data and associate it with another. The values in a dictionary are not stored in any particular order.

An empty dictionary can be created by using a pair of curly braces:

```
myDictionary = { }
```

A dictionary can also be initialized with values by adding a comma-separated list of key-value pairs. The key and value are separated by a colon (:), as shown here:

```
myDictionary = { "one" : 1, "two" : 2, "three" : 3}
```

To access a value, use the key like this:

```
myVariable = myDict['one']
```

This statement would assign the value of 1 to **myVariable**. A more interesting example would be the reverse form of this dictionary (note that the line wraps only because of the book's layout):

```
myDictionary = { 1: "one"  , 2: "two" ,  3 : "three" , 100 : _
    "one hundred"}
```

This dictionary of this type could be used to convert numerical values to strings for output. There are many operations for dictionaries, including these:

- *del dictionary [key]*—Deletes the key-value pair designated by *key*
- *dictionary.keys()*—Returns a list of the keys
- *dictionary.values()*—Returns a list of the values

The dictionary is used in the **ImExporter** object in Poser. The **ImExporter** object allows you to import and export models from files in OBJ, 3DS, DXF, and other formats. The import/export options can be accessed using a script like this one:

```
import poser
scene=poser.Scene()
imex=scene.ImExporter()
```

```
print "Obj Export Options\n"
exDict=imex.ExportOptions("obj", None)
print exDict
print "\n\nKeys"
print exDict.keys()
print "\nValues"
print exDict.values()

print "\n\n\nObj Import Options"
imDict=imex.ImportOptions("obj", None)
print imDict
print "\n\nKeys"
print imDict.keys()
print "\n\nValues"
print imDict.values()
```

The results of this script are shown in Figure 14.8. The relationship between
the option string name and its numerical value can be seen.

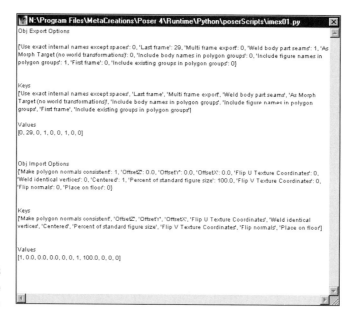

Figure 14.8
The results of using the
ImExporter object.

Poser Objects

We now return you to your friendly author for a few moments.

The preceding section gave you an idea of some of the elements that go into
Python scripting. While working with these elements, you have been able to
access some of the objects and data present in the Poser Pro Pack using the
import poser statement. It seems like a lot to remember—and in many ways it
is—but what you have just worked with will give you a basic understanding of
what a script should begin to look like.

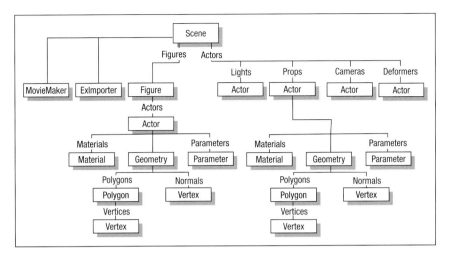

Figure 14.9
A hierarchy chart that will not only help you when building a model, but also when working with Python scripts.

As you do when you create a model for import into Poser or build basic bone structures in the Setup Room, you have to follow the hierarchical structure of the model when working with Python scripting. The chart in Figure 14.9 gives a graphic overview of this structure.

Now it's time to get your hands a bit dirtier and see some results from your diligence in the preceding section. You have had a brief taste of some of the functions, and here you will actually build a script that will have a dramatic effect on a character on the workspace. In this section, you will work with a feature called *function construction*.

With that said, I'll return you to John Brugioni.

Making a Doughboy

As an example of function construction, you'll work with the bulgeFigsNormal.py script that comes with the Pro Pack. You'll rearrange it so that the bulk of the work is in a function. Later on, you'll make use of this function. In the script that follows, I've moved the portion of the code that does the actual manipulation of the mesh into a separate function. By doing this, I've accomplished several things. First, the bulge functionality is now available for use by other portions of the script. The function could also be moved into a separate file and then imported into other scripts. Next, the function has generalized the capability. The function can be used on any actor, which could now include props. It can also be applied to a particular actor instead of to all the actors in all figures. Last, the code becomes easier to read and more maintainable, as shown here:

```
#
# Bulge out all the vertices in all the figures based on the _
    polygon normals...
#

#
```

```
#  module imports
#—————————————————————————————————
import random
import poser

#—————————————————————————————————
#  function definition
#—————————————————————————————————

def bulgeActor(actor, magnitude):
    """ This is the Bulge Actor Function """
    try:
        geom  = actor.Geometry()
    except:
        pass
    else:
        verts = geom.Vertices()
        norms = geom.Normals()
        i = 0
        for vert in verts:

            vert.SetX( vert.X() + magnitude*norms[i].X() )
            vert.SetY( vert.Y() + magnitude*norms[i].Y() )
            vert.SetZ( vert.Z() + magnitude*norms[i].Z() )
            i = i + 1
        #—————————————————————————————
        # So it gets written out with changes if user saves _
          the poser file...
        #—————————————————————————————
            actor.MarkGeomChanged()

    #—————————————————————————————————
    #  main body of script
    #—————————————————————————————————
    scene = poser.Scene()
    figs = scene.Figures()
    for fig in figs:
        for actor in fig.Actors():
            magnitude = 0.02
            bulgeActor(actor,magnitude)

    scene.DrawAll()
    print bulgeActor.__doc__
```

The results of this script can be seen in Figure 14.10.

Building a GUI

With Python, you can create graphic elements such as buttons to activate scripts you've created. In this next section, you will create a simple button to see how this works.

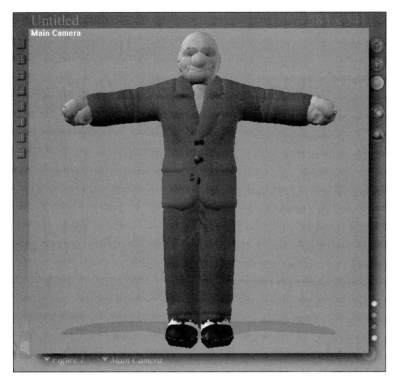

Figure 14.10
After the bulgeFigsNormal.py script is applied, poor ol' Poser dude looks like he just got stung by a swarm of bees.

A Greeting Button

Tkinter is the standard graphical user interface (GUI) package for Python. Tkinter is built on top of Tcl/Tk, which is a cross-platform scripting and GUI development toolkit. Although Tkinter is not the only GUI package for Python, it is the most commonly used and is portable across Unix, Mac, and Windows. Unless you plan to do a lot of work under the hood of Tkinter, such as developing completely new widgets, you generally won't need to know much about Tcl or Tk. For those who want to do extensive work in Tkinter, documentation links for Tcl/Tk and Tkinter are listed in Appendix A. Like Python, Tcl/Tk and Tkinter are open source, freeware programs.

The Tkinter interface is easy to use. The basic steps are instantiating the widget object, placing it in the GUI by using one of the geometry managers, and implementing a callback handler. Generally, two lines of code handle the first two tasks, and the callback is a straightforward function.

The Tkinter interface has roots in the Unix/Motif world, from which it borrowed the term *widget*. In terms of coding, Tkinter makes it simple to build a rather large GUI. Each widget has a callback function or functions that work on various actions. The data and state of the widget is accessible through a number of member functions that allow interactions; for example, filling a list box as the result of either a button click or the selection of an item in another widget.

A Tkinter GUI consists of a window, usually a frame window, inside of which are a number of controls such as buttons, labels, and edit boxes. In Tkinter, these controls are called *widgets*. Tkinter comes with a basic set of widgets as part of its standard distribution. These widgets can be combined and customized into a range of new widgets.

Figure 14.11

The Hello World button created with three lines of code.

You'll start with a minimal Tk script that will create a button like the one shown in Figure 14.11:

```
from Tkinter import *
Label(text="Hello World").pack()
mainloop()
```

The activity in this script consists of three parts:

1. Import the Tkinter module.

2. Construct a **Label** widget containing the text "Hello World". The **pack()** command (a geometry manager that will be discussed later), places the **Label** widget within the frame.

3. Use **mainloop()** to invoke the Tkinter event handler.

Hidden inside the **mainloop()** call is a lot of background processing that makes the GUI work. The primary function of this processing is to detect any mouse motions, mouse clicks, keyboard operations, or other user input. Once one of these interactions is detected, the callback function for the affected control is called by the **mainloop()** call. The control widgets each have one or more callback functions that are defined when the control is constructed in the code. Each one of the callback functions responds to a different event, such as button press, a set focus (the cursor being placed on the widget), or the selection of an item from a list. The label widget does not have a callback, and thus the only thing the little app can do is display text. The close, minimize, and maximize buttons come as part of the main window construction and the user does not have to write callbacks for them.

The following lines add a simple button to illustrate the callbacks and get the script to do something:

```
from Tkinter import *
def say_hi():
    print"hi there in the console\n"
Label(text="Hello World").pack()
Button(text="Hello", command=say_hi).pack()
mainloop()
```

Figure 14.12

A button has been added to the greeting interface.

This code creates a button like the one shown in Figure 14.12.

When you click the button, the phrase "hi there in the console" appears in the Poser Python console window, as shown in Figure 14.13.

Figure 14.13
The message that appears when you click the Hello button.

This script is different from the first one in that a button and a function were added. As was true with the label, the button is constructed by calling a function and passing in a number of keyword arguments. For most widgets, there is a **text** keyword that puts a label on the widget. The callback function is designated with the **command** keyword.

Before I go any further, I need to mention one thing you should be aware of when setting up a Tkinter GUI under Poser. You can run the button script by itself outside of Poser again and again with no problems. If you run the script once inside Poser, it will work fine. But if you try to run it a second time, you will get an error message like the one in Figure 14.14.

Figure 14.14
Why did this error message come up when running the Python script a second time?

What has happened is that when the script exits after the first running, it destroys the top-level Tk instance, which would be the local Tkinter environment. When the script runs a second time, there is no longer a Tkinter environment, and an error occurs. The fix is simple:

```
from Tkinter import *
root=Tk()
Label(root, text="Hello World").pack()
root.mainloop()
```

The critical line is **root = Tk()**. This invokes a top-level Tk widget instance whose **mainloop** is activated by **root.mainloop()**. When the application is closed, the root Tk widget is destroyed instead of the main Tk instance. This event prevents the error message and allows you to rerun the script without reinitializing Python.

Creating a Button That Affects Geometry

This section will show you how to build a list box and a button that will allow you to select a figure and then initiate some action. Look at the script below, which will generate the GUI seen in Figure 14.15. (This script is also provided in the Chapter 14 folder of the CD-ROM as BookTkinter01.py.)

Figure 14.15
You will create this GUI and the controls that affect selected geometry.

```
from Tkinter import *

root=Tk()
title="Figure"
frame=Frame(root)
frame.grid() # grid returns none
Label(frame, text=title).grid(row=0, col=0)
listbox=Listbox(frame, height=6, width=20)
listbox.grid(row=1, col=0)

root.mainloop()
```

The first line imports Tkinter. The second line generates the local Tk instance. The third line constructs a **frame** object. A **frame** is basically a holder for other widgets, allowing you to group them together and lay them out using different geometry managers. There are three base geometry managers in Tkinter: **place**, **grid**, and **pack**. **Pack** places the widgets in the master area one at a time from a specified side. The **grid** manager lays the widgets out in a row and column order. The **place** grid manager, meanwhile, can be used to position the widgets within the window or dialog using specific coordinates. Note that for both the frame and list box, I invoke the **grid** on a separate line instead of typing "frame=Frame(root).grid()". The reason for this is that this line would return None, which would then cause the frame variable to be **None**.

Next I add a label to the frame, passing the **frame** object to the **Label** constructor so that the **Label's** master is the **frame**, not the **root** window. Because I am not going to keep a separate **Label** variable, I applied the **grid** manager to the **Label** as part of the constructor.

The next item I added is a list box. The optional **height** and **width** keywords are used here to indicate size in number of text characters. I placed the label in row 0 and column 0. I then added the list box to column 0 and row 1 in order to place the list box below the label.

Okay, this doesn't do very much yet, but you're going to add a few things. First, you'll move the guts of the GUI into a separate class because you will want to make more than one GUI by the time you're done. You will also add a vertical scrollbar to the list box, in case the list has more than six items. (The two scripts listed here are also available in the Chapter 14 folder of this book's CD-ROM. Script 1 is BookTkinter02.py; Script 2 is PPPBookGui.py.)

```
Script 1:

from Tkinter import *
from PPPBookGui import *
import poser

root=Tk()
listBox=VScrolledListbox(root, "Actors")
```

```
scene=poser.Scene()
namelist=[]
for actor in scene.Actors():
    listBox.listbox.insert(END,actor.Name())
root.mainloop()
```

Script 2:

```
from Tkinter import *

class VScrolledListbox:
    def __init__(self, master, title):
            self.master=master
        self.frame=Frame(master)
        self.frame.grid()
            Label(self.frame, text=title).grid(row=0, col=0)
            self.vscroll=Scrollbar(self.frame)
            self.vscroll.grid(row=1, col=1, sticky=N+S)
            self.listbox=Listbox(self.frame, height=6, _
                width=20, yscrollcommand=self.vscroll.set)
            self.listbox.grid(row=1, col=0)
            self.vscroll.config(command=self.listbox.yview)
```

When you run this script, you should get the GUI shown in Figure 14.16. You should be able to scroll up and down the actors in the list using the scrollbar.

The script moves most of the GUI into a separate class and file and then imports it. When you run the main script, BookTkinter2.py, a compiled version of the PPPBookGui.py script will be generated with a file name of PPPBookGui.pyc. If you modify scripts that generate PYC files in this fashion, you must delete the PYC file for any changes to the PY file to be effective—otherwise Python will use the old PYC file.

Inside the GUI, the script adds a scrollbar widget and places it to the right of the list box using the grid manager. It then adds two callback-related commands. The first one in the list box sets up a callback so that, if you rearrange an item or items by clicking and dragging them, the scrollbar moves up and down in unison. The second one is the **sclf.vscroll.config**, which sets up a callback so that, if you move the scrollbar controls, the list in the list box scrolls up and down. The **sticky=N+S** in the scrollbar grid call stretches the scrollbar to fill the cell in the grid to match the list box.

In the main body of the code, the script imports Poser, gets a list of actors in the scene, and adds the actors' names to the list box. A best programming practice now would be to implement for the **VscrollListbox** a **Set** function that would take a list of strings and add them to the list box. For now, keep things as simple as possible and access the list box directly. The **insert** command, using the **end** keyword, adds the string argument onto the end of the list in the list box.

Figure 14.16
The modified GUI with a list of actors added to it.

The next thing to do is to change the actors to figures as well as add a button to manipulate a figure after you've made a selection. You will need to have at least one figure in the Poser scene for this script to work.

The script, which is available as BookTkinter03.py on this book's CD-ROM, is as follows:

```
from Tkinter import *
from PPPBookGui import *
import poser

class MyApp:
    def init__(self, master):
        self.master=master
        self.listBox=VScrolledListbox(self.master, "Figures")
        scene=poser.Scene()
        self.namelist=[]
        self.selectedFigureNames=[]
        for figure in scene.Figures():
            self.listBox.listbox.insert(END,figure.Name())
            self.namelist.append(figure.Name())
        self.button = Button(self.master, text="Do It!", _
          command=self.OnDoIt)
        self.button.grid(row=2, col=0)
    def OnDoIt(self):
        scene=poser.Scene()
        self.selectedFigureNames=[]
        currentSelection=self.listBox.listbox.curselection()
        for i in currentSelection:
            self.selectedFigureNames.append(self.namelist[int(i)])
        for figureName in self.selectedFigureNames:
            figure=scene.Figure(figureName)
            for actor in figure.Actors():
            self.bulgeActor(actor, 0.01)
        scene.DrawAll()
    def bulgeActor(self,actor, magnitude):
        """ This is the Bulge Actor Function """
        try:
            geom = actor.Geometry()
        except:
            pass
        else:
            verts = geom.Vertices()
            norms = geom.Normals()
            I = 0
            for vert in verts:
                vert.SetX( vert.X() + magnitude*norms[i].X() )
                vert.SetZ( vert.Z() + magnitude*norms[i].Z() )
                i = i + 1
```

```
#--------------------------------
# So it gets written out with changes if user saves _
    the poser file...
#--------------------------------
    actor.MarkGeomChanged()
root=Tk()
myapp=MyApp(root)
root.mainloop()
```

Figure 14.17

This GUI shows the actors changed to figures, plus the added button.

The result of this script is shown in Figure 14.17.

How is this script different from what you've learned thus far? First, the script created a **MyApp** class and moved the main application functionality into it. The main reason for this is to group the GUI-related variables and the functions that will use them together (hmm, sounds like the description of object-oriented programming, or OOP). You've also added a button labeled Do It! and a callback handler for it. The callback handler gets the selections from the list, which is a tuple of strings. Each tuple represents and inputs an equivalent of a zero-based index into the list. The selection strings are converted into integers using the **int** function. The equivalent figure string names come from a list made when the list box was being filled up. The script then loops over these figure names and then over the actors in them. The **bulgeActor** function made earlier is used on each of the actors. For a test, I put in the default female character with a skirt and shirt, as seen in Figure 14.18. I then selected the skirt Figure from the list and clicked the Do It! button several times. Figure 14.19 shows the result.

Figure 14.18

A female character with clothing added. The skirt will become the figure you change.

Figure 14.19
I have the feeling Posette wouldn't be caught dead in this skirt!

PROJECT Building a Corridor or Time Machine

It's time to try a big script. This script will generate a simple environment: a long cylindrical corridor (or duct or tunnel—which can even be used as a design for a time machine) with the under-floor lighting you see in Figure 14.20. Drooling fiends, genetic mutations, bloodthirsty aliens, or rampaging dinosaurs are not included.

Figure 14.20
This corridor was built entirely with a Python script.

The script builds up several functions and one class and then reuses them. The script may appear long, but if you look closely, there is a lot of cutting and pasting going on. You will find that in writing scripts, your first step will be to open a file in which you've created the effect or sequence before, then cut and paste the appropriate script content into the new file. Cut-and-paste errors can be a big source of bugs, but such bugs are usually easy to spot.

The first part of the script assigns the **Tube** class, which generates a tube of a given inner radius, outer radius, length, and number of sides. It is a nice example of the way that you can add geometry primitive props to Poser using a Python script. The first significant command is, in the **Tube** class **init** function, **self.geometry=poser.NewGeometry()**, which generates a new empty geometry in the scene. At the end of the **init** function is **self.geometry.AddGeneralMesh (polygons, sets, vertices)**, which adds a mesh to the geometry. All the code in between generates that mesh.

The **AddGeneralMesh** function uses several array variables that are included in Numpy (Numerical Python), a Python extension library. Sources for Numpy documentation are listed in Appendix A. Numpy incorporates a number of routines for handling arrays, matrices, Fast Fourier Transforms (FFT), random numbers, and many other high-end math functions.

Because the array variables are in native code, they run quickly under Python. For this script, three arrays will be generated. The first is the vertices array, which is of size **numberOfVertices x 3**. Each row lists the coordinates of one vertex with the *x* value in column 0, the *y* in column 1, and the *z* in column 2. The next array is the polygons array, which is of size **numberOfPolygons x 2**. The first column contains a start index into the sets array for the polygon, and the second column gives the number of vertices in the polygon. The final array is the sets array, which holds the information necessary to link the vertices together into polygons. The sets element is one dimensional, and each element in the sets array is an index into the vertices array.

If you look at the code with the **MakeFloor()** function in the following script, it will be somewhat clearer how each element in the sets array is an index into the vertices array. The **MakeFloor()** generates a single polygon to be used as the floor. The first thing you do is generate the three arrays with the **zeros** statement, which constructs an array of the requested size and shape with all the elements set to zero. You then fill out the values for the four vertices, one for each corner. The next step is the polygons array. You set the first element to the starting point for this polygon in the sets array, in this case zero because it's the first polygon. The second element of polygons is set to 4 for the number of vertices. You then match up the indices of the vertices into the sets array. In

a typical mesh, a vertex is shared among multiple polygons so it will appear multiple times in the sets array. Using the sets array, you need only one copy of the vertex data, and each polygon is constructed by using the indices into the vertex array to get the vertex data. Imagine that there was a second polygon in the floor to the right of the first one. Its start index would be 4, the first element after the last element of the first polygon. Its entry in the sets array could very well look something like this:

```
sets[4]=1
sets[5]=4
sets[6]=5
sets[7]=2
```

Because it would share the two right-hand vertices of the first polygon, the indices for those polygons appear in the sets entries for the second polygon:

```
from MakeFloor():
polygons=Numeric.zeros((1, 2 ))
sets=Numeric.zeros((1*4))
vertices=Numeric.zeros((4,3) , Numeric.Float)
vertices[0,0]=-width/2
vertices[0,1]=ytran
vertices[0,2]=0

vertices[1,0]=width/2
vertices[1,1]=ytran
vertices[1,2]=0

vertices[2,0]=width/2
vertices[2,1]=ytran
vertices[2,2]=-length

vertices[3,0]=-width/2
vertices[3,1]=ytran
vertices[3,2]=-length

polygons[0,0]=0
polygons[0,1]=4

sets[0]=0
sets[1]=1
sets[2]=2
sets[3]=3
```

To get a better light effect, you would break the floor up into multiple polygons, but this script was purposely left simple so you could easily see relationships in the mesh geometry data.

Once you have formed the three arrays, they can then be passed to the **AddGeneralMesh** function to add them to the geometry. After that, the **CreatePropFromGeom()** function is called to make a prop from the geometry. From there you can modify its material properties and position and rotate it within the scene. The actor object in Poser has **Materials()** and **Parameters()** functions that return a list of materials and parameters for the object. You can loop over the materials and set their properties (color, for example). For the parameters, you supply a string that is the parameter name and a value to set it to in the **SetParameter()** function. If you don't know the name of a parameter, the easiest way to find it is with a quick script like this:

```
for parameter in actor.Parameters():
    print parameter.Name() + " = " + 'param.Value()'
```

This code will give you a list of the parameter names for the actor and their current values.

The next big function in the script is **MakeSegments()**, which generates two tube props, one that's gray in color and another that's blue. After the props are created, they are positioned using **SetParameter**, and their colors are set using the **material Set** functions. Four lights are then generated; their colors and other light properties are set, and then they are positioned. Essentially, there are two lights under the floor throwing light up one of the walls and then two more lights on the walls pointing inward to give the appearance of light reflected off the walls onto the figures.

For this script to run properly, all lights, actors, and figures need to be cleared from the scene before it is run. It will take some time for the scene to construct itself, and it will definitely take some time rendering. This is not meant to be a finished environment; rather, it is more of an example of the kinds of things that can be set up with the Python interface. It is especially useful for many of the repetitive chores such as laying down props or lights.

Here is the entire script, which is also available in the Chapter 14 folder of this book's CD-ROM as Demo1.py:

```
Demo1.py
# Demo1.py
import poser
from math import sin,cos,pi

class Tube:
    def __init__(self, innerRadius, outerRadius, length,_
        numSides):
            self.geometry=None
            self.numPolygons=numSides*4
```

```
                    #  inside, outside, top, bottom
                        self.numVertices=self.numPolygons*4
# making quads
                        self.innerRadius=innerRadius
                        self.outerRadius=outerRadius
                        self.length=length
                        self.numSides= numSides
                        self.scene=poser.Scene()
                        self.MakeTubeBase()

            def MakeTubeBase(self):
                    # create a new blank geometry
                    self.geometry=poser.NewGeometry()

                    # create blank arrays to be filled in
                    polygons=Numeric.zeros((self.numPolygons,2 ))
                    sets=Numeric.zeros((self.numPolygons*4))
                    vertices=Numeric.zeros((self.numVertices,3) ,_
                        Numeric.Float)
                    # generate common vertex values
                    dTheta=2*pi/self.numSides
                    innerX=[]
                    innerY=[]
                    outerX=[]
                    outerY=[]

                    # do these calculations just once and store them
                    # for speed and consistency
                    for i in range(self.numSides):
                        ct=cos(i*dTheta)
                        st=sin(i*dTheta)
                        innerX.append(self.innerRadius*ct)
                        innerY.append(self.innerRadius*st)
                        outerX.append(self.outerRadius*ct)
                        outerY.append(self.outerRadius*st)

                    # make vertices
                    for i in range(self.numSides):
                        # top base inner ring
                        vertices[i,0]=innerX[i]
                        vertices[i,1]=innerY[i]
                        vertices[i,2]=0.0

                        # top base outer ring
                        vertices[i+self.numSides,0]=outerX[i]
                        vertices[i+self.numSides,1]=outerY[i]
                        vertices[i+self.numSides,2]=0.0
                        # top inner body ring
                        vertices[i+2*self.numSides,0]=innerX[i]
                        vertices[i+2*self.numSides,1]=innerY[i]
                        vertices[i+2*self.numSides,2]=0.0
```

```python
        # bottom inner body ring
        vertices[i+3*self.numSides,0]=innerX[i]
        vertices[i+3*self.numSides,1]=innerY[i]
        vertices[i+3*self.numSides,2]=-self.length

        # top outer  body ring
        vertices[i+4*self.numSides,0]=outerX[i]
        vertices[i+4*self.numSides,1]=outerY[i]
        vertices[i+4*self.numSides,2]=0.0

        # bottom outer body ring
        vertices[i+5*self.numSides,0]=outerX[i]
        vertices[i+5*self.numSides,1]=outerY[i]
        vertices[i+5*self.numSides,2]=-self.length

        # bottom inner ring
        vertices[i+6*self.numSides,0]=innerX[i]
        vertices[i+6*self.numSides,1]=innerY[i]
        vertices[i+6*self.numSides,2]=-self.length

        # bottom outer ring
        vertices[i+7*self.numSides,0]=outerX[i]
        vertices[i+7*self.numSides,1]=outerY[i]
        vertices[i+7*self.numSides,2]=-self.length
vertexCount=0
polygonCount=0

# filling in the sets and polygon arrays
#make top for i in range (0,self.numSides):
        # inner, outer, outer +1 , inner+1
        if i == self.numSides-1:
            sets[vertexCount]=i
            sets[vertexCount+1]=i+self.numSides
            sets[vertexCount+2]=self.numSides
            sets[vertexCount+3]=0
        else:
            sets[vertexCount]=i
            sets[vertexCount+1]=i+self.numSides
            sets[vertexCount+2]=i+1+self.numSides
            sets[vertexCount+3]=i+1
        polygons[polygonCount,0]=vertexCount
        polygons[polygonCount,1]=4
        vertexCount=vertexCount+4
        polygonCount=polygonCount+1

#make inner body
for i in range (2*self.numSides, 3*self.numSides):
    #top,  top+1, bottom +1 ,bottom
    if i == 3*self.numSides-1:
        sets[vertexCount]=i
        sets[vertexCount+1]=2*self.numSides
        sets[vertexCount+2]=3*self.numSides
        sets[vertexCount+3]=i+self.numSides
```

```
            else:
                sets[vertexCount]=i
                sets[vertexCount+1]=i+1
                sets[vertexCount+2]=i+1+self.numSides
                sets[vertexCount+3]=i+self.numSides
            polygons[polygonCount,0]=vertexCount
            polygons[polygonCount,1]=4
            vertexCount=vertexCount+4
            polygonCount=polygonCount+1

        #make outer body
        for i in range (4*self.numSides, 5*self.numSides):
            #top, bottom, bottom +1 , top+1
            if i == 5*self.numSides-1:
                sets[vertexCount]=i
                sets[vertexCount+1]=i+self.numSides
                sets[vertexCount+2]=5*self.numSides
                sets[vertexCount+3]=4*self.numSides
            else:
                sets[vertexCount]=i
                sets[vertexCount+1]=i+self.numSides
                sets[vertexCount+2]=i+1+self.numSides
                sets[vertexCount+3]=i+1
            polygons[polygonCount,0]=vertexCount
            polygons[polygonCount,1]=4
            vertexCount=vertexCount+4
            polygonCount=polygonCount+1

        #make bottom
        for i in range (6*self.numSides, 7*self.numSides):
            # inner, inner +1,  outer +1 , outer
            if i == 7*self.numSides-1:
                sets[vertexCount]=i
                sets[vertexCount+1]=6*self.numSides
                sets[vertexCount+2]=7*self.numSides
                sets[vertexCount+3]=i+self.numSides
            else:
                sets[vertexCount]=i
                sets[vertexCount+1]=i+1
                sets[vertexCount+2]=i+1+self.numSides
                sets[vertexCount+3]=i+self.numSides
            polygons[polygonCount,0]=vertexCount
            polygons[polygonCount,1]=4
            vertexCount=vertexCount+4
            polygonCount=polygonCount+1

        # add the mesh to the geometry
        self.geometry.AddGeneralMesh( polygons, sets, vertices)

def makeSegment(ztran,  number):
    # make a tube
    tube=Tube(.625, 1.0, 2.0, 256)
```

```
tubeProp = poser.Scene().CreatePropFromGeom _
  (tube.geometry,_"Tube"+'number*2')
tubeProp.SetParameter("yTran", 0.625)
tubeProp.SetParameter("zTran",ztran)
for material in tubeProp.Materials():
    material.SetAmbientColor( 0.0, 0.0, 0.0)
    material.SetDiffuseColor( 0.8, 0.8, 0.8)
    material.SetSpecularColor( 1.0, 1.0, 1.0)
    material.SetNs( 45.0)
#make another tube
tube=Tube(.625, 1.0, 1.0,256)
tubeProp = poser.Scene().CreatePropFromGeom(tube.geometry, _
  "Tube"+'number*2+1')
tubeProp.SetParameter("yTran", 0.625)
tubeProp.SetParameter("zTran",ztran-2.0)
for material in tubeProp.Materials():
    material.SetAmbientColor( 0.0, 0.0, 0.0)
    material.SetDiffuseColor( 0.2, 0.4,0.6)
    material.SetSpecularColor( 1.0, 1.0, 1.0)
    material.SetNs( 45.0)
#generate the underfloor and wall lights
numLights=4
for i in range(numLights):
    poser.Scene().CreateLight()
for actor in poser.Scene().Actors():
    if actor.IsLight():
        if actor.Name()=="Light "+'number*numLights+1':
            actor.SetParameter("Red", 1.0)
            actor.SetParameter("Green", 1.0)
            actor.SetParameter("Blue", 1.0)
            actor.SetParameter("xTran", 0.175)
            actor.SetParameter("yTran", 0.180)
            actor.SetParameter("zTran",ztran-1.0)
            actor.SetParameter("xRotate", 90.0)
            actor.SetParameter("yRotate", 0.0)
            actor.SetParameter("zRotate",-53.0)
            actor.SetParameter("Angle Start", 160.0)
            actor.SetParameter("Angle End", 160.0)
            actor.SetParameter("Intensity", 1.0)
            actor.SetParameter("Dist Start", 1.0)
            actor.SetParameter("Dist End", 3.0)
        elif actor.Name()=="Light "+'number*numLights+2':
            actor.SetParameter("Red", 1.0)
            actor.SetParameter("Green", 1.0)
            actor.SetParameter("Blue",1.0)
            actor.SetParameter("xTran",-0.175)
            actor.SetParameter("yTran", 0.180)
            actor.SetParameter("zTran",ztran-1.0)
            actor.SetParameter("xRotate", 90.0)
            actor.SetParameter("yRotate", 0.0)
            actor.SetParameter("zRotate", 53.0)
            actor.SetParameter("Angle Start", 160.0)
```

```
                                    actor.SetParameter("Angle End", 160.0)
                                    actor.SetParameter("Intensity", .9)
                                    actor.SetParameter("Dist Start", 1.0)
                                    actor.SetParameter("Dist End", 3.0)
                           elif actor.Name()=="Light "+'number*numLights+3':
                                    actor.SetParameter("Red", 1.0)
                                    actor.SetParameter("Green", 1.0)
                                    actor.SetParameter("Blue", 1.0)
                                    actor.SetParameter("xTran",-0.4)
                                    actor.SetParameter("yTran", 0.625)
                                    actor.SetParameter("zTran",ztran-1.0)
                                    actor.SetParameter("xRotate", 90.0)
                                    actor.SetParameter("yRotate", 90.0)
                                    actor.SetParameter("zRotate",-90.0)
                                    actor.SetParameter("Angle Start", 160.0)
                                    actor.SetParameter("Angle End", 160.0)
                                    actor.SetParameter("Intensity", 1.0)
                                    actor.SetParameter("Dist Start", 0.0)
                                    actor.SetParameter("Dist End", 3.0)
                           elif actor.Name()=="Light "+'number*numLights+4':
                                    actor.SetParameter("Red", 1.0)
                                    actor.SetParameter("Green", 1.0)
                                    actor.SetParameter("Blue", 1.0)
                                    actor.SetParameter("xTran",+0.4)
                                    actor.SetParameter("yTran", 0.625)
                                    actor.SetParameter("zTran",ztran-1.0)
                                    actor.SetParameter("xRotate", -90.0)
                                    actor.SetParameter("yRotate", 90.0)
                                    actor.SetParameter("zRotate",-90.0)
                                    actor.SetParameter("Angle Start", 160.0)
                                    actor.SetParameter("Angle End", 160.0)
                                    actor.SetParameter("Intensity", 1.0)
                                    actor.SetParameter("Dist Start", 0.0)
                                    actor.SetParameter("Dist End", 3.0)

            def MakeFloor(length, width,ytran):
                # make the floor
                floorGeometry=poser.NewGeometry()
                polygons=Numeric.zeros((1, 2 ))
                sets=Numeric.zeros((1*4))
                vertices=Numeric.zeros((4,3) , Numeric.Float)
                vertices[0,0]=-width/2
                vertices[0,1]=ytran
                vertices[0,2]=0

                vertices[1,0]=width/2
                vertices[1,1]=ytran
                vertices[1,2]=0

                vertices[2,0]=width/2
                vertices[2,1]=ytran
                vertices[2,2]=-length
```

```
        vertices[3,0]=-width/2
        vertices[3,1]=ytran
        vertices[3,2]=-length

        polygons[0,0]=0
        polygons[0,1]=4

        sets[0]=0
        sets[1]=1
        sets[2]=2
        sets[3]=3

        floorGeometry.AddGeneralMesh( polygons, sets, vertices)

        floorProp= poser.Scene().CreatePropFromGeom(floorGeometry,_
          "Floor")
        for material in floorProp.Materials():
            material.SetAmbientColor( 0.0, 0.0, 0.0)
            material.SetDiffuseColor( 0.1, 0.1, 0.1)
            material.SetSpecularColor( 1.0, 1.0, 1.0)
            material.SetNs( 45.0)

# main body of the code
makeSegment(0,0)
makeSegment(-3.0,1)
makeSegment(-6.0,2)
makeSegment(-9.0, 3)
makeSegment(-12.0, 4)
makeSegment(-15.0, 5)
makeSegment(-18.0, 6)
makeSegment(-21.0, 7)
makeSegment(-24.0, 8)

MakeFloor( 15.0, .6, .25)
poser.Scene().DrawAll()
```

Before I return you to the author, I would like to thank the staff at Curious Labs, especially Jack Walther, for their help and patience with my many questions on the Poser Python interface. I'd also like to thank Micah Henric of DAZ 3D for help in testing some of the scripts.

Closing Out

As you saw in this chapter, Python scripting is an extremely powerful tool—its true potential within Poser has yet to be really tapped. Taking the example you just built, you can add creatures, astronauts, or space or time explorers to the scene. Why, you could even set up a scenario in which you brought ferocious dinosaurs back from the past, as shown in Figure 14.21. You could use Python to create a wind effect and have it manipulate hair and clothing props

Figure 14.21

Why is it that, in every movie, a science experiment goes wrong and some nasty creature pops out to terrify humanity?

so they look as if they are blowing in the wind. You can create precise collision detection so objects careen off each other naturally or avoid obstacles. Again, this is a fully untapped area.

And with that, I would like to thank John Brugioni for his in-depth introduction to Python. (Big round of applause.) And I would like to thank you for purchasing this book. I definitely hope you have found it useful not only in understanding Poser and the Pro Pack upgrade, but in how to pose and animate your characters in a realistic fashion.

The Pro Pack is officially viewed as an interim upgrade, so you can expect that some time in early 2002, a full-fledged version 5 upgrade will be coming out. Until then, I hope you keep this book handy as you delve further and further into the realm of 3D modeling and animation.

Appendix A

Resources

The Poser community is extremely large—larger than many might think. When you begin surfing the Internet, you'll find literally hundreds of sites where you can obtain free and low-cost models, hints, tips, tutorials, and more. This Appendix lists Internet resources to give you a starting point on the road to Poser nirvana.

Programs

The following list provides Web sites for Poser and programs used for post-production work:

- *www.curiouslabs.com*—Developers of Poser and the Poser Pro Pack

- *www.newtek.com*—Developers of LightWave [6]

- *www.discreet.com*—Developers of 3D Studio Max

- *www.corel.com*—Developers of Bryce, a terrain-generation program

- *www.e-onsoftware.com*—Developers of Vue d'Esprit (PC only), a terrain-generation program

- *www.darksim.com/html/darktree_textures.html*—Developers of DarkTree Textures (PC only), a texture-generation program

- *www.righthemisphere.com*—Developers of Deep Paint 3D and Deep Paint 3D w/Texture Weapons (PC only at this writing), a texture-generation program

Poser Resources

The following lists Web sites for Poser models, discussion groups, and other resources (listed alphabetically):

- *http://groups.yahoo.com/group/poser*—An email discussion list of Poser and Poser-related topics. Boasts over 1,000 members.

- *http://home.main-rheiner.de/soft.rabbit*—The place to get the Poser MacConverter program (Mac only) that translates models made for the PC into the Mac format. An indispensable tool for Mac users.

- *http://renderosity.com*—One of the largest repositories of Poser models and information on the Internet.

- *www.baument.com*—Provides free and low-cost models and model packages.

- *www.bbay.com; www.freebay.com*—The first link takes you to Bbay's main site where you can purchase high-quality models made by Poser enthusiasts. The second Web site offers a free model each week.

- *www.daz3d.com*—Provides low-cost, high-quality models for Poser. Also features a free model of the week.

- *www.dedicateddigital.com*—Provides low-cost, high-quality models individually and in packages.

- *www.3dmodelworld.com*—A hefty resource for Poser, LightWave, 3D Studio Max, and other programs.

- *www.3dradiosity.com*—A new site, 3D Radiosity, devoted to expanding the knowledge of the Ricks effect introduced in this book.

- *www.uvmapper.com*—Download this indispensable program (Mac/PC) to assist you in creating texture maps for Poser models.

Python Resources

The following lists resources to assist you in working with Python Scripting:

- *www.python.org*—The Python Language Web site is the best starting point for working with Python. It contains downloads for Python 1.5 through 2; documentation and tutorials for Python, Tkinter, and Tcl/Tk; and links to many other sites.

- *http://numpy.sourceforge.net*—The Numerical Python site has documentation for Numpy and links to binaries and other resources.

- *http://starship.python.net*—The Starship Python site contains a collection of documents and a list of home pages with Python content.

- *www.pythonware.com*—The Pythonware site contains the Python Imaging Library (PIL) and other Python extension libraries. You will need to have a compiler or find an already compiled binary for your platform.

- *www.vex.net/parnassus*—This site (Vaults of Parnassus: Python Resources) has downloadable Python scripts, modules, extension libraries, etc. (In Greek mythology, a cave on Mount Parnassus was the home to the giant serpent, Python, which was slain by Apollo.)

Tkinter and Tcl/Tk

The following resources are some of the best for information on Tkinter and Tcl/Tk:

- *An Introduction to Tkinter*—This text by Fredrik Lundh (1999) is available online in HTML format from **www.pythonware.com/library/tkinter/introduction/index.htm** and in PDF format from **www.pythonware.com/library/an-introduction-to-tkinter.htm**.

- *http://pmw.sourceforge.net*—PMW Megawidgets is one of several Widget collections available for Python.

Appendix B

The Ricks Effect

This Appendix looks at a newly discovered technique that lets you create exciting radiosity-like effects—from lens flares to glowing objects—directly in Poser and the Poser Pro Pack.

Exclusive! A New Technique That Simulates Glowing Lights

Until now, creating an effect such as glowing lights has been thought to be impossible inside of Poser. That is no longer the case. Consider yourself on the cusp of a new era in Poser rendering. My thanks to the book's technical editor, James Ricks, for sharing this technique. A sample of what can be accomplished can be seen in the image on the back cover of this book.

The Ricks Effect

As James was reviewing the material for this book, he began playing with effects. As he is wont to do, he began fiddling with the materials settings and came up with the following way to create an effect that simulates radiosity effects in other programs without the use of image and transparency maps. I teased people like Larry Weinberg (the creator of Poser) and Steve Cooper (the President of Curious Labs and well-recognized Poser evangelist), with images like the one you see in Figure B.1, and they couldn't quite figure out how the effect was accomplished. Now they, as well as you, will know.

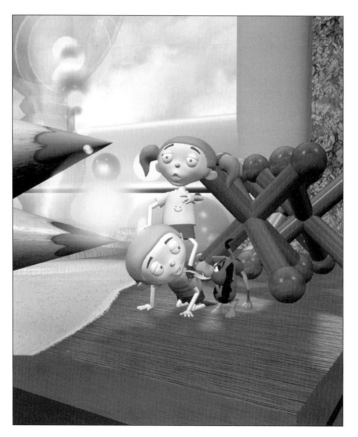

Figure B.1

The effects you see in this image, the glowing orb and the lens flares, up until now, have been thought to be impossible to accomplish in Poser.

To create the Ricks effect yourself, follow these steps:

1. Create a new document in Poser. Change the background color (Display|Background Color) to black. This isn't necessary to see the effect; it's just that, for what you are doing in this section, the black background will definitely make this effect look much better.

2. Place a ball prop on the workspace. Scale it to 250 and reposition the workspace so the ball is centered as shown in Figure B.2. Go to the Prop Info screen (Command/Control + I) and turn Shadows off. Then open the Surface Material screen.

Note: It is not necessary to always turn shadows off when creating this effect. Experimentation is the key. Sometimes leaving shadows active can give you interesting effects in stills and animations.

Figure B.2
The position you want the ball prop in so that you can get the best feel for the effect you're about to learn.

3. Change Object Color to pure black.

4. Next, change Highlight Color to a goldish yellow, Ambient Color to bright red, and Reflective Color to the same goldish yellow as the Highlight Color.

5. Set Transparency Min to 100.

6. Set Transparency Max to 5.

7. Set Transparency Falloff to 10 (its maximum). Now the Surface Material screen should look like it does in Figure B.3.

8. Click OK, then render the scene. Congratulations. You have just created the simulation of a glowing orb, as shown in Figure B.4.

To change the look of the scene, move the lights around. You can also change the shape of the ball to make even more interesting effects, such as the dual glowing lights in Figure B.5, which was accomplished merely by stretching the ball on the z-axis. The Appendix B folder of the CD-ROM contains two animations featuring this new effect.

Figure B.3

The settings for this effect as seen in the Surface Material screen.

Figure B.4

A glowing orb created entirely in Poser.

Figure B.5

Two glowing orbs created with one ball prop and this new technique.

You can also change color settings to create different color combinations that will fit your needs better. Change the Transparency Falloff setting to make the edges of the orb more distinct, or change the Transparency Max setting slightly to make the edge effects more pronounced. What you just learned is only the base effect; you can experiment with it and use your results to thrill the Poser community.

Also, by combining this technique with other objects, as well as well-placed texture or transparency maps, you can create scenes like the one in Figure B.6, which incorporates the ball prop, a cloud transparency (which is available as fog.jpg in the Appendix B folder of this book's CD-ROM), and this technique to create the look of mist surrounding the free Dedicated Digital dragon model that is exclusive to this book (and is located on the CD-ROM in tdragon.zip file in the Models\Dedicated_Digital folder).

Now it's up to you to experiment with how far this technique can be taken. At **www.3dradiosity.com** you can see examples of what James Ricks has created and share what super effects you come up with.

Note: I have created a Web site, **www.3dradiosity.com**, where more tutorials for this effect can be obtained.

Figure B.6
The look of a fog bank using the Ricks effect.

Index

A

Active areas in templates, 125
Actors changed to figures, 346
Add Key Frames button, 54, 55
Adobe AfterEffects, 13, 306
Adobe GoLive, 289, 292
Adobe LiveMotion, 19, 292
Adobe Photoshop. *See* Photoshop
Adobe Premiere, 13, 306
Aging signs, 104, 106, 108 (fig.)
AIFF files, 252
Airbrush tool, 131
Align Head To setting, 243, 240
Anger emotion using phonemes, 251
Angle End light setting, 211, 212
Animals, Figures model shelf, 169, 175, 227
Animating objects and characters
 ball, 141, 182, 183, 194, 198
 Bigfoot/boy, 193–198, 238
 dolphin, 227, 233–236
 droplet, 79
 human figure, 58–62
 integrated Poser characters, 306
 jack, 294–298
 kneeling to standing, 63–68
 large files, 302
 lip synch, 254, 255
 magician, 183, 184–186
 rock dragging, 306–315
 walking, 238–240, 240–243, 245–248
 Yo!Ball, 283–288
Animations, 52, 53–56, 316
 blending rendered files, 306
 colors, 140
 depth of field, 55–56
 file management, 13, 17, 18
 length, 80, 82, 84, 183, 196, 248
 materials, 141
 multiple-frame, 309
 Point At and parenting, 193–198
 rendering, 57, 91
 3D transformation, 83

Animation Sets screen, 232
Antialias and rendering process, 301
Arm element position, 60, 100, 286
 settings, 99
 symmetry, 183, 278
Array variables (Python), 349
Articulated props, 156
 and CR2 files, 163
 defined, 154–155
Assignment operator, 324
Audio editing programs, 252
Audio files, 252–253, 264
Avatars, 34
AVI file, 159

B

Background color, 215, 218, 365
Background layer, 147
Background picture, 89
Backlights, 204, 214
Ball prop, 50, 110
 animation, 141, 183, 194, 198
 compressed when bounced, 198
 eclipse, 215
 floating, 182
 and jack animation, 295, 296
 and magician scene, 179, 184
 with Magnet(s), 79, 80, 81–83
 parented to hand, 181, 195, 197
 position change, 197
 resizing, 179
 and Ricks effect, 365, 367
 Yo!Ball animation, 284
Barney character, 34, 35–37
 walking animation, 246, 248
Base lights default, 204
Base primitives, 56
Basic Animation control panel, 52–54, 80, 82, 141, 183, 227, 248
BBEdit for Python scripts, 320 (note)
Bend setting for hands, 183, 185, 197
Bertha character, 34, 36–37
Bevel and Emboss, 271

Bigfoot model, 138, 187, 193
 head position, 197, 198
 positioning, 195
 using Mimic, 262
Bigfoot/boy animation, 193–198
 motion blur, 238
Binary code, 320
Bitwise operators, 326
Blend Styles in Walk Designer, 242
Blink feature, 42, 261, 265
Blur feature, 5, 21, 143
 borders, 133
Bone Creation tool, 19, 156, 158
Bones
 adding, 172–175
 human structure, 173
 prebuilt, 159, 162
 setup, 154, 156–158
BoneyMaronie model, 164
Bowling pins prop, 213
Box prop, 50
 bones, 156, 159
 Mag Zone, 90
 resizing, 89
 with Wave Deformer, 88
Break Spline button, 236, 264
Broadcast Key URL (VET), 281
Browser plug-in, 268
Brugioni, John, 320, 358
Brush, 131, 144
Bryce 3D, 203, 306
Bulge function, 339, 347
Bump maps, 130, 133
 assigning, 148
 creating, 146
 defined, 123
 eclipse scene, 216
 modified, 137
 painting, 138
 shirts, 272, 274
Business Man model, 10, 12 (fig.), 73
 file, 167
 head position, 74
 height, 77, 78 (fig.)
 and lighting, 205, 210
Business Woman model, 262
BVH motion files, 243–245
Byte code, 320

C

C/C++, 320, 321
Callback handler, 341, 342, 347
Cameras
 changing, 32, 96
 controls, 26, 46–52
 Face, 103, 104
 posing, 100
 repositioning, 191
 views, 6, 95, 248
Canoma, 16, 268
Canvas texture, 146, 272
Carrara, 4, 72, 103, 166
 adding Poser characters, 306
 importing maps, 139
Cartoon-style models, 302
CasMan, 96, 97, 100, 101. *See also* Casual Man model.
Casts Shadow function, 113, 114
Casual Boy model, 193, 283, 286
Casual Girl model, 190
Casual Man model, 32, 51, 52, 63, 95, 308
 BVH files, 243, 244
 and Magnets, 83
 posing, 307
 rock dragging animation, 306
Casual Woman model, 39, 52, 98
CasWoman, 98. *See also* Casual Woman model.
Catch/kick lighting, 204
Caustics, 203
Centaur, 168–171
Characters. *See also* Models
 creating in Setup Room, 18
 default, 72
 multiple, 50
 transformation, 83
CheekBones setting, 106
Chest position, 65
Child elements, 162 (note)
 defined, 111
Choose Actor window, 191
Cinema 4D, 4, 72, 166
Clipping, 46
Clothing, 126, 273
Clouds. 133, 367
Code (programming), 320, 329
Collar element, 95, 195
 changing, 47
 Point At, 218
 position, 65, 67, 277, 286
 shirt, 74
Collision detection, 357
Color
 assigning, 311
 background, 215, 218, 365
 eclipse settings, 215
 Flash files, 299, 302
 hair, 311
 high- and low-resolution models, 302
 and lighting, 208, 218, 221
 LightWave, 310
 as materials, 140
 numbers of, 293, 298, 301
 opacity, 269, 272
 perception, 202

Ricks effects, 367
and shadows, 213
Comic books, 77
Compiled code, 320
Complex numbers, 325
Compositors, 227
Compression settings, 57, 58 (fig.), 91, 281
Concatenation, 330
Cone prop, 50, 110, 115
Conform function, clothing, 276
Conversational stances, 101
Cooper, Steve, 4
CorelDRAW, 120
CR2 files, 166, 167
defined, 163
Create Light button, 187, 210
Create Magnet option, 79 (note)
Create New Figure button, 98, 116, 160
Create Walk Path, 240–243, 245
Credo Interactive, 243
Cross-platform application, 166
Cryptography, 325
Curious Labs, 4, 357
hair texture, 311
Web site, 316
Current element pop-up, 35, 36, 50
Cycle Repeat setting for walking, 240
Cylinder prop, 109, 114
generating, 349–357
jack animation, 294, 296
as string, 283–284
Wave Deformer, 86

D

Data structures, 334
Daz 3D, 103, 154, 179, 187, 357
Bigfoot model, 138
Charger model, 120
Kids and Dog, 294
Poser characters, 4
Tunic Pack, 148
Dead air, 252–253
Deep Paint 3D, 120
Deep Paint w/Texture Weapons, 138, 140
Defaults
lighting, 204, 206–209, 210–213
Walk Designer, 239
Depth of field, 51
changing, 56
Dictionaries, 334, 337
Dinosaurs, 357
Display Frames control, 228
Display Time Code in Key Frames, 230
Dist End light setting, 211, 212
DLLs, 321
Document Display Style panel, 31–32

DOF. *See* Depth of field
Dolly camera controls, 47
Dolphin animation, 227, 233–236, 237
Dot notation, 321, 322
Dragon model, 367
Draw Outer Lines, 299
Droplet animation, 79
DTA file, 14
DXF format, 13
Dynamic link libraries. *See* DLLs

E

Ear lobes, 107
Easter egg, 29, 30 (fig.)
Eclipse simulation, 215–216
Edit Key Frames button, 54
Eee phoneme, 258
Effects artists, 227
Eff phoneme, 258
Element Properties window, 157, 192
Elements, 165, 236, 335
Emotions, 251, 252
Empty dictionary, 337
Empty geometry, 349
Empty list, 335
End Frame animation control, 53
Eovia, 166
Escape sequences, Python, 328
Export functions, 337
Flash files, 19, 293–294, 299, 303
Polo shirt, 281–282
Poser, 292
VET, 274, 280–282
Viewpoint Media Player Format, 17
Expressions (facial), 102, 250, 324
Extensions, 320 (note)
deleting, 282
dual, 282
library, 349
Eyebrows, 251
dials, 42
modifications, 265
using Mimic, 261
Eyedropper tool, 144
Eye elements
changing, 279
EyesBaggy setting, 106
EyesDown setting, 107
focusing, 102
lighting for, 219
parented to kick light, 220
positioning, 61, 62, 191, 192
using Mimic, 261
Eyelids, 43, 251

F

Face
 dials, 39–43
 expressions, 102, 250, 279, 324
 FaceLong setting, 105
 natural placement of features, 61–62
 and phonemes, 251, 256
 symmetry, 59–60
Face camera, 40, 44, 103, 148, 191
 changing, 47, 104
Faces model shelf with Phonemes, 256
Fairy Dance pose, 190
Falloff, 211
 defined, 205 (note)
 light, 212, 213
 transparency, 123, 365, 367
Female clothing, 126
Figures, 29
 adding, 35
 animation, 58–62
 controls, 72–77
 defined, 321
 height, 73
 image map, 5 (fig.)
 objects, 332, 333
Figure Parent window, 169, 180
Figures model shelf, 126, 169, 175, 262
 animals, 227
 T-shirt, 273
Fill layers, 133
Fill lighting, 203
Final Cut Pro, 13, 306
Finger elements
 aligning joints, 173
 changing positions, 75, 278, 284
 numbered segments, 76 (note)
First Frame animation control, 53
Fisheye lens, 46
Flags specifier, 334
Flash files, 21, 301
 animations, 20, 54
 exporting, 19, 292, 293–294, 299
 format, 293
 limitations, 303
 number of colors, 298 (tip), 302
 3D characters, 5, 19
 and transparencies, 302
Flash Shockwave. See Flash files
Float integer variable, 325, 334
Floor, 173, 328, 349–357
Focal dial, 50, 51
Focal length of camera, 44–45, 55
 changing, 46, 51, 52
 head, 217
 multiple characters, 50

portraiture, 47, 49
 short, 49
Fog bank with Ricks effect, 367
Foot elements, 65, 96–97
Forearm element, 195
 position, 66, 67, 185, 278, 286
 settings, 184
 transformed by Magnet, 83
Fortran code, 320
FPS
 Mimic screen, 259
 rate, 54, 57, 228
 Shockwave animation, 293
Frames. See also Key frames
 adding, 80
 controls on Animation palette, 230–232
 length, 253
 number fields, 53, 56
 rates. See FPS (frames per second), rate
 size, 57, 91
 walk animation settings, 239–240
Frames per second. See FPS
Frown setting, 41, 258, 259
 changing, 279
 lip-synch, 256, 257
Function construction, 339

G

Geometry, 164, 300
 button, 315
 defined, 34
 dense, 294
 managers and Tkinter, 341, 344
 primitive props, 349
 selection panel, 15, 16 (fig.)
 size, 294
Geometry Quality, 281
Ginger model, 294
Gladiator, 226
Global lighting, 205, 208
 defined, 203, 205
Glowing orb with Ricks effect, 365–367
GoLive. See Adobe GoLive
Gramps model, 294
 walking animation, 245, 246, 248
Graph Display window, 234
 lip-synch animation, 255, 263
Graphical user interface. See GUI
Graphics tablets, 141 (tip)
Grayscale, 130
 defined, 123
 images, 146, 272
Gremlin model, 241
Ground shadows, 80
 deactivate, 297, 299
 and elements placement, 63
 warping, 88 (note)

Grouping tool, 175
 for bone setup, 157, 158
GUI, 26
 actors changed to figures, 346–347
 cross-platform, 321
 Python scripting, 345
 Tkinter, 341, 342, 344

H

Hair, 193
 adding, 40, 98
 Casual Man animation, 307
 child, 283
 colors, 311
 effects, 138, 226
 female, 98
 Girl's Pig Tails, 190
 male, 98, 277
 texture, 310, 311
Hand elements
 aligning, 173
 assigning colors, 142
 bending, 185
 as child, 179
 enlarged, 75
 matched, 77
 as parent, 194, 285
 positioning, 66, 67, 191, 278
 realistic, 143
Happiness emotion, 251
Hash Animation:Master, 166
Head element, 104
 focal length, 217
 and lip-synch animation, 264–265
 positioning, 67, 74, 196, 197, 277, 287, 307
 tilt, 102, 196, 252
 using Mimic, 261
Head Light, 211, 212, 213
Height of characters, 77, 78 (fig.)
Heroic model, 169
Hide Figure feature, 100
Hierarchy Editor, 111, 167
 centaur creation, 168
 files, 163 (note), 164–165
 horse elements, 171
 parent/child relationship, 112, 116
 parent object, 160
Highlights
 defined, 204
 with kick lights, 221
 size setting, 216
High-resolution models, 294, 300–302
 and colors, 302
Hither camera control, 46
Hobbitlike Business Man character, 73, 78 (fig.)
Horizontal dual layout, 10, 11 (fig.)

Horse figure, 169, 175
House of Moves Motion Files, 244
HTML, 289
 generating documents, 282
 viewports, 281, 288
Humanoid model animation, 58–62

I

Ignore Camera Animation (VET), 281
IK. *See* Inverse Kinematics
ikChain, 165
Image editors, 125, 269
Image maps
 assigning, 148
 colors and lights, 221
 defined, 122
 of figures, 5 (fig.)
Images, 281
 manipulating, 276
 size for Flash export, 293
Immutable elements, 329
Import/export options, 337
Importing
 Poser animations, 306
 Poser module, 321, 323, 332
 rock object, 311
import string, 332
Index finger element, 76
Index (zero-based), 329, 347
Infini-D, 166, 306
Instances, 321
Integrated Development Environment (IDE), 320
Interactivity, 268, 282
Interface, 26, 27 (fig.)
Interpreted code, 320
Inverse Kinematics, 116
 for body parts, 165
 described, 63 (note)
 and feet position, 279

J

Jack animation, 294–298
Java scripting language, 320
Jawline, 104
Jaw position and phonemes, 252
Jeans, 276
Joint zone, 77
JPEG image, 89, 126

K

Key for dictionaries, 337
Key frames
 adding, 90
 assigning, 52
 Bigfoot/boy animation, 196
 button, 54, 80

controls, 54, 228
described, 228, 230–232
dolphin animation, 227
magician animation, 184
Mick animation, 299
rock dragging animation, 308
settings, 82, 197
Yo!Ball animation, 287
Kick lights, 220, 221
described, 219
Kneeling to standing animation, 63–68
Krause, Kai, 6

L

Label widget, 342, 343
Land mass, 89
Language, 320. *See also* Python scripting
Lasso tool, 125, 142, 147
Layouts of workspace, 6, 7, 10, 12, 26–30, 191
Leg element, 100, 279
len function, 326, 329, 333
Length of animations, 183, 307, 196, 294
changing, 80, 82, 84, 90
Flash export, 293
Lens
fisheye, 46, 49
group shots, 45
settings. *See* Focal length of camera
LifeForms animations, 243, 245
Light, 202
Light Controls, 188, 205, 207
Lighting, 205
animating, 289
and colors, 208, 218, 221
default in Poser, 204, 206–209, 210–213
diffusion, 317
for glowing orb, 365
intensity, 208
natural, 218
Python generated, 351
removing, 209
rendering, 213
specialists, 227
under-floor, 349–357
LightWave, 72, 83, 103, 166, 310
imports, 13–15
integrated with Poser, 306, 307, 317
map importing, 139
and mesh templates, 121
radiosity and caustics, 203
texture-creation, 317
walking animation, 243
LIPsinc, 259
Lip-synch animation
and head movement, 264–265
creating, 253–259

defined, 250
phonemes, 257
realistic, 252
using Mimic, 260, 261, 262
List box, 343–347
Lists
compared to strings, 335
defined, 334
functions, 336
LiveMotion. *See* Adobe LiveMotion
Load Scene window, 310
Logo, 271–272
creating, 282
Long integers, 325
Look It's A pose, 210
Looping animation, 55
control, 53, 231
interpolation, 230
and Python, 320
Low-polygon models, 34
Low-resolution models, 294, 299, 302
LWO format, 15

M

Macintosh computers
files, 263, 298
and LightWave [6.5], 310
memory allocation, 172 (note)
and Tkinter, 341
Macromedia Dreamweaver 4, 289
Macromedia Flash, 19, 292
Magic effects, 178, 182
Magician animation, 183, 184–186
Magic Wand tool, 130, 131, 271
Magnet Deformer, 77, 90
Magnets, 77
characterizing, 83–84
described, 79
location, 82 (note)
multiple, 81–83
parameters, 80
resizing, 90
saving changes, 300
Mag Zone
and ball prop, 81
described, 79
and forearm, 83
repositioning, 80
on wrist, 84
Make Movie, 237, 298, 299
window, 57, 91
Map Size controls, 207
Material Import screen, 138
Materials, 140, 141
Materials Editor, 113
Material Texture Library. *See* MTL files

Math
 functions, 320, 326–327
 modules, 327–328
 operators, 325–326
Matrix, The, and Poser, 318
Max Plug-In installer, 15
Maya, 83
Member functions of figure objects, 321
Merging function, 171
Mesh, 125
 added to geometry, 349
 anomaly, 129
 flattened, 138, 271
 mending, 277 (tip)
 templates, 120, 121 (fig.)
 T-shirt, 126, 135 (fig.)
MetaCreations, 4, 16, 166, 268
MetaStream, 4, 16, 268, 283
Michael model, 4, 216
 high-resolution, 294, 300–302
Mick model, 299
Mimic, 259, 260
 text added, 261
Minnie model, 20
Modeling programs, 139, 172
 PC, 166
Models
 hierarchical structures, 339
 original, 269
 replacing, 300, 301
Model shelf, 35. *See also* Faces model shelf with
 Phonemes; Figures Model Shelf
 hair, 40
 location, 32 (note)
 polo shirt, 276
 preexisting bones, 161
 props, 79
Modules, 321, 323, 327–328, 331, 332
Modulus operator, 326
Monitors, 12
 multiple setup, 95, 228
 dual setup, 12, 254
Morph channels, 309
Morphs, 38, 39–43
Morph target, 102
Motion blur feature, 146, 237–238, 271
Motion capture equipment, 243
Motion effects, 5
Motion files, 243, 309
Motion pictures, 166, 226, 318
Motion spline, 234, 235
Mouth element, 41, 107, 230
 corners, 108
 and phonemes, 250, 251
 settings for lip synch, 256, 257, 258
MS Word, 166, 320 (note)
MT. *See* Morph target

MTL files, 172
Multiple Magnets, 81–83
Multiplying Python strings, 331

N

Natural Stance, 97, 98
NetForce and Poser, 318
Numbers integrated in Python, 324–326
Numpy (Numerical Python), 349

O

OBJ files, 166, 167
 defined, 164
 format, 13
 saving, 172
Object Colors, 141
Object-oriented interpreted languages, 320, 321–323.
 See also Python scripting
Object-oriented programming, 347
Objects as constructs, 321
Oh phoneme, 257, 258
Old setting, 104, 105
One up/two down layout, 7, 8 (fig.), 95
Opacity layer, 126, 131, 133
 changing, 143
 for color, 269, 272
 setting, 144
OpenLips setting, 258, 259, 263, 264
Operations as functions, 321
Orbit camera controls, 47

P

Paint Brush tool, 143, 147
Painting, 143
 textures, 138–140
Parameters, 36, 63, 165, 351
 dial location, 38
 Magnet, 80
 settings, 41, 50, 52
 Wave, 86, 88
Parent element, 181, 220
 bone, 162 (note)
 defined, 111
 how to assign, 160 (note)
 setting, 116
Parent/child relationship, 154, 165, 193–198
 between objects, 178
Pedestaling, 47
Pencil tool, 146
P4 Nude Man model, 113, 168, 276
 bone structure, 173
P4 Nude Woman, 50, 120, 137, 148
 texture map, 141
PHI files, 164, 166
Phonemes, 252, 256
 assigning, 257
 changing, 263

combining for animation, 253
defined, 250
PhotoPaint, 120
Photo-quality images, 303
Photorealistic scenes, 317
Photoshop, 6, 100, 120, 122, 269
image maps, 123–129, 141
native format, 146
Piano model, 154
PICT image, 89
Pixels:3D, 103, 166
Play animation control, 53
Playback speed, 57–58
Play Range indicator, 232
Plug-ins, 15, 21, 166
adding, 13–14
creating, 22
Pocket illusion, 100
Point At feature, 190, 195, 218, 219
changing, 189
combined with parenting, 193–198
defined, 178
and Light Controls, 188
using, 187–189
Polo shirt, 275, 281–282
Polygons, 349, 350
Portrait lens, 44, 45
Pose Room, 20, 158, 175
Poser
Cinema list, 166
dot notation, 322
files used in Lightwave, 315
importing from Deep Paint into, 139
importing module, 321, 323, 332
integration, 318
phonemes, 250
simulating glowing orb, 365
textures, 203
Poser Hierarchy. *See* PHI files
Poser Pro Pack plug-ins, 13–14, 15, 166
Poses, 97, 148, 190
adding, 309, 310
Posette character, 40, 47, 49
Posing camera, 83, 100
Power Moves, 243
Power Walk setting, 242, 246
precision, 334
Preferences controls, 28
Preset lights, 206
Props, 50, 51
articulated, 154–155
ball, 79, 110, 179, 194
bowling pins, 213
box, 88, 89, 90
cone, 50, 110, 115
cylinder, 86, 109, 110, 114, 283–284, 294, 296, 349–357

elements combined, 159
made from geometry, 351
model shelf, 114
original, 113
static, 156
torus, 109, 110
Prop Properties window, 116, 156, 181
Przezak, Catharina, 216, 318
PSD file, 133
Pupil element, 192
PY files, 320 (note), 345
Python. *See also* Python scripting
extension library, 349
GUI, 341, 345
installation, 323
math functions, 326–327
math modules, 327–328
Python scripting, 22, 320
cylindrical corridor, 349–357
dictionaries, 337–338
format specifications, 334
generating lights, 351
hierarchical structure, 339
keywords, 322–323
lists, 334–336
object-oriented, 321
strings, 328–331, 331–334
tuples, 336
PZ3 files, 13, 14, 16, 306
deleting extension, 282

Q

Quad view, 32, 35, 187, 169
bone setup, 158 (note), 160, 162
lighting, 211, 219
multiple characters, 50
walk paths, 245
workspace layout, 7, 10, 12 (fig.)
Quaternion Interpolation, 230
QuickTime files, 54, 159

R

Radiosity, 317
defined, 202
simulation, 364
RAM, 172, 178
Ray Dream, 4, 72, 166, 306
Realism, 203
of hands, 143
of poses, 94, 102
of shadows, 213, 214
RealPlayer, 54
Rectangular Marquee tool, 126
Refraction, 203, 317
Rendering, 148
animations, 57, 91, 237, 259, 262, 299, 314
eclipse scene, 215, 216

high-quality, 294
image, 133
lighted scene, 213, 218
Michael Flash file, 301
with radiosity, 203
Renderosity.com, 138, 187
Repulser control, 110
Resting position, 154, 179 (note)
RGB settings, 269
Ricks, James, 364
Ricks effect, 141
creating, 365–367
Rock object
creating, 310
importing, 311
resizing, 313
Rotation
boy's body, 194
controls, 162
eyes, 192
model, 138, 139 (fig.)
settings, 181
RSR files, 163
Run setting, 242
Runtime folder, 164

S

Sand dollar pattern, 87
Sandstone texture, 271
Scale Factor, 281
Scars, 144
Scenes, 16, 332
creating, 15
defined, 321
Scrapes, 142
Screens, 6
dimensions, 293
multiple, 95
Scripting language, 320. *See also*, Python scripting
Scripting libraries, 321
Scripts
creating, 6
for parameter names, 351
writing, 349
Sequence variables, 334
Sets array, 349, 350
Setup Room
for bones, 154, 158, 161, 173
described, 18, 154
Sexy Walk setting, 242, 243
Shadows, 205
and backlights, 214
casting, 113, 114
controls, 207
intensity, 213–214
layers, 133

and Ricks effect, 365 (note)
setting, 208
Shin element, 63, 65, 113, 161
Shockwave files, 19, 20, 292, 303. *See also* Flash files
creating, 298
low-resolution models, 299
Shoes, 277
Shoulder element, 195
changing, 47
position, 66, 67, 278, 286
settings, 99
twist, 185
Show All Figures feature, 101
Shuffle setting, 242, 246
Simple Text, 166, 320 (note)
Simulation of glowing orb, 365
Sisemore, Ken, 213
Skin feature, 138, 144
color, 144
lighting and color, 218, 221
tightening, 105, 107
Skip Frames animation control, 54
Slicing, 330
Smile element
creating, 40–43
settings, 256, 257, 259
Soft Edges In HTML Window, 281
Sound files, 252–253, 264
Speed images, 21
Spline, 231, 265
Sports-style scenes, 178
Spotlights, 203
creating, 218
as kick lights, 221
Stage model, 179
Stances, 96
combat-like, 148
conversational, 100
natural, 97
repositioning, 96
settings, 95
women's, 100
Stand-alone files, 293
Statements, 322
Step Back/Forward animation controls, 53
Stop animation control, 53
Stride setting, 246
String, 283–284
parented to hand, 285
Strings (data type)
as characters, 328
concatenation, 330
defined, 323
member elements, 329
module, 331–332
parameter name and value, 351

Stripes, 133
 aligning, 126, 128 (fig.), 129
 merging, 131
Stuart Little, 226–227
Stylized Business Man model, 179
Subliminal element string, 288
Sugar Daddy character, 13, 14 (fig.), 15 (fig.)
Suitcase structure, 160, 161
Surface Editor, 311
Surface Material, 126, 133, 134, 148
 bump map, 274
 and object colors, 141
 Texture Map, 273
SWF. *See* Shockwave files
Symmetry
 arms, 96, 99, 183, 278
 facial, 59
 hands, 77
Syntax, 320, 332
 defined, 322

T

Table prop, 205, 208, 213
Tail element, 233, 234
 motion blur, 237
Taper setting, 74, 75
Teeth elements, 264
Television, 166, 318
Templates, 125, 271
 creating, 269
 defined, 120
Text description, 289
Text editors, 166, 320
 and Python, 323
Text input field, 261
Texture, 130, 138–140
 Canvas, 272
 creation engines, 317
 T-shirt, 271, 273, 274
Thigh element, 63, 65, 116
3D modeling programs, 103, 166
3DS format, 13, 138
3D Studio Max, 13, 72, 83, 103, 166, 243
 adding Poser characters, 306
 importing maps, 139
 importing Poser animations, 306
 integrated with Poser, 4, 315, 317
 and mesh templates, 121
 radiosity and caustics, 203
 setting up, 15
 texture-creation, 317
 workspace, 16 (fig.)
Throwing motion, 287–288
Thumb element, 76
TIFF image, 89
Tilt head, 102, 196, 252

Time indicator, 235
Timeline animation bar, 54, 67, 90, 196, 309
Tkinter interface
 geometry managers, 341, 344
 GUI capability, 321
 Python, 341
 setting up, 343
Tongue element, 41, 279
Torso, 109, 173
Torso Top in Hierarchy Editor, 112
Torus prop, 109
Translate tool, 49, 50, 61, 63, 74, 173
 and Mag Zone, 80
Transparencies, 215
 described, 134
 falloff, 365, 367
 Flash files, 302
 preserving, 131
Transparency maps, 4
 assigning, 136
 controls, 134
 described, 123
 example, 124 (fig.)
T-shirt model, 129
 logo, 271–272
 map, 270 (fig.)
 mesh, 126
 rendered, 137 (fig.)
 sleeveless, 134–137
 texture on template, 125
Tuples, 336, 347
Tweaks control, 239
Twist feature, 60, 61, 165, 185
 feet, 97
 tail fin, 234, 235
2D Motion Blur
 button, 237
 feature, 21
Two left/one right layout, 7, 9 (fig.)
Two up/one down layout, 7, 8 (fig.)

U

UltraMorph Man model, 103
UltraMorph Woman model, 103
Unary operators, 326
Under-floor lighting, 349–357
Underwater scenes, 13
Unix, 341
Urgency emotion, 251
Use Animation Sets (VET), 281
Use Wavelet Textures (VET), 281
User interface of Poser, 6
UVMap, 311
 and hair color, 312 (fig.)
 templates, 120, 121, 269

V

Values, 337
Variables, 325
 defined, 323
 GUI-related, 347
 as references to objects, 326
Vertex data, 350
Vertices array, 349
VET. *See* Viewpoint Experience Technology
Victoria model, 4, 103–108, 294
Viewpoint Experience Technology, 17, 268, 276
 animations, 283–288
 exporting to, 274, 280–282
Viewpoint Media Player, 17, 18
 controls described, 280
 install, 288
 previewing polo shirt, 275
Viewports, 6–10
 active, 32, 33 (fig.)
 multiple, 10, 12, 99
Views, 32–38
 changing, 32
 default, 6-10
VMP. *See* Viewpoint Media Player
Vue d3Esprit, 203

W

Wacom Intuos tablet, 141 (tip)
Walk Designer, 238, 242, 246
 controls described, 238–240
Walking animations, 238–240, 240–243
 controls, 239
 Cycle Repeat setting, 240
 movements, 59
Walk In Place setting, 240
Walk paths
 creating, 240–243
 multiple, 245–248
Warrior woman, 141–148
Wave, 85
Wave Deformer, 300
 assigned to cylinder, 86
 described, 85
 settings, 87
Waveforms
 defined, 252–253
 Mimic, 260
 reading, 253
WAV files, 252
Web browser, 288
Web page, 275
 creating, 282

Weinberg, Larry, 4
Welding bones, 158
Whole Group button, 172
Whu phoneme, 256
Widget objects
 defined, 342
 labeled, 342, 343
 scrollbar, 345
 Tkinter, 341
Wince morphs, 43
Wind effects, 357
Window Light, 212, 213
Windows, 341
Windowshade effect, 29 (tip)
Windows Media Player, 54
Word. *See* MS Word
Workspace, 7, 10, 191
 animation, 55
 lighting, 187
 posing, 95
 rearranging, 26–30
 single-screen layouts, 6, 12
Worry dials, 42
Wrinkling, 105
Wrist element, 84
 rotation, 59, 60, 61
www.charactermotion.com, 243
www.curiouslabs.com, 316
www.daz3d.com, 94
www.discreet.com, 166
www.eovia.com, 166
www.hash.com, 166
www.lipsinc.com, 259
www.maxoncomputer.com, 166
www.newtek.com, 166
www.pixels.net, 166
www.renderocity.com, 102, 103, 120, 138
www.uvmapper.com, 121
www.viewpoint.com, 268 (note)

X

x-, y-, zRotate lighting, 207
x-, y-, zTran lighting, 211

Y

Yo!Ball animation, 283–288

Z

Zero-based index, 329, 347
Zygote Media Group, 103
Zygote/DAZ 3D site, 187

If you *like* this book, you'll *love*...

Canoma™ Visual Insight
by Richard Schrand

ISBN #: 1-57610-626-8
$24.99 (US) $37.99 CANADA

Takes you on a guided tour of this powerful program, showing you the key features that will make your 2D work stand out in 3D. After you learn Canoma basics and tricks of the trade, you'll apply your skills to real-world projects like creating an interactive city complete with storefronts, houses, and people.

3ds max™ 4 In Depth
by Jon McFarland, Rob Polevoi
Media: CD-ROM

ISBN #: 1-57610-869-4
$59.99 (US) $89.99 CANADA

Provides you with a comprehensive reference for creating effects for films, movies, and games. This book covers the modeling and modification of structures from primitive objects, plus other parametric design tools found in the program. *3ds max 4 In Depth* contains various exercises to strengthen the concepts learned, with a color studio showing what can be done with this program.

Character Animation with LightWave™ [6]
by Doug Kelly
Media: CD-ROM

ISBN #: 1-57610-380-3
$59.99 U.S. $89.99 CANADA

Includes tips, tricks, and insider information on LightWave, which was used to create effects for *Men in Black*, *Titanic*, and *The Fifth Element*. Provides insight into mastering character animation with a special focus on facial animation and walking. The CD-ROM contains script-writing templates, sample storyboards, exposure sheets, a complete project soundtrack with original music and sound effects, and trial versions of LipService, Magpie Pro, Shave and A Haircut, plus other plug-ins and programs.

Bryce® 4 f/x & Design
by R. Shamms Mortier
Media: CD-ROM

ISBN #: 1-57610-482-6
$49.99 U.S. $74.99 CANADA

Bryce® is the software for developing photo-realistic environments, and *Bryce 4 f/x & Design* shows you the program's tricks. Learn from the masters as a dozen computer graphics and animation professionals share their secrets for creating spectacular effects and stunning scenes in Bryce.

What's on the CD-ROM

The Poser 4 Pro Pack f/x & Design companion CD-ROM contains elements specifically selected to enhance the usefulness of this book, including:

- A fully-functional demo version of Poser 4 for both the Mac and PC
- A fully-functional demo version of Deep Paint 3D w/ Texture Weapons (PC Only)
- Free models for Poser including:
 - Bigfoot from DAZ 3D
 - TDragon and TSword created specifically for the book from Dedicated Digital
 - A dozen props created by Ken Sisemore
 - Boxfish prop created by Robert Whisenant
- Animation files that demonstrate the tutorials and projects in the book
- An original texture by Catharina Przezak, recognized as the leading photorealistic texture creator for Poser and the Poser Pro Pack
- Original Python scripts developed by John Brugioni

Note: The following software is required to complete projects and tutorials for both PC and Macintosh:

- Poser 4 for either the Mac or PC. The demo version can be used to run the basic tutorials and projects, but the Poser 4 Pro Pack upgrade is necessary to work through many of the advanced features. You must have a full version of Poser 4 to run the Poser 4 Pro Pack.
- Adobe Photoshop, CorelDRAW, Painter, or similar image manipulation program.

System Requirements

Software:

- A PC running Windows 98, 2000, NT or higher
- A Macintosh PPC, G3 or G4 running System 8.0 or higher

Hardware:

For both systems, the more RAM you have installed, the better.

- Pentium system (or equivalent) with a minimum of 64MB RAM (128MB is preferable) running at 250MHz or greater. Color monitor and CD-ROM. 50MB free hard disk space minimum.
- Macintosh PPC, G3, or G4 with a minimum of 64MB RAM (128 preferable) running at 250MHz or greater. Color monitor and CD-ROM. 50MB free hard disk space minimum.